THE SMITH COLLEGE MUSEUM OF ART

EUROPEAN AND AMERICAN PAINTING AND SCULPTURE

1760–1960

THE
SMITH COLLEGE
MUSEUM
OF ART

EUROPEAN AND AMERICAN
PAINTING AND SCULPTURE
1760–1960

JOHN DAVIS AND JAROSLAW LESHKO

Introduction by Suzannah J. Fabing

HUDSON HILLS PRESS

NEW YORK

In Association with the Smith College Museum of Art,
Northampton, Massachusetts

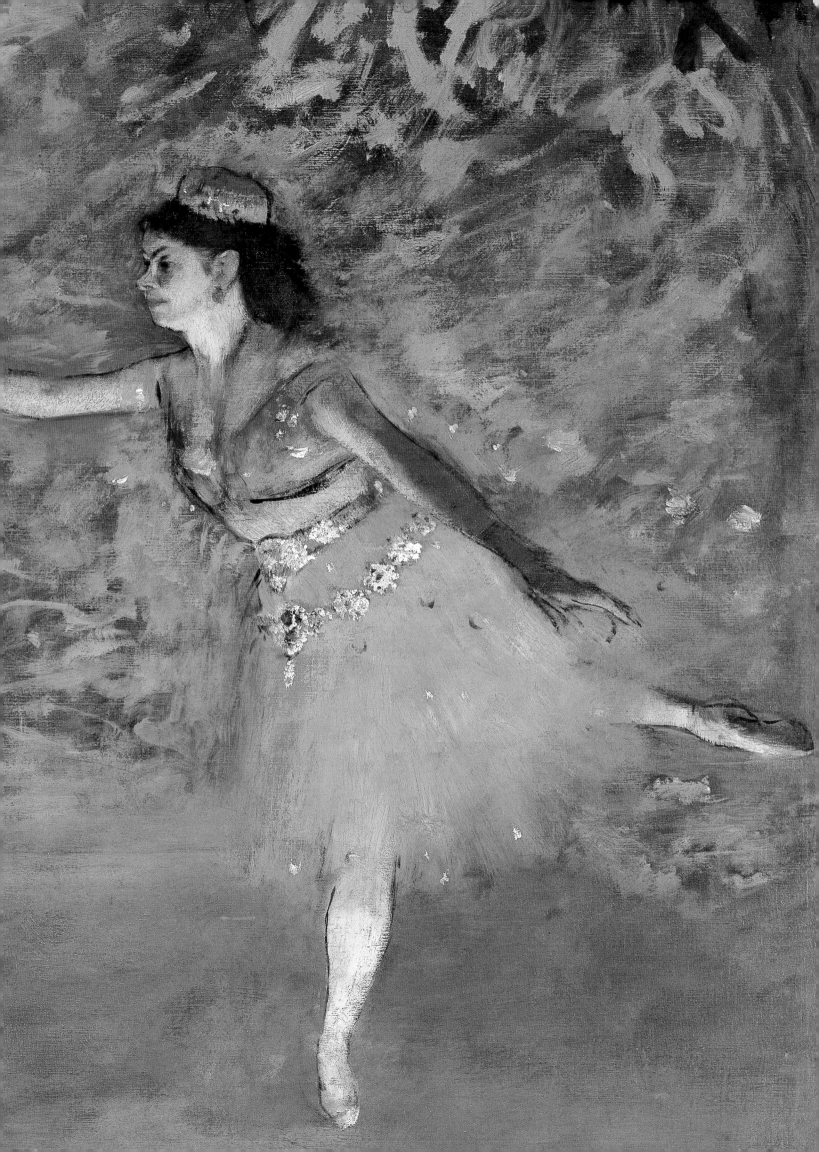

First Edition

© 2000 by the Smith College Museum of Art.

All rights reserved under International and Pan-American Copyright Conventions.

Published in the United States by Hudson Hills Press, Inc., 1133 Broadway, Suite 1301, New York, NY 10010-8001.

Distributed in the United States, its territories and possessions, and Canada by National Book Network.

Editor and Publisher: Paul Anbinder

Proofreader: Fronia W. Simpson

Indexer: Karla J. Knight

Designer: Martin Lubin

Composition: Angela Taormina

Manufactured in Japan by Toppan Printing Company.

Library of Congress Cataloguing-in-Publication Data

Smith College. Museum of Art.

Smith College Museum of Art: European and American painting and sculpture, 1760–1960 / John Davis and Jaroslaw Leshko; introduction by Suzannah J. Fabing. — 1st ed.

 p. cm.

"In association with the Smith College Museum of Art, Northampton, Massachusetts."

Includes bibliographical references and index.

ISBN: 1-55595-195-3 (paperback: alk. paper)

1. Art, European — Catalogues. 2. Art, American — Catalogues. 3. Art — Massachusetts — Northampton — Catalogues. 4. Smith College. Museum of Art — Catalogues. I. Davis, John, 1961– II. Leshko, Jaroslaw, 1939– III. Title.

N6750 .S67 2000

7098.4807474423 — dc21 00-40936

Cover illustrations: Front: Left, Ernst Ludwig Kirchner, *Dodo and Her Brother*, 1908/20; right, Augustus Saint-Gaudens, *Diana of the Tower*, 1899. Back: Left, Pablo Picasso, *Table, Guitar, and Bottle (La Table)*, 1919; right, Edwin Romanzo Elmer, *A Lady of Baptist Corner, Ashfield, Massachusetts* (detail), 1892.

CONTENTS

European Painting and Sculpture

American Painting and Sculpture

10 cents
EACH

THE SMITH COLLEGE MUSEUM OF ART
EUROPEAN AND AMERICAN PAINTING AND SCULPTURE
1760–1960

ACKNOWLEDGMENTS

Our foremost debt is to Suzannah Fabing, who first conceived of this volume and graciously invited us to become its authors. She then took on the task of editing the book, which she performed superbly. Suzannah's tenure as director of the Smith College Museum of Art has been marked by a series of fruitful collaborations between the museum and the art department. The benefits of this teamwork are manifold, and her efforts have had the virtue of returning the museum to its historical mission as a rich and rewarding teaching collection, as she outlines in her introduction. In this spirit, we are delighted to have been able to play a role in making one of Smith's greatest resources even more widely known to the larger public.

The museum's staff, in addition to its director, has facilitated our work by answering questions, making curatorial records available, and responding to repeated requests to view works in storage. Here David Dempsey, Stefne Lynch, and Linda Muehlig were notably generous with their time, and Michael Goodison deserves particular thanks. Michael capably managed all the details of this project from its inception, and in addition, he stepped in to type the European half of the manuscript. Nancy Noble, as well, performed a great service by compiling most of the bibliographies for the European section from which the selections were made. Daniel Bridgman was generous with his time and patience solving a vexing photograph problem.

The administration of Smith College, through the offices of the president, the provost, and the dean for academic development, has contributed to this project through the welcome gift of time; both authors were granted Harnish Fellowships from the college to lighten their teaching loads.

Although we had already come to know and love many of the works in this volume through our regular teaching, we are mindful of the students, colleagues, and friends who have previously conducted research on this collection and, in some cases, published their findings. We have greatly benefited from the intellectual labor of these scholars, especially Cynda Benson, Ann Boutelle, Walter Denny, Elizabeth Evans-Iliesiu, Amanda Glesmann, Caroline Jennings, Betsy Jones, Patricia Junker, Amy Kurtz, Megan McIntyre, Linda Merrill, Linda Muehlig, Margaret Oppenheimer, and Giovanna Sabatini.

Finally, John Davis would like to express his thanks to his partner, Jason Heffner, who among his other good deeds willingly put home life on hold when the deadline loomed. Jaroslaw Leshko wishes to thank his wife, Alla, and their daughter, Adriana, for their insight, patience, and loving support.

J.D. AND J.L.

INTRODUCTION

This book presents one hundred of the most admired paintings and sculptures belonging to the Smith College Museum of Art, which is widely acknowledged to have one of the most important art collections at an American liberal arts college. The authors are professors in Smith's art department who have thought about and taught from these works for years, and they here share their reflections with readers who may not have had the good fortune to sit in their classrooms. John Davis, whose field is American art and architecture, came to Smith from the National Gallery of Art in 1992, and Jaroslaw Leshko, whose specialty is nineteenth- and twentieth-century European art, has taught at Smith for more than thirty years, having begun his career at the college in 1968. Professor Davis has written the essays on fifty American works for this book, and Professor Leshko has written on fifty by European artists.

Choosing what to include in this publication was not easy, because the collection contains many memorable works of art. After considerable thought, we decided to focus on European and American works of the period 1760–1960, recognizing that the modern era has historically been the area of greatest strength in the museum's holdings. Smith is fortunate to have extensive collections of drawings, prints, and photographs from this period, but with reluctance we decided to concentrate on paintings and sculpture only. Had we not, the pain of narrowing the list to one hundred works would have been even more acute.[1]

How did a small liberal arts college come to have a collection of this importance? The answer is that it began early, acted adventurously, and from the outset established a focus for its activity. Its founders conceived of Smith College as a school that would have an academic rigor equivalent to the men's colleges of its day but that would differ in giving the arts equal emphasis with other disciplines. In 1872 a prospectus for the new college explained,

More time will be devoted than in other colleges to aesthetical study, to the principles on which the fine arts are founded, to the art of drawing and the science of perspective, to the examination of the great models of painting and statuary, to a familiar acquaintance with the works of the great musical composers, and the acquisition of musical skill.

In his inaugural address in 1875 the first president, Laurenus Clark Seelye, elaborated further:

In the fine arts, as in literature and science, the College should simply aim to give that broad and thorough acquaintance with mind which is in itself the best preparation for special work in any calling. If this be its aim, however, it cannot be true to its character and ignore art. Too many of the grandest creations of the human intellect are embodied in the fine arts to remain unnoticed by an institution which seeks the highest mental culture.... [The College] should have its gallery of art, where the student may be made directly familiar with the famous masterpieces....

To that end, Seelye saw to it that College Hall, the new school's first building, included an art gallery. Initially, as was customary in schools and even in America's few city museums of this era, the contents of the gallery were largely plaster casts of famous antique sculptures and engravings or photographs reproducing well-known paintings. Art students were typically trained by copying such models, and early photographs of Smith students at work in College Hall show that they, too, followed this practice. Seelye made it clear, however, that the arts should not be "mere accomplishments" for Smith students, "but . . . serious pursuits which demand strenuous intellectual work in order to prosecute them successfully."

With this in mind, President Seelye also believed that it was important for Smith students to become familiar with the work being made in America by artists of their own time. As early as 1879 he set about building a collection of contemporary paintings, often by buying work directly from the artists in their studios. Thomas Eakins's *In Grandmother's Time* (pp. 148–49) is one of the earliest of Seelye's purchases. By the end of 1879 the *Springfield Republican* wrote enthusiastically of the twenty-seven paintings that had been hung in the college art gallery, "It may well be doubted if there is as good a collection of the works of American artists to be found anywhere among the same number of paintings.... For the artists are for the most part representative men, and the pictures are representative paintings, as good as any they have produced." Seelye was advised in his buying initially by J. Wells Champney, a noted artist whom he had hired to teach drawing at Smith in the early years, and later by the tonalist landscape painter Dwight W. Tryon (see pp. 230–33), who joined the faculty in 1886 and remained until his retirement in 1923.

Tryon proved to be pivotal in the collection's development in more ways than one. As Henry White observed in a memorial tribute in 1924, "It was the good fortune of the College that, through Mr. Tryon's early association with most of the artists, in some cases before they had achieved success, he was able to acquire works for the College that are now beyond the reach of most of our museums and collectors." Tryon limited his buying

to American paintings of the last quarter of the nineteenth century, explaining that "the best examples of other art are usually out of our reach financially, and as I do not believe in adding any but the best it leaves us little scope." Whistler (pp. 234–35), Hunt, Chase (pp. 138–39), Kent (pp. 188–89), Blakelock, Dewing (pp. 144–45), Thayer, and Wyant were among the painters whose work he was influential in acquiring for Smith. Saint-Gaudens's *Diana of the Tower* (pp. 216–17) was an audacious early entry into sculpture collecting.

The college was remarkable in dedicating substantial funds to building its art program in its early years. Already in 1877 a trustee had offered a $2,000 gift for an art collection, with the proviso that the trustees appropriate a matching sum. Not only was that challenge met, but an additional $3,000 was raised by subscription, yielding $7,000—roughly the equivalent of $350,000 today. This money was largely used to purchase plaster casts of famous Greek and Roman sculptures and a series of autotypes by the photographer Adolphe Braun—reproductions of drawings and paintings in many of the great museums of Europe—for the art gallery in College Hall.

In 1881 a retired Northampton businessman named Winthrop Hillyer, who had previously indicated no particular interest in Smith or in art, came forward with an offer of $25,000 to construct an art building—if the college would commit $8,000 to increasing the art collection. Again, the college complied, and Hillyer Art Gallery was completed in 1882. The following year Hillyer died, having indicated his intent to give an additional $50,000 for increasing the art collection and maintaining the building. In 1887 his brother and sister fulfilled his intended bequest and also contributed $10,000 for an addition to Hillyer Art Gallery, and his sister established a $15,000 trust to fund the collection.

With a dedicated building for the study of art, plus not inconsequential funds with which to shape a collection, Smith had already differentiated itself from many of the other liberal arts colleges of its day. Often, the art collections at such colleges began as a hodgepodge of random gifts from alumni, curiosities picked up by traveling faculty or missionary graduates, and portraits of college worthies. At Smith, the collections were purposefully shaped from the college's inception, with its educational aims firmly guiding the choices made.

Alfred Vance Churchill played an important role in this shaping process. Churchill was hired in 1905 as the first incumbent of a chair of History and Interpretation of Art and given charge of the growing art collection. It was under his leadership that the first loan exhibition took place, a show of old master etchings held in 1911 for the benefit of students in Professor Churchill's Art 14, "History of Painting." Inspired by this show, student members of the Studio Club and their friends got together and bought a fine impression of Rembrandt's

Three Crosses, the first European work—and the first print—to enter the collection. In 1914 Churchill affirmed the expansion of the museum's collecting horizons with the purchase of a Rodin bronze, *Children with Lizard*, and finally in 1919—the year Churchill was named director of the Smith College Museum of Art and the collections were first formally so designated—he embarked on the purchase of European paintings, beginning with Georges Michel's *Landscape*.[2]

When they named him director, the college's trustees asked Churchill to articulate a collecting plan for the newly formalized Museum of Art. He termed his response a "Concentration Plan" and recommended the radical course of centering the collection on modern European and American art. In reflecting back at the end of his directorship, Churchill described his thought process in these terms:

No one engaged like myself in teaching the history of art could have failed to be impressed with the total inadequacy of a collection limited to American works. What, I reflected, would a professor of literature think if he had nothing for his students to read but American authors of the fourth quarter of the 19th century? A college museum of art ought surely to aim at representing the art of the world, not that of a single nation or period.

Yet selection and concentration imposed themselves inexorably. But what field ought we to choose? What nations and periods were of first importance?

It seemed to me that attention must be devoted, first of all, to the cultures from which our own is derived and on which it rests,—Egypt, Greece, Rome, and the rest, down through the Renaissance. We must follow the main stream of western civilization. The arts of Europe may not be more important in themselves than those of the Orient. They are more important *to us*.

But even this area was impossibly vast. While its chief phases might eventually be illustrated with a few examples we could never do justice to all. The only practicable plan was to do what we could for the great historic periods, and to choose a limited field for more adequate representation. The educated man has been defined as one who knows "everything of something and something of everything." So a college museum might hope to acquire "something" of every period, and richer and fuller illustrations (if not "everything") of one of them....

The next step was the choice of a special field for concentration—a difficult choice. My proposal was this: Let us select, not a nation or school but a *topic*—the Development of Modern Art.... Where does modern art begin?... Let us assume that modern art begins with the period of the French Revolution. At that period ancient beliefs, traditions and practices were ruptured and new ones started in every realm of thought including art. The break with the past has never been more complete.

The solution was novel and radical. No college had emphasized the modern period. Too often the interests of educational institutions had been "one with Nineveh and Tyre," and still are, as far as art is concerned. Yet the modern period is one of great richness and significance, and very close to our sympathies....

The other key plank in Churchill's platform was quality:

for our purpose quality had to be the first consideration. A weak or inferior work could only be misleading to the student. Everything in the collection must show the imaginative conception of the master who made it, must reveal something of his suppleness, strength, and beauty. And it must show his "handwriting": it must be "signed all over" with the characters that he and he alone has given the world or could give.

Unlike the best museums of Europe, however, he observed:

I was willing to acquire a *fragment* where they would not, for even a fragment may reveal the master. I would take an *unfinished work* where they would not, for such a work may convey quite as much as a finished one.

(While he recognized that European museums might acquire fragmentary or damaged works of antiquity or the Renaissance, Churchill saw his uniqueness in adopting this policy for "modern" art.) Among Churchill's acquisitions, Courbet's *Preparation of the Dead Girl* (pp. 38–39) and Cézanne's *Turn in the Road at La Roche-Guyon* (pp. 32–33) — both unfinished paintings by artists he considered "indispensable" to the collection — hold pride of place alongside Eakins's brilliant *Edith Mahon* (pp. 150–51).

Thus, Churchill set himself a dual mission: a "distribution project" involving collecting individual strong examples to establish a broad representation of the chief phases of Western civilization, and a "concentration project" covering modern art. The selections in this book, which very closely match the period of his "concentration project," are testimony that the museum's greatest strengths today lie in what Churchill defined as the modern era.

As the museum grew, its quarters in Hillyer Art Gallery became increasingly inadequate. Having long hoped to do so, in 1924 Dwight Tryon and his wife, Alice, pledged $100,000 to build a new, dedicated museum building. Tryon did not live to see his building realized; he died in July 1925, shortly after the groundbreaking. His will included a handsome endowment of $300,000 for maintenance of the new Tryon Gallery, adding to the art collection, and supporting the college's teaching in the field.

It was Churchill's successor as director, Jere Abbott, who turned the museum's acquisition funds to brilliant use. Abbott had been associate director of the Museum of Modern Art in New York during its initial years, immediately before he came to Smith in 1932. He arrived in Northampton armed with knowledge about the avant-garde art of Europe, acquaintance with many of the important taste-makers of the day, a discriminating eye, and President William Allan Neilson's mandate to run a professional museum at Smith. His early purchases,

including Picasso's cubist *Table, Guitar, and Bottle* (pp. 96–97), shocked many. "A geometrical nightmare," thundered the *Worcester Sunday Telegram* in 1938. Abbott bought boldly; many of the works that are today considered masterworks of the collection were purchased within a year or two of their creation. The Calder mobile (pp. 136–37) and Sheeler's *Rolling Power* (pp. 220–21) come readily to mind. He was instrumental in the college's decision in 1943 to commission a mural for the Hillyer Art Library from the Mexican artist Rufino Tamayo, who was little known in this country at the time. The resulting work, *Nature and the Artist: The Work of Art and the Observer,* was the artist's first American fresco. Important paintings and sculptures by Degas (pp. 42–49), Monet (pp. 82–87), Manet (pp. 78–79), Seurat (pp. 118–19), Vuillard (pp. 120–23), and many other artists entered the collection during Abbott's tenure.

Abbott left the directorship in 1946, to be succeeded for a year by Frederick Hartt, who was brought to Smith as acting director and as a visiting lecturer in the art department. With the concurrence of the art department, the president, and the trustees of the college, Hartt carried out a spate of deaccessioning of works considered to be of little use in teaching. Many of the American paintings acquired in the early years of the college were sold, for the most part at nominal prices, since these works were out of artistic fashion at the time. Some now grace the walls of other distinguished museums: Thayer's *Winged Figure* is at the Art Institute of Chicago, for example, and Dewing's *Lady with a Lute* can be seen at the National Gallery of Art in Washington. Others, such as two rare garden still lifes by Maria Oakey Dewing, cannot be traced. This regrettable chapter in the museum's history constitutes an object lesson in the vagaries of taste and the need for caution in "pruning" collections that should be heeded by museum directors everywhere.

The noted architectural historian Henry-Russell Hitchcock served as director from 1949 through 1955. He bought both American (pp. 168–69 and 222–23) and European (pp. 74–75, 88–89, 92–93, and 124–25) works, with a particular emphasis on strengthening the English holdings.

Robert Owen Parks succeeded Hitchcock and served as director until 1961. His wide-ranging acquisitions include Kirchner's *Dodo and Her Brother* (pp. 72–73) and Stuart's *Henrietta Elizabeth Frederica Vane* (pp. 228–29). He was followed in the directorship by Charles Chetham, during whose lengthy tenure (1962–88) the collection more than tripled in size. Chetham made a particular effort to build the museum's holdings of contemporary art and photography. Among his purchases were the Barye *Theseus Slaying the Centaur Bienor* (pp. 22–23), the Carpeaux *Bust of a Chinese Man* (pp. 30–31), Degas's *Dancer Moving Forward* (pp. 48–49), the Fantin-Latour *Mr. Becker* (pp. 52–53), the untitled

15

canvas by Joan Mitchell (pp. 198–99), two Rodin sculptures, *Man with the Broken Nose* (pp. 112–13) and *The Walking Man* (pp. 114–15), and John Singer Sargent's *My Dining Room* (pp. 218–19).

By the 1960s the popularity of art courses with students and the growth of the museum's collections again put pressure on the physical facilities, and planning for a new building began. Hillyer, Tryon, and Graham (an auditorium wing that had been added to Hillyer in 1910) were razed and replaced in 1972 by a new Fine Arts Center incorporating buildings that retained these three names, arranged around a central courtyard. Tryon Hall, the new home of the Smith College Museum, was four times the size of the former Tryon Art Gallery. It afforded space to show much more of the collection and state-of-the-art facilities for making those works not on display readily available on request to visitors and students.

Chetham's successors, Edward Nygren (director 1988–91), Charles Parkhurst (acting director 1991–92), and I, have faced a different challenge. While the most recent purchases to appear in this volume, Boilly's *Young Painter and His Model* (pp. 26–27) — executed on the eve of the French Revolution — and Guérin's *Clytemnestra Hesitating before Stabbing the Sleeping Agamemnon* (pp. 64–65), fall squarely within Churchill's "concentration" and would, I like to think, have met fully with his approval, it is no longer quite so straightforward to conclude, at the outset of the new millennium in America, that we must follow only the "main stream of western civilization." Today the art historical canon is being challenged and stretched in many directions. The curriculum addresses not only the Western tradition but the equally rich traditions of Africa, Asia, Islam, the Native American and pre-Columbian cultures, and the multiethnic strands, drawing on all of the above, that constitute the complex American cultural fabric. The historical roles of women and other formerly ignored groups are being reexamined. Contemporary art speaks not with a single voice, or even with two in opposition as in earlier times. It is a babble of many competing voices, delivered not only in conventional formats but also as installation and performance work and in forms incorporating video, film, sound, light, and computer imagery.

Our challenge, as a teaching museum that supports Smith's instructional mission, is to redefine the "distribution project" on which Churchill embarked and to realize it, while at the same time maintaining and building on our historic strength, already achieved by his farsighted "concentration project." It is a daunting challenge indeed. As we proceed, his exhortation to quality must remain ever in the forefront.

This is no longer a solitary effort, however. For the first seventy-five years of Smith's existence, the collections were shaped largely through purchases made by the key individuals discussed above. By the 1950s the few purchases the museum could make each year — usually no more than two or three paintings and sculptures — were already easily outnumbered by gifts. Increasingly as the second half of the century wore on, gifts became the primary means of building the collection. The body of alumnae who had learned to love art at Smith continued to swell. Some became collectors and remembered their alma mater; others worked in the arts or volunteered their talents there and used their connections to help the museum. Alumnae unable to contribute art to the museum themselves sometimes turned their friends' or families' munificence toward the college. Others with no connection to the college have supported the museum because of the high standard it upholds and because they recognize the importance of its mission. Without these donors, the museum's collection would be a much more modest affair, particularly as rising prices in the art market have diminished the power of the museum's acquisition funds. The generosity of alumnae and friends of the college has been remarkable, and their adherence to the standard of quality put forward by Churchill equally so.

Among the many donors to the museum, those associated with works in this book deserve special mention here. They include Jere Abbott; Mr. and Mrs. Duncan Boeckman (Elizabeth Mayer, class of 1954); Joseph Brummer; Mrs. Charles W. Carl (Marie Schuster, class of 1917); Jane Chace Carroll, class of 1953; Beatrice Oenslager Chace, class of 1928; the Chace Foundation, Inc.; Annie Swan Coburn (Mrs. Lewis Larned Coburn); Mr. and Mrs. Ralph F. Colin (I. Georgia Talmey, class of 1928); Eleanor Lamont Cunningham, class of 1932; Mrs. Henry T. Curtiss (Mina Kirstein, class of 1918); Mrs. John Stewart Dalrymple (Bernice Barber, class of 1910); the Dedalus Foundation; E. Porter Dickinson; Louise Ines Doyle, class of 1934; Mr. and Mrs. Allan D. Emil; Alice Rutherford Erving, class of 1929; Dr. and Mrs. Joel E. Goldthwait (Jessie Rand, class of 1890); Frank L. Harrington; Mr. and Mrs. Harold D. Hodgkinson (Laura White Cabot, class of 1922); Mrs. Charles Inslee (Marguerite Tuthill, class of 1915); Anne Holden Kieckhefer, class of 1952; Mrs. Sigmund W. Kunstadter (Maxine Weil, class of 1924); Anne Morrow Lindbergh, class of 1928; Mrs. Charles MacArthur (Helen Hayes, LHD 1940); Nanette Harrison Meech, class of 1938; Constance Morrow Morgan, class of 1935; Dwight W. Morrow, Jr.; Roy R. Neuberger; Louise Nevelson, DFA 1973; Eliot Chace Nolen, class of 1954; Mrs. John W. O'Boyle (Nancy Millar, class of 1952); Helen Haseltine Plowden; Mrs. Winthrop Merton Rice (Helen Swift Jones, class of 1910); Paul Rosenberg and Company; Madeleine H. Russell, class of 1937; Mrs. Otto Seiffert (Marjorie S. Allen, class of 1906); Ettie Stettheimer; Mrs. Robert S. Tangeman (E. Clementine Miller, class of 1927); Mrs. Charles Lincoln Taylor (Margaret Rand Goldthwait,

class of 1921); Bernice Hirschman Tumen, class of 1923; the Honorable and Mrs. Irwin Untermyer; the Carey Walker Foundation; Adeline F. Wing, class of 1898; Caroline R. Wing, class of 1896; and the Robert R. Young Foundation. Donors who have established endowment funds for the purchase of works of art are equally important. Our thanks go to Beatrice Oenslager Chace, class of 1928; donors to the Acquisition Fund in honor of Charles Chetham; Mr. and Mrs. Charles C. Cunningham (Eleanor Lamont, class of 1932); Elizabeth Halsey Dock, class of 1933; Mr. and Mrs. Richard Evans (Rebecca Morris, class of 1932); Rita Rich Fraad, class of 1937; Drayton Hillyer; Winthrop Hillyer; Janet Wright Ketcham, class of 1953; Sarah J. Mather; Eva W. Nair, class of 1928; Diane Allen Nixon, class of 1957; Janice Carlson Oresman, class of 1955; Katherine S. Pearce, class of 1915; Madeleine Haas Russell, class of 1937; Kathleen Compton Sherrerd, class of 1954; Josephine A. Stein, class of 1927; Dwight W. Tryon; donors to the Class of 1990 Art Fund; and donors to the Museum Acquisition Fund with gifts in honor of Marjorie Resnikoff Botwinik, class of 1937, Caroline Newburger Berkowitz, class of 1921, and Barbara Petchesky Jakobson, class of 1954.

Finally, I would like to thank the many people who have made this book possible. When the idea for such a volume first arose, it was the wholehearted enthusiasm of the museum's Visiting Committee and Tryon Associates that moved the project swiftly from dream to reality. Dr. and Mrs. Julius H. Jacobson II (Joan Leiman, class of 1947) immediately stepped forward with a generous gift to begin work, and the Tryon Associates, the Friends of the Museum, and the Kunstadter Fund have supported its continuation.

My colleagues in the art department, John Davis and Jaroslaw Leshko, also eagerly volunteered for the all-important task of writing the text. Although they may since have had second thoughts, they have graciously not voiced them as they have labored mightily to condense their insights into no more than six hundred words per object. It has been a genuine pleasure to work closely with them on this undertaking, one that will doubtless bear further fruit as they teach from the collection in the future. Paul Anbinder of Hudson Hills Press has been enormously helpful — and patient — throughout, and has given us a handsome volume. Fronia Wissman Simpson, class of 1974, was our admirable copy-editor. Stephen Petegorsky deserves kudos for the new transparencies used in production of the book. Many members of the museum staff have also been essential contributors to the effort. They are thanked in the authors' acknowledgments, and I heartily second those accolades.

Once again, the Smith College Museum of Art and the art department have outgrown their quarters. Before this book sees publication, the Fine Arts Center will have been emptied and a major renovation and expansion, designed by the Polshek Partnership, will have begun. The jewels of the collection — many of the works in this volume and others — will travel across the country in two separate exhibitions during the years 2000–2002, while building work proceeds. *American Spectrum*, featuring seventy-five of our most important American paintings and sculptures, will be shown at the Faulconer Gallery, Grinnell College, Grinnell, Iowa; National Academy of Design, New York, New York; Norton Museum of Art, West Palm Beach, Florida; Museum of Fine Arts, Houston, Texas; Pennsylvania Academy of the Fine Arts, Philadelphia, Pennsylvania; Memorial Art Gallery, Rochester, New York; and Tucson Museum of Art, Arizona. *Corot to Picasso*, fifty-seven European works bracketed by these artists, will be seen at the Indianapolis Museum of Art, Indiana; Faulconer Gallery, Grinnell College, Grinnell, Iowa; Cummer Museum and Gardens, Jacksonville, Florida; John and Mable Ringling Museum of Art, Sarasota, Florida; Iris and B. Gerald Cantor Center for Visual Arts of Stanford University, Stanford, California; Marion Koogler McNay Art Museum, San Antonio, Texas; and the Phillips Collection, Washington, D.C. A third exhibition, *Master Drawings from the Smith College Museum of Art*, will tour as well. Much as we deplore the necessity of depriving Smith students of these works for two years, we welcome the opportunity to share them with audiences across the country that might otherwise not come to know them. We hope that this volume will help accomplish that same goal.

Suzannah J. Fabing
Director and Chief Curator
September 1999

Notes

1 Some of the most significant drawings appear in *Master Drawings from the Smith College Museum of Art*, edited by Ann H. Sievers (New York: Hudson Hills Press, 2000). The two catalogues of the Selma Erving Collection, produced by the museum in 1977 and 1985, present the extraordinary *livres d'artiste* and prints of the late nineteenth and early twentieth century that came to the museum through this alumna's generosity. For a further representation of the museum's holdings, the reader is referred to our World Wide Web site or, preferably, encouraged to visit after the museum reopens in 2003, following extensive renovations and expansion.

2 Ironically, it was Dwight Tryon's most important patron, Charles Lang Freer, who had been responsible for the first non-American paintings entering the collection. Freer, a Detroit industrialist, had built a superb collection of Asian and American art that he later gave to establish the Freer Gallery, part of the Smithsonian Institution in Washington, D.C. Through his friendship with Tryon, one of a handful of American painters whose work he collected, Freer kept abreast of the burgeoning collection at Smith. In 1917 he presented the college with a modest group of Chinese and Japanese paintings, along with some Asian ceramics and bronzes, thereby single-handedly extending the painting collection's reach far beyond the American field.

European Painting
and Sculpture

Hans (Jean) Arp

Strassburg, Germany (now Strasbourg, France) 1886–1966 Basel, Switzerland

Torso, 1953

Marble

31¼ × 14½ × 13⅜ in. (79.4 × 36.8 × 34 cm)

Not signed or dated

Gift of Mr. and Mrs. Ralph F. Colin (I. Georgia Talmey, class of 1928)

1956:13

© 2000 Artists Rights Society (ARS), New York/VG Bild-Kunst, Bonn

Jean Arp's *Torso* was conceived as a small-scale plaster in 1930, at a time when the artist turned his attention to three-dimensional biomorphic forms he called concretions. *Torso* was transformed into a large, pristine marble in 1953, after Curt Valentin, Arp's friend and prominent art dealer, noticed the small plaster in the studio and asked him to create a more monumental version. According to Arp, the request came at a time when his own intent was to reintroduce human form into his art. Arp commented on the *Torso*: "I believe that this sculpture represents the realization of a basic shape of the female torso and that it is a descendant from the torsos and dolls appearing on reliefs and collages of the Dada period." Just how this graceful image could have been born out of Dada, the anti-art movement that plunged art into nihilistic spasms after World War I, becomes clear in the context of Arp's unique contributions to the movement. While he was philosophically positioned against rationalism and celebrated nonsense with wit and irony, he never lost sight of the aesthetic component of art. This was most consistently manifest in his use of the curving line closing in on itself to create biomorphic shapes. A form like the navel, which came into being during the Dada period and was often used in a humorous context with forks, anchors, bottles, and so forth, became a recurrent motif for Arp. Its centrality to life's processes and its oval, biomorphic shape established an early connection between organic forms and the creative process.

Arp experimented with automatism in a series of drawings made about 1916. His process, in which conscious will was suspended and the creative act was processed through the unconscious, was important for his later work in which images evolve organically and spontaneously, motivated not by a predetermined idea but by the inner necessity of the creative act. Throughout his long career he would explore countless permutations of the organic shape in all media.

Torso is a brilliant manifestation of Arp's lifelong researches, and it addresses important touchstones in his art. At the time he created the small plaster version of *Torso* he visited Constantin Brancusi, whose radically simplified forms encouraged Arp to turn to sculpture. In 1952, a year before executing the large marble version of the work, Arp traveled to Rome and Greece, reestablishing contact with classical thought and art. The classical world provided him with a vast array of formal and expressive possibilities — from the austere grace of the archaic Kouros figures to the writhing forms of the Laocoön group. Exposure to antiquity also reinforced his decision to use bronze and marble in his later work. The fragmented state of much of classical statuary, with missing heads and limbs, validated those omissions in his own work, which he also knew from Auguste Rodin's partial figures. Yet *Torso* differs in that it is interpreted as a cohesive organic entity — complete in its omissions.

Torso also differs from Brancusi's universal, iconic shapes on special pedestals set before the viewer for contemplation. Arp's work suggests an inner energy through the rhythm of swelling forms, evocative of fertility and organic growth. It provokes the viewer to move around it in a process of discovery and revelation. Art for Arp is a process of growth and is profoundly connected with nature's regenerative essence. He wrote in his diary, "Art is a fruit that grows in man, like a fruit on a plant, or a child in a mother's womb." *Torso* exemplifies this sentiment, for it is as much about art as it is about life.

Further Reading

Hancock, Jane, et al. *Arp, 1886–1966*. Cambridge: Cambridge University Press, 1987.

Soby, James Thrall, ed. *Arp*. New York: The Museum of Modern Art, 1958.

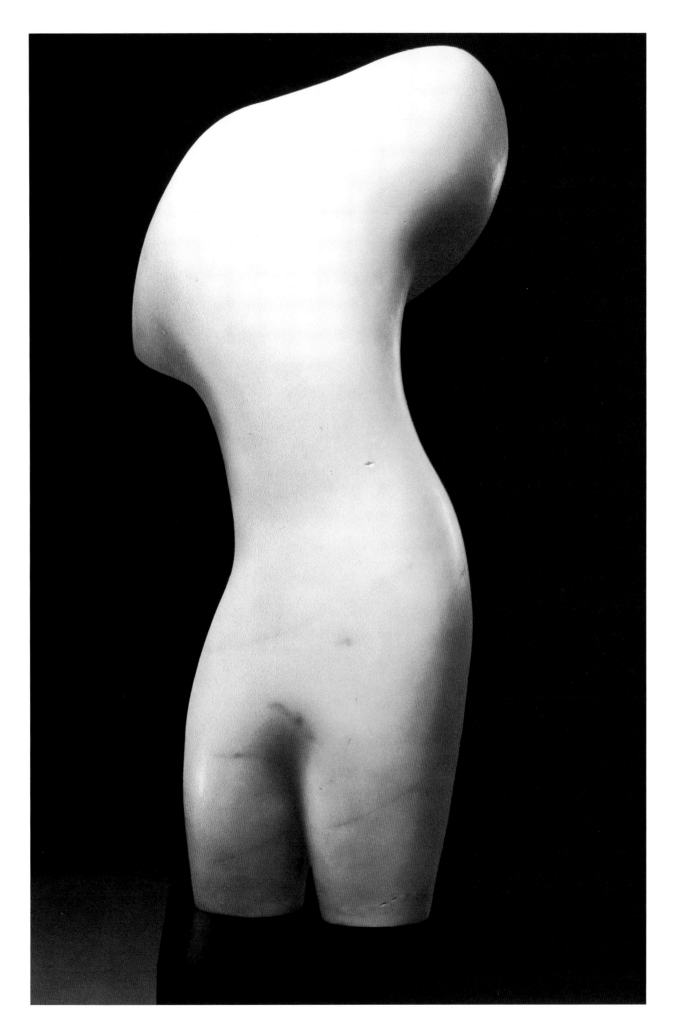

Antoine-Louis Barye

Paris, France 1796–1875 Paris, France

Theseus Slaying the Centaur Bienor,

modeled 1849–50

Bronze on self-base

21½ × 19 × 5 in. (54.6 × 48.2 × 12.7 cm)

Incised signature on rock, below proper left hind leg of centaur:
A. L. Barye

Foundry mark on rock, below proper right hind leg:
F. BARBEDIENNE Fondeur

Purchased

1973:4

Antoine-Louis Barye's sculptural career, which spanned nearly six decades, began in 1816 when Neoclassicism was the prevailing style with only early stirrings of Romanticism. The dominant sculptor was Antonio Canova, whose influence was universal. During the 1860s, toward the end of Barye's career, he taught the young Auguste Rodin. Barye's place in the historical span between these two major sculptors is important and indispensable.

Barye's ascendancy among the leaders of the romantic movement was assured by his immensely successful entry in the Salon of 1833, *Lion Crushing a Serpent* (Musée du Louvre, Paris), for which he received the cross of the Legion of Honor. For many viewers at the time, the image embodied the ideals of the July Revolution of 1830. By giving import to an animal conflict, Barye challenged the prevailing hierarchy of elevated subjects. He and Eugène Delacroix, the pre-eminent romantic painter, spent long hours in the Jardin des Plantes in Paris, sketching animals and studying their anatomy. Beyond their love of animals, Romanticism's major metaphor, Barye shared with Delacroix and other romantic artists a fascination with themes of cruelty and conflict. Barye's exploration of the animal initiated a school of sculptors known as the *animaliers*. Yet no other sculptor possessed Barye's capacity to marshal raw animal violence into a controlled coil of energy. The critic Théophile Gautier, after viewing Barye's *Jaguar Devouring a Hare* at the Salon of 1850 (Musée du Louvre, Paris), referred to the artist as the "Michelangelo of the menagerie."

Barye's other entry in the Salon of 1850 was *Theseus Slaying the Centaur Bienor,* based on a scene from Ovid's *Metamorphoses.* The complex composition is predicated on his 1840 sketch, *Lapith Combating a Centaur* (Walters Art Gallery, Baltimore), a conflict immortalized by Phidias in the metopes of the Parthenon. The

legend focuses on the intrusion of the centaurs into the wedding of Peirithous, king of Lapithae, and Deïdameïa. Theseus helped the king defeat the centaurs in their attempt to carry off the bride. While the Theseus group shares with many of Barye's animal groups the act of conflict, here the visceral life/death struggle of the animals is transformed into a confrontation whose outcome is preordained by the literary sources from which the themes are drawn. This sense of inevitability is most evident in the serene countenance of the hero, whose idealized features, based on classical prototypes, betray mere concentration on the coup de grâce he is about to inflict on the anguished, disheveled head of the centaur. Humanity will conquer barbarism, the rational will prevail over the irrational.

To give majesty to this noble theme, Barye invents one of his most ambitious and resolved compositions — a charged pyramid of rippling energy in which man, nature, and mythological beast — half man, half horse — participate in a struggle for primacy. The swelling rock and jagged plant atop it form a stark and precarious base on which the dramatic conflict is played out. In a brilliant conceit, Barye places Theseus in a posture of conquest atop the horse half of the centaur, transforming the beautifully articulated, tensed animal into an appropriate platform for his heroic deeds.

Romantic sculptors preferred the tactile, painterly quality of patinated bronze, whereas the neoclassicists gravitated toward highly polished marble. Barye's bronzes were made in editions of numerous casts — much like an edition of a print. Unlike a print, the sculpture could also be produced in various sizes. Barye offered the Theseus group, for example, in sizes up to fifty inches in height. Foundries like Barbedienne continued to produce high-quality casts of his work in different sizes. The Smith cast is a Barbedienne foundry reduction. There are many issues that Barye had to confront in dealing with edition sculptures, including those of uniqueness and quality of casts. Yet in establishing the viability of multiple casts in different sizes, Barye was instrumental in making sculpture accessible to a wide and receptive audience.

Further Reading

Benge, Glenn F. *Antoine-Louis Barye, Sculptor of Romantic Realism.* University Park: Pennsylvania State University Press, 1984.

Pivar, Stuart. *The Barye Bronzes.* Woodbridge, England: Antique Collectors' Club, 1974.

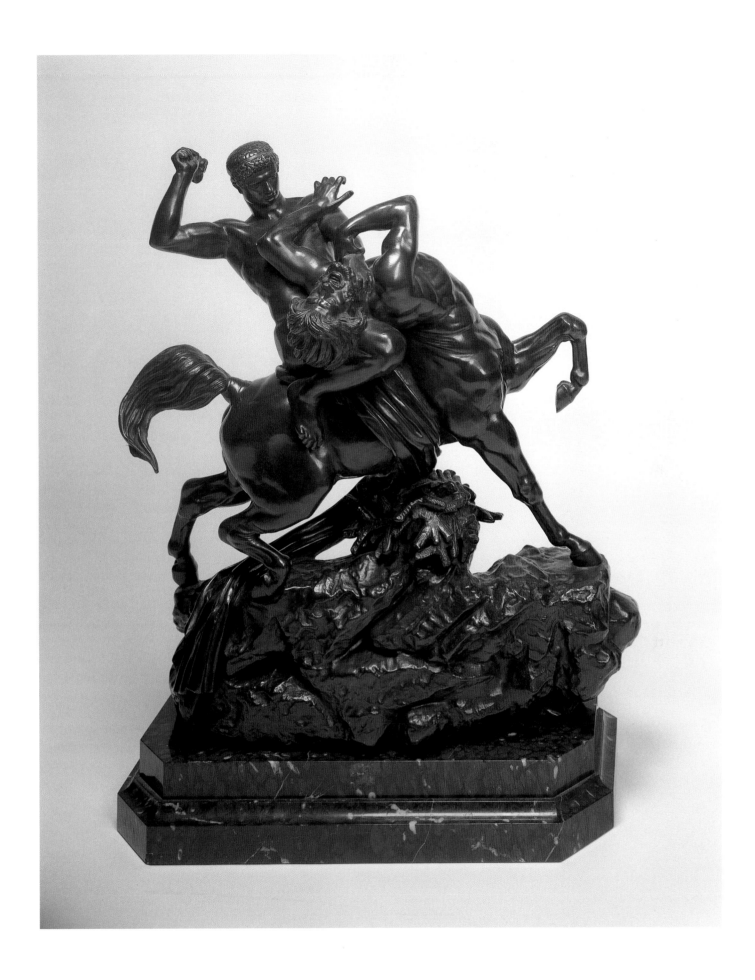

Vanessa Bell

London, England 1879–1961 Charleston, Firle, Sussex, England

Landscape with Haystack, Asheham, 1912

Oil on board

23¾ × 25⅞ in. (60.3 × 65.7 cm)

Not signed or dated

Purchased with funds given by Anne Holden Kieckhefer, class of 1952, in honor of Ruth Chandler Holden, class of 1926

1989:23

© 1961 Estate of Vanessa Bell, courtesy Henrietta Garnett

"You're doing splendid things, damn you, and mine will always be makeshift." This generous assessment of Vanessa Bell's art by Roger Fry, England's preeminent critic, at the expense of his own artistic effort, demonstrates her esteemed position among the members of the Bloomsbury Group. The artists and writers belonging to this unique assembly were bonded by friendship and a desire to bring modernism to England. The exhibitions of post-impressionist art organized by Fry in London in 1910 and 1912 caused a sensation and unnerved the conservative English public. In 1913 an even more advanced brand of European avant-garde was brought to New York in the notorious Armory Show, to a scandalized reception. With these events, the English-speaking art world was jolted into the twentieth century. Bell's *Landscape with Haystack, Asheham* was likely painted in the fall of 1912, on the eve of the second post-impressionist exhibition. In it she depicts the landscape around Asheham House (seen here partially behind the haystack), near Beddingham in Sussex Downs, which she and her sister Virginia had leased that year.

Virginia, who became one of the major literary figures of the century, married Leonard Woolf in the summer of 1912, and Asheham became their country home. It was an important gathering place for the members of the Bloomsbury Group. Vanessa and her husband, Clive Bell, the writer and critic whom she had married in 1907, frequently resided in the house.

Bell's artistic development was rich and prescient. Between 1901 and 1904 she studied with John Singer Sargent at the London Academy of Art, and then for a brief period at the Slade School of Art. By 1905 she had journeyed to Paris, where she saw the work of the post-impressionists and was especially taken with the works of Paul Cézanne.

Here Bell includes the house, underscoring her penchant for subjects with close personal resonance. Yet in focusing on the haystack, the artist is also referring to Claude Monet's famous series of grainstacks of the 1890s, painted at various times of day and in different seasons. Bell's painting is fundamentally about structure. There is no hot sun here, dissolving form and defining a moment, as in Monet. Bell has consciously gone beyond Impressionism toward Post-Impressionism. A black outline delineates the bold geometry of the haystack as in a cloissonist painting by Paul Gauguin. But her major inspiration is Cézanne. The color scheme of greens, browns, and blues, with hints of gray and mauve, approximates Cézanne's palette. The repetitive, regularized brushstrokes of the sky at the upper right and in the foreground area resemble Cézanne's constructivist brushstrokes, which give texture to the painted surface and structure to the composition. The form of the haystack establishes reciprocal relationships with the large house and two small ones to its right and with the dark shape of foliage to its left. The massing of large forms in the middle and background is contrasted with the relative emptiness of the foreground, into which we are introduced by a sweeping curve demarcated by the delicate, rhythmically cadenced posts. The central haystack stabilizes the composition by unifying foreground and background, left and right sides into a cohesive structural whole.

Structural design was, for her mentor Fry, the universalizing principle in all great painting, a lesson Bell took to heart. To create a landscape based on the laws of art and not of nature, in which the interplay of forms and the juxtaposition of colors dominate and unify the image, was for Bell the ultimate expression of freedom. In *Landscape with Haystack, Asheham,* she has indeed done "splendid things."

Further Reading

Shone, Richard, et al. *The Art of Bloomsbury: Roger Fry, Vanessa Bell and Duncan Grant.* London: Tate Gallery, 1999.

Spalding, Frances. *Vanessa Bell.* New Haven, Conn.: Ticknor & Fields, 1983.

Vanessa Bell, 1879–1961. Poughkeepsie, N.Y.: Vassar College Art Gallery, 1984.

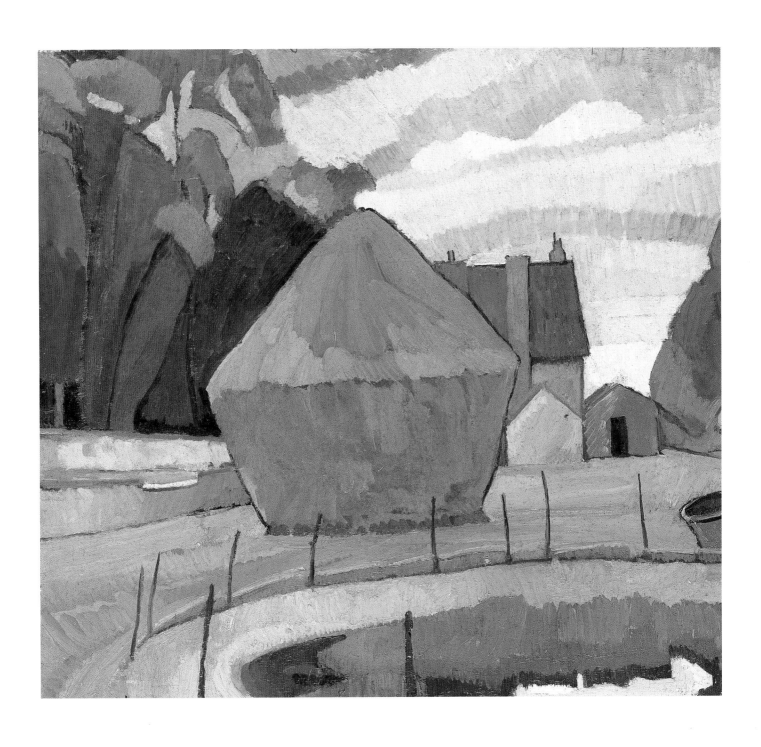

Louis-Léopold Boilly

La Bassée (near Lille), France 1761–1845 Paris, France

A Young Painter and His Model, c. 1788–92

Oil on canvas

18⅛ × 14⅞ in. (46 × 37.8 cm)

Signed in black paint, lower left (on the verso of the outermost of the stacked canvases): L Boilly ft

Purchased with the Beatrice Oenslager Chace, class of 1928, Art Acquisition Fund, the Madeleine H. Russell, class of 1937, Fund and the Hillyer, Mather, Tryon Fund

1996:21

Few artists chronicled the mores and societal changes of late-eighteenth- and early-nineteenth-century France with the acuity and sophistication of Louis-Léopold Boilly. The layered act of being, viewing, and chronicling events of the Revolutionary period and the Napoleonic era in France lies at the core of Boilly's art.

Soon after the artist arrived in Paris in 1785, his early work focused on gallant imagery — most often subjects of amorous dalliances still closely tethered to rococo sensibility. These small paintings, with their high finish and focus on rich interior settings, are reminiscent of seventeenth-century Dutch and Flemish cabinet pictures by such artists as Gabriel Metsu and Gerrit Dou. The active market for such old master paintings at the time also created a demand for Boilly's work.

A Young Painter and His Model belongs to this early period. In it we are privy to a flirtation in progress. A young artist is making his case to a seemingly engaged participant. He hovers over her shoulder and points to a canvas at the right, which depicts a sleeping barebreasted woman being fondled by a leering older man. The woman of the artist's desires tilts her head in the direction of the painting; her self-conscious smile, outstretched neck, and revealing décolletage suggest acquiescence.

The flirtation is taking place in a studio context, identifying the male figure as the artist and the female as a possible model. The artist's studio became a prominent and frequent theme in Boilly's art. Invariably the contents of a studio provide an introduction to the artist himself, defining his predisposition and erudition. The reference to the arts is here all-encompassing. In addition to the painting-within-the-painting at the right, to the left of the pair are two sculptures by Etienne-Maurice Falconet, the *Sleeping Bacchante* on the table in the foreground, *The Bather* in the background. Between them is a folio — likely of drawings and prints. A domed rotunda on Ionic columns looms in the background, loosely referencing both the Pantheon in Rome and the dome of the church of Ste. Geneviève in Paris, which was being built at the time. The table is covered by a beautiful Turkish carpet, likely from Ushak, and on it are books — one of which the woman holds in her hand. At the extreme left is a barely visible stringed instrument. Thus literature, music, and all of the visual arts are brilliantly woven into the fabric of this work.

A pink ribbon, which cascades from the folio down the side of the table, visually links the two sculptures and by extension the woman around whose torso the ribbon was tied just moments ago. The woman is flanked by works of art — a sculpture and a painting — in which the image of sleeping women perpetuates the idea of male gaze and desire. Yet the different presentation of the two reflects the painting's complexity. The sleeping woman in the painting adds an element of vulnerability to the narrative of violation. The *Sleeping Bacchante* sculpture is admired as both an image of a nude and an exquisitely resolved work of art.

To the eighteenth-century viewer, books would have been seen as objects of a woman's temptation and fall, often identified with specific texts of illicit liaisons, such as the popular medieval love story of Héloise and Abelard. Boilly's painting is less specific in its protagonists and less explicit in its narrative, deliberately remaining an image of flirtation, perhaps to appeal to a wider audience. Yet Boilly convincingly orchestrates an arsenal of keenly observed elements that enhance the content and meaning of the work. He takes us beyond the realm of gallant imagery into a discourse about the meaning of art and its capacity to enrich and persuade.

Further Reading

Rand, Richard, et al. *Intimate Encounters: Love and Domesticity in Eighteenth-Century France.* Hanover, N.H.: Hood Museum of Art, Dartmouth College; Princeton, N.J.: Princeton University Press, 1997.

Siegfried, Susan L. *The Art of Louis-Léopold Boilly: Modern Life in Napoleonic France.* New Haven, Conn.: Yale University Press, 1995.

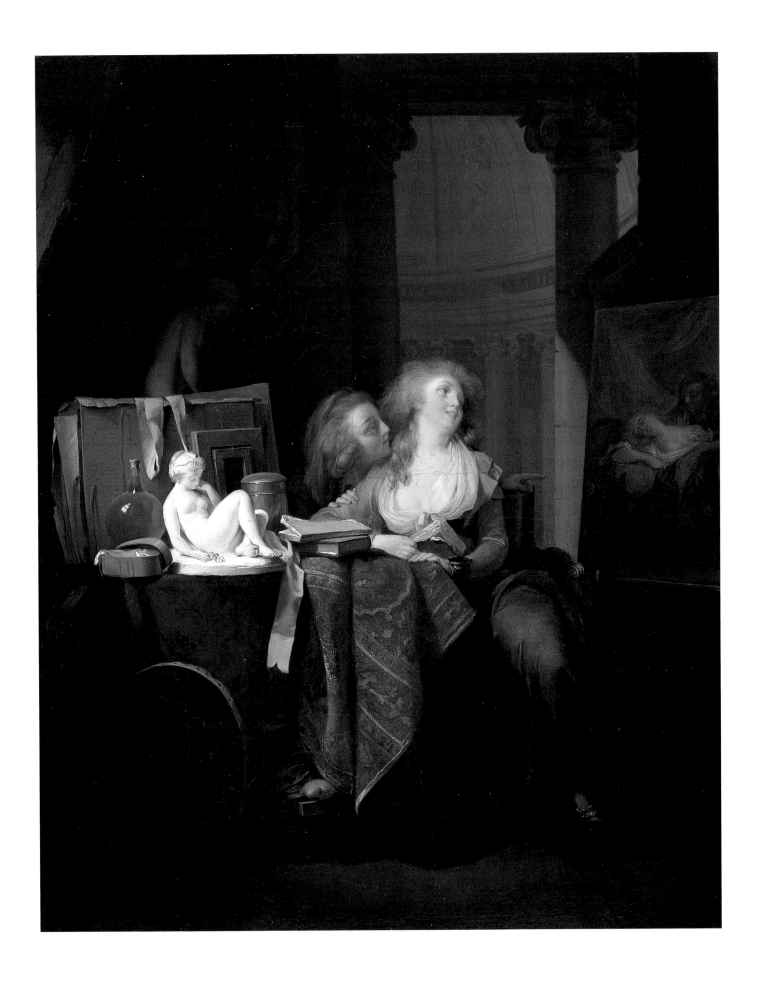

Pierre Bonnard

Fontenay-aux-Roses (near Paris), France 1867–1947 Le Cannet, France

***Landscape in Normandy* (formerly *Landscape in the Midi*),** 1920 (completed later)

Oil on canvas

24⅞ × 32 in. (62.5 × 81.3 cm)

Signed in thinned black paint, lower left of center: Bonnard

Purchased, Drayton Hillyer Fund

1937:8

Landscape in Normandy exemplifies the uniqueness of Bonnard's artistic vision and his singular place in twentieth-century modernism. He recognized that his approach to nature was out of line with the dramatic "isms" that defined art in the first decades of the century. "The march of progress is rapid, and the world was ready to welcome Cubism and Surrealism before we had achieved what we had set out to do. We felt ourselves suspended in mid-air," he wrote.

This most private of artists initiated his dialogue with modernism as a member of the Nabis (Hebrew for "prophet"), a group of artists, including Maurice Denis and Edouard Vuillard, who defined issues of Symbolism during the 1890s. He was first exposed to Paul Gauguin's theories of expressive use of color, and only thereafter did he explore Impressionism. This reversal of historical sequence led him to transform Impressionism into an expressive idiom. "When my friends and I sought to pursue the investigation of Impressionists and develop them further, we wanted to go beyond the naturalistic impression of color. Art is not nature," he explained. After the initial contact with the motif, "I leave [it], control it, come back to it and then return to it after a while. That way I don't allow [myself] to be absorbed by the object itself." To that end, he worked exclusively in his studio, where, "before I start painting, I reflect, I dream."

In *Landscape in Normandy* the evocation of an image rather than the image itself is the determining norm. As our eye scans the colorful speckled sky or moves across the diagonal path from lower right toward the house at left, it always comes back to the exuberant cluster of trees in the middle. Varied in size, shape, and vegetation, they create a dazzling silhouette that is generously diffused into the surrounds. Combinations of color add to the richness. The dark green of the path is juxtaposed above with a stretch of yellow-gold and below with the lighter green of the tree. The dark green and yellow-gold are further linked with black vertical forms arranged in a rhythmic pattern, which could be interpreted as people walking down the path. The triangular shape of the green tree at center left both stabilizes the composition and releases an explosion of nature's fireworks, in which trees, sky, and ground are subsumed in a luxuriant display. It is here that we perceive not only the artist's sensitive and restless eye but his whole being immersed in the joy of color, the drama of form created by an extensive array of marks moving across the canvas boldly or tentatively but insistently, to soothe, to startle, to bring sensual joy. We are awed by the inspiring spectacle of nature's beauty and the artist's ability to release it from his imaginings.

The colors in *Landscape in Normandy* are so lush and saturated with nature's warmth that for years the painting was thought to have been done in the Midi, the southern region of France, which has inspired brilliant celebratory landscapes by Henri Matisse, André Derain, and others. The present title was given to the Smith painting only after an affinity was noted with Bonnard's *Landscape in Normandy* of 1920 (Musée d'Unterlinden, Colmar), which depicts the same trees and house. In his confession that "Personally, I am very weak. It is difficult for me to control myself in front of an object," Bonnard, in fact, defines his strength. It is precisely that passionate intensity through which he transforms nature into art.

Further Reading

Hyman, Timothy. *Bonnard.* New York: Thames and Hudson, 1998.

Newman, Sasha M., ed. *Bonnard: The Late Paintings.* New York: Thames and Hudson, 1984.

Whitfield, Sarah, and John Elderfield. *Bonnard.* New York: Harry N. Abrams, 1998.

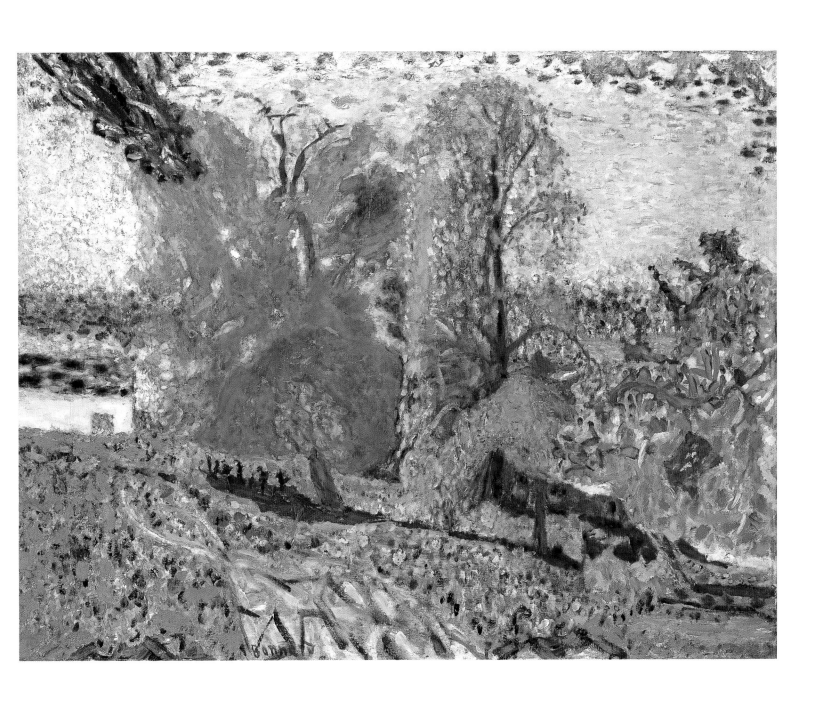

Jean-Baptiste Carpeaux

Valenciennes, France 1827–1875 Courbevoie, France

Bust of a Chinese Man (Le Chinois),

modeled 1868; cast c. 1872–74

Bronze

26½ × 20½ × 13⅝ in. (67.3 × 52.1 × 34.6 cm)

Signature incised under proper right shoulder termination: Carpeaux

Stamped twice inside the base: Propriété Carpeaux

Purchased

1970:4

Jean-Baptiste Carpeaux's career, often viewed as a manifestation of the effusive elegance of the Second Empire, is also a brilliant coda to Romanticism. Carpeaux entered the Ecole des Beaux-Arts in 1844 as a student of François Rude, an influential romantic sculptor best known for his monumental stone relief, *Departure of the Volunteers*, for Paris's Arc de Triomphe. Carpeaux admired Rude's artistic discipline, and his own *Fisherboy Listening to a Seashell* of 1857 (plaster, Musée du Louvre, Paris) is an homage to the naturalism of his mentor's *Neapolitan Fisherboy* of 1833 (marble, Musée du Louvre, Paris). Rude's uncompromising republican politics limited his official acceptance, so Carpeaux, in a desire to enhance his career, soon left his studio for that of Francisque Duret, a less talented but less controversial artist than Rude.

In 1854, after years of trying, Carpeaux won the Prix de Rome, but an illness postponed his departure until 1856. A trip to Florence in August 1858 galvanized his interest in Michelangelo, under whose influence he sculpted *Ugolino and His Sons* of 1860 (marble version of 1867, The Metropolitan Museum of Art). Based on the story of Count Ugolino in Dante's *Inferno*, canto 33, the large, chillingly powerful group established Carpeaux's career as a sculptor of monumental works. The figures of the sons writhe around the anguished Ugolino, creating a dynamic circular pattern that Carpeaux employed in a number of his public monuments. The exuberant *Dance* of 1866–69 on the façade of Charles Garnier's Opéra (removed to Musée d'Orsay, Paris), Carpeaux's most popular and resolved work, is a brilliant example of such centrifugal energy.

Circular movement also dominates his last monumental project, *Four Parts of the World*, commissioned by the architect Gabriel Jean-Antoine Davioud in 1867 as the culminating group of the Fontaine de l'Observatoire in the Luxembourg Gardens in Paris. The monument, which was unveiled in 1874, depicts four large female nudes representing Africa, America, Asia, and Europe, holding up a sphere whose shape reiterates their circular, animated motion. *Le Chinois* is a more finished variant of an earlier sketch for the figure of Asia. Because Carpeaux could not find a Chinese woman to model, he had a man pose for him. He then grafted the male features onto a female body for the monument. *Le Chinois* is typical of Carpeaux's practice of casting individual figures or groups from his most famous public monuments. Yet Carpeaux transformed *Le Chinois* significantly enough to consider it an independent work — at once a portrait and a representation of a racial type.

The power of the image derives from its dynamic torque, an expression in a single figure of the concern with movement found in his monumental, multifigural works. From the frontal upper torso, the neck and head turn sharply to the right, riveted there by the intense gaze. The viewer is compelled to move around the work, and each new vantage point is a discovery. From the right, the intensity and integrity of the character reveal themselves in the full face of the model. In the back, a serpentine braid snakes as an independent force from the back of the head at left to the lower right, a brilliant reiteration of the work's pattern of movement.

One of Carpeaux's frustrations with the monument for the fountain was that it was not polychromed. Carpeaux was keenly aware of the expressive power of color in sculpture, an important trend among nineteenth-century sculptors. Smith's cast of *Le Chinois* is especially fine, its expressiveness reinforced by the different patination of the face, hair, and garment of the model. The reflected light from the rippling surface enhances the colors and adds further vibrancy to the whole. In this compelling image of *Le Chinois*, the elements that most fully define Carpeaux's art coalesce — movement, light, color, and psychological insight.

Further Reading

Lovett, Jennifer Gordon. *A Romance with Realism: The Art of Jean-Baptiste Carpeaux*. Williamstown, Mass.: Sterling and Francine Clark Art Institute, 1989.

Wagner, Anne Middleton. *Jean-Baptiste Carpeaux: Sculptor of the Second Empire*. New Haven, Conn.: Yale University Press, 1986.

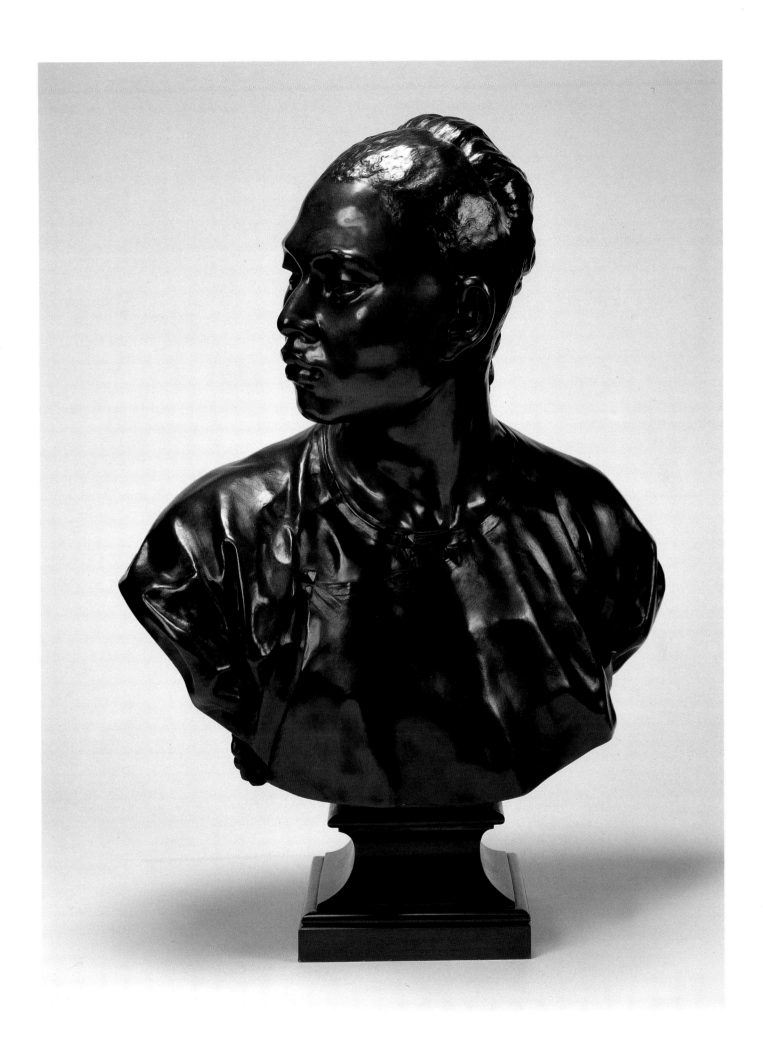

Paul Cézanne

Aix-en-Provence, France 1839–1906 Aix-en-Provence, France

A *Turn in the Road at La Roche-Guyon* (*La Route tournante à La Roche-Guyon*), c. 1885

Oil on canvas
25¼ × 31½ in. (64.1 × 80 cm)
Not signed or dated
Purchased
1932:2

Cézanne painted this work during a summer spent with his friend Pierre-Auguste Renoir in the village of La Roche-Guyon, northwest of Paris along the Seine. Camille Pissarro, the dean of the impressionists and Cézanne's early mentor, had already explored numerous views of the region in the 1870s.

In *A Turn in the Road at La Roche-Guyon* the image reveals itself grudgingly and profoundly. The lower left quadrant depicts the turning road, which disappears behind the building at the left as abruptly as it appears. The road consists largely of unpainted canvas, which dramatically reiterates its two-dimensionality and deliberately limits the viewer's movement into the painting. Cézanne creates a physical and psychological barrier and thus redirects our involvement with the painting to the visual and analytical realm, that is, to painting as process. His colors are limited to beiges, ochers, greens and light blues, and the brushstroke, rather than serving as surrogate for nature's furtiveness, becomes a building block by which the painting is constructed. Cézanne, who could spend hours, days, weeks in front of a motif extracting its essential characteristics, involves us here deeply in the art of seeing. The unfinished state of the painting, with areas of raw canvas, pencil markings, passages partially resolved with halting strokes, aids in our discovery by exposing stages of Cézanne's working process. Here the act of painting unfolds over time and reveals layers of reality in direct contrast to the specificity of time and space in an impressionist painting.

A Turn in the Road at La Roche-Guyon has become an important work in Cézanne's historiography since the publication of John Rewald's site photograph showing the mountain range as much smaller and more distant than in the painting. Erle Loran in *Cézanne's Composition* concludes that Cézanne radically col-

lapsed the space in the painting by moving the range closer to the foreground and upward, thus making it larger. Conversely, others have since demonstrated that by placing the camera farther to the right and aligning the intersections to correspond with those in the painting, a photograph would show the mountain range adhering closely to that in the painting.

Of course no mechanical process that arrests a single moment and place can replicate Cézanne's probing, thinking eye assessing a motif from a variety of positions over a period of time. As an example, the chalk cliff at left center, which in site photographs is at an oblique angle, in the painting appears parallel to the picture plane, thus demonstrating the principle of multiple vantage points. The chalk cliff's undulating outline, seen to its best advantage frontally, echoes that of the building in the left foreground. The cluster of houses, simplified geometric volumes at the epicenter of the composition, defined by lines of varied dimensions and energies, color and tonal contrasts, is set off by a backdrop silhouette of foliage whose gentle curves move around the houses to the right and reappear with frenetic force in the right foreground. The density of the expressive brushstrokes creates a counterpoint to the compact geometry of overlapping houses, and both are directed and contained by the dynamic arc of the road, the dominant element in the painting. It compresses the busy middle of the painting between the powerful empty space of the road and the looming mountain range in which the curve of the road is reiterated in the slope of the mountain at upper right. Such counterpoints and reciprocities imbue the painting with vitality and tension.

What Cézanne makes manifest in this work is his intense, probing, sustained effort in distilling from nature a radically new pictorial order that is his lasting legacy.

Further Reading

Machotka, Pavel. *Cézanne: Landscape into Art.* New Haven, Conn.: Yale University Press, 1996.

Rewald, John. *Cézanne: A Biography.* New York: Harry N. Abrams, 1986.

Schapiro, Meyer. *Paul Cézanne.* New York: Harry N. Abrams, 1952.

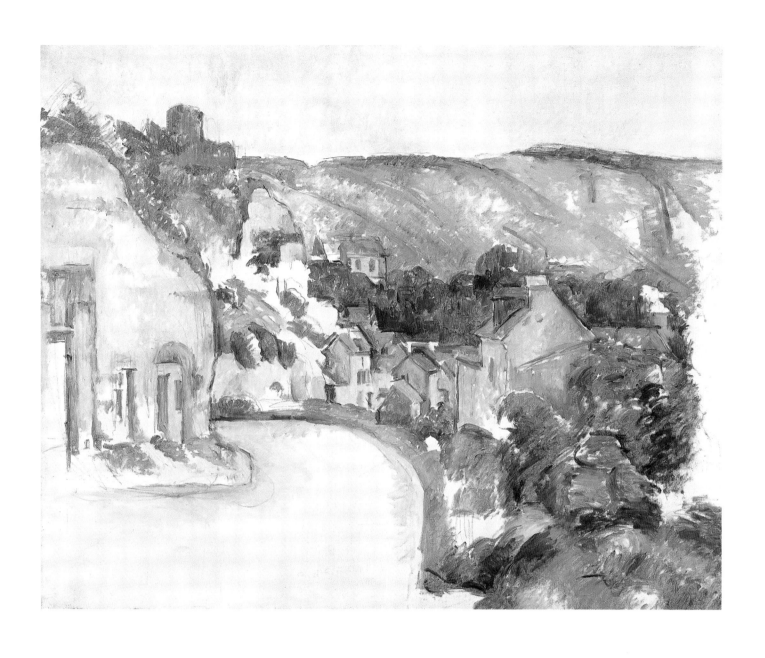

Jean-Baptiste-Camille Corot

Paris, France 1796–1875 Paris, France

The Fair Maid of Gascony
(La Blonde Gasconne), c. 1850

Oil on canvas

15¾ × 11⅞ in. (40 × 30.2 cm)

Sale stamp in red paint, lower left: VENTE COROT [Lugt 461]

Purchased, Drayton Hillyer Fund

1934:7

Camille Corot's gentle nature and the charm of his paintings make him one of the beloved artists of the nineteenth century. Yet his immense popularity too often obscures his true historical achievements. As artists in England and Germany were establishing a rich landscape tradition in the early decades of the nineteenth century, French artists concerned themselves mainly with subjects taken from history, allegory, and the like, which advanced figural imagery. It was Corot who more than any other artist established the integrity of French landscape painting, paving the way for the Barbizon artists, many of whom were his friends, and later the impressionists. His early landscapes of the 1820s and 1830s, especially of Italy, are among his most compelling works, transforming well-known sites into masterpieces through the poetry of light and form. His late landscapes, especially those of the 1860s — dreamy evocations of sylvan nature — are among his most popular works.

Corot's figural paintings are less well known and constitute a smaller portion of his oeuvre. They are, nonetheless, a pivotal and integral component of his art. Corot's interest in the figure can be traced to the 1830s, but the largest number and most important of his figural works date from the late phase of his career, especially the 1860s. The emphasis on the human form in these late works can be seen on one level as a counterpoint to the ephemerality of his late landscapes.

The generally accepted date of about 1850 for La Blonde Gasconne lies on the threshold of Corot's late achievement as a figure painter. The magnetic power of the painting rests primarily in its restraint and discipline and in the imposing presence of the sitter, whose identity we do not know. The viewer is forced to address the image on its own terms. It is as if Corot grasped the extraordinary physical and psychological power of the sitter and subordinated all else to her. Elements that tend to delight in so many of his canvases are here suppressed. Vestiges of a tree, Corot's beloved motif, which originally formed part of an extensive background, can still be discerned beneath the overpaint to the right of the sitter. What remains is an insistently reductive setting consisting of a blue sky layered by gray-brown clouds, a small triangle at the lower right that likely represents water, and a stone block at the lower left placed parallel to the picture plane.

Presiding majestically over the scene is a young woman whose direct pose and simplicity of dress are a perfect complement to the unadorned setting. The separate, distinctive features in the work galvanize around the figure, who at once dominates the scene and is of the scene. Her arms help define the placement of the figure's volume in a spatial context as they move across her torso in a seamless curve and meet in the gently touching hands that serve as the unifying metaphor for the whole work. Subtle passages like the space between her neck and the wisp of hair gently cascading onto her shoulders, or the space between her left arm and torso, further integrate the figure into the surrounding space. Serenity and dignity emanate from the ample features of her face, whose arched brows and large eyes reiterate the exquisite oval of the head. The simple formality of pose and setting are rooted in the classical tradition of Western art — in the serene quietude of the Aldobrandini Wedding (Vatican Museums, Rome), the perfectible beauty of Renaissance portraiture, and the magisterial figures of Nicolas Poussin.

La Blonde Gasconne remained in the artist's possession until his death in 1875. Its seminal role in Corot's oeuvre is underscored by its prominent inclusion in the two most resolved of six versions of his Artist's Studio of 1865–70 (National Gallery of Art, Washington, D.C., and Musée du Louvre, Paris). In these paintings, a woman sits before an easel reflecting on the artist's recently completed landscape. By placing La Blonde Gasconne on the wall immediately above the landscape painting on the easel, Corot comments on his dual passions. Here La Blonde Gasconne underscores his overarching interest in the human figure.

Further Reading

Hours, Madeleine. Jean-Baptiste-Camille Corot. New York: Harry N. Abrams, 1984.

Tinterow, Gary, et al. Corot. New York: The Metropolitan Museum of Art, 1996.

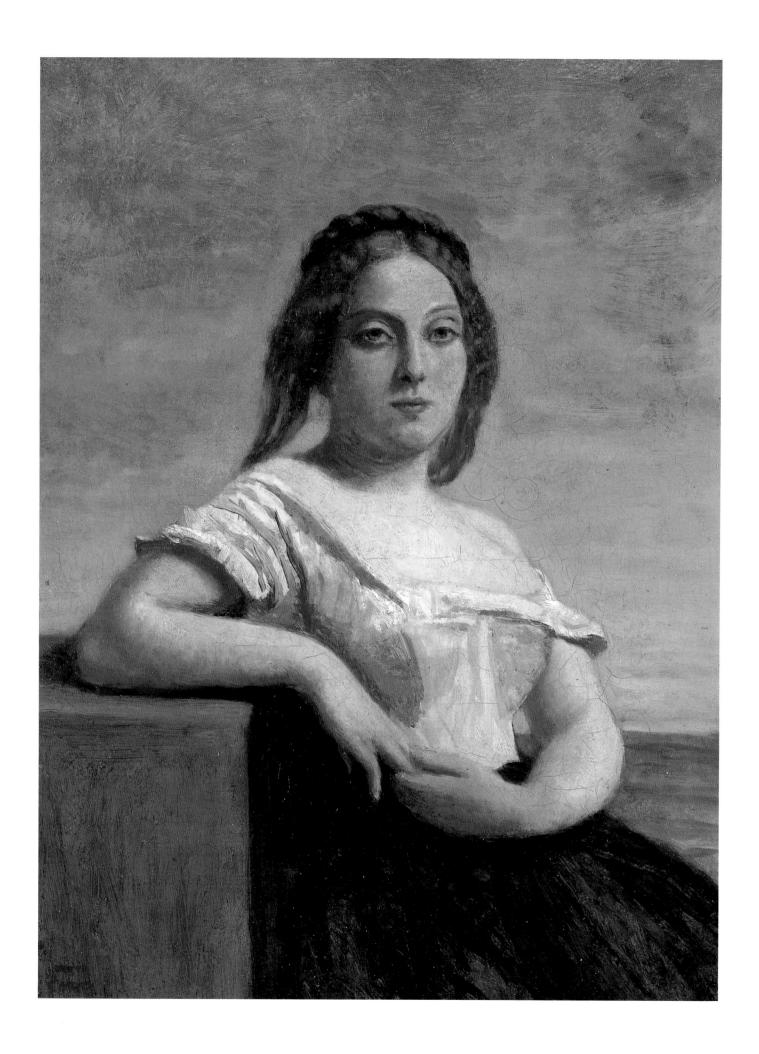

Jean-Baptiste-Camille Corot

Paris, France 1796–1875 Paris, France

Dubuisson's Grove at Brunoy, 1868

Oil on canvas
18 × 21½ in. (45.7 × 54.6 cm)
Signed in black paint, lower left: COROT
Purchased with funds given by Louise Ines Doyle, class of 1934
1952:116

Louis-Désiré Dubuisson and his family were friends of Corot and collected his work. When the artist visited one day he found no one at home; while waiting he made sketches of the grove that he later translated in his studio into *Dubuisson's Grove at Brunoy*. The landscape is an example of Corot's lyrical late style of feathery brushstrokes and sylvan green-gray foliage tonally arranged in a rhythmic light-dark pattern across the canvas. A field of grass and flowers in the foreground invites the viewer into the grove. A path at the right leads to distant sheds. The willowy trees on either side of the path create a perspectival funnel. The paired trees respond to a swaying rhythm as if engaged in a flirtatious dance. The trees left of center are dispersed more uniformly across the meadow, like markers defining space. Two of the foreground trees bracket the woman with a child, and to either side two girls bend in unison to pick flowers. The figures add a splash of bright color to the work. A thin dark tree appears to emanate from the back of the girl at right and then dissolves into the foliage above—an apt metaphor for the light, lyrical quality of the whole.

Commentary on Corot's late works often focuses on his *souvenir* paintings, evocations of suffused nature recalling places Corot had visited earlier or mere inventions painted from his imagination. Nymphs and other creatures only add to the flight of fancy in these Arcadian settings. In fact, the preponderance of Corot's late landscapes represent specific sites like *Dubuisson's Grove at Brunoy*. In both cases, however, Corot's late landscapes are a vehicle for emotional escapism, a salve for an aging artist who can still delight countless followers with his visual poems.

By 1868, the year of the Smith painting, Corot was a revered elder statesman among landscapists—a clear indication that his moment had passed. Even as he was being remembered for giving impetus to French landscape painting earlier in the century, a new vision of nature was being formulated by the young impressionists. Thus while his role as the precursor to Impressionism was well established, he was personally wary of many of its members, and the vision of his late landscapes did not accord with theirs.

The dilemma even for his admirers is tellingly expressed by Emile Zola: "If M. Corot agreed to kill off, once and for all, the nymphs with which he populated his works and replace them with peasant women I would like him beyond measure." *Dubuisson's Grove at Brunoy*, with its simply clad figures in the field, shifts the discourse only in degree and not in kind. Dubuisson's grove is less frenetic without nymphs dancing across it, and our reverie focuses more on nature's allure. Zola concludes, "I prefer a thousand times a study, a sketch made by him right out in the fields, face to face with powerful reality." In this statement Zola clearly aligns himself with the impressionist future while acknowledging Corot's mastery at painting a sketch "right out in the fields." *Dubuisson's Grove at Brunoy* may have evolved from such a sketch. Yet Corot was always a poet of nature. As he sketched in Dubuisson's grove, he was constructing in his mind a poetic tribute to his friend's environs. For him the feeling of nature had become more important than its actuality.

Further Reading

Clarke, Michael. *Corot and the Art of Landscape*. New York: Cross River Press, 1991.

Tinterow, Gary, et al. *Corot*. New York: The Metropolitan Museum of Art, 1996.

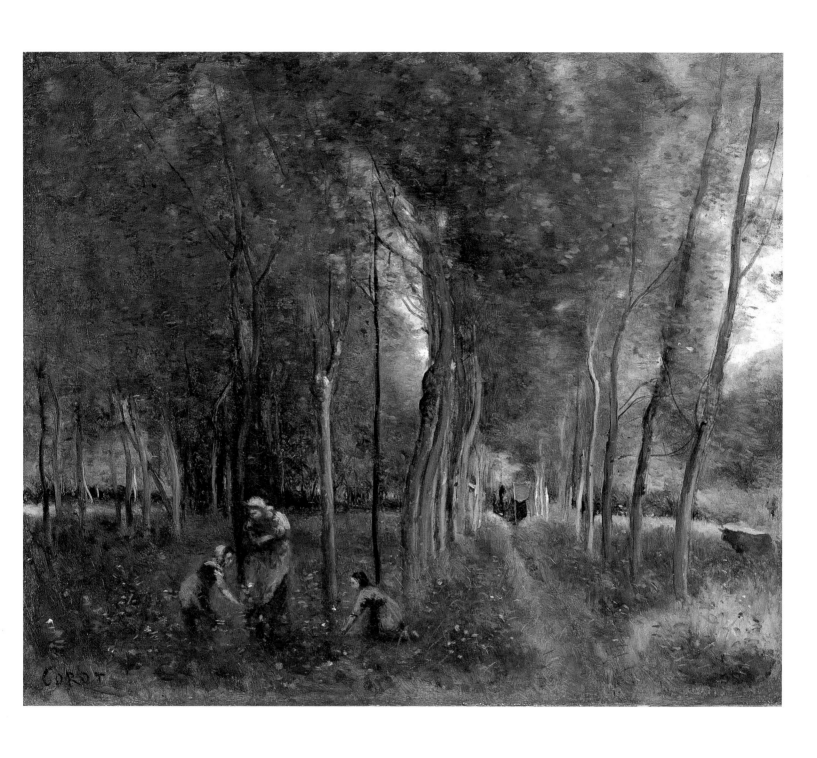

Gustave Courbet

Ornans, Franche-Comté, France 1819–1877 La Tour-de-Peilz (near Vevey), Switzerland

The Preparation of the Dead Girl (La Toilette de la morte), formerly called The Preparation of the Bride (La Toilette de la mariée), c. 1850–55

Oil on canvas
74 × 99 in. (188 × 251.5 cm)
Not signed or dated
Purchased, Drayton Hillyer Fund
1929:1

Gustave Courbet's *Preparation of the Dead Girl* demonstrates that works of art in museums are constantly open to scholarly reinterpretation. Most often, labels change in museums because of reattributions. A painting that is by Rembrandt one day may not be the next. In the case of this painting, it is not the authorship but the subject that was reappraised during research for a major Courbet retrospective exhibition in 1977–78. The painting had remained in Courbet's possession until his death in 1877, when it passed to his sister, Juliette. It was then bequeathed to Mmes de Tastes and La Pierre, who auctioned it in 1919 as *The Preparation of the Bride*. The painting entered the Smith College Museum of Art in 1929 with that title, which was unchallenged until 1977. In working on the catalogue for the Courbet exhibition of 1977–78, the researchers, unable to find evidence that Courbet had ever painted a work titled *The Preparation of the Bride*, concluded that this canvas must instead be the documented but lost *Preparation of the Dead Girl*.

X-radiographs of the painting taken in 1960 reveal that the central seated figure was originally nude, her head slumped and her left land lying across her lap. The painting was apparently deliberately overpainted in critical areas, probably to make it more marketable around the time of the 1919 sale, when it also acquired its new title. An unknown hand painted in the dress, lifted the head, raised the left hand, and placed a mirror in it, thus transforming a corpse into a bride looking into a mirror as she prepares for her wedding. The awkward overpainting was generally overlooked, partly because of the overall unfinished state of the painting.

The funereal theme is reinforced by many passages in the painting. The women hovering around the seated corpse are preparing it for the funeral — the tub at her feet is there to wash the body. The two women at left are spreading a winding sheet over the bed, which is being readied for the corpse. The table at right is being prepared for the wake, and the group of women at its far end are probably reciting prayers for the dead from their prayer books. The dark areas of the canopied bed, the open door and stairway above the central group, as well as the open window at right all add to the somber mood and may also allude to the passage to the hereafter.

The ambitious scale of *The Preparation of a Dead Girl*, its probable date of execution in the early 1850s, and especially its theme align it with Courbet's masterpiece, *A Burial at Ornans* of 1849 (Musée d'Orsay, Paris). The latter became a clarion call for a new generation of realist artists of whom Courbet was the leader. In these works of the 1850s Courbet was seeking artistic truths predicated not on elevated subjects of history, allegory, or religion, but on depicting the lives and rituals of everyday people.

In *A Burial at Ornans*, as in *The Preparation of the Dead Girl*, Courbet depicts the death of ordinary individuals whose identities we do not know, thus defying the convention of celebrating the heroic deaths of famous people. *The Preparation of the Dead Girl* captures a moment prior to the burial — the preparation for the funeral and wake that takes place in the home. The two paintings complement each other and underscore Courbet's commitment to record and commemorate local customs, which were being eroded by societal change.

Further Reading

Faunce, Sarah. *Gustave Courbet*. New York: Harry N. Abrams, 1993.

Toussaint, Hélène, and Marie Thérèse de Forges. *Gustave Courbet, 1819–1877*. Translated by P. S. Falla. London: Arts Council of Great Britain, 1978.

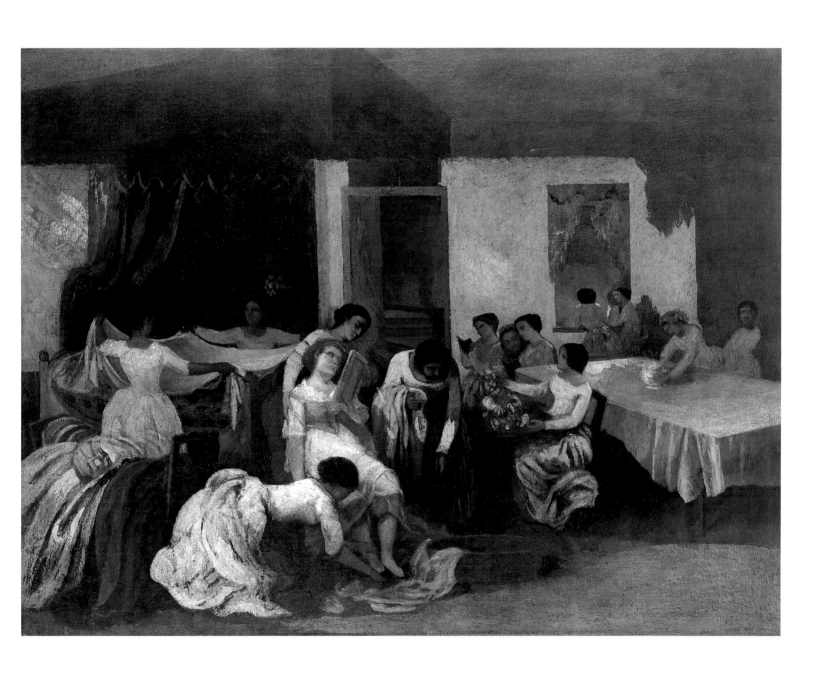

Gustave Courbet

Ornans, Franche-Comté, France 1819–1877 La Tour-de-Peilz (near Vevey), Switzerland

Monsieur Nodler the Elder at Trouville, 1865

Oil on canvas

36¼ × 28¾ in. (92.1 × 73 cm)

Signed and dated in reddish orange paint, lower left: 66/G.Courbet

Purchased, Winthrop Hillyer Fund

1935:3

The Courbet who painted *Monsieur Nodler the Elder* in 1865 is a significantly different artist from the firebrand of the 1850s whose treatment of contemporary life transformed the subject matter of art (see pp. 38–39). By the 1860s Courbet had turned his attention away from genre painting and focused on landscape and portraiture.

In the late summer of 1865 Courbet arrived at Trouville, a bustling seaside resort town on the English Channel made prominent a decade earlier by the duc de Morny and rendered accessible to the Parisian leisure class by the railroad. Courbet's notoriety and his larger-than-life persona as much as his immeasurable talent assured him of commissions for portraits and seascapes. Courbet in the 1850s would have focused his attention on the fishermen of the region who were being displaced by the vacationers. Now he was content to establish himself among these well-to-do clients.

During this time Courbet befriended Claude Monet, whom he observed struggling with his large figural work, *Women in the Garden* of 1866–67 (Musée d'Orsay, Paris). In trying to capture on canvas nature's changeable moods, Monet often had to wait long periods for proper weather conditions. Courbet's sense of reality was too robust and concrete for such an approach. In this and several other portraits painted at Trouville, Courbet used the coastal setting as a backdrop to contextualize the image, rendering the figure and the landscape as two distinct, interdependent components.

In *Monsieur Nodler the Elder*, Courbet defines the leisure class. A handsome young man of means is being painted by a prominent artist. There is an inherent discreet formality to the relationship that is evidenced in the erect pose of the sitter, whose pyramidal structure can be traced back to Renaissance portraiture. This somewhat formal presentation of leisure is apparent in Nodler's accoutrements—his dress, appropriate for leisure activities, the simple ladder-back chair on which he sits slightly turned to one side, and the cane or riding crop in his hand. The coastal setting creates a luminous background that underscores the place and time of leisure.

In November 1865 Courbet wrote to his parents: "Besides the portraits of women, I have done two men and many seascapes." There is ample other documentation identifying the two male sitters as the Nodler brothers. It is a happy coincidence that these two portraits are today in museums only twenty miles apart, the elder brother at Smith and *Monsieur Nodler the Younger* at the Museum of Fine Arts, Springfield, Massachusetts. Despite their execution in 1865, Courbet deliberately dated both works 1866 to make them seem more current when he included them in his solo exhibition at the Pavillon de l'Alma in 1867.

The familial resemblance between the two sitters can be seen in the structure of their faces, and both hold the same riding crop or cane. Yet the two are very different images. The younger brother is painted against a neutral, dark background and presented in three-quarter view. Wearing a robe and a loose bow tie, hair flowing over his forehead, he is an archetypal romantic figure. In contrast, a formal grace characterizes the portrait of the older brother. The artist seems to project aspects of his own identity onto his subjects. The romantic spirit of the young Nodler brother evokes Courbet's youthful self-portraits, which had been done in a self-consciously romantic style. But the elder Nodler in many respects reflects the current self-image of Courbet, the handsome, prosperous, self-assured artist who hobnobs with the aristocracy and moneyed clients.

Further Reading

Faunce, Sarah, and Linda Nochlin. *Courbet Reconsidered.* Brooklyn: The Brooklyn Museum, 1988.

Toussaint, Hélène, and Marie Thérèse de Forges. *Gustave Courbet, 1819–1877.* Translated by P. S. Falla. London: Arts Council of Great Britain, 1978.

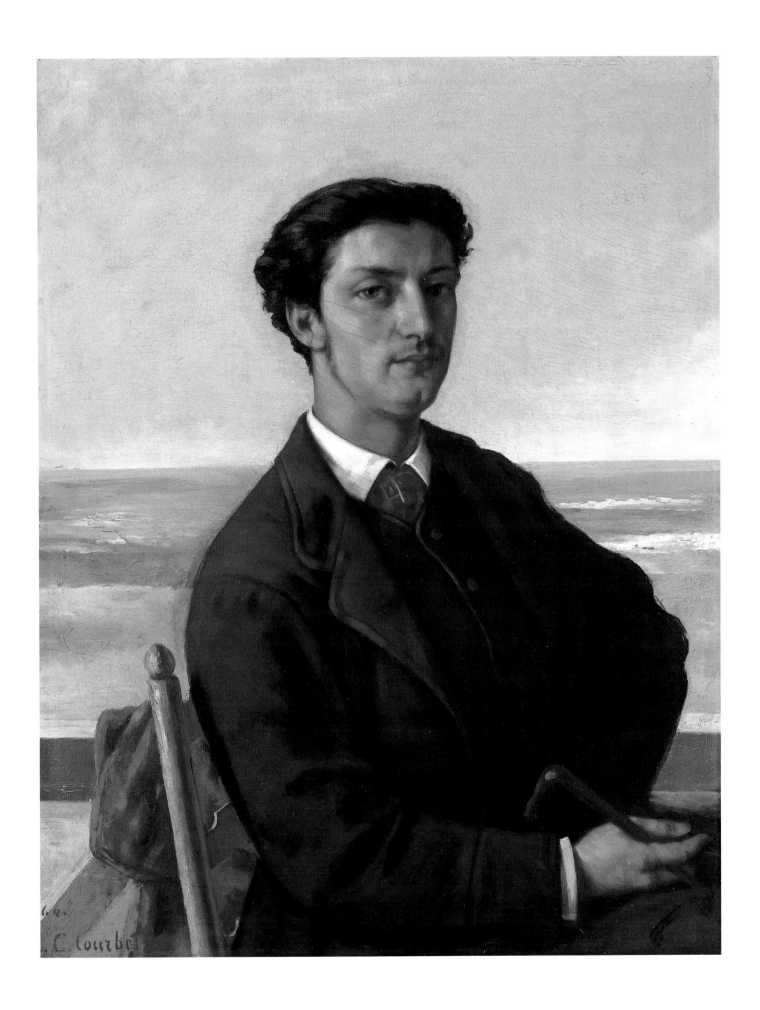

Edgar Degas

Paris, France 1834–1917 Paris, France

René de Gas (1845–1926), 1855

Oil on canvas

36¼ × 29½ in. (92.1 × 74.9 cm)

Not signed or dated

Purchased, Drayton Hillyer Fund

1935:12

Edgar Degas's early career is often viewed as a preamble to his later achievements—a period when he searched for his artistic voice by studying the old masters at the Louvre, during his stay in Italy, and briefly as a student at the Ecole des Beaux-Arts. Yet during this same early phase Degas produced some of his most memorable portraits, mainly of family members, among them the monumental *Bellelli Family* of 1858–67 (Musée d'Orsay, Paris) and the arresting double portrait of his sister Thérèse and her husband, *M. and Mme Edmondo Morbilli,* of 1865 (Museum of Fine Arts, Boston).

Degas's portrait of his younger brother, René de Gas, painted in the spring of 1855, is among his earliest essays in portraiture, and in it are distilled both the tentativeness of a youthful work and the promise of genius. The portrait captures an exquisite moment in their relationship—a passage in their nascent growth. The image is at once formal and intimate, and both artist and model are caught up in the serious act of making art. René, who at age ten posed for Degas after school in his student uniform, exhibits a near-reverential respect toward his older brother and his capacity to breathe life onto a canvas. Edgar in turn brings to the process the solemnity of serious effort evident in the formal stillness of the pose, the somber palette, and a conscious affirmation of a tradition of portraiture that began with the Renaissance masters and continued up to the brilliant portraits of Ingres. The latter's sumptuous, elaborate portraits of women as well as his more austere male portraits, which often have a simple, dark background, set the tone for a whole generation of younger artists.

Degas arranges the various aspects of the work into a cohesive visual and iconographic whole, giving it its psychological acuity. The still life to the left of René comprises a thick book, notebooks, inkwell, and pen. These attributes of a young student form a second nexus in the painting and establish an interactive reciprocity with the sitter. Degas positions René's right hand, holding a cap, close to the still life, reinforcing the bond between the student and his tools. Furthermore, the face of René, his shirt and red bow tie, and the elements of the still life are the only vividly colored passages in the composition. The portrait is among the first in which Degas contextualizes the sitter by introducing a significant supportive element in the form of a still life. He would later often explore this idea in inventive ways, as he did, for example, in *Woman Seated beside a Vase of Flowers* of 1865 (The Metropolitan Museum of Art).

Here, as often in his later works, Degas energizes the periphery of the painting as a critical compositional construct. The dark backdrop, which isolates and highlights René, does not reach the outer edges of the painting, leaving vividly rendered strips on either side. The subtle drama of the hands also guides the viewer toward the outer edge. The right hand moves toward the still life, while the left disappears into the trouser pocket at lower right—a casual, even irreverent gesture shared between brothers. Ultimately it is in the image of René that the psychological power of the painting resides. The deep bond between the artist and his youthful brother, evident in every aspect of René's demeanor, is palpable and memorable. Degas's greatest gift as a portraitist is already apparent here: his ability to insinuate himself as an integral force into the interiority of his sitter.

Further Reading

Baumann, Felix, and Marianne Karabelnik, eds. *Degas Portraits.* London: Merrell Holberton, 1994.

Boggs, Jean Sutherland, et al. *Degas.* New York: The Metropolitan Museum of Art; Ottawa: National Gallery of Canada, 1988.

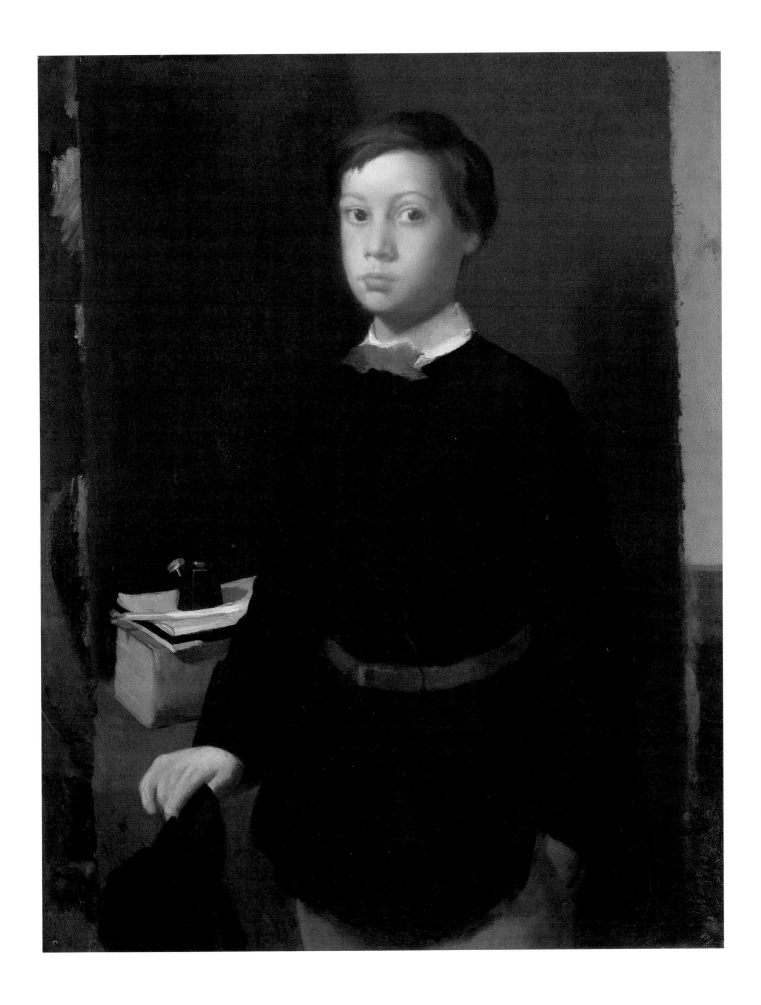

Edgar Degas

Paris, France 1834–1917 Paris, France

The Daughter of Jephthah, 1859–60

Oil on canvas
77 × 117½ in. (195.6 × 298.5 cm)
Sale stamp in reddish orange paint, lower left: Degas [Lugt 658]
Purchased, Drayton Hillyer Fund
1933:9

Degas began this painting soon after returning to Paris from a three-year sojourn in Italy. Its extraordinary scale and ambition are in large measure the result of that interlude, during which Degas was exposed to Italian art and antiquity. While there he also befriended Gustave Moreau, who became a mentor and introduced him to the work of Eugène Delacroix. *The Daughter of Jephthah* reflects the influence both of the Italian masters, especially those of the early Renaissance, and of Delacroix. The matte finish and suffused, muted colors relate to fresco cycles by quattrocento masters such as Piero della Francesca, while the intense, brilliant coloristic accents can be directly related to passages in Delacroix's works, some of which Degas refers to specifically in his letters. The large scale of the painting and its religious subject reflect the frescoes, but also Delacroix's grand compositions depicting historical, religious, and literary subjects.

The biblical theme of the painting derives from the Book of Judges. Jephthah the Gileadite is recalled from exile by the Israelites to do battle with the Ammonites. To assure victory, Jephthah vows to God to sacrifice on his return "whatsoever cometh forth of the doors of my house to meet me." Tragically his daughter and only child is the first to greet him. His moment of greatest triumph turns into one of deepest despair. Degas depicts the piercing instant of recognition and awareness and orchestrates all the elements in the painting to heighten the drama. The horse comes to an abrupt halt, and Jephthah raises his arm — too late to shield himself from the horrific inevitability of the unfolding events. Degas's choice of the story of Jephthah was especially popular among nineteenth-century writers, and his interpretation of the scene, which focuses attention on the daughter's fate, has been linked to Alfred de Vigny's dramatic poem "La Fille de Jephté" of 1820. Degas's choice may also reflect his concern for the fate of Italy and the role of Napoleon III in its political events.

The achievement of *The Daughter of Jephthah* must ultimately be judged by the integrity of its pictorial experiments and the degree to which these point to Degas's subsequent development. The many human figures in a variety of poses and groupings underscore the artist's fascination with human form as the pivotal instrument of his artistic investigation. Many of the figures derive from identifiable Renaissance sources; the cluster of women in the background, for example, is taken from Andrea Mantegna's *Crucifixion* (Musée du Louvre, Paris), of which Degas made a loose copy in 1861 (Musée des Beaux-Arts, Tours). Degas saw copying from old masters as necessary and sustaining for his artistic growth. The reductively simple landscape is the product of numerous studies, influences, and radical changes — an early indicator of the seriousness with which Degas would explore the landscape tradition. The aggressively tilted vista without a horizon, which serves as an arena for the unfolding events, also prefigures the stage sets of Degas's later ballet paintings. A dramatic tension leaps across this space, from Jephthah in the center to his daughter in the background group, reinforced by the poses and gestures of others. The tension of figures relating across a void would become one of Degas's most successful compositional devices; in his ballet rehearsals it is evident in the relationship between the ballet master and the ballerinas.

Degas eventually left the oversized canvas unfinished and kept it until his death. Of his early historical paintings, it remains the most problematical and challenging. Its scale, incipient drama, and sheer bravura, declare it as a very early landmark in the artist's development, and its lessons for him were numerous and profound.

Further Reading

Reff, Theodore. *Degas: The Artist's Mind.* Cambridge, Mass.: Belknap Press of Harvard University Press, 1987.

Sutton, Denys. *Edgar Degas: Life and Work.* New York: Rizzoli, 1986.

Edgar Degas

Paris, France 1834–1917 Paris, France

Dancer on the Stage, c. 1877–80

Oil on canvas

36 × 46½ in. (91.4 × 118.1 cm)

Sale stamp in reddish orange paint, lower left: Degas [Lugt 658]

Gift of Paul Rosenberg and Company

1955:14

Few artists have assimilated another art form as part of their own identity as completely as Degas has the ballet. From his first essays on the theme in 1867, he became increasingly interested in the ballet world, attending rehearsals and performances to observe his "rats," as the young dancers were called, and to learn about the ballet with them. Their animated poses and groupings on stage or in rehearsal halls became the vehicle for his own "performances," as he transformed their balletic rituals into some of the most compelling paintings of the century. In some of the works Degas comments obliquely but powerfully on the existing social conditions of the ballet world, which had declined in public esteem. In such works we discover the young age of the dancers and learn of their modest background — initially from the lower classes, later from families of Opéra staff members, musicians, and others. We learn how the socially powerful members of the Jockey Club interacted behind the scenes with the ballerinas, whose performance for them did not end on the stage. We also meet the dance masters, musicians, and ambitious backstage mothers. Degas's panoply of images traces these sobering and exhilarating realities — from arduous rehearsals to graceful bows at the end of performances. We view these scenes from exciting, unusual vantage points — from the wings, from rows near the orchestra pit, from the loge where the emperor would have viewed them, and from backstage, where the dancers relaxed, adjusted their costumes, and even arranged liaisons with Jockey Club members.

Dancer on the Stage depicts a ballerina in a gauzy light blue-green costume whose sparkling accessories suggest an orientalizing motif. Her long black hair and full chin have been likened to those of the prominent Spanish ballerina Rosita Mauri, who made her debut in Paris in 1878. While not all have accepted this intriguing identification, it is evident that this lone dancer on stage in midperformance is an *étoile* — a principal dancer, literally a star. Scenes of individual performers are rarer in Degas's oeuvre than those of ensemble performances, rehearsals, or dancers at rest. The positioning of the ballerina at extreme right reflects the artist's assimilation of the compositional devices of Japanese prints, a prevalent influence at the time. The atypical vantage point from which we usually view Degas's ballet scenes is absent here. Unable to discern our locus, we are thrust into close proximity to the action, as if on stage — only a sliver of dark at the lower right provides a degree of separation. The precise moment depicted seems to be when the ballerina enters the stage from the right. Her graceful pose extends her presence in all directions as she balances her forward movement with outstretched arms and contrapuntal leg extended back. The dancer and the loosely painted background, evocative of foliage, establish a dual focus that holds the composition in taut balance.

In *Dancer on the Stage* the ballerina's expansive yet purposeful, animated pose is controlled by the decorum of her discipline. In contrast, Degas gives his brush free rein in treating the background — an exuberant, swirling array of gestural strokes — generating a kind of abstract, expressive force that encompasses the dancer and shares the stage with her. *Dancer on the Stage* is foremost a compelling depiction of a ballet scene by Degas, but it is also an intriguing commentary on the complex interaction between the art of ballet and the art of painting.

Further Reading

Muehlig, Linda D. *Degas and the Dance.* Northampton, Mass.: Smith College Museum of Art, 1979.

Shackelford, George T. M. *Degas: The Dancers.* Washington, D.C.: National Gallery of Art, 1984.

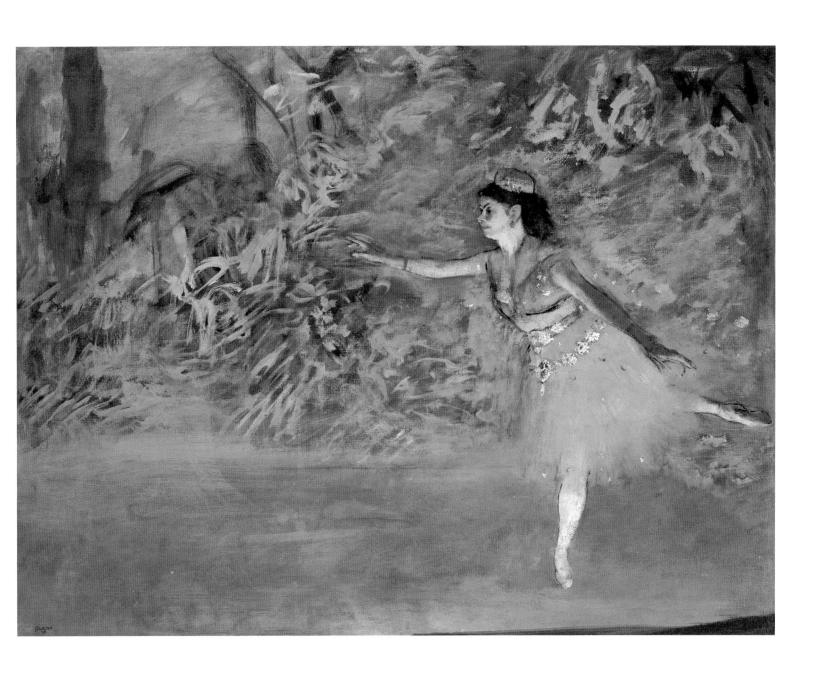

Edgar Degas

Paris, France 1834–1917 Paris, France

**Dancer Moving Forward, Arms Raised,
Right Leg Forward,** modeled 1882–95 (cast posthumously)

Bronze

25 × 12⅝ × 8¼ in. (63.5 × 32.1 × 21 cm)

Incised signature, cast number, and founder's mark on proper left foot: Degas/72/E/CIRE PERDUE A.A. HEBRARD

Purchased

1965:29

After Degas's death in 1917, his dealer Durand-Ruel discovered in his studio approximately 150 pieces of sculpture, some whole, others as fragments, made mainly of wax but also of plastiline and plaster. Seventy-four of these were cast in bronze, in an edition of twenty-two plus a master set, by the foundry of A.-A. Hébrard under the supervision of its master founder, Albino Palazzolo. *Dancer Moving Forward* is among the works that was thus preserved for posterity. Today many of these works grace private collections and museums and have contributed to Degas's reputation as the greatest painter-sculptor of the nineteenth century. Yet during his lifetime the public knew Degas as sculptor by the single work he exhibited. *Little Dancer Aged Fourteen,* which caused a sensation at the 1881 impressionist exhibition, has since become one of the best-known and most beloved sculptures of the century. It marked a pivotal moment in Degas's development as a sculptor. During the 1860s and 1870s he painted scenes of race horses and the ballet, but his early sculptures were exclusively of racehorses. *Little Dancer Aged Fourteen* was his first sculpture of a ballet dancer and, indeed, his first human figure. At the same time, it is atypical in the use of real accessories like the gauze skirt, silk bodice, and ribbon. It is also unique in Degas's oeuvre in its high level of finish, the penetrating psychological insight into the young dancer, and its coiled tautness.

With the exception of a few portrait heads, most of Degas's surviving sculptures, like *Dancer Moving Forward,* are studies of form in motion, as if fulfilling the potential of *Little Dancer Aged Fourteen.* Degas's sculptures, with their textured surfaces reflecting light, come closer to Impressionism than do his paintings, which fre-quently depict figures in interiors that are artificially lit. Of the pieces that were cast, *Dancer Moving Forward,* while among the least well preserved, is most revealing of Degas's working practices. The artist's legendary inability to let go of a work of art, always reworking it over extended periods, applies equally to his sculptures. Half the sculptures found in his studio could not be cast at all, having deteriorated in part because of Degas's repeated experimenting with them over time. His obliviousness to accepted sculpture practices is evident in *Dancer Moving Forward.* The missing right forearm reveals a flimsy armature, and the lower legs are fragmentary. Degas's lack of formal training in sculpture was a contributory factor, but so were the nature and purpose of these works, which he viewed as "exercises to get me going: documentary, preparatory notions, nothing more. None of this was intended for sale." These private exercises were also varied. Some relate directly to his paintings, pastels, and drawings, while others exist as independent works. In the case of *Dancer Moving Forward,* its graceful pose with upraised arms, right foot forward, basic to ballet, recurs often in his works and thus does not relate to a specific image.

Degas's reliance on sculpture increased as his eyesight deteriorated, and late in his career it became a substitute for painting. Yet his interest in sculpture goes back to the early years of his career. His artistic genius lies in his ability to draw on the expressive aspect of each medium to enhance the others. Of his sculptures, he said, "the only reason that I made wax figures of animals and humans was . . . to give my paintings and drawings greater expression, greater ardour, and more life." Yet sculptures such as *Dancer Moving Forward* possess these traits because they are informed by an artistic intelligence that has probed the same ideas in other media.

Further Reading

Kendall, Richard, et al. *Degas and the Little Dancer.* New Haven, Conn.: Yale University Press; Omaha: The Joslyn Art Museum, 1998.

Millard, Charles W. *The Sculpture of Edgar Degas.* Princeton, N.J.: Princeton University Press, 1976.

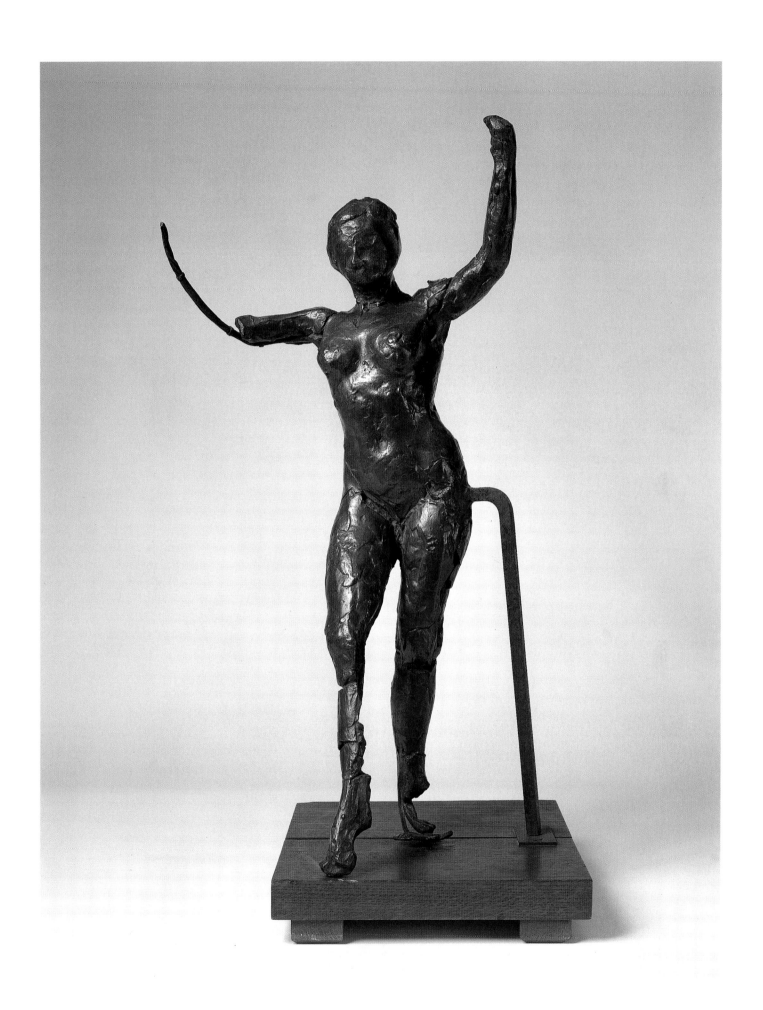

Narcisse Virgile Diaz de la Peña

Bordeaux, France 1807–1876 Menton, France

Forest Pool, Barbizon, 1862

Oil on canvas
30¼ × 38¾ in. (76.7 × 98.4 cm)
Signed and dated in black paint, lower right: N. Diaz. 1862.
Gift of Mrs. Otto H. Seiffert (Marjorie S. Allen, class of 1906)
1950:57

The truism that it is impossible to separate the artist from the person is especially valid in the case of Narcisse Diaz de la Peña. Born in Bordeaux in 1807 to a Spanish emigrant family, he was by age ten an orphan wandering the streets of Paris. He also lost a leg in an accident as a youth. Despite or perhaps because of such misfortunes, Diaz became a genuinely positive individual — a wit, a charmer, an effervescent presence at all occasions. A telling example of his character was his response to the peg leg he was forced to wear. Diaz's *pilon* became part of his persona and a source of endless stories.

He began his career as a porcelain painter, not unlike Pierre-Auguste Renoir and other artists, including Jules Dupré, who worked with Diaz in the Sèvres factory and became a fellow Barbizoner. Diaz had little formal training, and his early work of the 1830s and 1840s consists largely of charming Venuses, cupids, gypsies, and so on — themes evocative of eighteenth-century imagery, which had an important revival at the time. To accommodate public taste for soft, charming images, his figures reflected the influence of artists like Correggio, Leonardo da Vinci, and Pierre-Paul Prud'hon. His popular and highly saleable works made him quite well off.

Diaz was rescued from his popularity only by his talent. He was interested in landscape from the beginning of his career. While the sources for his genre pictures were eclectic, his master in landscape was primarily Théodore Rousseau, who was central to all issues dealing with French landscape at the time. From the outset Diaz admired his works and wanted to learn his secrets. He studied his compositions assiduously, and it was Rousseau who unlocked the mystery of the forest and its surrounds for him. When Diaz had earned enough money, he moved to Barbizon to be closer to his master and to explore the Fontainebleau forest. Diaz's artistic temperament differed significantly, however, from Rousseau's deeply emotional, moralizing outlook. Diaz's evolution as a landscapist, which blossomed to maturity after 1850, reflected that difference. He would entice the viewer with his virtuoso technique and his willingness to people his forest scenes with the Venuses, cupids, and sundry characters of his earlier period.

Forest Pool is an excellent example of Diaz's mature style, in which he explores one of his most important motifs — the forest interior. The darkness of the scene is pried open with a sliver of blue sky at the upper left — a passage for light to enter and enliven the grottolike interior of the forest with a rhythmic cadence of flecks of brilliant light on the tree trunks and their gnarled branches. The pool of water, which partly receives the light and reflects the trees, is a calming, life-sustaining oasis deep in the heart of the forest. A lone faggotgatherer, left of center, is a picturesque and poignant presence in the scene.

Diaz establishes here a compelling duality. His free, gestural strokes of bright color are light's surrogates, penetrating the forest. They also exist as a material presence vibrantly animating the canvas surface. The twentieth century has for too long turned a blind eye to the Barbizon artists, celebrating instead the revolutionaries they helped to spawn, the impressionists. Only in recent decades has interest rekindled in the work of the earlier artists. An image like Diaz's *Forest Pool*, evoking nature's unspoiled glory, has deep emotional resonance, and in its vigorous, assertive, gestural style of painting it is also a precursor to similar tendencies in twentieth-century art.

Further Reading

Adams, Steven. *The Barbizon School and the Origins of Impressionism.* London: Phaidon Press, 1994.

Herbert, Robert L. *Barbizon Revisited.* New York: Clarke & Way, 1962.

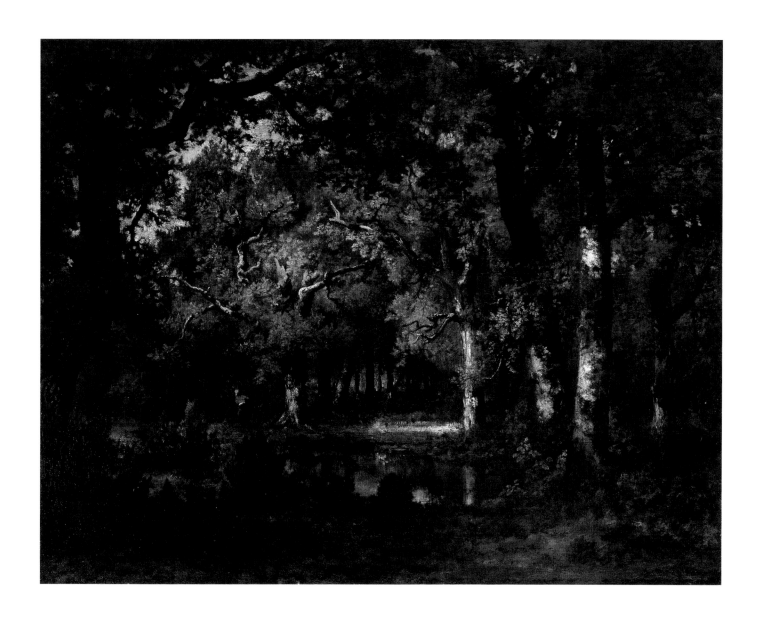

Henri Fantin-Latour

Grenoble, France 1836–1904 Buré, Orne, France

Mr. Becker, 1886

Oil on canvas

40 × 32½ in. (101.6 × 82.5 cm)

Signed and dated in brown paint, upper left: Fantin. 86

Purchased

1964:33

Henri Fantin-Latour counted among his closest friends artists who changed the face of nineteenth-century painting. Although he was witness to the impressionist revolution, he was not a participant. His vision of art was predicated on different principles. For example, in an impressionist painting sunlight as a specific source often permeates a scene, eliminating tonal distinctions. In Fantin's work, light is primarily a function of modeling—it need not have a specific source, and its main purpose is to articulate the form's light and dark passages to give an object a palpable three-dimensional reality. His refined technique, seen to great advantage in *Mr. Becker,* quite literally layers on paint like a membrane, giving the flesh luminescence.

Other than the fact that he was an American in Paris, we know little about Mr. Becker—not even his first name. He accompanied a mysterious woman to Fantin's studio. She gave her name as Mme Leroy, but Fantin thought it to be fictitious. She was eager to have her portrait painted, for which she paid in advance. When Fantin completed the portrait, she took it away in a cab, never to be seen again. At the time, Mr. Becker decided to have his portrait painted by the artist as well. The only further hint of his identity comes from an American artist living in Paris, Frank Boggs, who saw the portrait at the dealer Hector Brame's and proclaimed it to represent his uncle.

Mr. Becker has all the traits of a classic Fantin male portrait—reserved and formal, respectful of the sitter and of the decorum of portraiture. It recalls most closely seventeenth-century Dutch male portraits, where dark-clothed men in formal dress, with a white accent of a ruffled collar, are usually arranged against a dark background. In this work Fantin shows his mastery of the genre. Faced with enlivening the large dark area of

Mr. Becker's suit, he arranges the hands and the white shirt as accents at intervals that animate the lower, middle, and upper part of the suit. The Kazak prayer rug adds vibrant touches of color at the lower left. The composition culminates near the top with the thoughtful, graying and balding head of the sitter.

The most distinctive aspect of the pose is Mr. Becker's right hand, partly tucked between the buttons of the suit—a gesture made prominent by Napoleon and immortalized in numerous images, most notably in Jacques-Louis David's evocative *Napoleon in His Study* of 1812 (National Gallery of Art, Washington, D.C.). Fantin's direct source for this gesture, however, even to the upturned thumb, is Edouard Manet's *Portrait of Zacharie Astruc* of 1866 (Kunsthalle, Bremen).

Fantin was keenly aware of Manet's portrait of Astruc. One of Fantin's most celebrated group portraits is *L'Atelier des Batignolles* of 1870 (Musée d'Orsay, Paris)—an homage to his friend Manet, who is depicted seated before an easel surrounded by other artists and writers. Manet is shown painting the very same Astruc, seated in the foreground next to him. Indeed, Fantin's arrangement of the composition into a dense, dark area of figures at right and a lighter, more open area at left reflects in general Manet's bifurcated *Portrait of Zacharie Astruc.* Thus the source of Mr. Becker's gesture is irrefutable, but why Fantin turned to the earlier image is open to interpretation. Manet's death in 1883 may have been a motivation. Mr. Becker was, after all, a stranger to Fantin. Fantin, a very private person happiest in the company of family and friends, has personalized the commission by assimilating into *Mr. Becker* a pose from a portrait by a departed friend, whose creation he documented in *L'Atelier des Batignolles.*

Further Reading

Druick, Douglas W., and Michel Hoog. *Fantin-Latour.* Ottawa: National Gallery of Canada, National Museums of Canada, 1983.

Henri Fantin-Latour, 1836–1904. Northampton, Mass.: Smith College Museum of Art, 1966.

Lucie-Smith, Edward. *Henri Fantin-Latour.* New York: Rizzoli, 1977.

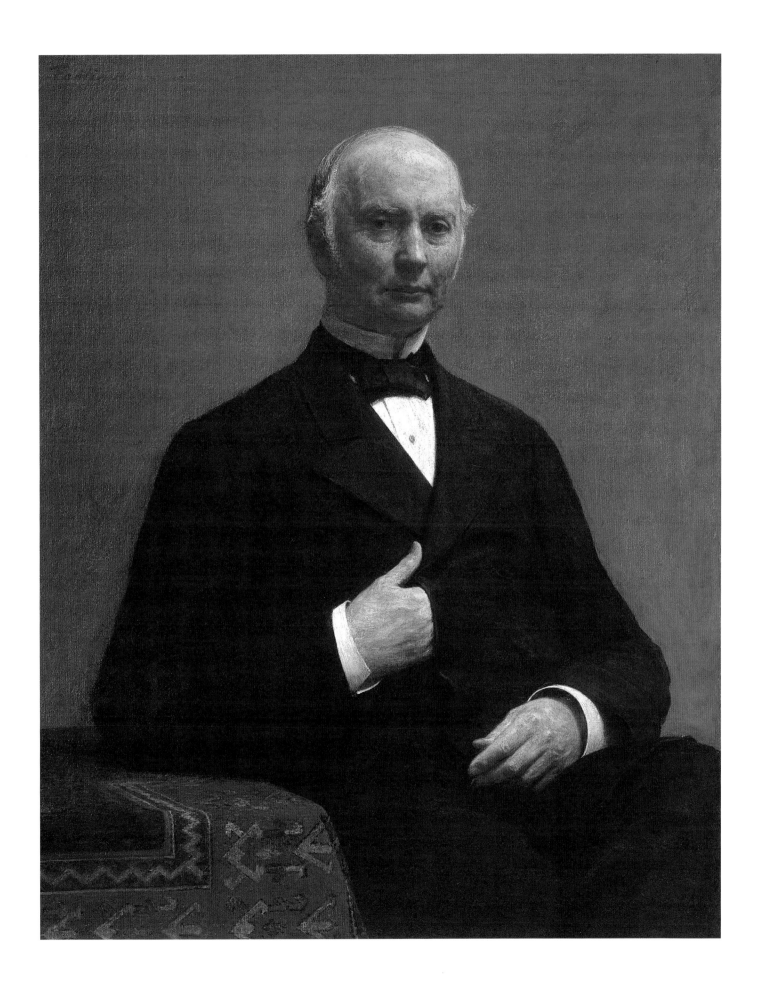

Unknown French Artist

(possibly Anne-Louis Girodet-Trioson)

Portrait of a Youth, possibly c. 1795

Oil on canvas

18⅜ × 15 in. (46.7 × 38.1 cm)

Not signed or dated

Purchased, Drayton Hillyer Fund

1931:6

When this *Portrait of a Youth* entered the collection in 1931, it was generally accepted as a work of Théodore Gericault, the progenitor of the romantic movement in France. Some considered it to be one of the lost portraits of the insane that Gericault painted in 1822 for his friend Dr. Etienne Giorget, who was engaged in pioneering work on mental illness. Only five portraits survive from this series of at least ten. Most modern scholars have rejected the Gericault attribution, yet the high quality of the painting is so evident that this orphaned youth has nearly always graced the walls of the museum.

Over the years there have been numerous unconvincing attempts at attribution. It is therefore a happy coincidence that as the present volume is to be published, a plausible attribution of the painting to Anne-Louis Girodet-Trioson has been put forth by Margaret Oppenheimer, an independent art historian. She bases her thesis on careful comparison of *Portrait of a Youth* with other Girodet male portraits, such as *Portrait of Jacques Cathelineau (1759–1793)*, known as the "Saint of Anjou," of 1824 (Musée d'Art et d'Histoire, Cholet). This full-length portrait was done some thirty years after Cathelineau's death, so it was of necessity idealized since no other image of him exists. In most respects the head of Cathelineau is very close to *Portrait of a Youth*. They share a near identical turn and tilt of the head. The eyes, glancing sideways and upward, bear the same relationship to the nose and lips. Oppenheimer postulates a date in the mid-1790s for Smith's portrait, on the basis of the sitter's hairstyle — long in front and short in back, exposing the neck in defiant reference to the ubiquitous guillotine. It is possible that this early work, or one like it, served as a prototype for Girodet's idealized interpretation of Cathelineau some thirty years later.

A contemporary document citing a half-length life-size study of a youth with arms crossed and head turned in three-quarter view may refer to Smith's *Portrait of a Youth*. It records dimensions of 67.5 × 41.6 cm, larger than the Smith portrait, but a conservation examination reveals that the Smith canvas has been cut down. The treatment of the shoulders — somewhat slumped and pulled forward, much as they would be if the arms were crossed, suggests that the portrait may indeed originally have been a half-length.

The strength of the image lies in its physicality and directness of presentation. We confront the simply dressed youth on his own terms and are impressed by his bearing — self-possessed and conscious of things around him. His romantic appearance — tousled hair, upturned collar, and engaged, gleaming eyes — speaks to his youth. Girodet's male sitters are often prominent, recognized individuals more formally dressed. Yet they generally share with *Portrait of a Youth* a romantic air, enhanced by an absorbed gaze. If *Portrait of a Youth* is an early Girodet, it will complement the museum's other impressive Girodet portrait of approximately a decade later (see pp. 60–61).

Further Reading

French Painting, 1774–1830: The Age of Revolution. Detroit: The Detroit Institute of Arts; New York: The Metropolitan Museum of Art, 1975.

Wintermute, Alan, ed. *1789: French Art during the Revolution.* New York: Colnaghi, 1989.

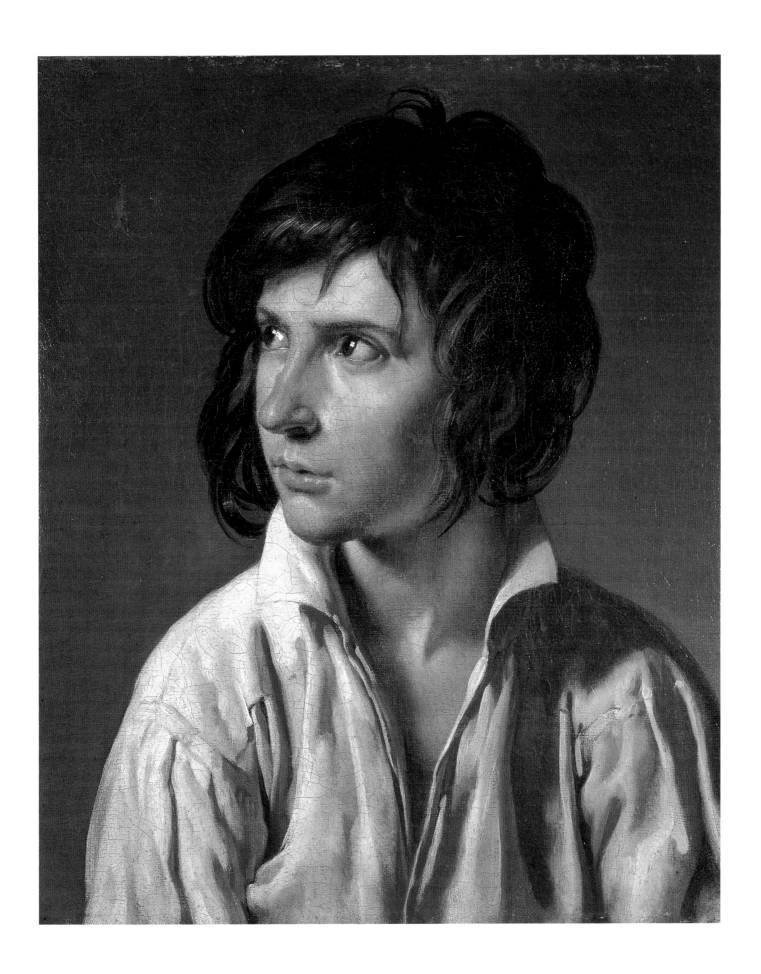

Paul Gauguin

Paris, France 1848–1903 Atuona, Marquesas Islands

The Market Gardens of Vaugirard, 1879

Oil on canvas

26 × 39½ in. (66 × 100.3 cm)

Signed and dated in blue paint, lower left: P. Gauguin 79

Purchased

1953:55

By 1879, the year Gauguin painted *The Market Gardens of Vaugirard,* his relationship to Impressionism and to the impressionists themselves had evolved in important ways. The young financier/banker-turned-artist, who as early as 1876 had exhibited in the official Salon, had only a few years later become a significant collector of the impressionists, specifically Camille Pissarro. In fact, he lent two paintings and a fan decoration by Pissarro to the fourth impressionist exhibition of 1879, to which he also contributed a portrait bust of his older child, Emil.

The following year, Gauguin contributed seven paintings and a portrait bust of his wife, Mette Sophie (Courtauld Gallery, London), to the fifth impressionist exhibition. Among these was *The Market Gardens of Vaugirard,* a painting heavily indebted to Pissarro, who had become his mentor, but also to Paul Cézanne. Mark Roskill argues convincingly that the short, even brushstrokes in this work come from Cézanne's *Harvest* of about 1876 (private collection), which Gauguin probably owned by this time and which he also used as a source for a fan and a pot. It has also been observed that the horizontal planes in this work derive from similarly arranged village scenes by Cézanne and Pissarro.

Gauguin lavished great attention on *The Market Gardens of Vaugirard.* It depicts the neighborhood south of the Seine in Paris where the artist lived with his wife and two children. In positioning himself on the upper story of his house to paint the scene, Gauguin conforms to one of the impressionists' most compelling innovations: defining the energy of their city motifs from a high vantage point. From this position Gauguin depicts in slightly angled parallel passages the garden, a long wall beyond which is a street lined with trees, and atop this a line of houses that define and animate the horizon line. This, too, is a convention favored by the impressionists, especially Pissarro, who frequently depicted an interestingly arranged expanse of open space in the foreground, culminating in a horizontal strip of buildings. The chimney of Gauguin's house, in the left foreground, initiates a vertical counterpoint to the prevalent horizontality. A house above the chimney in the middle part of the composition helps unify the foreground with the houses in the background.

While *The Market Gardens of Vaugirard* underscores Gauguin's connection to Impressionism, it also strongly hints at his later development. The repoussoir tree at the lower left, a conventional device that here establishes the foreground-background axis, will eventually evolve into a significant pictorial element in such seminal works as *A Vision after the Sermon: Jacob Wrestling with the Angel* of 1888 (National Gallery of Scotland, Edinburgh).

In a rather surprising gesture for a young artist trying to emulate his impressionist mentors, Gauguin fills the sky with clouds, depriving the scene of the sparkle of sunlight. The lack of sunlight prevents the diffusion of form and thus allows the tightly arranged brushstrokes to define clear, broad areas of color, for example in the garden area and the wall, prefiguring Gauguin's later synthetist style.

Further Reading

Goldwater, Robert. *Paul Gauguin.* New York: Harry N. Abrams, 1957.

Roskill, Mark. *Van Gogh, Gauguin, and the Impressionist Circle.* Greenwich, Conn.: New York Graphic Society, 1970.

Thomson, Belinda. *Gauguin.* New York: Thames and Hudson, 1987.

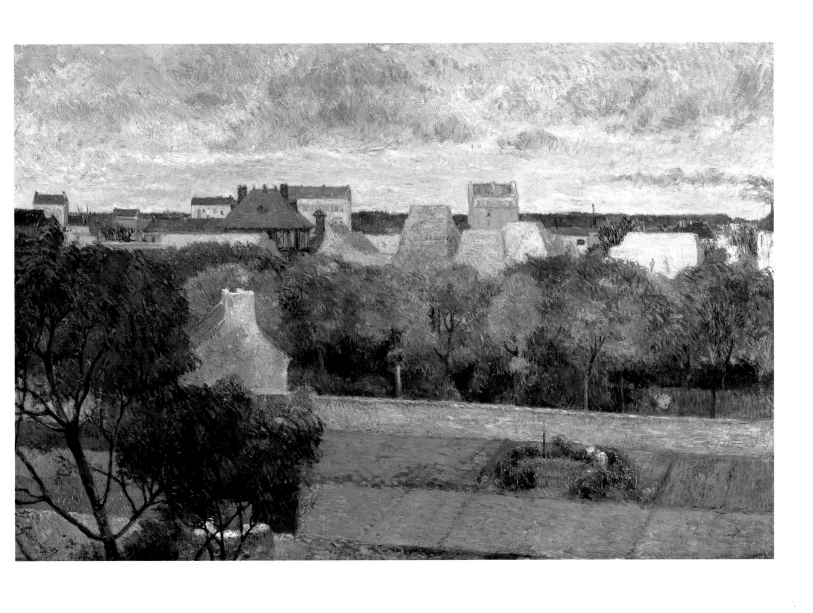

Anne-Louis Girodet-Trioson

Montargis, Loiret, France 1767–1824 Paris, France

Madame Benoit-François Trioson (?), 1804

Oil on canvas

25½ × 21⅜ in. (64.8 × 54.3 cm)

Signed with the artist's monogram and dated in brown paint, lower right: GRT/1804

Purchased with the assistance of the Eleanor Lamont Cunningham, class of 1932, Fund

1956:19

On the face of it, the career of Anne-Louis Girodet-Trioson followed the course of other successful neoclassical artists who were trained in the studio of Jacques-Louis David. David considered Girodet among his most talented students, and in 1789, the year of the Revolution, Girodet won the Prix de Rome. He departed for Rome a year later and stayed for five years. While there he produced his most important work, *The Sleep of Endymion* (Musée du Louvre, Paris), which was a success at the Salon of 1793. In this highly personal interpretation of the scene, Girodet depicts the sleeping youth in a languorous recumbent pose, visited by the goddess Diana in the form of a moonbeam. The dreamy, suffused quality of the painting, evocative of Correggio and Leonardo, presented a challenge to David's Neo-classicism. Girodet tried consciously, even willfully, to distinguish himself in this work from his master and to manifest his originality. In his quest to be original and in the visionary imagery of this and other works, Girodet prefigures the romantic movement.

This romantic tendency is also seen in his portraiture, but Girodet's *Madame Benoit-François Trioson (?)* of 1804 emphasizes that classicism remained for him a viable and important avenue of self-expression. It embodies a tradition of portraiture prevalent in the first decade of the nineteenth century, as evidenced by the distinctive coiffure that many portraits of the period share. The fashion is Empire, as indicated by the high waistline of the dress, and the image is at once elegant and discreet, formal and accessible.

Issues of light were always of paramount importance to Girodet. Here the sitter emerges from a dark green background as a pristine, exquisitely modeled form. The source of light is direct, just to the viewer's left, and the play of light and shade is subtle and sustained. The shaded part of the face is outlined by a thin string of light, which at once helps define the form of the head and establishes distance from the background. The braid, tightly arranged across the sitter's meticulously coiffed head, initiates a cascade of curls encircling the forehead. Rather than being flattened against the forehead as in Ingres's *Mme Philibert Rivière* (Musée du Louvre, Paris), here the curls, illuminated from the front, animate space around the head by casting shadows on the forehead. The calligraphy of the curls and their shadows is the most exuberant passage in the painting. It initiates a process that is echoed in the border of the elaborately articulated shawl and in the delicate outline of the dress, whose waistline is braided, much like the hair, thus completing the cycle. Within this refined, exquisitely detailed image, Girodet achieves a degree of intimacy and openness through the engaged gaze of the sitter's large oval eyes and his choice of subtly modulated warm colors, ranging from soft white to beiges and pinks.

When the painting entered the collection in 1956, George Levetine published it as *Madame Benoit-François Trioson*. He based his conclusion on a document referring to a portrait of Mme Trioson dated 1804. Believing the Smith painting to be Girodet's only extant portrait of a woman dated 1804, he concluded that it must be that of Mme Trioson, the young wife of Dr. Benoit-François Trioson, Girodet's guardian, who would adopt the artist in 1806 and who was probably his natural father. This deductive identification has been challenged by subsequent scholars, notably Stephanie Nevison-Brown, who has discovered other portraits by Girodet also dated 1804, among them one of Mme Merlin, which in many respects is similar to the Smith portrait. Levetine's identification of the sitter therefore awaits further documentary confirmation.

Further Reading

Honour, Hugh. *Neo-classicism.* Harmondsworth, England: Penguin Books, 1991.

French Painting, 1774–1830: The Age of Revolution. Detroit: The Detroit Institute of Arts; New York: The Metropolitan Museum of Art, 1975.

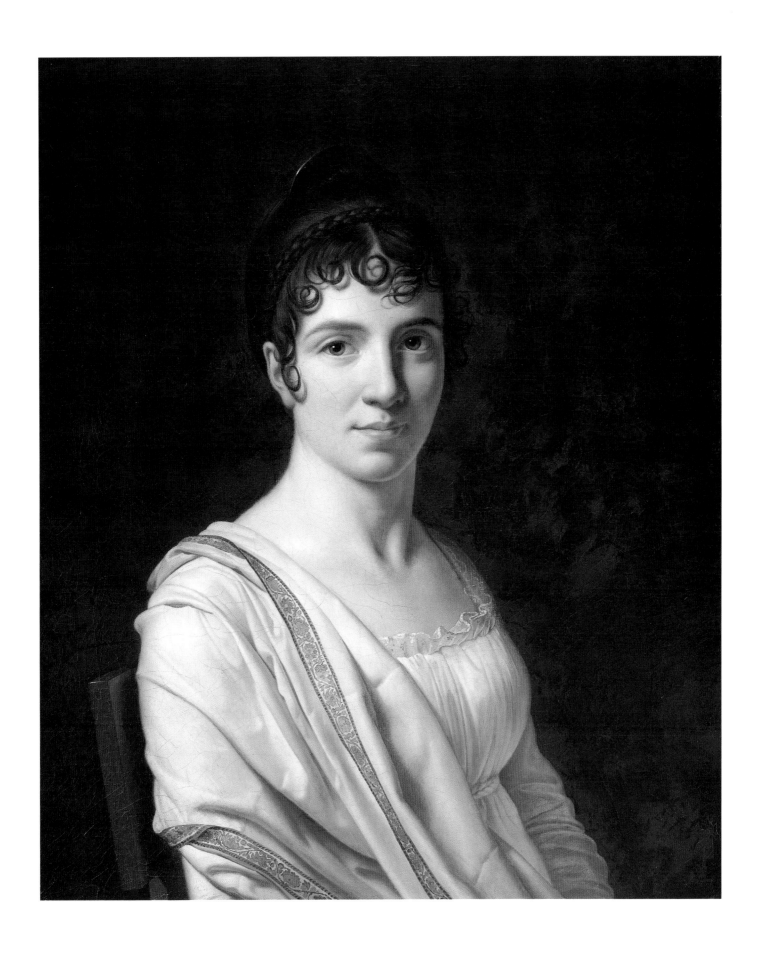

Juan Gris

Madrid, Spain 1887–1927 Boulogne-sur-Seine, France

Fruit Dish, Glass, and Newspaper, 1916

Oil on canvas
13 × 18¼ in. (33 × 46.4 cm)
Signed and dated in brown paint, lower left: Juan Gris 1916
Gift of Joseph Brummer
1923:2-1
© 2000 Artists Rights Society (ARS), New York/ADAGP, Paris

Juan Gris is well established as one of the four great masters in the history of Cubism, the others being Georges Braque and Pablo Picasso, the founders of the movement, and Fernand Léger. Gris began his career in his native Spain, in provincial Madrid rather than advanced Barcelona. When he arrived in Paris in 1906 and searched out his compatriots at the Bateau Lavoir (Laundry Boat), a complex of artists' studios in Montmartre, Gris could not have known that he had positioned himself at the epicenter of artistic innovation. He worked as a graphic artist for a newspaper but kept a watchful and respectful eye on the Bateau Lavoir's most famous tenant, Picasso. By 1910, when Braque's and Picasso's Cubism had reached its analytic phase, Gris made the fateful decision to devote himself to art and to the new visual language of Cubism.

Gris's art is closely aligned thematically with that of Braque and Picasso, deriving its subjects from the studio and the café world. Yet his interpretation of these themes was from the outset distinctly his own. Braque's and Picasso's cubist paintings are intuited from facet to facet, while Gris establishes an a priori gridlike structure onto which he arranges the various elements of a composition. He articulates his vision with clarity and precision—a by-product of an analytic temperament, but also the result of having been emboldened by the pioneering work of his predecessors.

Gris's most prolific subject is the still life. Gertrude Stein observed that for Gris, "still life was a religion," underscoring the single-mindedness of his commitment. Stein's words also allude to a spirituality and a contemplative stillness that has been likened to the still lifes of the seventeenth-century Spanish master Francisco de Zurbarán. The early gray still lifes of 1911–12 correspond to Braque's and Picasso's brown-ocher monochrome analytic cubist works, but in 1913 Gris introduced exuberant colors, reflecting the influence of Robert Delaunay's Orphism, in which the cubist facet and vibrant color are merged.

Fruit Dish, Glass, and Newspaper belongs to a larger group of oil paintings of 1916, arranged with similar elements. In this work a host of important influences coalesce. As in other paintings of that year, its color scheme is more subdued—limited to brown, beige, violet, greens, and one or two other colors. Gris focuses on the textural materiality of objects, in which we can discern the pervasive influence of collage. This is evident in the reference to the newspaper, in the wood graining of the table, and in the white cloth at the lower center, whose thickly built-up crosshatched strokes approximate the texture of rough cloth. Gris was very conscious of the tradition of super-real imagery in Spanish art.

In this and other still lifes done in 1916, the fruit dish dominates the composition. It derives from one of Paul Cézanne's most significant works, *Still Life with Compotier,* of about 1879–80 (The Museum of Modern Art, New York). Gris repeats the asymmetry of Cézanne's compotier, as well as the dual vantage point—seeing both the side and the top simultaneously—one of Cézanne's key contributions to Cubism. "Cézanne turns a bottle into a cylinder. . . . I make a bottle, a particular bottle, out of a cylinder," he commented, distinguishing his more conceptualized approach to art from Cézanne's emphasis on extracting form from observable reality.

Fruit Dish, Glass, and Newspaper brings together all that was artistically current at the time, yet Gris transforms the momentary aspect of the work into a meditation on and elucidation of pictorial issues.

Further Reading

Green, Christopher, et al. *Juan Gris.* London: Whitechapel Art Gallery; New Haven, Conn.: Yale University Press, 1992.

Kahnweiler, Daniel-Henry. *Juan Gris: His Life and Work.* Translated by Douglas Cooper. New York: Harry N. Abrams, 1969.

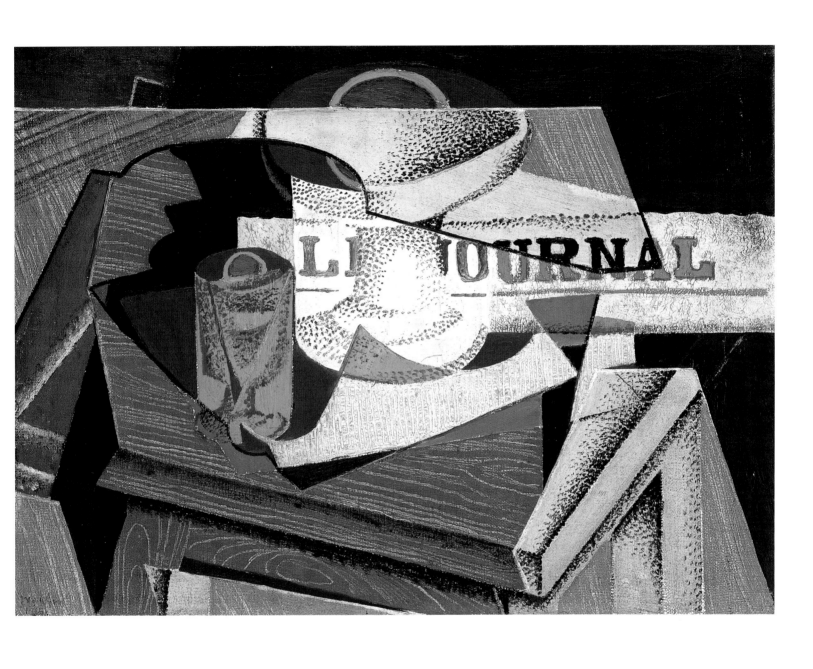

Pierre-Narcisse Guérin

Paris, France 1774–1833 Rome, Italy

Clytemnestra Hesitating before Stabbing the Sleeping Agamemnon, c. 1817

Oil on canvas

30 × 33½ in. (76.2 × 85.1 cm)

Signed with the artist's monogram in black paint, lower left (base of column): PG

Purchased with the Hillyer, Mather, Tryon Fund and with funds realized from the sale of works given by Caroline R. Wing, class of 1896, Adeline F. Wing, class of 1898, and Mr. and Mrs. Allan D. Emil

1999:24

Baron Pierre-Narcisse Guérin is one of the most celebrated and accomplished neoclassical artists, bridging the late eighteenth and early nineteenth centuries. He was born on the threshold of the neoclassical movement and died at the height of Romanticism; in different ways he contributed to both. Guérin had a deep appreciation of the historical sweep of the French classical tradition, with its roots in the works of Nicolas Poussin. Although never a student of Jacques-Louis David, he was nonetheless strongly influenced by him.

Guérin's career began early and progressed rapidly. His most influential early teacher was Jean-Baptiste Regnault. During the 1790s Guérin was at the Académie, and in 1797 he won the coveted Prix de Rome for his interpretation of the Death of Cato (Ecole Nationale Supérieure des Beaux-Arts, Paris). Poor health limited Guérin's productivity, and in his later years he focused on teaching. Among his students were many celebrated artists of the romantic movement, including Théodore Gericault, Eugène Delacroix, and Ary Scheffer.

Smith's canvas is a smaller replica of Guérin's 1817 painting in the Louvre. It is an image of betrayal, revenge, love, lust, and murder—all intertwined in the convoluted story of Agamemnon, King of Mycenae, and his wife, Clytemnestra. As the leader of the Greeks during the Trojan wars, he beseeched the goddess Artemis for aid, appeasing her by sacrificing their daughter Iphigenia—an act that Clytemnestra could not comprehend or forgive. Meanwhile, in Agamemnon's absence at war, Clytemnestra betrayed him with her lover Aegisthus. In Homer's account, she and her paramour threw a banquet for Agamemnon upon his return, during which he was killed. Aeschylus places the murderous deed in the king's chamber while he bathed. Guérin, in contrast, depicts the king asleep in his chamber, as Aegisthus urges the hesitant Clytemnestra to kill him.

Guérin takes care to represent a scene of archaeological verisimilitude—from the dress of the figures to Agamemnon's military hardware to the building at upper right, which evokes the palace of Argos. What keeps the image from spilling over into melodrama, more than the archaeological references, is the discipline of its pictorial structure. The background divides and distinctly defines space for each of the three protagonists—an idea already brilliantly resolved by Jacques-Louis David in his highly ordered *Oath of the Horatii* of 1784 (Musée du Louvre, Paris). Guérin's debt to David is also evident in the figure of the sleeping Agamemnon, with his military garb and weapons, reminiscent of David's dead Hector in *Andromache Mourning Hector* of 1783 (Musée du Louvre, Paris).

The dramatic poses and gestures in this work evoke artists such as Henry Fuseli, but even more importantly they underscore Guérin's lifelong love of the theater. The story unfolds here like a stage play. The dramatically colored tripartite division of the backdrop is pregnant with symbolic meaning. The scene at left is cast in darkness, which is linked with death as it envelops the urn with Iphigenia's ashes at extreme left, and with guilt as it highlights the leaning figure of the duplicitous Aegisthus. Thus the two conflicting yet intertwined impulses for Clytemnestra's act emanate from this dark passage. At right, the pose of the sleeping Agamemnon, illuminated with an eerie pink glow, links the notion of sleep with his impending death. In the center, the lantern glows through the curtain, and light becomes heat as the lurid red-orange engulfs Clytemnestra's tense, anguished silhouette, revealing and intensifying her conflicted passions. As she stands at the precipice—hesitant, determined, resigned—about to plunge the knife into her husband—she is the embodiment of the complex nature of human actions. This painting demonstrates how Guérin continued to be nourished by his neoclassical roots, even as he responded to the new romantic artistic and cultural currents.

Further Reading

French Painting, 1774–1830: The Age of Revolution. Detroit: The Detroit Institute of Arts; New York: The Metropolitan Museum of Art, 1975.

Rosenblum, Robert. *Transformations in Late Eighteenth Century Art.* Princeton, N.J.: Princeton University Press, 1969.

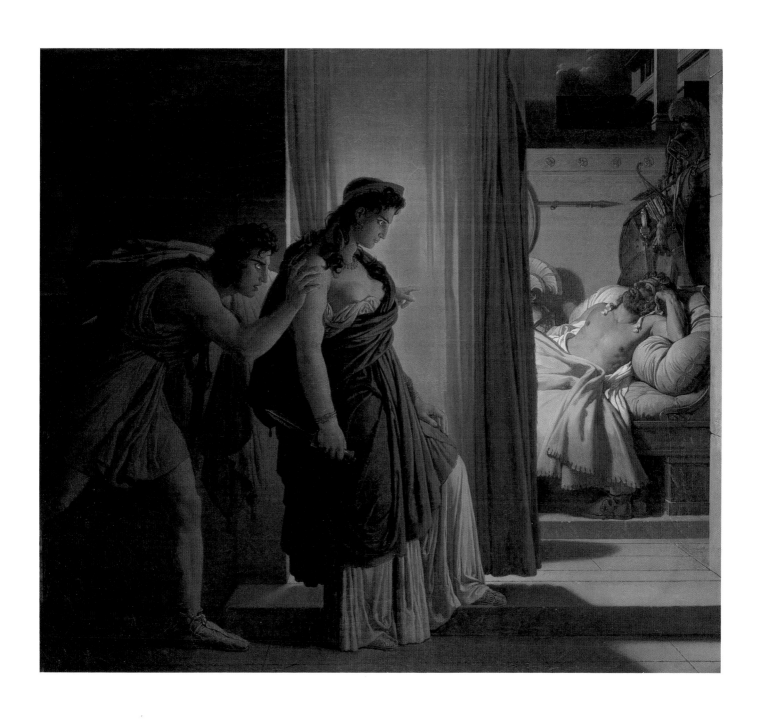

Jean-Antoine Houdon

Versailles, France 1741–1828 Paris, France

Bust of the Abbé Barthélemy (1716–1795),

1793/94–before 1802

Marble

20½ × 11⅞ × 11¼ in. (52.1 × 30.2 × 28.6 cm)

Not signed or dated

Purchased with the Hillyer, Mather, Tryon Fund

1989:22

Jean-Antoine Houdon, the Enlightenment's most brilliant portraitist, studied with some of the best sculptors of the period, including René-Michel Slodtz, Jean-Baptiste Lemoyne, and Jean-Baptiste Pigalle. He won the Prix de Rome in 1761 at the age of twenty. After three years at the Ecole des Elèves Protégés, he traveled to Rome in 1764 and stayed for four years. His most important sculpture from this period was *Saint Bruno* for the church of Santa Maria degli Angeli, Rome.

Houdon established himself as a portraitist with the bust of Denis Diderot of 1771 (painted plaster, Yale University Art Gallery, New Haven), the most successful image of the great encyclopedist. It was at once an excellent likeness and a penetrating, insightful formulation of Diderot's physical and intellectual vibrancy. It set the tone for portraits of other men of the Enlightenment, especially his full-length image of the seated, elderly Voltaire of 1778–80 (terra cotta, Musée Fabre, Montpellier, France). He is best known in America for his busts of Benjamin Franklin (marble, The Metropolitan Museum of Art) and Thomas Jefferson of 1789 (marble, Museum of Fine Arts, Boston). One of his most successful statues was a full-length, life-size marble portrait of George Washington (1786–96) for the State Capitol in Richmond, Virginia.

Houdon's activity waned soon after the French Revolution, in part because Jacques-Louis David, the dominant artist of the period, actively disliked him and limited his access to commissions. *Abbé Barthélemy* was the sculptor's only entry in the Salon of 1795. It must have been a source of some pleasure and solace for Houdon to work on the portrait of an individual who so clearly embodied the ideals of the Enlightenment. Jean-Jacques Barthélemy, known as Abbé, was for many

years the curator of the Cabinet des Médailles de la Bibliothèque du Roi. Yet his reputation rests on his immensely successful book, *Voyage du jeune Anacharsis en Grèce*, published in 1788, which helped rekindle interest in Greek culture. He uses the literary device of a Greek traveler in the fourth century B.C. who details the history, customs, philosophy, and art of ancient Greece, intertwining them with moving human stories. Its compendium of factual information was a great resource for artists.

Houdon's portrait of Abbé Barthélemy reflects the sensibility of his Enlightenment portraits of the 1770s and 1780s. This is an old, wizened head—thoughtful, reflective, unself-conscious. The subtle smile and insightful eyes are at once the instruments of his wisdom and the defining features of his gentle character. The keenly observed details of Barthélemy's physiognomy reflect the artist's method of taking precise measurements of the sitter's features, often even making a life mask. Yet the resulting portrait goes far beyond the factual data. Houdon's rich, complex character study rests on his willingness to sublimate his artistic temperament to the character of the sitter and on his ability to inculcate the image with the defining ideas of the Enlightenment. In choosing to depict Barthélemy on a herm base, the artist alludes to the sitter's knowledge of the ancient world.

The Smith marble portrait was originally given by Houdon to the medallist Jean-Pierre Droz, after a break in the neck made further work on it impractical. When the Smith portrait is compared with a completed marble of Barthélemy, it is clear that the break occurred well into the process, for only the degree of finish separates the two. The main difference is in the eyes. In the completed version the pupils are carved deeply so that Barthélemy's glance to the side is directed and alert. In the Smith portrait the pupils are left blank, making the image more frontal and pensive in demeanor.

Further Reading

Arnason, H. H. *The Sculptures of Houdon.* New York: Oxford University Press, 1975.

Levey, Michael. *Painting and Sculpture in France, 1700–1789.* New Haven, Conn.: Yale University Press, 1993.

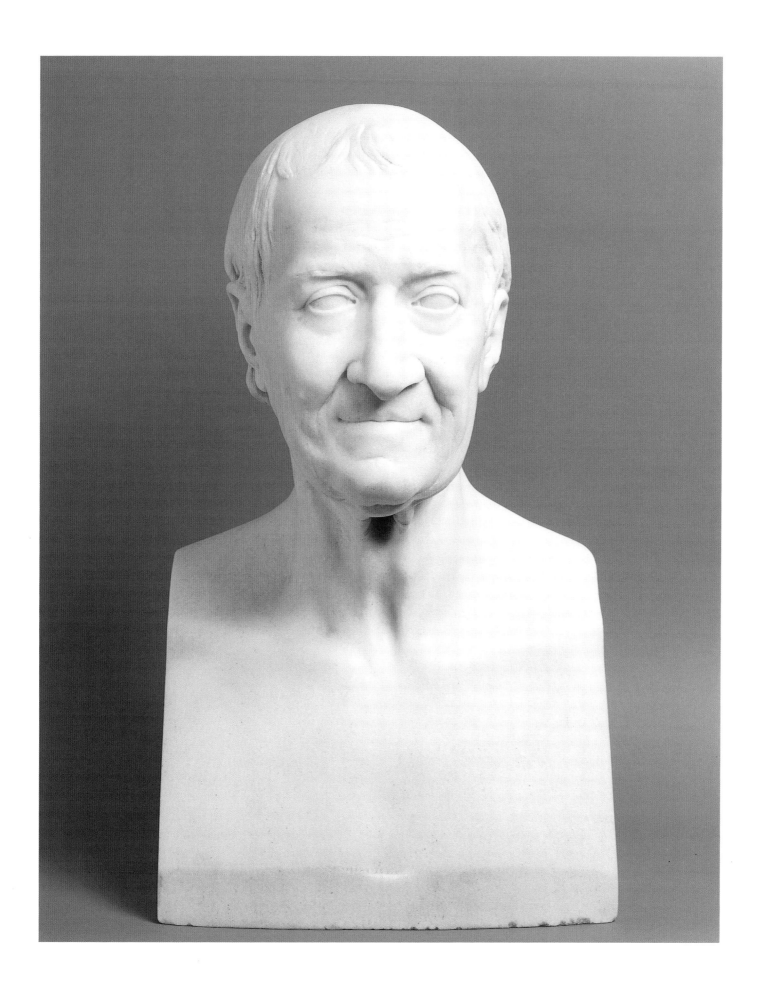

Jean-Auguste-Dominique Ingres

Montauban, France 1780–1867 Paris, France

The Death of Leonardo da Vinci, c. 1851

Oil on canvas
16¼ × 19¼ in. (41.3 × 48.9 cm)
Not signed or dated
Purchased
1950:98

This canvas is a later variant of a painting done in 1818 for the comte de Blacas, a prominent statesman who was the French ambassador to Naples and then Rome. *The Death of Leonardo da Vinci* belongs to a group of paintings executed in the troubadour style between 1814 and 1825. Ingres's troubadour paintings, usually small in scale, are rich in narrative and detail, vibrant in color, and eloquent in their manipulation of line. In these, he adopts a style for each painting that corresponds to the historical period depicted. Among them are such prominent works as *Raphael and the Fornarina* of 1814 (Harvard University Art Museums, Cambridge, Massachusetts) and *Paolo and Francesca* of 1818 (Musée des Beaux-Arts, Angers), both of which likewise exist in multiple versions.

The Death of Leonardo da Vinci, like *Raphael and the Fornarina*, focuses on the life of a famous artist, an immensely popular theme. The death of Leonardo had been a subject for paintings from the late seventeenth century onward, most famously in François-Guillaume Menageot's version shown in the Salon of 1781 (Musée de l'Hôtel-de-Ville, Amboise). Ingres depicts a story taken from Vasari's *Vite* of 1551, which relates that Francis I arrived at the last moment to catch the expiring genius in his arms.

Leonardo died on May 2, 1519, at the château du Clos-Lucé, near Amboise. While it is documented that Francis I wept on hearing of Leonardo's death, there is no proof that he was present at the event.

Ingres, like his hero Nicolas Poussin in the seventeenth century, had spent much of his career in Italy and drew heavily on Italian sources. (Indeed, his head of Francis I here is based on a portrait by Titian [Musée du Louvre, Paris]). He thus embodied the synergy between France and Italy and made it an important subtext of the work. Francis I, who had lured Leonardo to France,

was instrumental in the development of French art and architecture. Implicit in depicting Leonardo in his arms is the transfer of artistic hegemony from Italy to France. With this gesture, Francis I also shows his deep humanity and elevates the stature of the artist in society.

Recent scholarship has argued for a date of about 1851 for the Smith work, since it depicts the *Mona Lisa* in the background. This relates it to the Etienne-Achille Réveil print of 1851, which, unlike other variants, includes the Leonardo masterpiece. In comparing the Smith version with the 1818 painting (Petit Palais, Paris), we see differences both obvious and discreet. The Smith variant reverses the original and has a simpler, more summary treatment of the figures and of such elements as the chair and bed canopy. The elaborate incised treatment of the floor suggests that Ingres may have intended to carry the Smith painting further.

There are enough subtle but important differences between the original and the Smith version to suggest a fundamental rethinking of the narrative by Ingres. Three key figures carry the emotional message of the painting: Francis I, Leonardo, and the figure standing behind the chair, who may represent Leonardo's friend Melzi. In the 1818 version he serves as an interlocutor, gesturing with both arms toward the deathbed scene, where the heads of Francis I and Leonardo are closely bonded, both physically and emotionally. Although this version was generally well received, critics pointed out that Francis I appeared to be suffocating Leonardo. In the Smith version, the two heads are held apart and the emotional burden has been transferred to the figure behind the chair, who is shown despairing and wringing his hands. It would appear that Ingres remembered the criticism of the original in working on the later version and decided to reorder a major dynamic in the painting.

Further Reading

Condon, Patricia, et al. *Ingres, In Pursuit of Perfection: The Art of J.-A.-D. Ingres.* Edited by Debra Edelstein. Louisville, Ky.: The J. B. Speed Art Museum; Bloomington: Indiana University Press, 1983.

Rosenblum, Robert. *Jean-Auguste-Dominique Ingres.* London: Thames and Hudson, 1990.

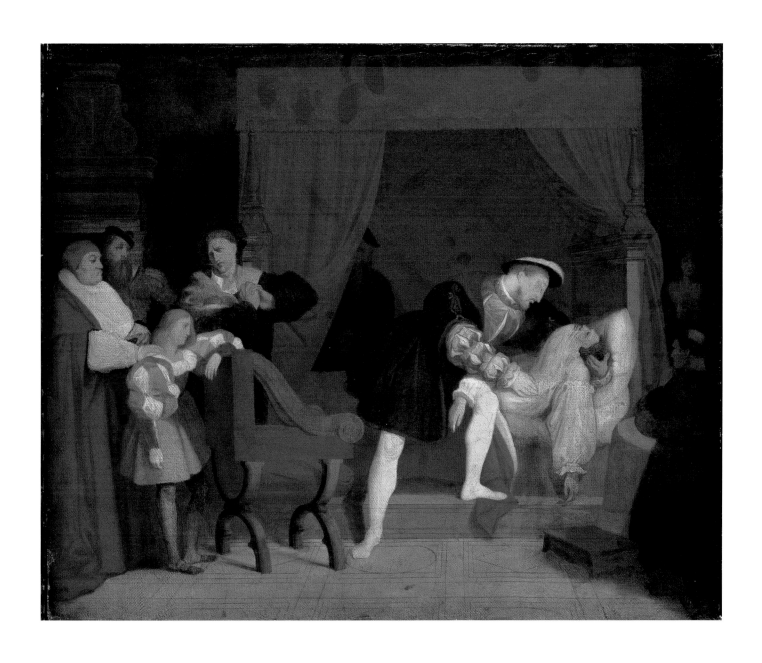

Wassily Kandinsky

Moscow, Russia 1866–1944 Neuilly-sur-Seine, France

Autumn Impression, 1908

Oil on paperboard

13 × 17½ in. (33 × 44.5 cm)

Signed in red paint, lower right: KANDINSKY

Bequest of Mrs. Robert S. Tangeman (E. Clementine Miller, class of 1927)

1996:24-1

© 2000 Artists Rights Society (ARS), New York/ADAGP, Paris

Autumn Impression was painted in 1908, probably in late September, in the small Bavarian town of Murnau, nestled in the foothills of the Alps south of Munich. Between 1907 and 1914 Kandinsky stayed there for extended periods with his companion, the artist Gabriele Münter. His investigation of form and color achieved a new intensity during this period, manifested most fully in his landscapes. A few years earlier, in Paris, Kandinsky had exhibited at the historic Salon d'Automne of 1905. There he was exposed to the startling coloristic experiments of the Fauves, led by Henri Matisse.

This important contact with the French avant-garde partly explains the sonorous, rich color rhythms of Kandinsky's work. The fauves validated his own experiments on the properties of color. Yet for Kandinsky color has an interactive synesthetic connection to sound and music, serving as predicate to art's spiritual essence: "The word is an inner sound. It springs partly, perhaps principally, from the object denoted. Thus green, yellow or red trees in a meadow are accidental realizations of the concept 'tree' which we formed upon hearing the word."

Autumn Impression, a celebratory view of nature, seems to embody Kandinsky's words. In it, he creates a rich array of brightly colored and varied shapes, evoking trees and other natural forms and dominated by a blue and white church and steeple. These move horizontally in a rhythmic pattern across a field locked between the snowcapped deep blue mountain range in the distance and the green meadow in the foreground.

The astonishingly liberated treatment of the middle passage allows for multiple interpretations. The brown-red mosaicked shape that moves up the mountain at the left next to the green tree, for example, may be read as a running horse. The horse was pivotal for Kandinsky from the outset of his career. In 1911 Kandinsky and Franz Marc named their historic movement Der Blaue Reiter (The Blue Rider), emphasizing the significance for both of the horse-and-rider motif.

Kandinsky's artistic evolution reflected both his Russian origins and his exposure to Western art. His refined sensibility resulted from the interaction of a keen intellect and deep spirituality, and he absorbed impulses from varied, often surprising sources. In *Autumn Impression* we discern lessons learned from the Fauves and their predecessors, Paul Gauguin and Vincent van Gogh. The rich traditions of Russian fairy tales and folk art are also evident here, as is the luminosity of Bavarian reverse glass painting, to which the artist was introduced by Münter at about this time.

Early in his career Kandinsky became aware of art's abstract potential. At an impressionist exhibition in Moscow in 1896, just a month before he moved to Munich, Kandinsky reportedly stood transfixed before a painting of a grainstack by Claude Monet, unable to recognize the subject of the work immediately, responding instead to its bold forms and vivid colors. In his seminal treatise *Concerning the Spiritual in Art*, written in 1910 and published in 1912, still a few years before his own paintings became fully abstract, Kandinsky invests color with meaning derived from other references: "color directly influences the soul, color is the keyboard, the eyes are the hammer, the soul is the piano with many strings." In *Autumn Impression,* colors and forms cascade across the surface like so many musical sounds, creating a richly resonant, suggestive vision of nature. Shortly thereafter, this vision would be transformed into one of art's earliest and most compelling experiments in abstraction.

Further Reading

Grohmann, Will. *Wassily Kandinsky: Life and Work.* New York: Harry N. Abrams, 1958.

Kandinsky in Munich: 1896–1914. New York: Solomon R. Guggenheim Foundation, 1982.

Weiss, Peg. *Kandinsky in Munich: The Formative Jugendstil Years.* Princeton, N.J.: Princeton University Press, 1979.

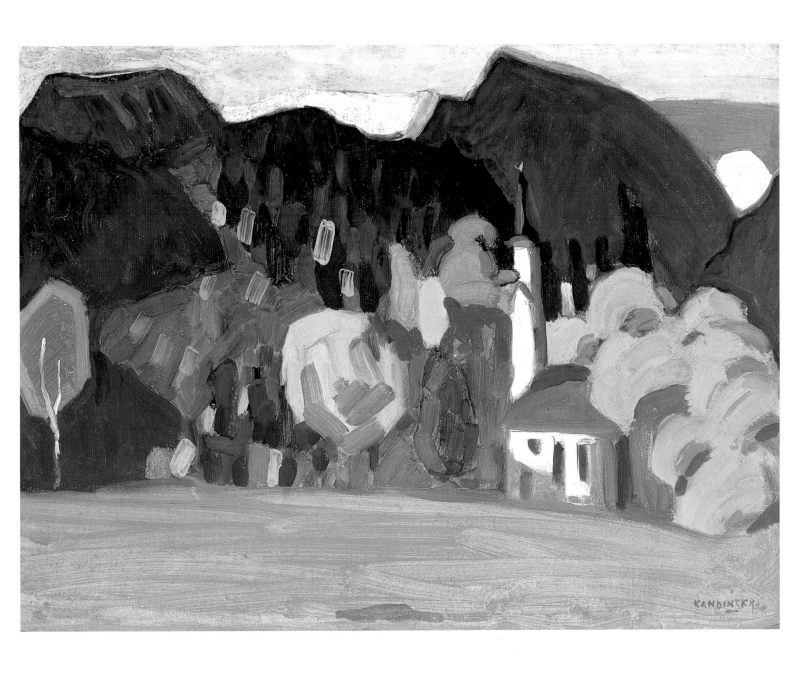

Ernst Ludwig Kirchner

Aschaffenburg, Germany 1880–1938 Frauenkirch, Switzerland

Dodo and Her Brother, 1908/20

Oil on canvas
67⅛ × 37⁷⁄₁₆ in. (170.5 × 95.1 cm)
Signed in black paint, lower left: E.L. Kirchner
Purchased
1955:59

Kirchner painted *Dodo and Her Brother* in late 1908 and retouched it about 1920, when he was systematically repainting earlier canvases. The painting comes at an important moment in Kirchner's early development. Three years earlier, in 1905, he and three other architecture students in Dresden—Fritz Bleyl, Erich Heckel, and Karl Schmidt-Rottluff—had formed an artist group called Die Brücke (The Bridge). It was the earliest twentieth-century manifestation of a cohesive modern artistic program north of the Alps. From the outset, Kirchner was the group's leader and its most talented artist. The Fauves, founded in France that same year under Henri Matisse's leadership, would especially influence Die Brücke artists in the use of an intensified color palette.

Dodo was Kirchner's friend and most important model during this period. She is depicted with her brother in a frontal pose, completely filling the narrow canvas and shallow space so that our confrontation with them is total and inevitable. They are posed and dressed formally. Shattering the decorum are the high-pitched, dissonant colors, aggressively applied.

At this critical juncture, where form and content intersect, the influence of Vincent van Gogh, Paul Gauguin, and Edvard Munch becomes apparent. Kirchner strongly responded to their expressive palette and to the emotional and psychological acuity of their art. In the bold blue outlining of the man's suit and the sinuous line of the woman's bright yellow dress he evokes the expressive use of the curvilinear by these artists. The intense green and red backdrop defining the shallow space, especially behind the brother, is a device they often used. In numerous self-portraits these artists used red, alone or in combination with other colors, to enhance the psychological impact. Indeed, Kirchner could have taken Van Gogh's description of his *Night Café* (Yale University Art Gallery, New Haven, Conn.) as the credo for his painting: "I have tried to express in this picture the terrible passions of humanity by means of red and green." Munch shared Van Gogh's concern for existential issues. He often framed them in the context of city dwellers, and this had special resonance for Kirchner. *Dodo and Her Brother* is an extension of themes that Kirchner addresses in his early masterpiece *The Street* (The Museum of Modern Art, New York), also painted in 1908, which depends extensively on Munch's powerful and haunting *Evening on Karl Johann Strasse* (Rasmus Meyers Samlinger, Bergen, Norway) of 1889. Kirchner's use of color is bolder than Munch's, evoking the legacy of Van Gogh and Gauguin but also of the fauves. Unlike the fauves, however, Kirchner here uses color as a vehicle for content. It becomes the language in which he articulates the unspeakable anxiety of modern society, whose identity was being challenged on every front.

The male-female context, a critical subject for Kirchner that taps into one of Munch's central themes, is explicit in this painting. Despite their familial ties, the tension between the two is palpable. She dominates the composition as he recedes, wedged into a space that barely contains him. His strutting pose, the exaggerated moustache on his lime green face, and his red ears render him at once startling and comical. Dodo's larger physical presence is enhanced by the exuberance of her costume, topped off by an enormous, vibrantly colored hat. Her sexuality is underscored by the outline of her legs beneath the dress, her black gloved arms linked at her midriff, and the open fan she holds over her genital area. The cigar that her brother holds in a pink hand furthers the painting's sexual interplay, as does the suggestive pink stroke between his legs.

In this unnerving, powerful work Kirchner explores some of his major themes, creating an archetype of twentieth-century humanity.

Further Reading

Gordon, Donald E. *Ernst Ludwig Kirchner: A Retrospective Exhibition.* Boston: Museum of Fine Arts, 1968.

Gordon, Donald E. *Ernst Ludwig Kirchner.* Cambridge, Mass.: Harvard University Press, 1968.

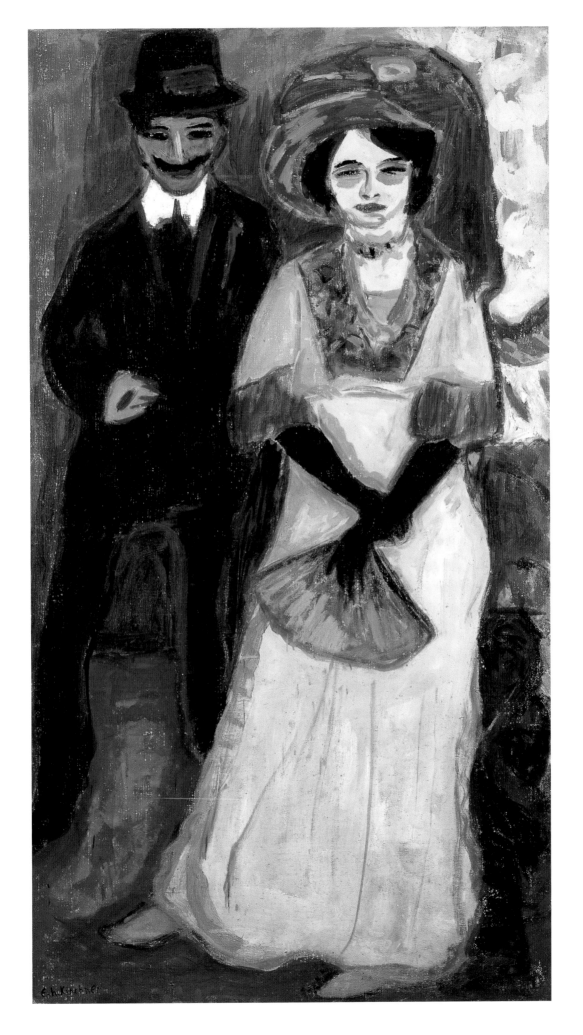

Fernand Léger

Argentan, Orne, France 1881–1955 Gif-sur-Yvette, Seine-et-Oise, France

Mechanical Element I, 1924

Oil on canvas

25½ × 20 in. (64.8 × 50.8 cm)

Signed and dated in gray paint, lower right: F. Leger. 24

Purchased, Joseph Brummer Fund

1954:75

© 2000 Artists Rights Society (ARS), New York/ADAGP, Paris

Mechanical Element I is a defining statement of Léger's impassioned belief in modernism as codified by the machine age. At the outset of the 1920s the machine became a focus of attention for many artists. Léger's evolution toward this historic moment began when he was a soldier in World War I, when for the first time he found himself in surroundings outside the art world. Previously he had evolved his own distinctive brand of Cubism, more robust and concrete than Georges Braque's and Pablo Picasso's. His tubular forms, depicted at times in mechanized motion, had clearly defined and interlocked shapes, differing from the penetrating planes of Analytic Cubism.

Léger was prepared for his conversion when it came: "I was dazzled by the breech of a 75-millimeter gun that was standing uncovered in the sunlight: the magic of light on white metal. This was enough to make me forget the abstract art of 1912–13. A complete revelation to me — both as a man and as a painter." This experience made Léger a champion of everyman — the engineer, the artisan, the soldier — seeing in their contributions acts more worthy and profound than those of the aesthetes of the art world, and it reiterated the centrality of the machine for his artistic vision.

The early 1920s were immensely productive for Léger. His experiment with cinema culminated in *Ballet Mécanique* of 1924, in which he explored the action and interaction of fragmented mechanical and human forms. In his important *Grand Déjeuner* of 1921 (The Museum of Modern Art, New York), three tubular female nudes inhabit a room with corresponding furnishings, anticipating by two years Le Corbusier's famous dictum, "a house is a machine for living." In its formality and clarity this painting also reflects the larger revival of classicism at the time and posits Léger among such distinguished French classicists as Nicolas Poussin and Jacques-Louis David. For Léger, clarity and order were manifest in the machine, a view also shared by Purism.

In *Mechanical Element I* Léger clarifies and reconciles the relationship between machine and art. In a lecture at the Collège de France in 1923, he explained: "I never played around by copying machinery. I invent machines as others invent landscapes." He assimilates into his art the principle of the machine — its precision, the logic and clarity of its formal arrangement — and then invents forms that suggest machine parts.

The iconic force of *Mechanical Element* is in its directness. Three small black circles vertically arranged at the left and four horizontal ones at the upper right bolt the structure of interlocking forms to the canvas. The straight strip of ocher-red, which moves diagonally through the middle from top to bottom where it jigs to the left, is the main color accent in a painting in which blacks, grays, and whites prevail, accented in places by yellows and reds. A white semicircle overlaps the diagonal. Its pristine curving body, modeled from light to dark like glistening metal, is the most assertively three-dimensional form in the painting, propelling the whole image forward. Tension between flat and three-dimensional forms, color and non-color, curvilinear and rectilinear shapes — all arranged along a diagonal axis — infuses the work with dynamic energy.

Some of the forms in *Mechanical Element I* recur in other paintings by Léger, much as machine parts are used interchangeably. Ultimately, Léger's forms function in this painting primarily as an art machine, recalling Charles Baudelaire's commentary on the Salon of 1846, "A picture is a machine the systems of which are intelligible to the practiced eye."

Further Reading

De Francia, Peter. *Fernand Léger.* New Haven, Conn.: Yale University Press, 1983.

Kosinski, Dorothy, ed. *Fernand Léger 1911–1924: The Rhythm of Modern Life.* Munich: Prestel-Verlag, 1994.

Lanchner, Carolyn, et al. *Fernand Léger.* New York: The Museum of Modern Art, 1998.

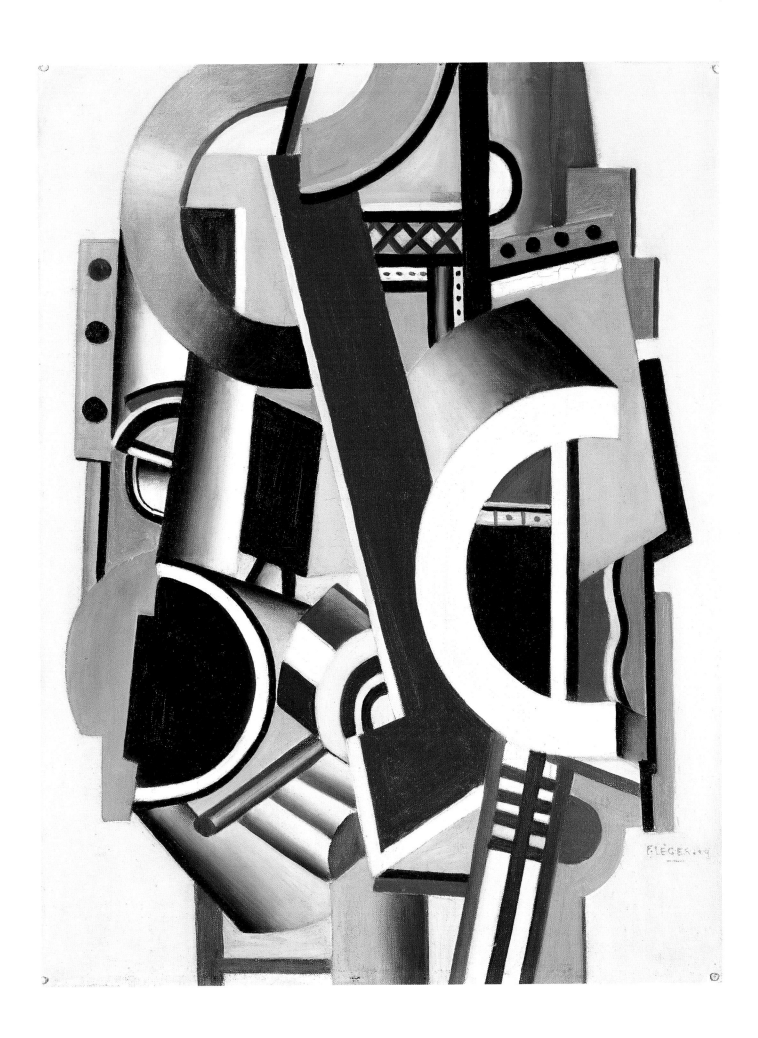

Wilhelm Lehmbruck

Duisburg-Meiderich, Germany 1881–1919 Berlin, Germany

Torso of the Pensive Woman, 1913–14

Cast concrete on self-base, reworked
50⅞ × 18 × 13⅛ in. (129.2 × 45.7 × 33.3 cm)
Not signed or dated
Purchased, Winthrop Hillyer Fund
1922:19

Wilhelm Lehmbruck, a miner's son, underwent rigorous academic training at the Kunstakademie in Düsseldorf under Karl Janssen. An artist of extraordinary sensibility and emotional depth, he searched for universal verities through the vehicle of the human form. His first major influence was Auguste Rodin, from whom he learned the expressive potential of the body as carrier of psychological import. By 1910 Lehmbruck had moved to Paris, where he became acquainted with Aristide Maillol, whose work embodies the classical Mediterranean tradition. He also responded to the classicism of the German painter Hans von Marees, his native Gothic past, and imagery of the Belgian symbolist sculptor George Minne.

Lehmbruck's artistic ascendancy occurred at the time when young German artists were in the throes of a revolution. German Expressionism, led by the Brücke (Bridge) group and later by Der Blaue Reiter (The Blue Rider), as well as by a number of independent artists, reached its apex in the first two decades of the twentieth century. Lehmbruck and Ernst Barlach were its major sculptors. Lehmbruck's relationship to German Expressionism is predicated on common goals of expressing through art a heightened emotional and psychological state. His articulation of this state necessitated a resolution or rather a reconciliation of all the impulses that helped define his vision. The tension between the classical and northern traditions as they are filtered through a sensitive, introspective temperament lies at the core of Lehmbruck's art. This tension is defined in a sculpture like *Torso of the Pensive Woman,* which is a truncated variant of a larger work, *Pensive Woman* (family of the artist, on loan to the Nationalgalerie, Berlin) of the same date, 1913–14.

In *Pensive Woman* Lehmbruck tempers the northern impulse and adds an emotional expressiveness to his classical idiom. He reconciles the Gothic imagery and gaunt, elongated forms of his famous *Kneeling Woman* of 1911 (The Museum of Modern Art, New York) with the Maillol-inspired classicism of works like *Standing Woman* of 1910 (National Gallery of Art, Washington, D.C.) to produce a synthesis. The full figure of *Pensive Woman,* with her left leg bearing weight and her right leg slightly forward and bent at the knee, evokes a classic contrapposto stance. In a gesture of self-absorption, her left arm is entwined behind the lower back as her left hand grasps her right arm, which hangs by her side. Her eyes glance downward, and her tilted head on an elongated neck further adds to the reflective mood.

The relationship between *Pensive Woman* and Smith's *Torso of the Pensive Woman* is both evident and intriguing. In *Torso of the Pensive Woman* Lehmbruck omits the head, cuts the arms cleanly above the biceps, and shows only the upper legs. In doing so, he eliminates those aspects of the full figure that carry its introspective, lyrical quality. *Torso of the Pensive Woman* is, instead, an erect, alert form throbbing with controlled intensity—at once elegant, assertive, and vulnerable.

As one moves around the torso to the back view, a rough area along the lower back and down the right hip indicates where the arms of *Pensive Woman* were located. The variants of *Torso of the Pensive Woman* that exist today are in bronze and cast concrete, the marble having been destroyed. Cast concrete, the material of the Smith torso, was used as an inexpensive substitute for bronze. Yet its matte, granular texture gives a physicality to the form that is absent in the dissolved, reflective surface of the bronze.

Just how much passion courses through Lehmbruck's work is indicated by his tragic suicide in 1919, a product of his irreconcilable revulsion to World War I. In *Torso of the Pensive Woman* that passion is manifest in an extraordinarily disciplined, nuanced interpretation of one of Western art's enduring motifs.

Further Reading

Heller, Reinhold. *The Art of Wilhelm Lehmbruck.* Washington, D.C.: National Gallery of Art, 1972.

Hoff, August. *Wilhelm Lehmbruck: Life and Work.* New York: Praeger, 1969.

Hofmann, Werner. *Wilhelm Lehmbruck.* New York: Universe Books, 1959.

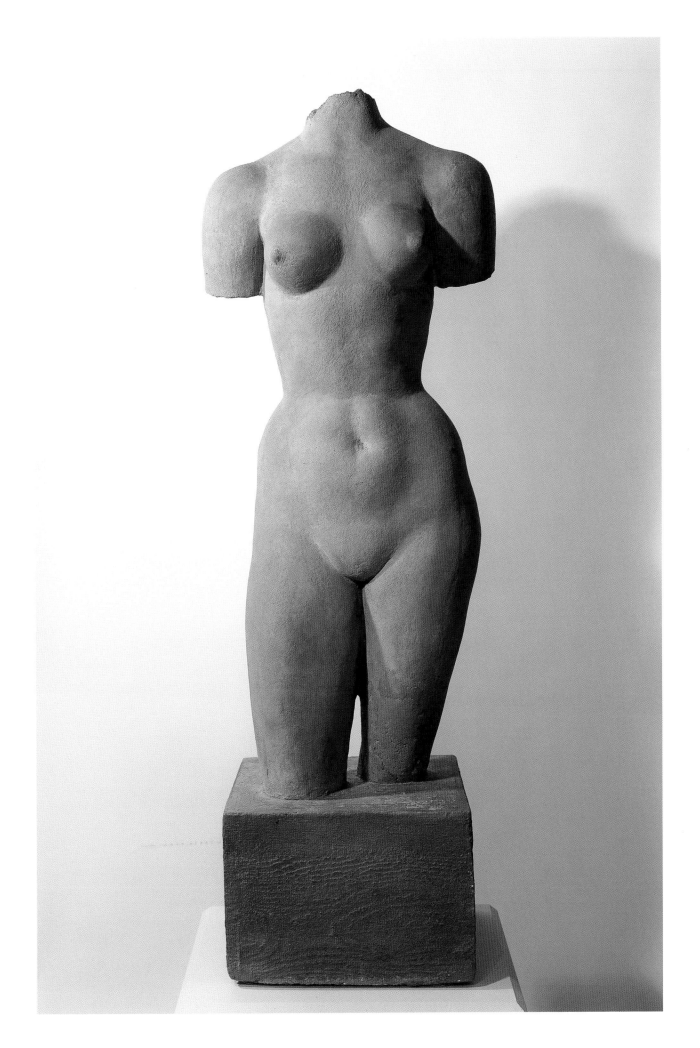

Edouard Manet

Paris, France 1832–1883 Paris, France

Marguérite de Conflans, 1873

Oil on canvas
21 × 17½ in. (53.3 × 44.5 cm)
Signed and dated in black paint, lower left: Manet/1873
Purchased, Drayton Hillyer Fund
1945:6

The accessibility of this portrait results from its forth-right informality. The brilliant painting technique of animated, varied strokes arranges Marguérite's negligee and her loose, cascading hair. The spontaneous, quick execution is the perfect vehicle to reinforce the casual nature of the portrait, established by the sitter's pose and demeanor. She is shown at half length, close to the viewer, enveloped by a green sofa, her elbow resting on its arm (where Manet signs and dates the work). Her head, while more tightly painted, is filled with vibrant passages. The thick black eyebrows arch above white and brown markings that create the eyes' sparkle, and smudged red paint forms an uneven outline of the upturned mouth. Her tilted head is propped up by fingers whose malleable curves are defined by strokes of color. As Paul Mantz has written of another Manet portrait, "the head and hands are in a merely indicated, unexecuted state."

Manet, who was a close friend of Marguérite's family, painted her five times. Her father was related to the Guillemardet family, which owned works by Francisco Goya that Manet was able to study in the 1860s. Given that Marguérite was only seventeen when this work was done, Adolphe Tabarant suggests that she must have posed for the portrait at home, a more appropriate venue than the artist's studio. Anne Coffin Hanson identified a photograph of Marguérite in a similar pose in Manet's family album (Bibliothèque Nationale, Paris). After exploring the possibility that Manet used the photograph for the painting, she concluded that the affinity may also be coincidental.

Marguérite's casual attitude and state of dress, mirrored in the loose, painterly brushwork, challenge the convention of portraiture as a lasting formal record of an individual. The contrast with one of Ingres's elaborate, tightly painted female portraits is dramatic, the two styles articulating profoundly different visions of portraiture.

Manet insists on presenting the work primarily as a portrait. The image of woman *en déshabillé,* as Marguérite is here, has a long tradition going back to antiquity and had an especially delicious moment during the rococo period. In the nineteenth century, Gustave Courbet's *Portrait of Jo, the Beautiful Irish Girl* of 1865 (The Metropolitan Museum of Art) is an important antecedent. Courbet's sitter is an identifiable individual, James McNeill Whistler's mistress, but she is shown looking in a mirror and running her fingers through her hair in a self-absorbed private moment, which allows for casualness more akin to genre painting than to portraiture. Manet's Marguérite is similarly casual but clearly posing for her portrait.

The issue of Manet's intent in this work comes into play because of his consistent ability to shock and to dislodge the operative norm. Such is the case with his two most scandalous works—*Olympia* and *Luncheon on the Grass* (both 1863, Musée d'Orsay, Paris). In both, a nude woman confronts us directly. One is a prostitute, the other is picnicking in the company of dressed men and a semiclad companion. It is in this context that we dare wonder whether Manet has here transformed the seventeen-year-old daughter of a friend into a *demi-mondaine.* The question is unanswerable. Yet in its astonishing matter-of-factness, Manet's *Marguérite de Conflans* provokes speculation and challenges the decorum of portrait conventions.

Further Reading

Fried, Michael. *Manet's Modernism, or, the Face of Painting in the 1860s.* Chicago: University of Chicago Press, 1996.

Hanson, Anne Coffin. *Edouard Manet: 1832–1883.* Philadelphia: Philadelphia Museum of Art; Chicago: The Art Institute of Chicago, 1966.

Tabarant, Adolphe. *Manet et ses oeuvres.* Paris: Gallimard, 1947.

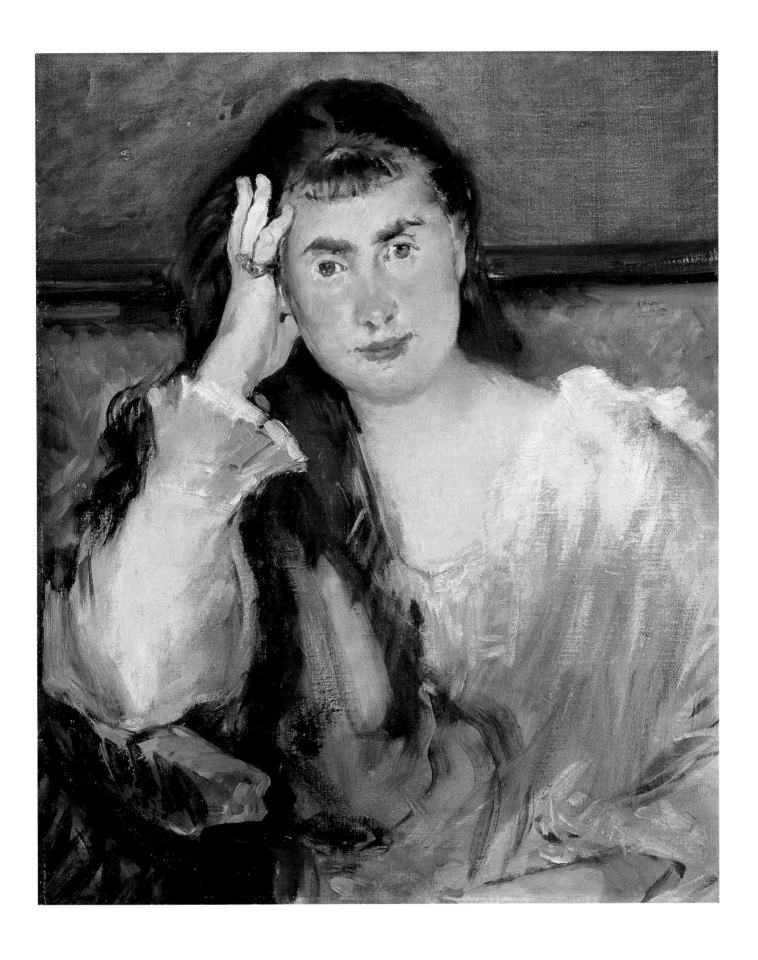

Jean-François Millet

Gruchy, near Gréville, France 1814–1875 Barbizon, France

Farm at Gruchy, 1854

Oil on canvas

21¼ × 28⅝ in. (54 × 72.7 cm)

Sale stamp in red paint, lower left: J. F. Millet [Lugt 1415]

Purchased, Tryon Fund

1931:10

Farm at Gruchy was painted during the epochal period of Millet's most famous works, *The Sower* of 1850 (Museum of Fine Arts, Boston) and *The Gleaners* of 1857 (Musée d'Orsay, Paris). He defines in them, more powerfully than any other artist, the epic drama of the peasants and the land they work. These paintings secured the artist's stature as a seminal figure in the realist movement and exposed for the disquieted public the brutal reality of the working classes.

Farm at Gruchy depicts an area of Millet's native coastal hamlet near Gréville, not far from Cherbourg. His early years in the region, often doing farm chores as the son of prosperous peasants, would have a lasting impact. In 1849 he abandoned Paris after four years' stay and chose the village of Barbizon on the edge of the Fontainebleau forest, where he could again observe the arduous ritual of peasant life that would inspire his many paintings. In *The Sower*, his most important work, the heroic figure strides across the hilly landscape of Millet's native region.

The artist and his family returned to Gruchy for the summer of 1854 after a long absence, although he had visited the village briefly in 1853 for the funeral of his mother. When he had initially left Gruchy in 1844, Millet was ten years younger and a vastly different artist, painting mainly portraits and pastoral scenes. During his summer stay he reconnected with the region of his youth by painting and drawing its environs. In the interim, his style and vision had been profoundly transformed by the social upheavals of 1848 and the concomitant revolution in art toward naturalism.

Farm at Gruchy also addresses the larger question of Millet as landscapist. His closest friend at Barbizon was Théodore Rousseau, who, along with Camille Corot, was the most important landscapist of the generation. Yet for Millet pure landscape held little interest, and only toward the end of his career did he turn to it in a more sustained way. Landscape mattered to him mainly as a way to elucidate the drama of his heroic peasants. When he painted landscapes, he invariably depicted land that had been worked by human hands.

In *Farm at Gruchy*, verdant nature subsumes the landscape thickly painted in broad, soft strokes of contrasting light-and-dark patterns, which enhance the gentle undulating rhythm of the rolling meadows and trees. In the background, along with the trees, are houses that announce the village. We stand with our back to the precipitous drop of the rocky seashore. The middle is dominated by a stone wall, which at once protects from the strong sea winds and divides and orders the land into discrete parcels. The sun illuminates the wall's left side, where a dark shaft indicates an entrance. The light dances along the top of the middle wall and highlights a crumbled portion indicative of time's ravages. The dominant horizontal wall, cast in shadow, engulfs a peasant shouldering a tool as he strides from right to left. His daily ritual is reminiscent of the equally small image of the country priest engaged in his daily routine in Rousseau's famous *Under the Birches, Evening* of 1842–43 (The Toledo Museum of Art, Ohio). Significantly, in Rousseau's work majestic birches tower over the priest on horseback, whereas in Millet's painting the man-made wall encases the peasant. By diminishing the scale of the peasant, Millet here consciously emphasizes the landscape, but one in which man's physical effort is an indispensable component.

Further Reading

Herbert, Robert L. *Jean-François Millet*. London: Arts Council of Great Britain, 1976.

Murphy, Alexandra R. *Jean-François Millet*. Boston: Museum of Fine Arts, 1984.

Claude Monet

Paris, France 1840–1926 Giverny, France

The Seine at Bougival, Evening, 1869

Oil on canvas

23⅝ × 28⅞ in. (60 × 73.3 cm)

Signed in reddish orange paint, lower right: Claude Monet

Purchased

1946:4

Monet's *Seine at Bougival, Evening* represents a pivotal time and place in the early years of Impressionism. During that moment, three practitioners of the evolving movement, Monet, Pierre-Auguste Renoir, and Camille Pissarro, interacted for the first time; they exchanged ideas about the nature of plein-air painting and created works that expanded their artistic vocabulary—still years away from being derisively labeled Impressionism. Monet and Renoir initiated the habit of working together on the same motif. During the summer the two painted nearly identical views of La Grenouillère, a popular resort featuring a round island called "Camembert." Their vibrant interpretation of a place where people engaged in such leisure activities as dining, boating, and swimming defined a carefree era. Years later, Renoir said nostalgically of this lost moment, "The world knew how to laugh in those days."

The village of Bougival had come into its own during the reign of Louis XIV, who built a château in nearby Marly as a retreat from Versailles. His successors continued to enjoy the region, and the châteaux that grace the landscape date from the pre-Revolutionary period. By the mid-nineteenth century, Bougival had become a popular retreat for the prosperous and for prominent artists and writers as well as pleasure-seekers. Seventeen kilometers northwest of Paris, easily accessible by railroad from the Gare Saint-Lazare, it sits on the banks of the Seine surrounded by gently rolling hills. Bougival's natural beauty and its artistic milieu distinguished it from other places in the region.

The Seine at Bougival, Evening is Monet's first painting at Bougival. He chose a picturesque motif that includes the houses across the river, the Croissy Island wedged into the right foreground, and, on the horizon, the dramatic silhouette of an aqueduct between Bougival and Port-Marly, built during the reign of Louis XIV. A modern bridge below the aqueduct is barely visible. All is subsumed in the awesome beauty of a sunset. Monet here creates a work apart from his more prevalent images bathed in high sun. The focus on an emblazoned sky at the end of the day gives the work an emotional intensity that is more melancholy than joyous. A restless, vigorous brushstroke evident in the dramatic sky, in the lush green of the island, and in the fluidity of the river creates a scene of flux for which the boat with two figures at the left serves as a metaphor.

The insistent romantic mood of the painting is tied to the sensibility of the Barbizon artists, who, in reviving a tradition of French landscape painting at midcentury, paved the way for the impressionists. Specifically, Monet turns here to the work of Charles-François Daubigny, an artist he greatly admired and toward whose work the term *impression* was first applied critically. Daubigny was a preeminent essayist of river views, especially of his beloved Oise. One of the pioneering artists to paint *en plein air,* he traversed the river on a studio boat he had built, from which he painted motifs—an idea Monet would later emulate. Eugène Boudin, another pioneer who became Monet's major mentor, taught him to paint directly from nature along his native northwest coast, in places like Trouville and Saint-Adresse.

Monet's vaulting ambition and exceptional talent transcended both Daubigny and Boudin, as his exploration of nature transformed the history of art. *The Seine at Bougival, Evening* is a reminder of Monet's awareness of the earlier landscape tradition, even as the vigorous energy coursing through the canvas already indicates a pictorial investigation of a different order.

Further Reading

Champa, Kermit Swiler. *Studies in Early Impressionism.* New Haven, Conn.: Yale University Press, 1973.

Champa, Kermit Swiler, and Dianne W. Pitman. *Monet and Bazille: A Collaboration.* Edited by David A. Brenneman. Atlanta: High Museum of Art; New York: Harry N. Abrams, 1999.

Herbert, Robert L. *Impressionism: Art, Leisure, and Parisian Society.* New Haven, Conn.: Yale University Press, 1988.

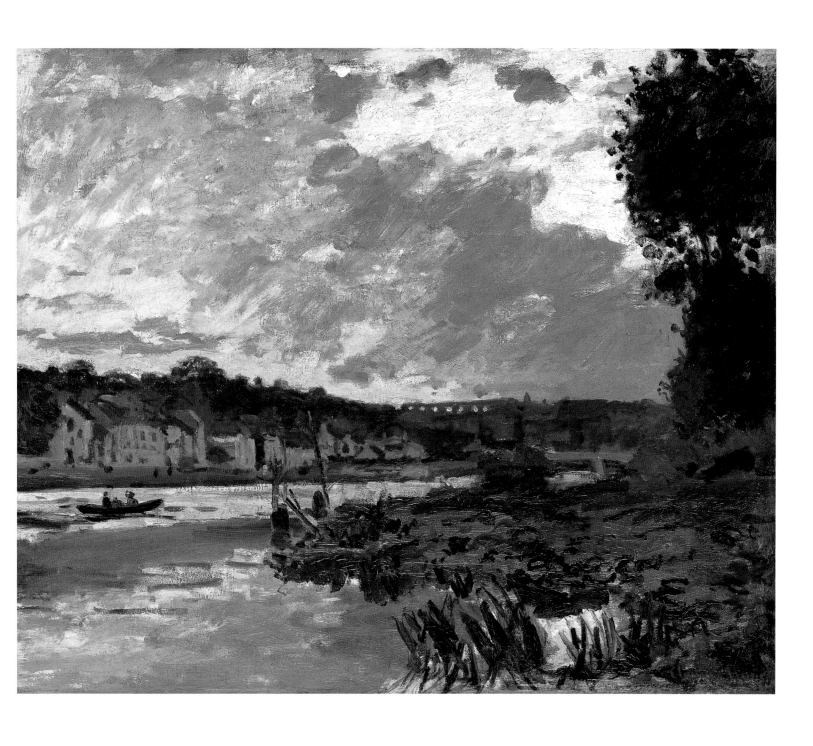

Claude Monet

Paris, France 1840–1926 Giverny, France

Field of Poppies, 1890

Oil on canvas

23½ × 39½ in. (59.7 × 100.3 cm)

Signed and dated in reddish orange paint, lower right: Claude Monet 90

Gift of the Honorable and Mrs. Irwin Untermyer in honor of their daughter Joan L. Untermyer, class of 1940

1940:10

Field of Poppies of 1890 initiated a decade in Monet's creative life that would establish this preeminent impressionist as the most important artist of his generation. By the 1880s the impressionist revolution had become the inevitable instrument against which the next generation of artists rebelled—led by Georges Seurat's Neo-Impressionism. During that decade Pierre-Auguste Renoir had a crisis of confidence about Impressionism's aims, and Camille Pissarro actually bolted for a time to the neo-impressionist camp. Monet, however, remained committed to the movement. During the 1880s he disengaged from the subject of Paris and its surroundings. He criss-crossed France, searching out its most picturesque motifs from Etretat to Antibes, to reassert the vitality of the movement and establish his own broader authority.

By 1890 Monet had purchased a home in Giverny, where he had been renting since 1883, and settled into a more permanent residency. He turned his attention to painting series of the same motif—the ultimate validation of Impressionism's aims. Nearly all of his major series paintings of the 1890s were done near Giverny. The only exception, the Rouen Cathedral series, was painted a mere sixty kilometers away and finished in Giverny. Works like *Field of Poppies,* along with the closely related group of paintings of the Oat Fields and his famous Grainstacks series, underscore Monet's interest in the agrarian character of the region around Giverny.

Field of Poppies is arranged in horizontal striations: the poppy field, a row of trees, and the sky. Each holds our interest, distributing the visual energy throughout the work. The densely packed field of red poppies interspersed with green establishes a base for the eloquent orchestration of various silhouettes of trees, closely clustered at the left, more sparsely arranged at the right. The artist gives the trees at the right more dramatic, tall silhouettes—as if to compensate for their limited number—and unifies them by the diagonal of the hill of Giverny in the background. All this is under a sky that subsumes more than half the painting.

One telling feature that differentiates the many paintings Renoir and Monet painted side by side is Monet's emphasis on a dynamic horizon. In *Field of Poppies* the horizon, with its strip of trees, dominates and holds our interest more than either the poppy field or the sky. Such intricate horizons give many of Monet's paintings that special visual intelligence about which Paul Cézanne commented, "Monet is just an eye—but what an eye!"

Smith's painting is one of four variants of the same motif likely painted in July 1890, at different times of day. Others belong to the White Fund, Lawrence, Massachusetts (on extended loan to the Museum of Fine Arts, Boston) and the Art Institute of Chicago. The Chicago painting is bathed most directly in sunlight, so that the trees are a yellow-green color. The sky is bright blue, with only a few puffy clouds. In contrast, in the Smith canvas the sky is predominantly filled with clouds, and shadows turn the trees dark violet mottled with intense green. This coloristic intensity carries over to the poppy field.

The Field of Poppies paintings were executed at about the same time as the Grainstacks series but are not usually considered a series. The reason is in part quantitative—there are four Field of Poppies paintings and a great many Grainstacks. Monet's subject—a rather expansive view of the poppy fields in the meadows of Les Essarts—lacks an identifiable focal object such as the grainstacks or a cathedral façade. Otherwise *Field of Poppies* adheres to the same principles as the series paintings—a singular achievement unmatched by any other impressionist.

Further Reading

Monet's Years at Giverny: Beyond Impressionism. New York: The Metropolitan Museum of Art, 1978.

Tucker, Paul Hayes. *Monet in the '90s: The Series Paintings.* Boston: Museum of Fine Arts; New Haven, Conn.: Yale University Press, 1989.

Claude Monet

Paris, France 1840–1926 Giverny, France

Cathedral at Rouen (La Cour d'Albane), 1892–94

Oil on canvas

36½ × 29¹⁄₁₆ in. (92.7 × 73.8 cm)

Signed and dated in brown paint, lower right: Claude Monet 94

Gift of Adeline F. Wing, class of 1898, and Caroline R. Wing, class of 1896

1956:24

This painting initiates Monet's most celebrated series. He painted some thirty canvases of Rouen cathedral between 1892 and 1894. Twenty were exhibited in 1895 at the Durand-Ruel Gallery in Paris, where they became a focus of serious critical commentary. Georges Clemenceau wrote: "With twenty pictures the painter has given us the feeling that he could have made . . . fifty, one hundred, one thousand, as many as there are seconds in a day."

By reiterating numerous versions of a motif, differing primarily in treatment of light and atmosphere, these works go to the very core of Impressionism's raison d'être. In them, Monet achieves the most comprehensive symbiosis of creative expression with nature's changeable processes. Monet's primary concern is to interpret the unfolding drama of the interplay of light on the intricate lacework of the cathedral's gray stone at various moments of the day.

Like Clemenceau, twentieth-century artists from Kasimir Malevich to Roy Lichtenstein have focused on the formal aspects of the series. Malevich viewed it as a precursor to his suprematist abstractions, noting that the theme of the cathedral "is not so important, with regards to the pictorial relationships and to the changes of colored elements."

To be sure, Monet's own stated indifference to the cathedral as subject contributed to this line of criticism. Yet it is impossible to overlook the significance of the cathedral as subject in Monet's series, much as it is impossible not to consider the profound impact of Russian icons on Malevich's abstract works.

Smith's painting is at once an integral part of the cathedral series and unique in the representation of the motif. It takes as its subject not the façade, the focus of most of the paintings in the series, but the Tour d'Albane as viewed from the courtyard. It is also only one of two paintings in the series that Monet painted out of doors. All of the others, mainly façades, were painted indoors, where Monet was able to narrow his "picture window" and concentrate on the façade to the near exclusion of all else. The result is a series of close-up views of the façade that shimmer with color and light like visions—at once adhering to the principles of Impressionism and reflective of the new tendency toward Symbolism and spirituality in the 1890s.

In contrast, by placing himself outdoors to paint the Tour d'Albane, Monet observed and absorbed into the work a broader context of relationships of the tower to the side of the cathedral seen partially at left, and to the adjoining structures—a haphazard array of secular buildings that cluster around the tower like children clinging to their mother, establishing a bond that references the cathedral's societal and religious functions.

Instead of emphasizing the picturesque silhouette of the cathedral and tower that gives the courtyard its charm, Monet cuts off the top of the tower and focuses on the extraordinary intersection—a juncture between the spiritual and secular, between earth and sky. As such, the artist allows for a reading that addresses both the formal concerns and the relationship of the Gothic cathedral to the people as a transcendent symbol that defines France like no other.

The Rouen Cathedral series is the only one where Monet uses an existing historically and artistically significant monument as a point of departure for his work, thus creating a connectedness that bridges centuries. As stone was transformed by the Gothic mason into a compelling vision of heaven on earth, so Monet's brush, saturating the portals, pinnacles, and in this case the tower and adjoining structures with color and light, imbues the cathedral with the transient beauty of nature. By focusing here on the cathedral's interaction with its secular surroundings, Monet explores yet another layer of meaning in this endlessly revealing series.

Further Reading

Pissarro, Joachim. *Monet's Cathedral: Rouen, 1892–1894.* New York: Alfred A. Knopf, 1990.

Tucker, Paul Hayes. *Monet in the '90s: The Series Paintings.* Boston: Museum of Fine Arts; New Haven, Conn.: Yale University Press, 1989.

Henry Moore

Castleford, England 1898–1986 Perry Green, Much Hadham, England

Working Model for Time-Life Screen, 1952–53

Bronze

14⅞ × 39⅛ × 3 in. (37.8 × 99.4 × 7.6 cm)

Not signed or dated

Purchased from the artist

1953:114

Reproduced by permission of the Henry Moore Foundation

Working Model for Time-Life Screen is a model for Henry Moore's large-scale screen on the Time-Life Building on New Bond Street in London, which was completed in June 1953. The commission came to Moore late in the selection process. After models from four other sculptors were rejected, Barbara Hepworth was asked to work on the project. She responded eagerly to the idea but suddenly withdrew when, it has been suggested, she discovered that Ben Nicholson, from whom she was recently divorced, was working on the murals in the building. Moore, who was already doing a draped reclining female figure for the terrace where the screen would be placed, was then approached and enthusiastically accepted the challenge. Within months he presented four working models to the committee. The Smith sculpture, the last and most resolved of the four, was chosen to be translated into the large Portland stone screen, with some further changes.

Moore's enthusiasm about the project grew from his belief that sculpture and architecture enhance each other:

I think architecture is the poorer for the absence of sculpture and I also think that the sculptor, by not collaborating with the architect misses opportunities of his work being used socially and being seen by a wider public. And it was [the] feeling that the time is coming for architects and sculptors to work together again that brought me to do the double commission for the Time Life building in [New] Bond Street.

The architect, Michael Rosenauer, designed the six-story building with a drop-off to a lower floor on one side to accommodate a screened-off terrace. The screen could have been simply architectural, but, in an act of farsightedness and courage, Rosenauer decided to adorn the International Style structure with a sculpted screen. The horizontal rectilinearity of Moore's screen continues the horizontal bands on the building that visually define the floors. Its division into four panels echoes the cadence of the fenestration. The sculptures within each opening are both organic and abstract. The cartoonist Francis Brennan recalls watching the evolution of the concept:

As we talked Moore pulled down a battered old shoe-box from a shelf. It was brim filled with old bones and weather-worn stones of wondrous shapes and sizes. Picking through them, he'd choose one, hold it up and turn it around in the light, much as a jeweller might show a gemstone. Finally he had a collection of a dozen or so laid out on his drawing board. I began to see his idea for the screen—a quartet of icon-like images, mysteriously ancient in feeling, yet unmistakably modern in execution.

Each of the four sculptures is finished front and back, but their placement within the framed openings limits their functioning in the round. Moore wanted each sculpture to be rotated on its axis at intervals—he suggested once a month or seasonally. He felt this would make the sculptures more interactive with the public, since they would physically hover over the space below, "like some of those half animals that look as if they are escaping through the walls in Romanesque architecture." Due to the heaviness of each piece and the possibility of a mishap, the idea proved unworkable.

The terrace space and the street relate through the perforations in the sculptures themselves and the zones between each frame and sculpture. It is here that the relationship between sculpture and architecture is most fully explored. Each opening is irregularly shaped in response to the format of the sculpture, even as the sculptures in their arrangement respond to the demands of the architecture. The rich promise of collaboration between architecture and sculpture, rarely met in this century, is fulfilled here.

Further Reading

Henry Moore: The Human Dimension. London: HMF Enterprises for the Henry Moore Foundation in association with the British Council, 1991.

McCaughey, Patrick. *Henry Moore and the Heroic: A Centenary Tribute.* New Haven, Conn.: Yale Center for British Art, 1999.

Moore, Henry. *Henry Moore on Sculpture: A Collection of the Sculptor's Writings and Spoken Words.* Edited with an introduction by Philip James. New York: Viking Press, 1971.

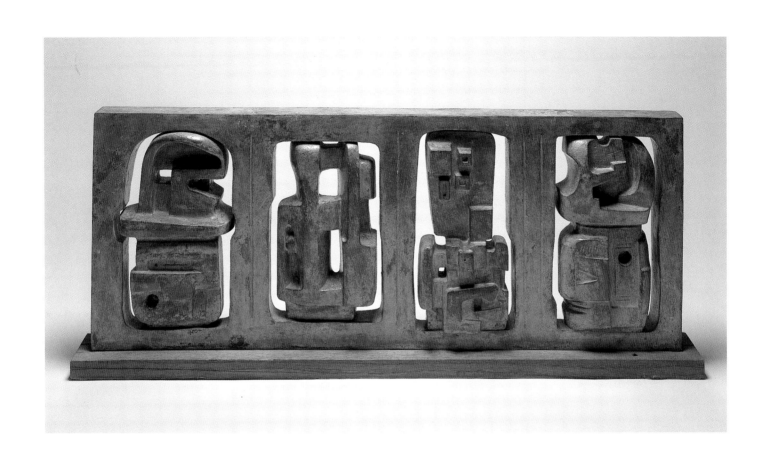

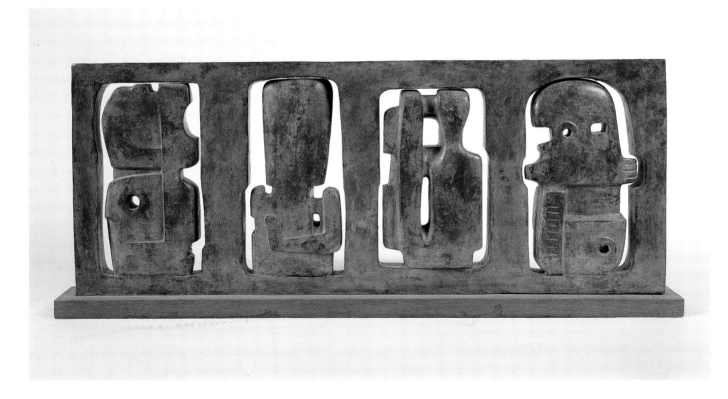

Berthe Morisot

Bourges, Cher, France 1841–1895 Paris, France

The Mozart Sonata, 1894

Oil on canvas

18⅛ × 21¹⁵⁄₁₆ in. (46 × 55.7 cm)

Sale stamp in blue paint, lower right: Berthe Morisot [Lugt 1826]

Bequest of Mrs. Robert S. Tangeman (E. Clementine Miller, class of 1927)

1996:24–2

Berthe Morisot's upper-middle-class parents considered art a civilizing component of her upbringing from an early age. From her early teacher, Camille Corot, she absorbed the feathery, flickering stroke of his late, lyrical style and his love of nature. She exhibited with some success in the Salon from the mid-1860s into the early 1870s and became a friend of Henri Fantin-Latour and Edouard Manet. Manet painted her handsome dark features many times. In 1874 Morisot married his brother Eugène, who would be a devoted husband, supportive of her artistic activities.

That year Morisot exhibited nine paintings in the first impressionist exhibition, alongside works by Edgar Degas, Pierre-Auguste Renoir, Claude Monet, Camille Pissarro, and Paul Cézanne, among others. Thereafter she abandoned the Salon and took part in all but one of the impressionist shows. She was vilified alongside her male colleagues in Louis Leroy's now famous satirical review of the first impressionist exhibition:

Now take Mlle Morisot! That young lady is not interested in reproducing trifling details. When she has a hand to paint, she makes exactly as many brushstrokes as there are fingers and the business is done. Stupid people who are finicky about the drawing of a hand don't understand a thing about impressionism.

Too often those sympathetic to Impressionism have misunderstood her role in it, and only recently has a more balanced account of her achievement emerged. Neither her historic marginalization by scholars nor the image of her as an intuitive feminine painter naturally suited to the surface superficiality of Impressionism does justice to her important contribution to the movement. For Morisot, the élan of her painterly gesture was hard-won.

Morisot did not exhibit with the impressionists in 1879 because she was recuperating after the birth of her daughter, Julie, in 1878. This was a transforming event that provided one of her main motifs. She documented every phase of Julie's life in her paintings, drawings, and prints, her daughter's growth paralleling her own development as an artist. A shift in her art in the 1890s corresponds to a different artistic climate enunciated by the symbolists, whose main literary force, the poet Stéphane Mallarmé, was one of Morisot's closest friends. Her portraits of Julie from the 1890s are psychologically more probing—pensive, introspective, and sensual. This shift parallels Julie's maturity into young womanhood—a process Morisot explored with fascination and generosity.

The Mozart Sonata, painted a year before Morisot's untimely death in 1895, is a brilliant example of her late work. The calligraphic, airy strokes of her earlier paintings have become thicker, restless gestures densely covering the surface. The impressionist premise of the work is defined by the brilliant light piercing the window at center background. It illuminates the room and announces the proximity of the outdoors, yet it suggests more than defines. The light negates our view through the window and subsumes the forms within. Julie, playing the violin, and her cousin Jeannie Gobillard at the piano are defined by curving strokes that function as a metaphor for the music they play. Their faces and hands have blurred in the sunlight, and their bodies have become dramatic silhouettes. The violin seems to succumb to the force of light, losing its materiality at the point where Julie's bowless right hand comes close to the strings. Mallarmé's proposition, that the essence of a work lies in that which is not expressed, seems to emerge out of this impressionist context.

During the early 1890s Morisot painted a number of portraits of Julie playing the violin. The fact that she could paint as her daughter played, thus documenting their common creative experience, was a source of immense satisfaction for the artist.

Further Reading

Adler, Kathleen, and Tamar Garb. Berthe Morisot. Ithaca, N.Y.: Cornell University Press, 1987.

Higonnet, Anne. Berthe Morisot's Images of Women. Cambridge, Mass.: Harvard University Press, 1992.

Shennan, Margaret. Berthe Morisot: The First Lady of Impressionism. Thrupp, Stroud, Gloucestershire: Sutton Pub., 1996.

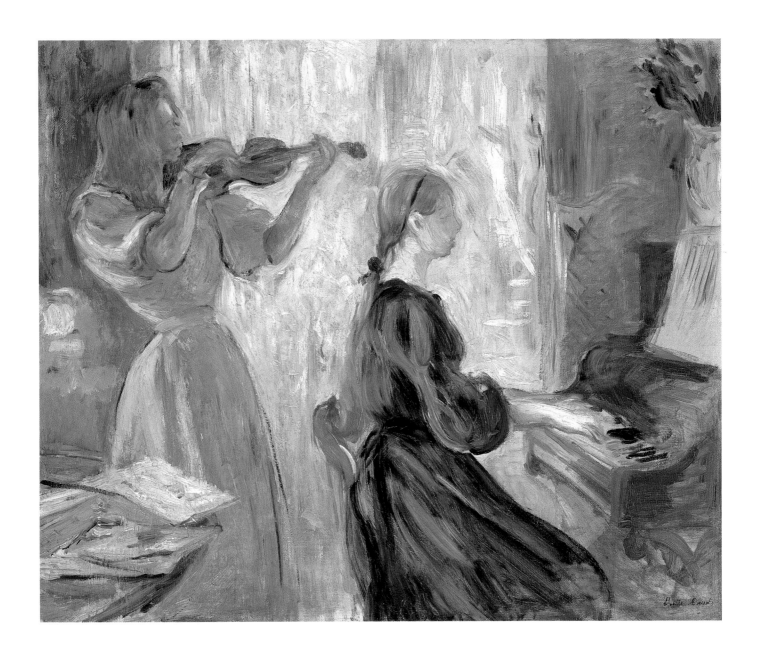

Ben Nicholson

Denham, Buckinghamshire, England 1894–1982 London, England

Still Life (West Penwith), 1949

Oil and graphite on canvas

47 × 71¾ in. (119.4 × 182.2 cm)

Signed, dated, and titled in pencil on back, upper left: Ben/ Nicholson/Octo 30/-49/Still/life/(West Penwith)

Purchased, Eleanor Lamont Cunningham, class of 1932, Fund 1955:15

© 2000 Artists Rights Society (ARS), New York/DACS, London

Ben Nicholson was a cultivated artist whose nuanced style belies the expansiveness of his vision and his passionate pursuit of it. His father, Sir William Nicholson (1872–1949), a prominent artist, was a powerful early influence. Nicholson recalled:

I owe a lot to my father, especially to his poetic idea and to his still-life theme . . . not only from what he made as a painter, but from the very beautiful striped and spotted jugs, mugs and goblets, and the octagonal and hexagonal glass objects he collected. Having these things in the house was an unforgettable early experience.

Nicholson's formal training was limited to a few terms at the Slade School of Art during 1910–11. His real education came from his artistic heritage and from his thoughtful, considered analysis of pictorial problems. In that he was aided by his interaction with fellow artists in England, especially the sculptor Barbara Hepworth, who became his second wife and encouraged him to explore nonfigurative work. Visiting the Continent with Hepworth in the early 1930s, he met many artists who came to maturity after World War I, among them Constantin Brancusi, Joan Miró, Jean Arp, and Piet Mondrian. From the mid-1920s Nicholson began to incorporate the principles of Cubism, which would become the most comprehensive and sustaining influence on his work. He especially responded to the still lifes of Georges Braque and Pablo Picasso from the 1920s. One need only compare Still Life (West Penwith) with Picasso's Table, Guitar, and Bottle of 1919 (pp. 96–97) to see the affinity of their pictorial idiom.

The lucidity of this canvas, discreet and unobtrusive despite its large size, belies its complexity. The subtly modulated, thinly applied colors become a perfect receptacle for the elegant calligraphy of drawn shapes. They are either abstract or suggest outlines, mostly partial, of tabletop objects like pitchers, goblets, glasses, and cups. The vessels, stripped of their materiality, integrate seamlessly with the abstract shapes into the larger formal ensemble, which is enframed by a light brown border. The adumbrated passages are toned from light gray to black and are mostly done in graphite. They help define shapes or create independent ones and facilitate the interplay of the thin planar membranes within the shallow space. Their arrangement across the surface of the painting enlivens the composition and creates its own rhythm.

Nicholson defines reality variously. The still life is painted in front of a window in West Penwith, Cornwall, where he and Hepworth moved in 1939. The abstract rectilinear shapes of gray-blue and light blue at upper middle allude to ocean and sky. This poetic evocation of reality is every bit as compelling to him as an outline of a pitcher. In 1921 he recalled viewing an abstracted cubist painting by Picasso from 1915: "And in the center there was an absolutely miraculous green — very deep, very potent and absolutely real . . . it still remains a standard by which I judge any reality in my own work."

When Nicholson was starting his artistic career, his mother, herself a painter whose advice he valued, introduced him to a ritual of scrubbing a table surface clean. This simple act resonated with him both as a tactile, physical act and as an idea of a clean slate. There is something of a scrubbed quality to the thinly painted surface of Still Life (West Penwith). The tabletop on which he posits the various forms and the surface of the painting are an integrated whole. Through his eloquent visual language he transforms and positions the image at a unique intersection of realities, through which he explores the expansive interaction of art and nature.

Further Reading

Lewison, Jeremy. Ben Nicholson. London: Tate Gallery, 1993.

Lynton, Norbert. Ben Nicholson. London: Phaidon Press, 1993.

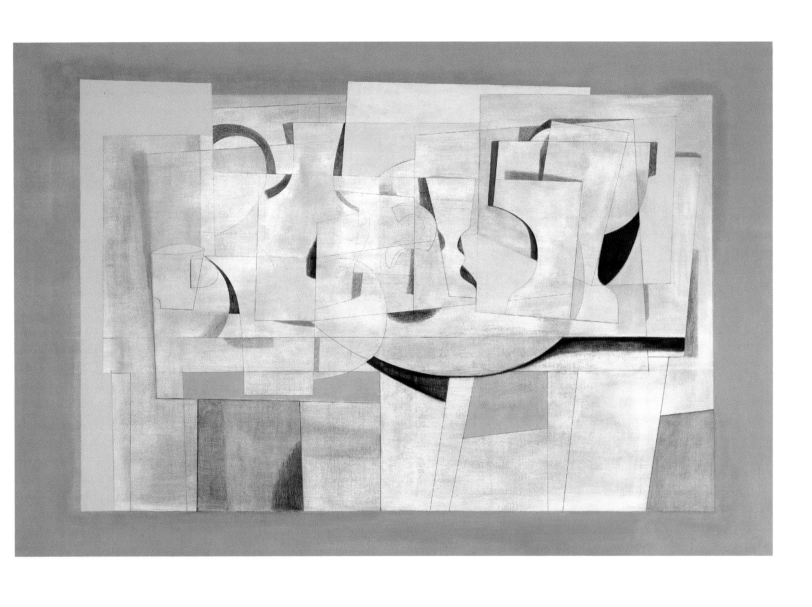

Pablo Picasso

Málaga, Spain 1881–1973 Mougins, France

Figures by the Sea (Les Misérables au bord de la mer), 1903

Oil on canvas
23½ × 19½ in. (59.7 × 49.5 cm)
Signed in black paint, upper right: Picasso
Gift of Jere Abbott
1965:33

In the winter of 1901 a blue veil enveloped Picasso's art. The varied themes and eclectic styles of his formative years gave way to a sustained investigation of the dispossessed, the poor, the disadvantaged. Rendered in blue tonality, this body of work from Picasso's Blue Period has a searing poignancy: Lone figures or small groups are isolated against a stark setting, collapsed onto themselves in their misery.

Picasso's decision to explore these themes comprehensively goes to the core of his own vulnerable state and to his overarching ambition as an artist. When he returned to Barcelona from Paris in 1902, he was poor and little known — still some years removed from becoming Paris's leading light. Themes focusing on human misery would seem a natural outgrowth of his state of mind.

In his Blue Period works, Picasso for the first time established a powerful link between the condition of his life and his need to express it through his art. This equation would become a hallmark by which he defined his persona. In putting his own imprimatur on the universal theme of poverty and despair, he established a dialogue with a rich artistic tradition. In 1901 he had seen a retrospective exhibition of the works of Honoré Daumier, whose transient saltimbanque families, moving like apparitions through the streets of Paris, had a great impact on him. In his native Spain a fellow artist, Isidro Nonell y Monturiol, depicted the poor in a manner similar to Picasso's. El Greco's work exposed Picasso to imagery of gaunt, elongated saints that he would apply to his downtrodden. Symbolists in France and the north — England and Norway, among other countries — dealt with similar themes. Picasso's favorite café, El Quatre Gats, the meeting place for all that was stimulating in Barcelona, was referred to as "a Gothic tavern for those in love with the North."

Figures by the Sea (Les Misérables au bord de la mer) depicts a man and woman walking in unison like Adam and Eve after the Fall — their silhouettes joined in misery that each suffers separately. The man extends his arm to a boy in front of him, who reciprocates the gesture of tender union and vulnerability. The man, with a stiff gait, head tilted upward, tethered to the boy, has been described as blind, a type Picasso employed often during the Blue Period. The woman, huddled in a red shawl, holds an infant subsumed in her gaunt silhouette. Her head covering creates a deep shadow around her face, whose lit profile is like a sad quarter moon. A swirling calligraphic stroke animates the bodies, adding expressive intensity to the tragic scene. The Rothko-like bands of sky, sea, and land serve as the backdrop, underscoring the barrenness of the figures' existence.

The theme of humanity at water's edge as an expression of despair can be traced back to Caspar David Friedrich's *Monk by the Sea* of 1809–10 (Schloss Charlottenburg, Berlin). In this German romantic painting an isolated figure on a barren shore defines for one of the first times the issue of existential aloneness. Picasso assimilated this central theme through the works of Edvard Munch, whose protagonists, often rendered at water's edge, are directly related to Friedrich's. Yet the most compelling prototype for Picasso's work is Pierre Puvis de Chavannes's *Poor Fisherman* of 1881 (Musée d'Orsay, Paris), in which the despairing family of the fisherman, his daughter and an infant, confront their dilemma in a stark setting of water, land, and sky. In Puvis's poignant, powerful work Picasso found a resonant voice in articulating the universal issues of poverty and deprivation.

Further Reading

Daix, Pierre, and Georges Boudaille. *Picasso: The Blue and Rose Periods, a Catalogue Raisonné of the Paintings, 1900–1906.* Translated by Phoebe Pool. Greenwich, Conn.: New York Graphic Society, 1967.

McCully, Marilyn, ed. *Picasso: The Early Years, 1892–1906.* Washington, D.C.: National Gallery of Art, 1997.

Palau i Fabre, Josep. *Picasso, the Early Years, 1881–1907.* New York: Rizzoli, 1981.

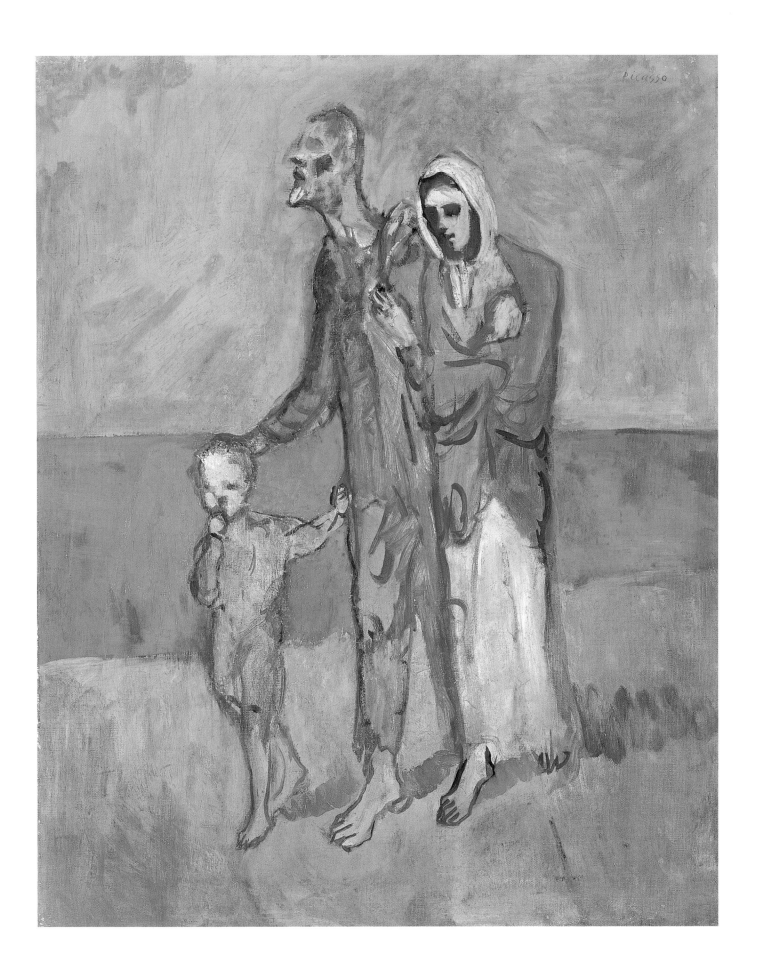

Pablo Picasso

Málaga, Spain 1881–1973 Mougins, France

Table, Guitar, and Bottle (La Table), 1919

Oil on canvas

50 × 29½ in. (127 × 74.9 cm)

Signed in black paint, lower right: *Picasso*

Purchased, Sarah J. Mather Fund

1932:15

© 2000 Estate of Pablo Picasso/Artists Rights Society (ARS), New York

Table, Guitar, and Bottle is among Picasso's most abstract cubist works. Because Picasso's art is wedded to objective reality, the term *abstract* is not, strictly speaking, applicable here. A series of objects—table, guitar, and bottle—are embedded in the complex maze of shapes and colors, yielding their identities grudgingly.

Between 1908 and 1911 Picasso and Georges Braque developed a radically new artistic style that came to be known as Analytical Cubism, in which forms were broken into transparent, interpenetrating facets that dissolved into space. This painting belongs to the subsequent phase known as Synthetic Cubism. Synthetic cubist paintings and collages, dating from 1912 onward, were more colorful, exuberant, even witty, with facets that were larger, flatter, opaque, and interlocking. In the case of collages, varied materials added textural and iconographic interest. Rather than analyzing objects, Picasso was now inventing them. By 1918 a new movement, Purism, predicated on the clarity and precision of the machine aesthetic, began to challenge Cubism. It was at variance with the studio and café subject matter of Cubism and with its formal language, which valued suggestiveness over clarity. *Table, Guitar, and Bottle* is the culminating statement in a series of synthetic cubist works structured in a strictly geometric, planar arrangement. Its sustained intensity may be in part Picasso's response to Purism's challenge. Picasso is here insisting on the seriousness of effort inherent in cubist painting.

The large rectilinear shape defined along the left border of the vertical canvas delineates a table. Yet the gentle S-curve at lower left suggests a leg of a pedestal table whose top could be the white rectangle at the upper left. Many of the smaller rectilinear and curvilinear forms are suggestions of the shape of the bottle. The small circle above the center is the round opening of the guitar. Its bottom is the curved, striated shape to its left, and its top is the angled and curved form jutting out at the right. Musical instruments are common in Picasso's cubist works, and this painting is the perfect analogue for music's abstract language.

It is precisely this aspect of the work that speaks most forcefully. Its imagery is secondary to its formal language. In this sense, Picasso here comes closest to the conceptual vocabulary of Analytic Cubism and to abstraction. The painting is predicated on the interactive resonance of its myriad forms. Curving shapes of all sizes and swellings, massed mainly but not only on the left, serve as counterpoints to the triangular shapes dispersed mostly in the center and at right. This contrapuntal activity is absorbed into and leavened by rectilinear forms of all sizes and shapes that layer the composition from top to bottom. They overlap and wedge into one another—a process reinforced by a series of L and T shapes. The result is an extraordinarily balanced and stable composition cadenced by a series of strong vertical lines.

Picasso employs an array of nuanced colors: shades of gray to black, white into ivory, light and dark browns, rusts and olive greens, light blues, beiges, and yellows. Adding texture to the painting are the striated forms. This effect was achieved by applying corrugated board to wet paint, and then painting in the lines. Both the textural and the coloristic arrangements are an integral part of the painting's subtle interplay.

Table, Guitar, and Bottle is an effort of extraordinary visual thinking. It is for Picasso an act of faith. In this large, ambitious work he reiterates in unequivocal terms the viability and validity of the cubist experiment.

Further Reading

Barr, Alfred H., Jr. *Picasso: Fifty Years of His Art.* New York: The Museum of Modern Art, 1946.

Boggs, Jean Sutherland, et al. *Picasso and Things.* Cleveland: Cleveland Museum of Art, 1992.

Cowling, Elizabeth, and John Golding. *Picasso: Sculptor/Painter.* London: Tate Gallery, 1994.

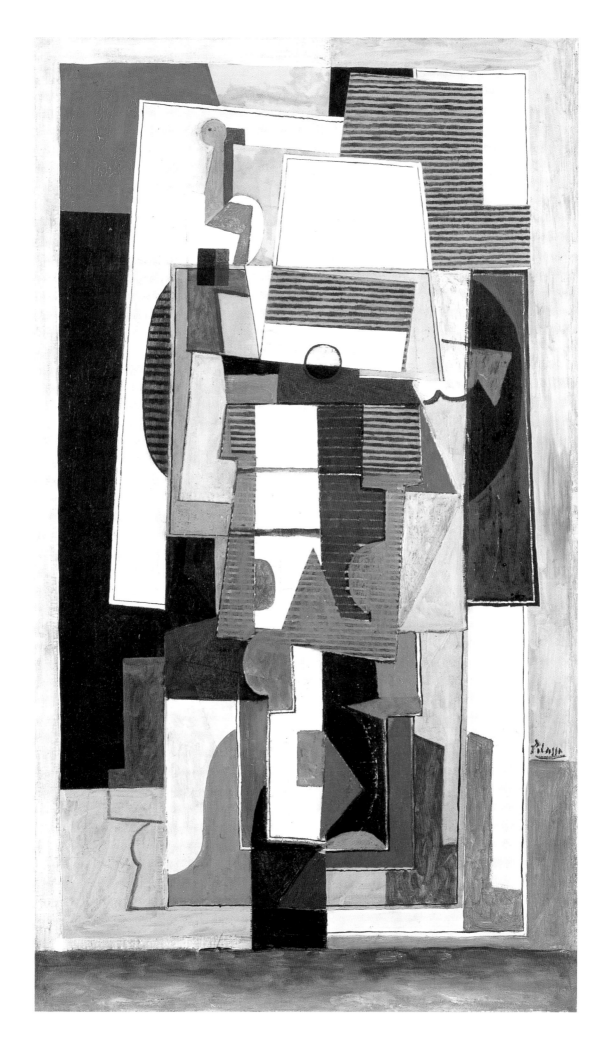

97

Pablo Picasso

Málaga, Spain 1881–1973 Mougins, France

Seated Nude, 1922

Oil on canvas
25⅝ × 21³⁄₁₆ in. (65.1 × 53.8 cm)
Signed in brown paint, upper left: Picasso
Gift of the Carey Walker Foundation
1993:19
© 2000 Estate of Pablo Picasso/Artists Rights Society (ARS), New York

From the moment Picasso set pencil to paper as a precocious student in the academies of Madrid and Barcelona, he began to explore the classical world through copying casts. Picasso always saw himself as part of the Mediterranean tradition. Throughout his career the imagery of the classical world would inform his art, and its mythology would charge his fantasy and imagination. Classicism became a foundation that gave Picasso license, even courage, to experiment freely. The sustaining rootedness of the classical world permeated all aspects of his artistic inquiry, allowing Jean Cocteau to comment that "Cubism was Classicism." Picasso would return to the classical ideal at different intervals during his career, interpreting it differently each time. This Seated Nude belongs to his most heroic classical period of the early 1920s. That this is also the moment of his greatest synthetic cubist works underscores Picasso's capacity to work concurrently in different styles.

Various influences contributed to Picasso's monumental classicism at this time. In 1917 he visited Italy for two months to work on the curtain design for Cocteau's Parade, being performed by Serge Diaghilev's Ballets Russes. While there, he viewed major sites in Rome, Florence, Naples, and also Herculaneum and Pompeii, directly absorbing the experience of antiquity. On a personal level, Picasso's classical periods correspond to times of relative tranquility in his life. The birth of his son Paul in 1921 led to such a moment. It inspired the artist to explore the serenity of the mother and child motif. These images also had a more public meaning, addressing the need for regeneration in postwar France. Viewed in this light, Picasso's classicism reflects a palpable longing among the people for peace and stability after the devastating cataclysm of World War I. The heavy-limbed monumentality of Picasso's figures has antecedents in his own early work and in the imagery of such artists as Paul Gauguin and Aristide Maillol. But on the most profound level, these works are a reaffirmation of his faith in humanity's enduring strength, which the classical tradition has sustained for millennia.

In this context, Seated Nude is an intriguing image. Picasso repeats the figure's pose with slight variations in a number of paintings and drawings, as if working out pictorial and thematic ideas toward a final state. The background in Seated Nude is rendered summarily, with vertical and horizontal lines suggesting rather than defining space. The figure is modeled with light flesh-toned colors and outlined with a resolute line. The head is carefully constructed and fully resolved, giving the image as a whole a cognitive presence.

That Picasso was searching for a symbolic figure is convincingly argued by Kenneth Silver. In his book Esprit de Corps, he concludes that the artist's Woman in White of 1923 (The Metropolitan Museum of Art) is his "greatest postwar meditation on the endurance of culture." Picasso's Seated Nude approximates closely the physiognomy and the psychological aspect of Woman in White. The two establish an interesting parallel with Pierre Puvis de Chavannes's two versions of Hope, one nude (Musée d'Orsay, Paris), one in a white dress (The Walters Art Gallery, Baltimore), painted in 1872 as the embodiment of rebirth after the devastation of the Franco-Prussian War. It may be that Picasso, in searching for the archetype to define a pivotal moment in France's history, explored the possibility of a monumental nude to fill that role before deciding on Woman in White, and that Smith's Seated Nude is the most complete expression of that image.

Further Reading

Cowling, Elizabeth, and Jennifer Mundy. On Classic Ground: Picasso, Léger, de Chirico, and the New Classicism, 1910–1930. London: Tate Gallery, 1990.

Silver, Kenneth E. Esprit de Corps: The Art of the Parisian Avant-Garde and the First World War, 1914–1925. Princeton, N.J.: Princeton University Press, 1989.

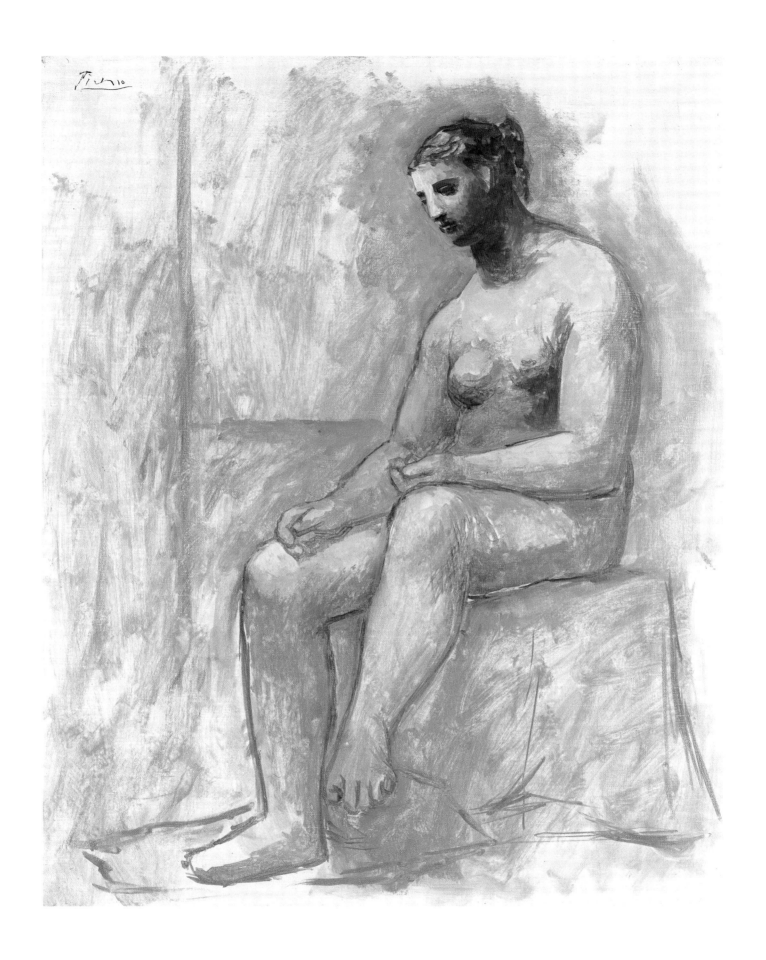

Pierre Puvis de Chavannes

Lyon, France 1824–1898 Paris, France

The Poor Fisherman, c. 1879–81 (possibly 1887)

Oil on canvas

28¾ × 36¼ in. (73 × 92.1 cm)

Not signed or dated

Gift of Mrs. Charles Lincoln Taylor (Margaret Rand Goldthwait, class of 1921) in memory of Dr. Joel E. Goldthwait

1966:10

The Poor Fisherman of 1881 (Musée d'Orsay, Paris) is Puvis's best-known work, rivaled only by his murals of the life of St. Geneviève in the Panthéon in Paris. The large canvas defines his unique artistic vision, which gained him respect from artists representing both the conservative and the avant-garde factions in the French art world of his day. *The Poor Fisherman* has neither the polished finish of an academic work nor the shimmering vibrancy of an impressionist painting. The boat in the foreground is reiterated rather than reflected in the water, whose opaque surface and muted green color are the perfect complement to the isolated pose of the fisherman in establishing the painting's melancholy mood.

Unique, too, is the painting's universalizing theme, differing from the academic hierarchy of subjects and from the impressionists' focus on leisure and nature. The painting has become an important archetype for artists dealing with existential issues of poverty and aloneness. Pablo Picasso's *Figures by the Sea* (pp. 94–95), depicting a poor family at water's edge, is directly related to it. Although the subject of *The Poor Fisherman* is not overtly religious, the fisherman, in his vulnerable pose, has been associated with Christ from the outset. Puvis seems to reinforce this reading by having the sliver of land at the upper left extend across the mast to create a cruciform shape. The pose of the fisherman references numerous examples of the subject in the nineteenth century, including Puvis's own *Ecce Homo* (private collection) of about 1858. Paul Gauguin in *Christ in the Garden of Olives* (Norton Museum of Art, West Palm Beach, Florida) uses the pose of Puvis's fisherman for the prayerful, vulnerable Christ, whom he represents as a self-portrait.

Puvis conceived *The Poor Fisherman* while visiting Honfleur on the northwestern coast of France. Already the fishermen in the coastal towns had been supplanted in importance by vacationing city dwellers, the subjects of numerous impressionist paintings. Puvis tells us that the female figure in the background is the fisherman's daughter and the child's older sister. This fact intensifies the poignancy of the scene and reminds us that the artist had lost his mother in his youth and had been brought up by his older sister.

Smith's painting is a smaller, unfinished version of the original in the Musée d'Orsay. Some scholars have judged Smith's painting to be a contemporary copy, while others have called it a later version, executed by the artist himself. The fact that the painting lacks final definition and is missing the critical detail of the rope connecting the post to the trap would argue for its being by the artist, but set aside before completion. In 1887 *The Poor Fisherman* was selected for the French national collection as representative of Puvis's oeuvre from the collection of Emile Boivin, an astute and important collector. Puvis may have started Smith's painting as a replica to compensate Boivin for his loss. Before completing it, however, he may have decided on a more original variant. Boivin was ultimately presented with a painting of vertical format, in which the child was placed in the boat and the girl was omitted, thus substantively transforming the pictorial and iconographic focus of the original.

Puvis de Chavannes was one of the titans of the art world during his lifetime. In recent decades there has been an extensive reappraisal of his important contributions. In this context, we have gained a deeper appreciation of *The Poor Fisherman* as one of the pivotal canvases of its time.

Further Reading

d'Argencourt, Louise, et al. *Puvis de Chavannes: 1824–1898.* Ottawa: National Gallery of Canada, 1977.

Price, Aimée Brown, et al. *Pierre Puvis de Chavannes.* New York: Rizzoli, 1994.

Wattenmaker, Richard J. *Puvis de Chavannes and the Modern Tradition.* Toronto: Art Gallery of Ontario, 1975.

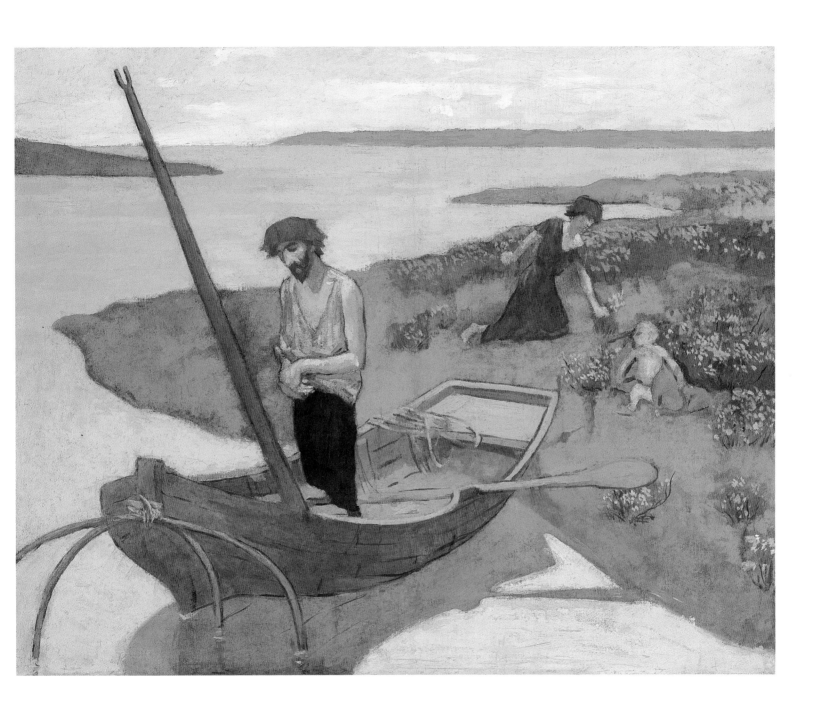

Odilon Redon

Bordeaux, France 1840–1916 Paris, France

With Closed Eyes (Les Yeux Clos), c. 1895–1905

Oil on canvas

25¾ × 20 in. (65.4 × 50.8 cm)

Signed in red paint, lower right: ODILON/REDON

Gift of Mrs. Charles Inslee (Marguerite Tuthill, class of 1915)

1956:16

Redon's singular vision makes him one of the most distinctive artists of his time. He was of the impressionists' generation, but his art delved into the interior world of dreams rather than celebrating nature's external verities. The search for alternatives to Impressionism began in the 1880s, and by 1890 the symbolist movement, closely aligned to its literary manifestation, coalesced around such artists as Gustave Moreau, Pierre Puvis de Chavannes, and Redon. Of these, Redon belonged to the tradition of artists of fantastic imagery, such as Francisco Goya and Hieronymous Bosch, both of whom he admired.

Moreau's dictum, "I believe only in what I do not see and solely in what I feel," expresses one of Symbolism's key tenets, the primacy of idea over nature. Redon's *Yeux Clos*, depicting a head with closed eyes, would seem to be its visual manifestation. Yet the relationship of art and nature for Redon was more complex. Early in Redon's career, the botanist Armand Clevaud exposed him to all aspects of biological studies including microscopic life. The artist speaks succinctly of his powers of observation and their impact on his art: "After the effort of copying minutely a pebble, a blade of grass, a hand, a face or any other object from the organic or inorganic world, I experience mental elation; I then need to create, to allow myself to move to the representation of the imaginary." The creatures that crawl out of his imagination are that much more compelling because of Redon's deep understanding of nature's processes.

Les Yeux Clos is among Redon's most important images. Conceived in 1889 as a painting, it exists in a number of variants, including a lithograph of 1890. The most resolved and authoritative interpretation is a painting of 1889–90, done soon after the original, which was acquired by the State for the Musée du Luxembourg in 1904 (now Musée d'Orsay, Paris). The work demarcates two distinct, interrelated halves of Redon's oeuvre, being the first significant image in which he introduced color. Previously in his graphic work he had used black and white almost exclusively. Referring to black as "the prince of color," he had extracted from it extraordinarily rich effects in fashioning his world of fantastic images, for example a head depicted as a marsh flower or an eye as a floating balloon.

The head's distinctive features in *Les Yeux Clos* have been related to those of Redon's wife, and the artist himself called it "this androgynous head," alluding to Symbolism's view of androgyny as an ideal human state. In his journal, *A soi-même (To Myself)*, Redon writes of contemplating "the closed eyes of the *Slave*" by Michelangelo in the Louvre. His moving assessment of it could apply to *Les Yeux Clos:* "He sleeps, and the worried dream that crosses the brow of this marble lifts our dreams into a pensive and moving world."

The difference between the earlier versions and the Smith College painting is substantive. In the earlier image Redon uses color tentatively, as he begins to explore its potential, while here he is its master. In the earlier works the locus of the dream is concentrated in the lone head, partly lit but mostly in shadow—an apt metaphor for the introspective state evoked by the closed eyes. In the Smith painting, the head, smaller and less well defined, has been subsumed into a larger ensemble, floating in a sumptuously colored aureole of clouds and flowers. The internalized world behind the closed eyes has been given outward manifestation, and we are witness to a transcendent, otherworldly realm.

Further Reading

Berger, Klaus. *Odilon Redon: Fantasy and Colour.* Translated by Michael Bullock. New York: McGraw-Hill, 1965.

Druick, Douglas W., et al. *Odilon Redon: Prince of Dreams, 1840–1916.* Chicago: The Art Institute of Chicago; Amsterdam: Van Gogh Museum; London: Royal Academy of Arts; New York: Harry N. Abrams, 1994.

Redon, Odilon. *To Myself: Notes on Life, Art, and Artists.* Translated by Mira Jacob and Jeanne L. Wasserman. New York: George Braziller, 1986.

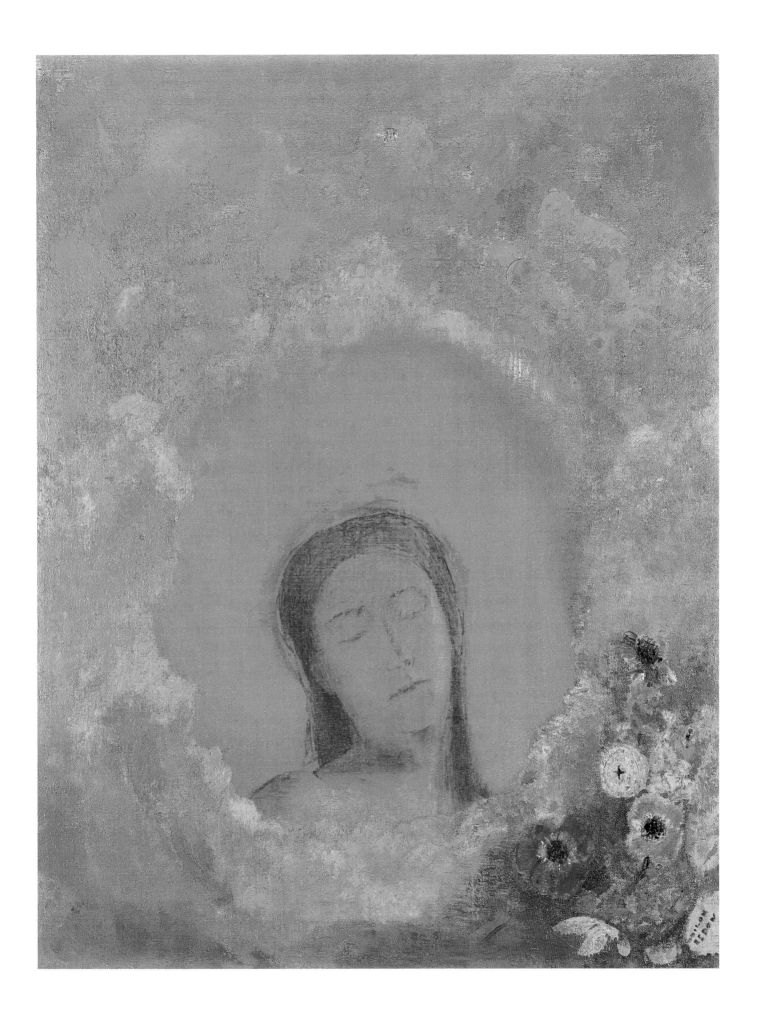

Pierre-Auguste Renoir

Limoges, France 1841–1919 Cagnes-sur-Mer, France

Rapha Maître (Madame Edmond Maître),

c. 1870–71

Oil on canvas

14¾ × 12¾ in. (37.5 × 32.4 cm)

Signed in brown paint, upper left: Renoir

Purchased

1924:16

Renoir's hold on the public imagination as the purveyor of sun-drenched days of leisure — of boating parties, dancing couples, ample nudes at river's edge — is so pervasive that it takes a conscious effort to think of him as a portraitist. Yet his portraits are among his singular achievements. Georges Rivière's comment that "no other artist has looked so deeply into the sitter's soul nor captured its essence with such economy" unnecessarily excludes some artists — Edgar Degas comes to mind — but nonetheless is essentially valid in assessing Renoir's achievements as a portraitist. What Renoir brings to the task is his own generous nature, revealing an artist of deep humanity. Renoir's most penetrating portraits are of people he knew best, so that he could draw on the experience of his interaction with them to forge an image. For example, his portrait of Victor Chocquet (Harvard University Art Museums, Cambridge, Massachusetts), a customs official who on a limited salary helped many young artists by purchasing their works, reveals an individual of uncommon goodness and of disciplined sensibility and refinement.

Rapha Maître of about 1870–71 depicts the lifelong mistress who took the name of her lover, Louis-Edmond Maître, a civil servant devoted to music and art. He was an avid supporter of avant-garde artists, and among his close friends were Frédéric Bazille and Henri Fantin-Latour. Renoir's friendship with Rapha is not well documented, but his three portraits of her, as well as his relationship with the family, are evidence of a close bond. During 1870, just before entering the military, he stayed in their apartment on an irregular basis. An early date of spring of 1870 has plausibly been suggested for the Smith portrait, which was probably painted during one of Renoir's stays with the Maîtres. After having left the military, Renoir painted another portrait of her

(private collection) in April 1871, on which he lavished great attention. In this more formal and expansive work, Rapha is shown in a fashionable floor-length costume, holding a fan and glancing at a birdcage. There is an array of flowers at her feet and a decorative trellis wall-paper as a backdrop. In its opulent display, this second portrait evokes the works of James Tissot and even more those of Alfred Stevens. While it is very much a document of the sitter's station in life, the earlier Smith portrait focuses on her interiority. The fact that the nature of the relationship between sitter and artist is unknown makes the image that much more compelling. The reason for the existence of this work is to record a friendship and to probe its nature.

The large Maître portrait has been interpreted as Renoir's reaffirmation of the joy of painting after the debilitating events of the Commune. It may be that the Smith portrait, painted just months before his conscription into the military, reveals Renoir's desire during those anxious days to record a moment of quiet intimacy with a friend. To achieve this, Renoir renders an image close-up and in a small format. He centers the head so that it becomes the focus of his insight. The white cushion with geometric design behind her head echoes the black, gray, and white checkered costume. Undulating strokes of brown and ocher in the upper background reiterate the sweeping energy of the loosely painted jet black hair. The tilted, frontal head is modeled with a physicality reminiscent of portraits by Gustave Courbet. Rapha looks back with eyes that are reflective and engaged — probing the artist as he investigates her features and records her insight. The formal decorum of portraiture has been discarded in this image of total involvement and unself-consciousness.

Further Reading

Adriani, Götz. *Renoir.* Cologne: DuMont; New Haven, Conn.: Yale University Press, 1999.

Bailey, Colin B., et al. *Renoir's Portraits: Impressions of an Age.* New Haven, Conn.: Yale University Press; Ottawa: National Gallery of Canada, 1997.

Rouart, Denis. *Renoir.* Translated by James Emmons. New York: Skira/Rizzoli, 1985.

Joshua Reynolds

Plympton, Devon, England 1723–1792 London, England

Mrs. Nesbitt as Circe, 1781

Oil on canvas

49¼ × 39½ in. (125.1 × 100.3 cm)

Not signed or dated

Gift of Dwight W. Morrow, Jr., Anne Morrow Lindbergh, class of 1928, and Constance Morrow Morgan, class of 1935

1958:4

Sir Joshua Reynolds, one of England's preeminent artists of the eighteenth century, was determined to elevate English art to the level of art on the Continent. This goal motivated his artistic vision, defined in his famous "Discourses on Art" delivered at the Royal Academy between 1769 and 1790. He believed that art was not mimesis but an expressive force filtered through the intellect, that art should strive for the universal rather than the particular, that history painting is the highest category of art, and, above all, that artists should learn by emulating masters of the past. His role as the first president of the Royal Academy provided him the opportunity to create a climate in England receptive to his ideas and ambition. Reynolds's artistic reputation depends largely on his portraits. These exhibit a breadth of expression and interpretation often based on earlier artists such as Rembrandt van Rijn and Anthony van Dyck; Van Dyck's elegant portraits were especially popular during the second half of the eighteenth century. In 1781, the year Reynolds painted Mrs. Nesbitt as Circe, he traveled to Flanders to study the great seventeenth-century masters, especially Peter Paul Rubens and van Dyck.

In Mrs. Nesbitt as Circe, Reynolds confronts a fascinating sitter. Her mysterious early years, filled with rumors of an immoral past, would remain part of her allure. She became the mistress of Augustus John Harvey, third earl of Bristol, who was a confidant of George III. Harvey died in 1779, leaving her most of his estate, including a house in Norwood. Her proximity to the monarchy would engage her in affairs of state as a secret agent for the government during the momentous upheavals in Europe. She brought to the task well-honed attributes—especially her facility with men and languages.

Reynolds depicts Mrs. Nesbitt as Circe, daughter of the sun god Helios, who dwelt on the island of Aeaea to which she enticed men with wine and other delights, then turned them into docile animals by the touch of her wand. Reynolds made famous this type of portrait, in which the sitter is imbued with historical, mythological, or allegorical attributes. In this way he elevated portraiture, which was much in demand, close to the level of history painting, for which commissions were fewer. Here he depicts Lady Nesbitt seated in natural surroundings with a dominant tree behind her—a ubiquitous prop in eighteenth-century English portraits. Her simple white dress evokes classicizing drapery and underscores her pale features. Her carefully rendered face, beautiful and intelligent, glances out alertly at the viewer. Her pose and the animals around her define her powers and domain. In the right hand she holds her wand, and her left hand rests near the gilded goblet used for libations for her guests. As she crosses her left leg, she makes explicit the distinction between her space and ours.

The domesticated white cat, its paws in its mistress's lap, is further identified with her because it echoes her dress in color. The monkey, which in the eighteenth century was often associated with licentious behavior, may refer to her allegedly scandalous past. Like Circe on her isle, Mrs. Nesbitt presided over her estate at Norwood, where she charmed and impressed prominent men including the king. The tame leopard at the lower left may refer to this special company of powerful men, over whom she was able to manifest her will. In this extraordinarily erudite and refined portrait, Reynolds achieves his ambition of elevating English art to international stature.

Further Reading

Pointon, Marcia. Hanging the Head: Portraiture and Social Formation in Eighteenth-Century England. New Haven, Conn.: Yale University Press, 1993.

Wendorf, Richard. Sir Joshua Reynolds: The Painter in Society. Cambridge, Mass.: Harvard University Press, 1996.

Hubert Robert

Paris, France 1733–1808 Paris, France

Pyramids, c. 1760

Oil on panel
24 × 28½ in. (61 × 72.4 cm)
Not signed or dated
Purchased
1950:15

Hubert Robert's reputation rests on his inventive translation of Roman architectural ruins. He began his training in Paris under the sculptor René-Michel (Michel-Ange) Slodtz. He arrived in Rome in 1754 in the entourage of the French ambassador to the Holy See, comte de Stainville. During the next eleven years in Italy, Robert became one of the most popular and accomplished interpreters of Roman architecture. His love of Roman ruins was strongly influenced by Giovanni Paolo Pannini, his teacher and friend, and by Giovanni Battista Piranesi, also a friend. In different ways, these three artists reclaimed for the generation of the Enlightenment the glory of antique architecture.

A number of tendencies intersect in Robert's art. The whimsy and charm of the landscape environs in which he places architectural ruins display a rococo sensibility. His rich and supple handling of surfaces comes close to Fragonard, whom he met in Rome. In his commitment to antiquity he shares a philosophical link with Neoclassicism. And in his dramatic rendering of scenes, touching on the sublime, he is a precursor to Romanticism.

In *Pyramids* of about 1760, Robert transports the viewer through time and space to the Egypt of the pharaohs. A massive partial pyramid, dominated by a diagonal, anchors the scene. The small size of a second pyramid at lower right implies a vast open space between the two structures. At the extreme right stand two obelisks, grand in scale in proportion to the people below but, like all else in the painting, insignificant next to the pyramid. We are convinced, as every eighteenth-century viewer of the painting must have been, that we are in the presence of one of the wonders of the world — permanent, timeless, compelling in the clarity of its idea and purity of its geometry.

Such is Robert's interpretive power that it comes as a surprise to discover that the pyramid in the painting is based on the pyramid of Caius Cestius located outside Rome, which is much smaller and steeper than the pyramids at Giza. In effectively transforming the setting and scale of the Caius Cestius pyramid, Robert retained one important element of that structure, namely its steep angle, which adds significantly to the sense of soaring height.

Other inventive interpretations add to the painting's dramatic effect. The arched openings at the base of the pyramid absorb the diminutive figures in an awesome processional ritual. The clouds, rare in Egypt's dry climate, are more common to Rome's environs, where the motif was conceived. They move across the upper part of the pyramid, emphasizing the immense size of the structure. Only careful scrutiny of the work yields a patch of blue at upper left, indicating the pyramid's downward slope. In focusing on the pyramid and arch, Robert isolates two perfectible forms that feature in contemporary utopian renderings by architects such as Etienne-Louis Boulée and Claude-Nicolas Ledoux.

Ancient Egyptian culture exercised a sustained hold on Robert's imagination from the outset. Public interest in Egyptian motifs intensified greatly toward the end of the eighteenth century as a result of Napoleon's campaign in Egypt. Nearly forty years after executing Smith's canvas, Robert painted *Young Girls Dancing around an Obelisk* (Museum of Fine Arts, Montréal). His investigation and inventive adaptation of Egyptian art, predicated on works brought to Rome from Egypt by ancient Romans, yielded some of his most visionary and compelling images.

Further Reading

Hubert Robert: The Pleasure of Ruins. New York: Wildenstein, 1988.

Radisich, Paula Rea. *Hubert Robert: Painted Spaces of the Enlightenment.* Cambridge: Cambridge University Press, 1998.

French Painting, 1774–1830: The Age of Revolution. Detroit: The Detroit Institute of Arts; New York: The Metropolitan Museum of Art, 1975.

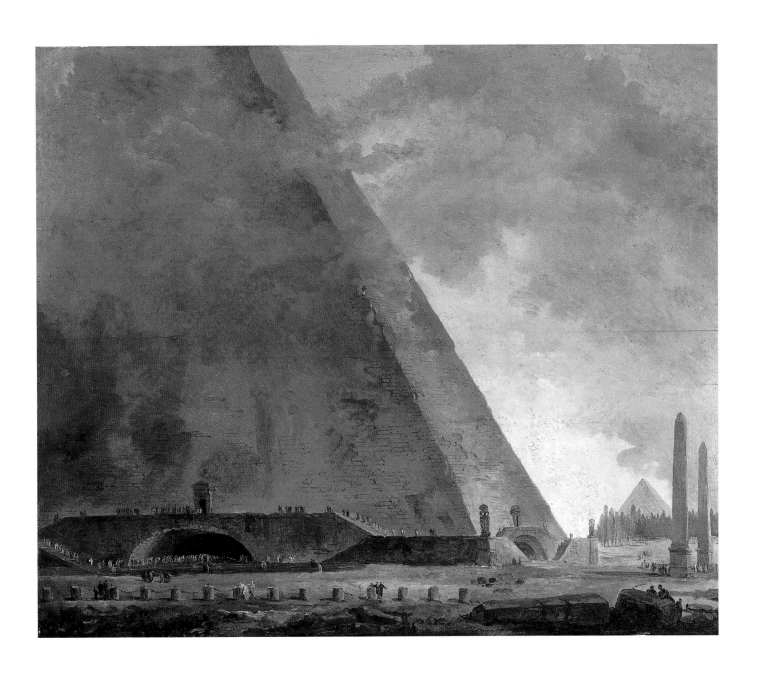

Auguste Rodin

Paris, France 1840–1917 Meudon, France

Man with the Broken Nose, modeled 1863–64;
this cast c. 1900

Bronze

12 × 7½ × 6¾ in. (30.5 × 19 × 17.1 cm)

Signature incised at neck termination, proper right: A. Rodin

Stamped inside, in relief, proper left: A. Rodin

Purchased

1963:57

Man with the Broken Nose, one of Rodin's best-known works, was indispensable for the artist's development. Executed in 1863–64, it was among his earliest images. He considered it "the first good piece of modeling I ever did," and the work became his talisman: "I have kept that mask before my mind in everything I have done," he later said.

The reference to it as a mask is telling. The original clay head on which the artist had worked for over a year cracked during extremely cold weather in Rodin's drafty studio, leaving the interior exposed as in a mask. Rodin decided to turn accident into invention. Realizing its expressive potential in its new format, he presented the work to the Salon of 1865, only to be rejected. Despite this setback, Rodin's tendency to take advantage of unforeseen circumstances to explore new creative possibilities would become a hallmark of his artistic process.

The model for the original was a local worker named Bibi who, according to Rodin, had "a fine head . . . no matter if it was brutalized." The broken nose, its most vulnerable feature, introduces the head's other plastic features: the deeply furrowed forehead and blank eyes give the face special poignancy. In the process of manipulating clay to give form to his insights, Rodin understood art's expressive potential. Through a sustained expenditure of effort over a long period, he produced a highly orchestrated image in which each aspect has been worked through for maximum effect. Even the psychological impact of the forward tilt of the head has been considered. The malleable clay, which defines the sitter's features with such intensity, would be handled with greater flexibility and freedom in his maturity. The looser, more abstract surfaces of his later works become expressive passages in themselves and thus help interpret rather than define the image.

Rodin's transcendent realism in *Man with the Broken Nose* imbues the head with noble dignity that reflects his early concentrated study of ancient sculpture in the Louvre. The restrained emotional resonance of the features and the frankness of their interpretation evoke traits in Hellenistic portraiture. Part of a ribbon or fillet can be seen running across the top of the head, an adornment common on classical sculptures. Rodin reworked the sculpture in a plaster in 1872, which was then translated into marble in 1875. He depicted this version as a bust with upper torso and shoulders, much like an antique philosopher portrait, and it was given the title *Portrait of M. B. . . .* (marble, Musée Rodin, Paris). A portrait of Crysippus in the Louvre has been suggested as a possible source. Because of the evident quotation from the antique, the marble was readily accepted for the Salon of 1875.

Due to its popularity, many casts were made of *Man with the Broken Nose*. Smith's cast is said to have been acquired from Rodin by Mrs. Emil Hesslein, sister of the prominent English artist William Rothenstein. The most recent scholarship suggests a date around the turn of the century. Among its distinguishing characteristics is a bit of hair loss at the left center of the forehead, resulting from a casting flaw.

A youthful work transforms many artists' careers. But it is much rarer to come across an early work like *Man with the Broken Nose*, which in its artistic integrity, humanity, and inventiveness establishes itself as a masterpiece and cogently defines the critical issues for the artist's future development.

Further Reading

Elsen, Albert E., ed. *Rodin Rediscovered*. Washington, D.C.: National Gallery of Art, 1981.

Wasserman, Jeanne, ed. *Metamorphoses in Nineteenth-Century Sculpture*. Cambridge, Mass.: Fogg Art Museum, Harvard University, 1975.

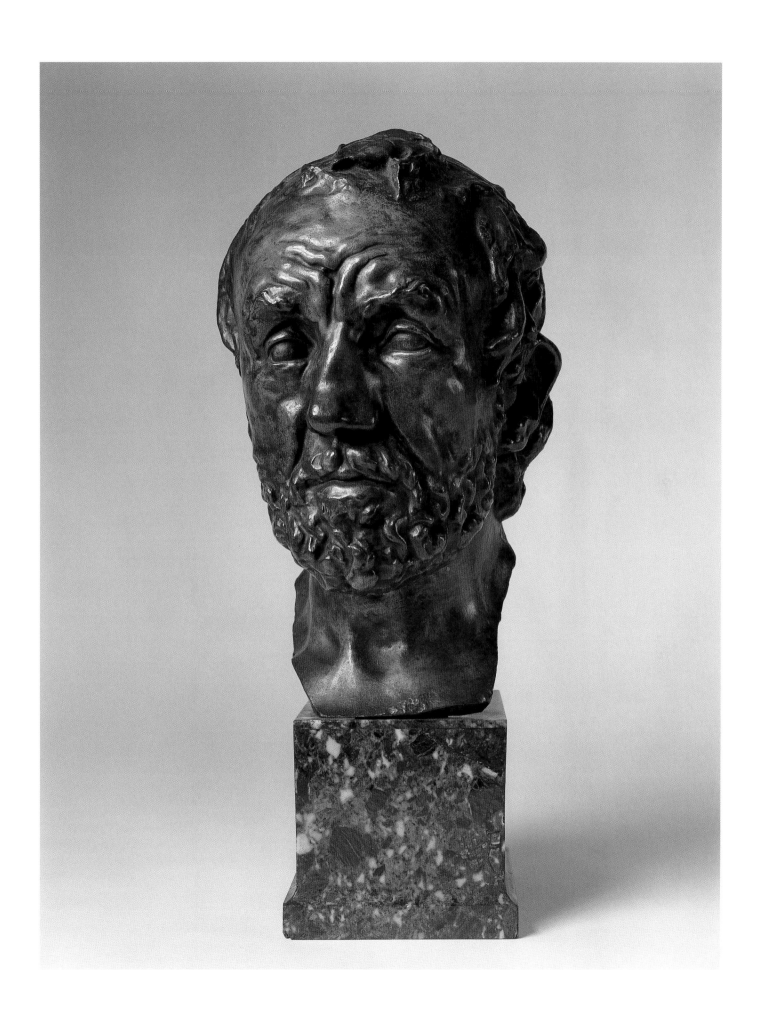

Auguste Rodin

Paris, France 1840–1917 Meudon, France

The Walking Man, modeled 1877–78; this cast 1965

Bronze

7½ × 2½ × 5¼ ft. (228.6 × 76.2 × 160 cm)

Signature incised in base: A. Rodin; incised at rear of base:
© by Musée Rodin. 1965; incised at proper right side of base:
Georges Rudier./.Fondeur. Paris.

Purchased

1965:30

The evolution of *The Walking Man* to this monumental scale is an intriguing process that began with a scandal. When in 1877 Rodin exhibited his first freestanding male nude, *Age of Bronze* (The Metropolitan Museum of Art), the realism of the image was so compelling that he was accused of having cast it from life. To answer his critics, he created *St. John the Baptist* in 1878 (Musée Rodin, Paris). The passive, introspective pose of *Age of Bronze* was replaced by a striding figure of such dynamic force, nervous energy, and purpose that it was impossible to accuse the artist of casting it from life. Related to *St. John the Baptist* is a freely executed, vigorous image, *Torso* (Petit Palais, Paris). Balanced on the right leg cut off at the knee, with its other extremities missing, *Torso* is, as well, the starting point for *The Walking Man.*

The heroic demeanor of *Torso* has been compared with fragmented antique torsos and to terra-cotta torsos attributed to Michelangelo, whose influence on Rodin was profound. *Torso*'s violated features also echo imagery from Francisco Goya's *Disasters of War* etchings of 1820–23. In one of these, *Great Deeds against the Dead,* a body without head and arms, bearing an affinity to *Torso,* hangs upside down from a tree branch.

Considering that *St. John the Baptist* became one of Rodin's most popular sculptures, his decision to explore the theme further and in a more radical context is indicative of the constancy and intensity of his search for new expression. *The Walking Man* is more than an amalgam of *Torso* and the powerful striding legs taken from *St. John the Baptist.* As it evolved into the new, highly charged entity, it clearly became more than the sum of its parts.

Judith Cladel, Rodin's companion and confidante, proposed that the torso and legs of *The Walking Man* were brought together only in 1900, a suggestion rein-

forced in Ruth Butler's authoritative biography, in which she related the assembling of fragments of sculptures, including the torso and legs, to Rodin's exhibition of 165 works at the 1900 Exposition Universelle.

The gait of *St. John the Baptist,* which has the right shoulder and leg moving forward in unison, is explained by the forward thrust of the saint's gesticulating arm. In the armless *Walking Man,* this unique alignment of leg and shoulder acquires an elemental force that thrusts the figure forward. The torso's bruised passages not only relate to missing appendages but also exist as independent expressive pockets, as for example the gouge on the right side of the back. The legs, pillars of rippling energy, are more finished than the torso. To capture the heroic essence of movement rather than its fleeting actuality, Rodin rivets both feet to the uneven base, which in its sweep helps to propel the back leg forward. By elongating the rear leg he captures the stride at the nascent moment when weight shifts from the back to the front leg. In ignoring anatomical correctness for expressive results, he invokes Masaccio's Adam in the *Expulsion* fresco in the Brancacci Chapel (c. 1427, Santa Maria del Carmine, Florence).

The Walking Man has become one of Rodin's most resonant images, supplanting *St. John the Baptist* as the incarnation of a striding figure. It avoids the symbolic, religious, or historical context that characterizes much nineteenth-century sculpture and thus attains universality. Its radical presentation startles the viewer, posing more questions than it answers. In this sense it is a resoundingly modern work. It at once addresses our fears and our hopes. Its arch dichotomy between torso and legs is resolved in the act of walking. It is a manifestation of indomitable spirit, even as it documents life's vicissitudes.

Further Reading

Butler, Ruth. *Rodin: The Shape of Genius.* New Haven, Conn.: Yale University Press, 1993.

Elsen, Albert. *Rodin.* New York: The Museum of Modern Art, 1963.

Tancock, John L. *The Sculpture of Auguste Rodin: The Collection of the Rodin Museum, Philadelphia.* Boston: David R. Godine; Philadelphia: Philadelphia Museum of Art, 1976.

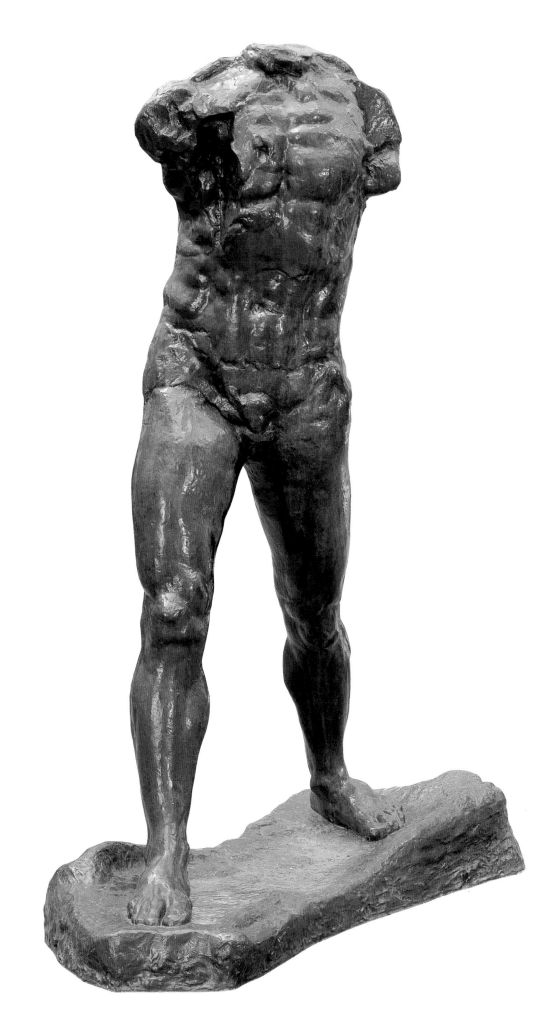

Théodore Rousseau

Paris, France 1812–1867 Barbizon, France

The Bridge at Moret, c. 1828–29

Oil on canvas
10½ × 13¼ in. (26.7 × 33.7 cm)
Stamped in brown paint, lower left: TH.R [Lugt 2436]
Purchased
1957:32

When Rousseau painted *The Bridge at Moret* in 1828–29, he was a sixteen year old on the threshold of an important career as one of France's major landscapists and the leader of the Barbizon school.

French art of the 1820s was dominated by the emergence of Jean-Auguste-Dominique Ingres and Eugène Delacroix. For them, landscape was a component of a larger drama — be it the background of an Ingres portrait or a setting for one of Delacroix's literary or historical paintings. In England, meanwhile, J. M. W. Turner, John Constable, and Richard Parkes Bonington established the primacy of landscape.

The influence of Bonington and Constable was especially significant in France, which was in the process of developing its own landscape tradition during the 1820s. A special category for historical landscape had already been established for the Prix de Rome in 1817, and Achille-Etna Michallon, the mentor of the young Camille Corot, was its first winner. Rousseau and Corot became the preeminent landscapists of their generation. During the 1820s they were already following similar paths. Each painted in the Fontainebleau forest — Corot earlier in the decade, Rousseau toward the end — long before it became the favorite haunt for the Barbizon artists. Both also visited Moret-sur-Loing, a few miles southeast of Fontainebleau, and painted its medieval bridge. By the 1840s they had become close friends.

Rousseau's *Bridge at Moret* is at once formal and picturesque. Slivers of land at the left and right foreground introduce the motif and distance us from it. The bridge's three arches move across the middle of the composition in a paced cadence. The outer interior walls of the left and right arches are rendered as wider than the inner ones, thus positioning the viewer directly on line with the center of the middle arch. This specificity of vantage point and the reflection of the arches in the still water add formal clarity to the work. Corot's freely sketched *Bridge at Moret* of 1822 (private collection) depicts a close-up view of one of the bridge's supporting posts, surrounded by lively water energized by a waterfall. Its palpable immediacy and freshness contrast with Rousseau's measured, comprehensive view of the town's distinctive features, to which land, water, and sky serve as complements.

The picturesque cluster of structures at the right creates a visually alluring passage. The various buildings begin at water's edge, where the top floor of the house overhangs the river in deference to its potential for flooding. The wooden buttresses propping up the house enunciate a series of repetitive rhythmic patterns throughout the work. Above and beyond the house are more substantive buildings, including the tower announcing the bridge, behind it a compact Romanesque chapel, and in the middle of the bridge a millhouse. Passages like the flickering of light across the stone wall atop the bridge, the wedge stones of the bridge's arches, and the subdivision of the house's windows at the right into discrete panes all add visual vibrancy to the painting.

Rousseau's capacity to hold the energy of the smaller details in complementary balance with the dynamic of larger passages proved to be one of his great strengths as an artist. This vivid, richly painted landscape underscores his ability to orchestrate elements of nature and man-made structures into a compelling and appealing whole. In *The Bridge at Moret*, Rousseau moves beyond early promise.

Further Reading

Adams, Steven. *The Barbizon School and the Origins of Impressionism.* London: Phaidon Press, 1994.

Green, Nicholas. *Théodore Rousseau, 1812–1867.* Norwich, England: Sainsbury Centre for the Visual Arts, University of East Anglia, 1982.

Herbert, Robert L. *Barbizon Revisited.* New York: Clarke & Way, 1962.

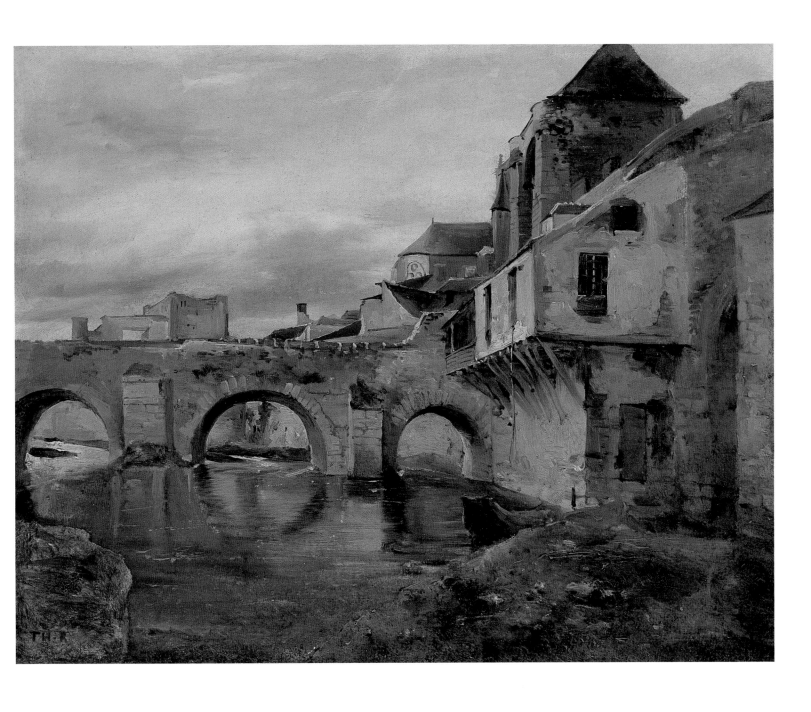

Georges Seurat

Paris, France 1859–1891 Paris, France

Woman with a Monkey (study for A Sunday Afternoon on the Island of La Grande Jatte), 1884

Oil on wood panel
9¾ × 6¼ in. (24.8 × 15.9 cm)
Not signed or dated
Purchased, Tryon Fund
1934:2-1

Woman with a Monkey, a sketch for Seurat's *Sunday Afternoon on the Island of La Grande Jatte* of 1884–86 (The Art Institute of Chicago), helps to elucidate that painting's role as one of the seminal works of nineteenth-century art.

The year 1886 marked the last group exhibition of the impressionists. Tellingly, the most important canvas exhibited was Seurat's masterpiece, which more than any other image defined the direction of art beyond Impressionism. In presenting an alternative to the impressionists' search for nature's fugitive moments, Seurat extracts nature's order, encased in its immutable laws. Through a system of highly regulated and tightly arranged small strokes, the artist explores the laws of color interaction predicated on the earlier investigations of Eugène Delacroix and the researches of Michel-Eugène Chevreul, Charles Henry, and Ogden Rood. Thematically, he evokes such images of leisure as Jean Antoine Watteau's *Pilgrimage to the Isle of Cythera* (1718, Musée du Louvre, Paris). In his search for more permanent and timeless priorities, he turns to early Renaissance art and to the Persian and Egyptian traditions. In establishing a link with a historical period of great innovation, he refers to the classical world of Phidias's Parthenon frieze: "The Panathenaeans of Phidias formed a procession. I want to make modern people, in their essential traits, move about as they do on those friezes." In addressing the moderns, Seurat's modishly dressed two-dimensional figures reference contemporary advertising practices. Thus *A Sunday Afternoon on the Island of La Grande Jatte* is an amalgam of an extraordinary array of disparate impulses, filtered through Seurat's unique vision to create a document both radical and cohesive.

Woman with a Monkey is one of a large group of small oil sketches executed early in the painting's development. In it, the artist introduces a structural order that points to his distinctive transformation of Impressionism, even as the luminous colors of areas of sunlight remind us of Seurat's roots in that movement. He experiments with color interactions, using an intense mixture of light blue and violet-blue that, like a haze, permeates the foreground, the dark areas between trees, their shadows, and every aspect of the woman's clothing including the parasol, thus interacting with every other color in the sketch. The hatched brushstrokes give the work textural unity, and their sustained pattern carries over to the strict organization of the compositional elements. The diminishing scale of tree trunks and horizontal shadows creates a perspectival grid. The vertical pattern of the cluster of trees at the right is reiterated in the woman, whose front becomes the dominant vertical, unifying top and bottom, foreground and near background. Her curved back with the exaggerated bustle creates a counterpoint to the curves of the tree at the upper left. The undulating silhouette of the monkey and its exuberantly curving tail reiterate the curving patterns in the work, as does the parasol in the upper right.

The monkey, traditionally associated with lust, may also be a mildly ironic commentary on the woman's pretentiousness. Or perhaps Seurat simply endowed the most important figure in his painting with an exotic attribute, making her and her consort appear as royalty among their subjects in the final work.

Many sketches for the painting depict the woman with her top-hatted, dapperly dressed partner. This sketch is unique in presenting the woman alone, in profile, with her monkey. The most critical and compelling passages of the final painting have already coalesced in this intelligent, highly resolved image.

Further Reading

Herbert, Robert L., et al. *Georges Seurat, 1859–1891.* New York: The Metropolitan Museum of Art, 1991.

Homer, William Innes. *Seurat and the Science of Painting.* Cambridge, Mass.: M.I.T. Press, 1964.

Smith, Paul. *Seurat and the Avant-Garde.* New Haven, Conn.: Yale University Press, 1997.

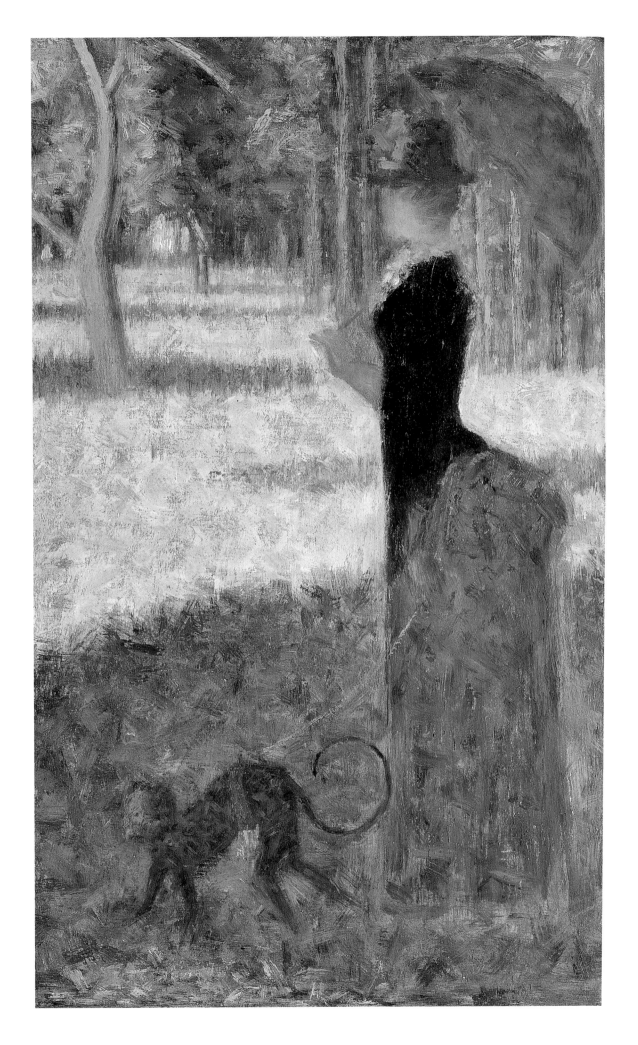

Edouard Vuillard

Cuiseaux, Saône-et-Loire, France 1868–1940 La Baule, near Saint-Nazaire, France

The Suitor (also called The Workshop; formerly Interior at l'Etang-la-Ville), 1893

Oil on millboard panel
12½ × 14¹⁵⁄₁₆ in. (31.8 × 37.9 cm)
Signed and dated in thinned black paint, lower right: V. 93
Purchased, Drayton Hillyer Fund
1938:15
© 2000 Artists Rights Society (ARS), New York/ADAGP, Paris

For Edouard Vuillard, the interior, especially one peopled by his closest relatives and friends, was a source of comfort, solace, and endless pictorial possibilities. He never tired of revisiting it, and each encounter produced new revelations. The quiet drama of these intimate paintings is dependent on their evocative properties. They suggest much but explain little, echoing the attitude toward poetry of his close friend Stéphane Mallarmé, "To name an object is to do away with three quarters of the enjoyment of the poem . . . to suggest it, to evoke it—that is what charms the imagination."

Vuillard, an intensely private artist, flourished during the 1890s, a decade when introspection was the dominant creative focus. At the core of Vuillard's introspection was the interior space of his everyday experiences, which defined and sustained his emotional life. It is not surprising that among earlier artists he favored the seventeenth-century Dutch masters of genre scenes and Jean Baptiste Siméon Chardin, even as his own interpretation of such spaces would differ markedly from theirs.

In The Suitor, Vuillard orchestrates a scene of extraordinary visual complexity and subtlety, surprising in its animated human drama and laced with wit and charm. The protagonists are the artist's mother, a dressmaker; his older sister Marie; and a fellow Nabi artist and close friend, Ker-Xavier Roussel—the suitor of the title—who would marry Marie in the same year. The setting is Madame Vuillard's workroom in the rue St. Honoré. The scene develops from the mundane—Marie, with her back to us, is arranging a blue cloth on a table, while her mother leans out the window holding fabric in her hand as if to air it out. In the center the bearded Roussel appears, partly hidden, from behind a partition and exchanges glances with Marie, an intimate moment enhanced by the mother's obliviousness. It is a spring day, an apt metaphor for the young couple; the open window is dappled with sunshine, nearly obscuring the outline of a flowering tree.

The pictorial drama enhances the human one. The work is divided horizontally just below the middle, producing two distinct yet complementary areas. The bottom is a dazzling array of angled shapes of the floor, shafts of light, stools, table legs, and multicolored cloth, establishing a lively, vibrant pulse for the love dance of the young couple. The upper part physically and metaphorically adds texture to the scene, transforming it into an evocative, magical moment. The decorative floral wallpaper pattern is rendered in patches of paint that animate the surface and, along with the tightly mottled pattern of Marie's dress, become so many pulsating particles, creating a weightless environment of floating forms. At the epicenter the curving black silhouette of Roussel seems to emerge as from a genie's bottle. He not only surprises Marie, he startles the viewer and challenges the viewer's acuity. The charming scene gives up its secrets grudgingly as we only slowly identify a differently patterned rectangle, from behind which Roussel is emerging. Usually termed a screen, it may be a door. Its upper edge is angled as would be an open door, and the square shape to the right of Marie's sleeve corresponds to the position of a plaque for a doorknob and keyhole. The subtle insinuation of the door alerts us to a sequence of other vertical shapes: the open window, the window frame, and the orange armoire at the left, which establish a cadence of shifting forms. Vuillard arranges and orchestrates all these elements to delight the viewer with a moment of joy in the life of those closest to him and in the creative act.

Further Reading

Easton, Elizabeth Wynne. The Intimate Interiors of Edouard Vuillard. Houston: The Museum of Fine Arts; Washington, D.C.: Smithsonian Institution Press, 1989.

Thomson, Belinda. Vuillard. New York: Abbeville Press, 1988.

Warnod, Jeanine. E. Vuillard. New York: Crown Publishers, 1989.

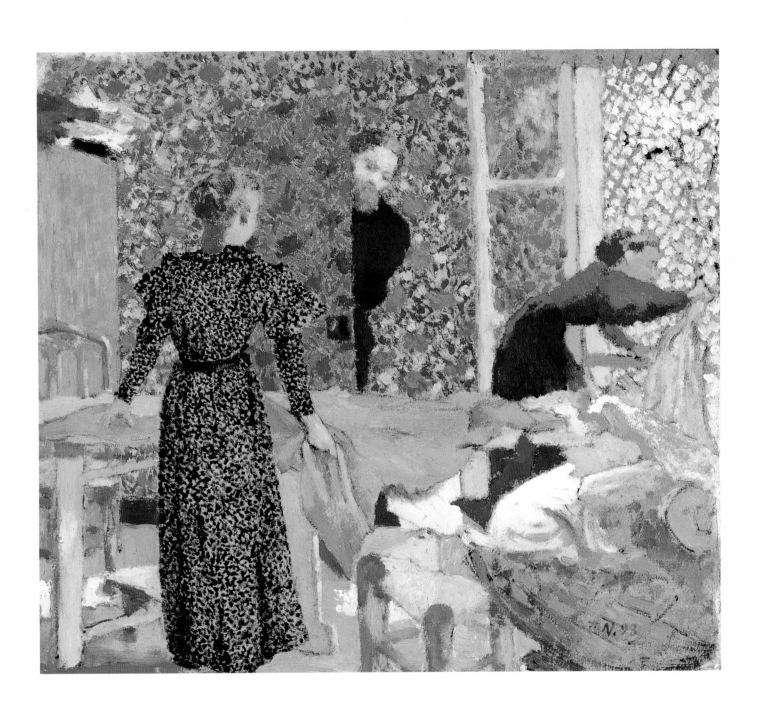

Joseph Wright of Derby

Derby, England 1734–1797 Derby, England

A Cavern, Evening, 1774

Oil on canvas

40 × 50 in. (101.6 × 127 cm)

Signed and dated, lower right: J. Wright/1774

Purchased

1950:16

Joseph Wright of Derby remained little known outside England until recent decades. In 1950 the Smith College Museum of Art acquired *A Cavern, Evening,* of 1774, and in 1955 it held the first exhibition in America devoted to the artist, thus contributing to the early interest in his art in this country.

Wright lived contentedly for most of his life in Derby, where he made his livelihood as an established portrait painter. Derby was a vital community, and, while not London, it provided him much intellectual and cultural stimulus. He belonged to the Lunar Society, which met on Mondays closest to the full moon to discuss scientific issues. Among its members were such prominent figures as Josiah Wedgwood and Dr. Erasmus Darwin. The discovery of laws that govern the physical world, the planets, and the stars was a source of great fascination for Wright, a child of the Enlightenment. His two greatest paintings were devoted to scientific experiments. In 1766 he painted *A Philosopher Lecturing on the Orrery* (Derby Museum and Art Gallery)—a model showing the movement of the solar system—and in 1768, *An Experiment on a Bird in the Air Pump* (National Gallery, London). These two works affirm Wright's deep interest in the use of light to affect both the pictorial drama and the meaning of his paintings. Among the artists whose use of light he admired are Caravaggio, Gerrit van Honthorst, and Rembrandt.

Wright's only trip to the Continent was a two-year sojourn in Italy. On a visit to the Kingdom of Naples, he witnessed the erupting Vesuvius in October 1774; it would become his most frequently painted motif. He also visited coastal caverns near Naples, overlooking the Gulf of Salerno on the Mediterranean Sea. He recorded the view from the grottoes in two highly finished drawings and, on returning to Rome, used them as the basis for a pair of large paintings, *A Cavern, Morning* (private collection) and this work, *A Cavern, Evening.* As pendants depicting different times of day, they are important precursors to romantic interpretations of such themes, as in the work of Caspar David Friedrich and J. M. W. Turner.

Rarely has Wright aligned the poetry of art so perfectly with scientific observation as in *A Cavern, Evening.* His geologist friend John Whitehurst from the Lunar Society must have been pleased with the artist's scrupulous recording of the rock's formations.

Wright's brilliant conceit of positioning the viewer on the right ledge inside the cavern and his glorious use of light instill poetry in the scene. The limpid light of an early Mediterranean evening, the sky still vividly blue, insinuates itself into the cavern through the irregular opening and gives form to the surrounding rocks, whose gray-brown surface is interspersed with lively sparkles of white and passages of pinks and ochers. The still water, delineated with thin wavy lines, flows deep into the cavern, and as light reflects on it the whole interior is filled with awesome calm. Outside the cavern, three small sailboats on the horizon catch our eye, yet we remain, transfixed, within, as if held there by an elemental force. It would be over one hundred years before there would be as dramatic a juxtaposition of sky, sea, and rock—in Claude Monet's depictions of La Manneporte in the cliffs at Etretat.

Further Reading

Egerton, Judy, et al. *Wright of Derby.* London: Tate Gallery, 1990.

Nicolson, Benedict. *Joseph Wright of Derby, Painter of Light.* 2 vols. London: Paul Mellon Foundation for British Art, and Routledge and K. Paul; New York: Pantheon Books, 1968.

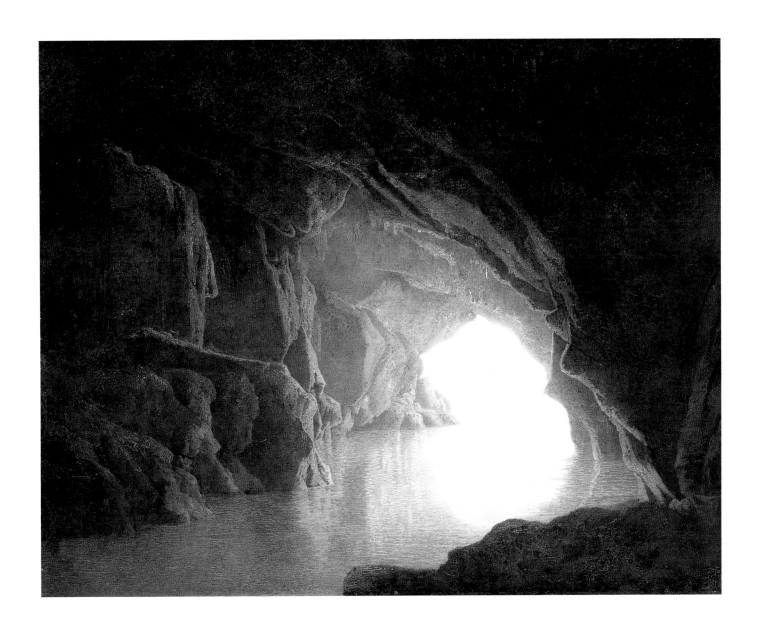

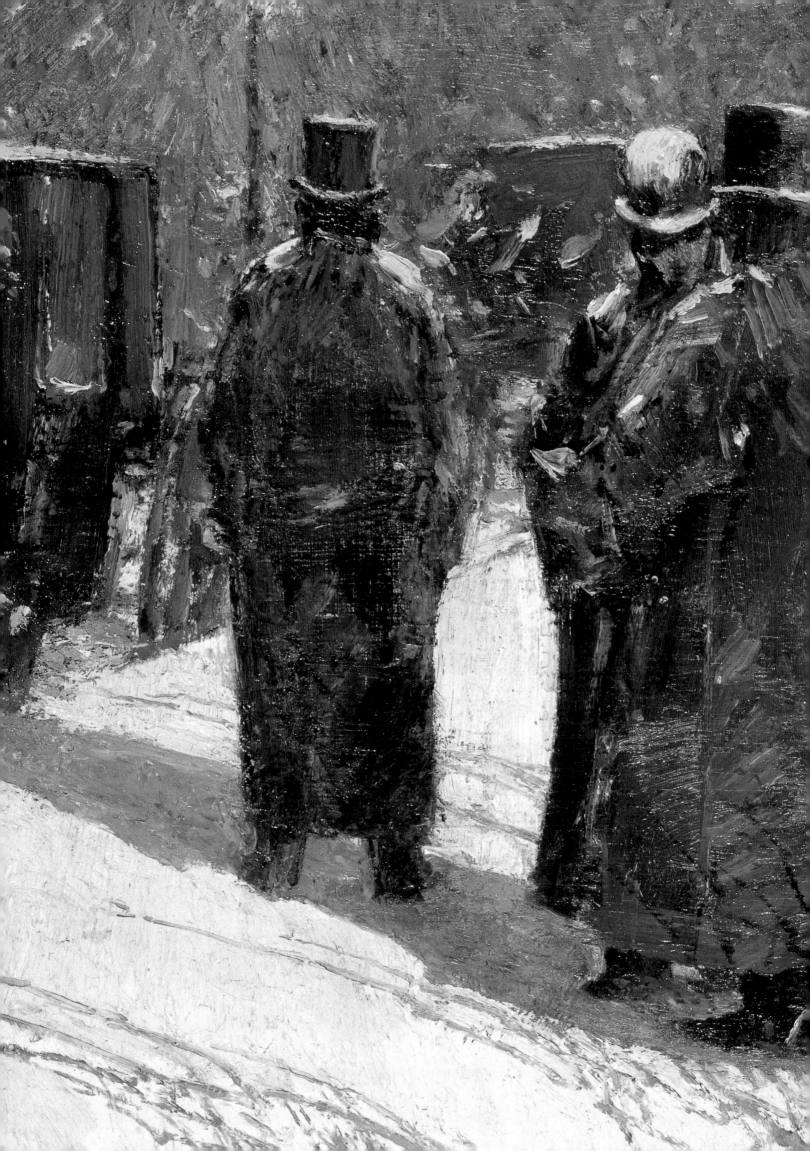

American Painting
and Sculpture

Milton Avery

Sand Bank (now Altmar), New York 1885–1965 New York, New York

Surf Fisherman, 1950

Oil on canvas
30 × 42 in. (76.2 × 106.7 cm)
Signed and dated, lower left: Milton Avery 1950
Gift of Roy R. Neuberger
1953:51
© 2000 Milton Avery Trust/Artists Rights Society (ARS), New York

In the decades before his critical "discovery" in the mid-1940s, Milton Avery was known as a painter's painter—appreciated, even revered, by his peers but largely ignored by most writers on art. In particular, several of the group who would later be known as the abstract expressionists—Mark Rothko, Adolph Gottlieb, and Hans Hofmann—found inspiration in his flat, simplified paintings and, even more, in his expressive use of broad areas of color as the principal building blocks of his compositions. *Surf Fisherman* is a classic example of Avery's mature work, not only in its strong, interlocking design, which so appealed to his colleagues, but also in its seaside theme, a perennial subject the artist pursued during many summers spent in Gloucester and Provincetown, Massachusetts, among other northeastern locations.

Against his typical three-banded background (shore, water, sky), Avery has arranged his limited repertoire of forms: three gulls, two fish, and the gravitational center of the image, the heavy-limbed fisherman. That several of the gulls, as well as the fisherman, cross the borders between the horizontal registers only serves to weave together figure and ground, heightening the sense of two-dimensional design. The fuzzy-edged forms appear almost as crudely torn collage elements arranged on a page, awaiting their final placement by the artist. Avery's composition, however, is far from improvisatory. He almost always worked up his oil paintings from preliminary drawings and watercolors, carefully laying in the forms on his canvas with charcoal. Here, he has made use of underpainting and compositional reserve areas, with the several layers of dry color overlapping and meeting along the contours of his forms, a tonal calibration that concerned him greatly and that accounts for the resonant, vaguely vibrational quality of his pure chromatic shapes.

The magic of Avery's painting is his ability, in a severely reduced format, to convey a remarkable range of expressive nuances, without recourse to narrative detail or linear description. Instead, the energetic interaction of color, shape, and space is responsible for communicating the "content" of his work. The close-toned avocado and olive hues, for example, forge a link between man and sea, and the fish on either side of him form a complementary pair of simplified lavender and blue forms (their scaly surfaces indicated by Avery's characteristic scratching into the paint, often using a fork as his tool). Most remarkable is the way that the figure of the man, though greatly pared down and lacking any trace of modeling, nevertheless leaves us with a visceral sense of posture, weight, heft, and balance. In a surprising move, the artist has painted out the taut rod and line initially held in the meaty hands of the sportsman, perhaps concluding that it rendered his work too explicit and illustrative. The result is an even better sense of the tensions and relationships—the abstract balance—between the man and forms that seemingly rotate around him. As usual with Avery, it is the overall unity of the pictorial field, rather than the emphasized part, that leaves a lasting impact.

Further Reading

Haskell, Barbara. *Milton Avery.* New York: Whitney Museum of American Art, 1982.

Hobbs, Robert. *Milton Avery.* New York: Hudson Hills Press, 1990.

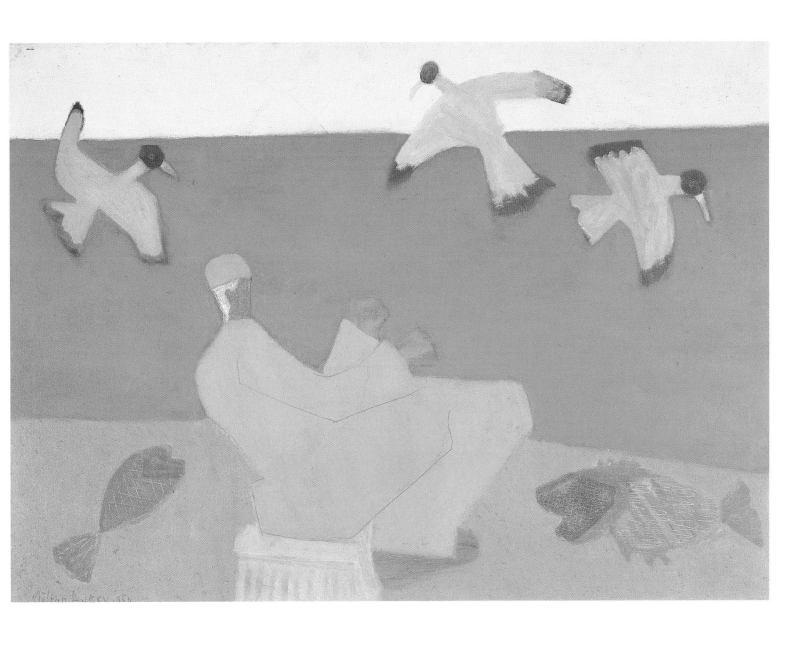

Albert Bierstadt

Solingen, Germany 1830–1902 New York, New York

Echo Lake, Franconia Mountains, New Hampshire, 1861

Oil on canvas

25¼ × 39⅛ in. (64.1 × 99.3 cm)

Signed and dated in red paint, lower left, initials conjoined:
ABierstadt. /1861.

Purchased with the assistance of funds given by Mrs. John Stewart
Dalrymple (Bernice Barber, class of 1910)

1960:37

Although the highly successful landscape painter
Albert Bierstadt tends to be associated either with the
European subjects that inaugurated his career or the
oversized views of the Rocky Mountains that sustained
it, he actually had close ties to New England, as his
impressive *Echo Lake, Franconia Mountains, New
Hampshire* attests. Born in Germany, Bierstadt was
brought at age two to New Bedford, Massachusetts,
where his father established a barrel-making business.
There the young artist began offering instruction in
painting as early as 1850; his earliest canvases were exhib-
ited in New Bedford and in Boston. By 1853, however,
he had left for Düsseldorf, joining a loosely federated
group of international artists and immersing himself
in the countryside of Germany and Italy. On his
return to the United States, the training of his lengthy
European sketching treks prepared him well for the
most important trip of his life: his journey westward
with the explorer Frederick Lander in 1859. From this
and subsequent visits came a steady stream of panoramic
"machines" of enormous dimensions—all celebrating
the open wilderness as an almost holy field for United
States expansion.

During this early period in his career, Bierstadt was
nevertheless making regular trips to the highest and most
rugged region of New England, the White Mountains of
New Hampshire. Often traveling with family members,
he is known to have spent several summers sketching
among these peaks in the 1850s and early 1860s. By this
time, the White Mountains had become a popular
tourist destination, and painters by the dozens flocked
to their lakes and "notches," where grand hotels offered
comfortable lodgings undreamed of by earlier artist-
travelers such as Thomas Cole. Although Bierstadt
included evidence of human civilization in other
New Hampshire landscapes, *Echo Lake, Franconia
Mountains* bears no trace of the touristic enterprise
that surrounded such pristine sites at the time. Indeed,
Cannon Mountain, one of the dark, pine-clad slopes
that seem to form a protective wall around this serene
and quiet scene, was actually named for the periodic
summer practice of firing a cannon over the lake, to
induce a thunderous echo and delight hotel guests.

Critics complained of a certain sameness in
Bierstadt's works, and this painting was once assumed
to depict generic western scenery, a not uncommon
element of confusion in his oeuvre. Yet the distinctive
profile of Eagle Cliff in the center of the canvas clearly
identifies the New Hampshire location, and the paint-
ing is now known to have been the sole New England
subject sent by the artist to the important National
Academy of Design annual exhibition in 1861. Bierstadt
has worked with the local topographic features and has
skillfully managed his light to avoid another frequently
mentioned defect in his compositions: a jarring, abrupt
jump from middle ground to distant mountain peaks.
In this instance, the double scallop of the shore at left
leads the eye gradually and rhythmically to the further
reaches of the lake. Periodic bursts of sun manage to
pierce the cloud cover and create an incremental pro-
gression of highlighted areas, which, following the beau-
tiful column of rising mist, moves into the cradle of blue
hills beyond. Bierstadt's celebrated attention to detail
(which is often simply the *impression* of detail, applied
selectively with a small brush over a loosely painted
background) animates the foreground. Thick dollops
of green impasto become floating lily pads, and quick
hatch marks dance along the surface to form coarse
shoots of grass. Perhaps his most affecting touch, how-
ever, is the pair of diminutive turtles, one sunning itself
on a prominent, lichen-coated rock, the other floating
half-submerged in the cool, dark shallows of the undis-
turbed water.

Further Reading

Campbell, Catherine. "Albert Bierstadt and the White
Mountains." *Archives of American Art Journal* 21, no. 3 (1981):
14–23.

Ferber, Linda S., and Nancy K. Anderson. *Albert Bierstadt:
Art and Enterprise.* New York: Hudson Hills Press, 1990.

Hendricks, Gordon. *Albert Bierstadt: Painter of the American
West.* New York: Harry N. Abrams, 1974.

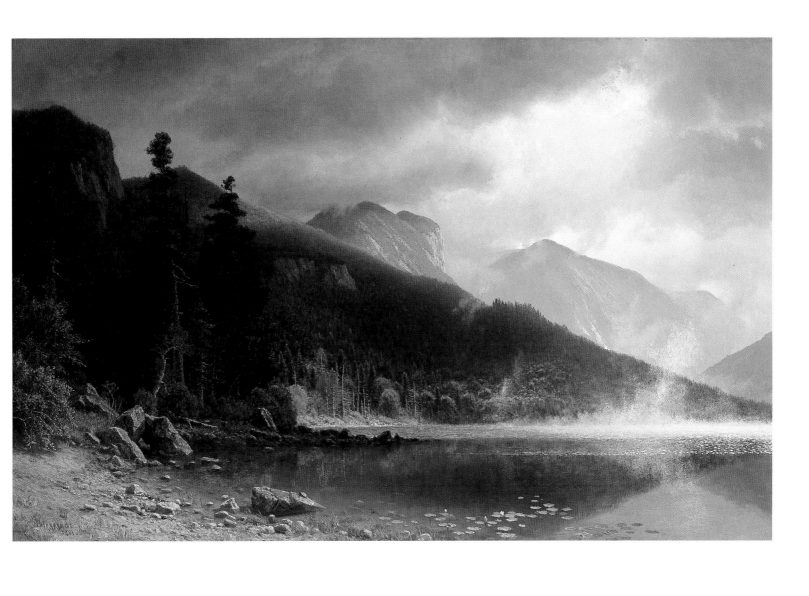

Joseph Blackburn

Born London, England; active in North America 1754–63

Andrew Faneuil Phillips, 1755

Oil on canvas
50⅜ × 40⅜ in. (128 × 102.5 cm)
Signed and dated in black paint, left, below midline: Jos. Blackburn Pinxit 1755
Gift of Mrs. Winthrop Merton Rice (Helen Swift Jones, class of 1910)
1973:25

Ann Phillips, 1755

Oil on canvas
50⁷⁄₁₆ × 40⁵⁄₁₆ in. (128.1 × 102.3 cm)
Signed and dated in black paint, left, below midline: I. Blackburn Pinxit 1755
Gift of Mrs. Winthrop Merton Rice (Helen Swift Jones, class of 1910)
1982:27

Few artists of his era have left less of a paper trail than Joseph Blackburn, whose first name was not even known to modern scholarship until experts in the early twentieth century discovered the faint, wispy signature (unique in his oeuvre) on Smith's portrait of Andrew Phillips. And yet few eighteenth-century Anglo-American artists have left such a clearly marked body of work (some one hundred American portraits), a corpus of images bearing the distinct personality imprint of a gracious painter steeped in the rococo vocabulary of Georgian London. It was this repertoire of refined stylistic effects that made his brief fame in New England, and for about a decade in the late 1750s and early 1760s he reigned supreme as the preeminent portraitist in the region. His influence was felt most notably by the young John Singleton Copley, whose work underwent a sudden shift toward lighter pastel colors, elaborate costumes, and contrived poses in the wake of the older man's arrival in Boston.

Smith College possesses a suite of four Blackburn portraits, still in their original frames, of members of the well-to-do Phillips family: father Gillam, mother Mary Faneuil (sister of the noted merchant Peter Faneuil), and their two children, pictured here, Andrew (1729–1775) and Ann (1736–before 1770), neither of whom lived into old age or appears to have married. The small family was the recipient of substantial inheritances from both the husband's and the wife's lines, and their mercantile standing, along with their loyalist sympathies, made them perfect customers for Blackburn's modish London likenesses. In the son's and the daughter's portraits, we see the standard stylistic "tics" of the artist: high foreheads, flattened facial planes, elongated fingers, lateral glances, and a pursed expression to the lips — what one scholar has dubbed "the Blackburn smirk."

Andrew Phillips appears in a lilac or dove-colored outer coat and breeches, his icy blue waistcoat — fashionably flared, most likely, with the aid of inserted wires at the bottom edges — encrusted with silver gilt. The fingers of his right hand fan out impossibly, their slightly queasy curves serving as a prominent marker of the sitter's exaggerated elegance. Above, all is prim and composed: a tightly knotted neckcloth, a powdered wig with carefully curled side rolls, and the dark bow of his queue falling lightly down his back. His cool, even delicate, composure provides a dramatic contrast to the darkly mysterious landscape setting, with skeletal branches reaching in from the left and a shaggy, beetling cliff forming a more unrestrained backdrop for his head.

Andrew's sister Ann finds herself in a more protected interior space, complete with a marble-topped table and paired swags enframing her upper body. The paint on her sack-type dress is applied thickly, with a roseate hue worked over an underlayer of white to approximate the ever-changing reflective qualities of silk. A much finer brush was employed for the sumptuous lace collar and sleeve attachments (or *engageants*). Here, Blackburn has attended with great care to the complex pattern of different-sized flowers, leaves, and geometric borders of the lace; he was especially known for his ability to render this important sign of economic status. Elsewhere, his invented accessories appear more fantastic, particularly the glassy roped pearls and pendant festooned across the bodice, the multiple hair ornaments, and the flyaway shawl. Most striking of all, however, is the Chinese vase with its costly tulips, which Ann holds protectively. These objects of the transatlantic luxury trade would have served as a reminder of the source of her family's unusual wealth.

Further Reading

Bolton, Theodore, and Harry Lorin Binsse. "An American Artist of Formula: Joseph Blackburn." *Antiquarian* 15 (November 1930): 50–53, 88, 90, 92.

Morgan, John Hill. "Further Notes on Blackburn." *Brooklyn Museum Quarterly* 7 (July 1919): 147–55.

Park, Lawrence. "Joseph Blackburn: Portrait Painter." *Proceedings of the American Antiquarian Society* n.s. 32 (1923): 271–79, 308–10.

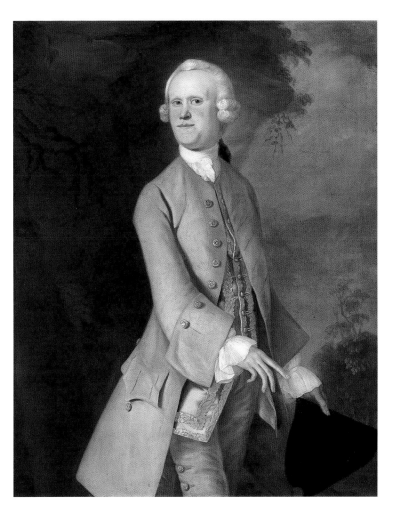 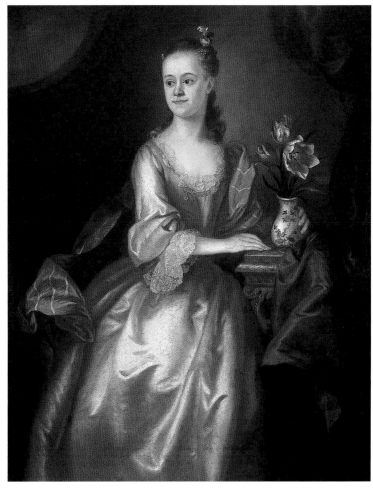

Lee Bontecou

Providence, Rhode Island 1931

Untitled, 1959

Canvas and metal
20½ × 20¹³⁄₁₆ × 7¼ in. (52.1 × 52.8 × 18.4 cm)
Signed and dated, lower right: BONTECOU 59
Purchased with a gift from the Chace Foundation, Inc.
1960:14

When Lee Bontecou had her first one-person show in 1959 at the age of twenty-eight, her canvas wall constructions—linear welded metal armatures with planes of salvaged canvas stretched between the ribs and secured with tiny twisted wires—caused something of a sensation in the New York art world, even if subsequent critical opinion has often failed to understand her achievement as anything but a brief, isolated event. Difficult to classify (are they paintings or sculptures? abstract expressionist or neo-surrealist?), Bontecou's reliefs were hailed on the one hand as an important feminist statement in their evocation of traditional patchwork fabric assemblage, and on the other as a groundbreaking development in a new sculptural vocabulary.

Smith's wall relief is an early example of the type, rather pure in its exclusive use of found canvas, unlike her later, larger works which came to include saw blades, zippers, or other metal objects. These reliefs from the 1960s are often characterized as menacing, aggressive, and sinister, but in Bontecou's early sculptures, such as this one, the mysterious plastic effects are somewhat less

heightened, more subtle and evocative. The imagery is at once topographic and biomorphic, with the forms—sometimes sharply faceted and angled, sometimes nestled in telescoping, concentric arcs—pushing forward as if subject to pressure from within.

Evocative of both a vast terraced landscape and a small barnacle or crustacean, the tentlike shapes appear to mutate and develop asymmetrically as we watch. The surface cells vary considerably. Some swatches of canvas are bleached white, others bear random smudge marks; some are finely woven, others have the alligatored texture of fire hoses. The puckering, fraying, and wrinkling of the cloth further differentiates these random patches of "skin." Though segmented, the relief is a single, unified form, with a seemingly organic visual momentum building up to the central crater. Thus, the ribs approaching the hole are set closer and closer together, and the antlike wire "sutures" increase in number. This busyness of line results in a bristling, intensified texture toward the center, a charged spikiness that ultimately gives way to the embrace of the velvet-lined, angled cavity, the focal point of almost every Bontecou relief.

Further Reading

Field, Richard S. *Prints and Drawings by Lee Bontecou.* Middletown, Conn.: Wesleyan University, 1975.

Smith, Elizabeth A. T. *Lee Bontecou: Sculpture and Drawings of the 1960s.* Los Angeles: Museum of Contemporary Art, 1993.

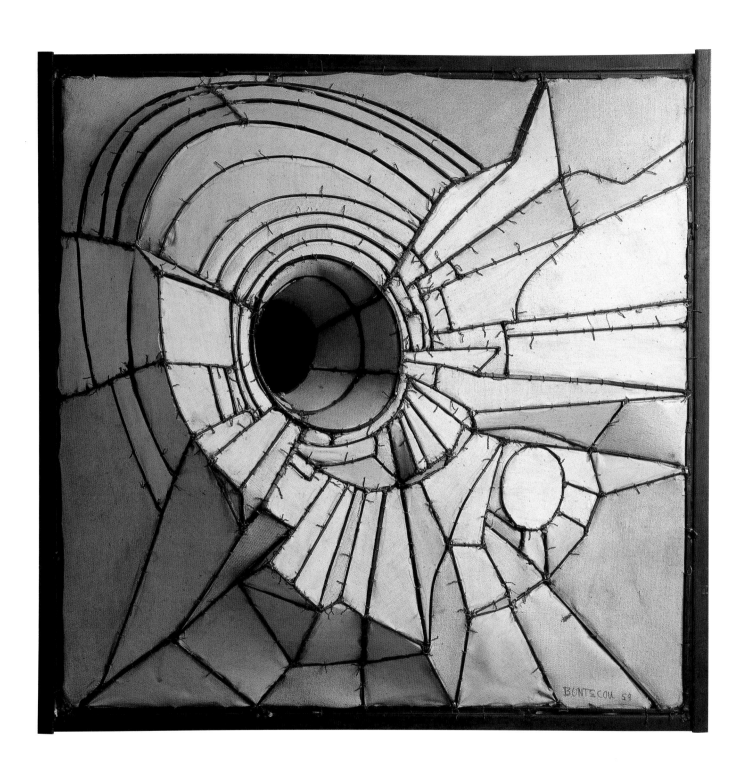

Alexander Calder

Philadelphia, Pennsylvania 1898–1976 New York, New York

Mobile, 1934

Nickel-plated wood, wire, and steel

42½ × 11⅞ in. (107.9 × 30.2 cm); base diameter 11⅞ in. (30.2 cm)

Not signed or dated

Purchased, Director's Purchase Fund

1935:11

© 2000 Estate of Alexander Calder/Artists Rights Society (ARS), New York

It is a rare distinction to have invented an art form as ubiquitous as the mobile is in contemporary culture, but until Alexander Calder began his exploration of gravity-defying objects hanging from nested, cantilevered arms, there was simply nothing like these delicate compositions of shape, color, motion, balance, and counterbalance. With a degree in engineering, Calder was perhaps predisposed toward an interest in mechanics and kinetics. Still, the fertile artistic environment of Paris in the late 1920s and early 1930s — in which he was immersed to an extent unusual for an American — also had a telling impact on the sculptor's researches. It was one of his French colleagues, Marcel Duchamp, in fact, who is credited with coining the term *mobile*.

His earliest such creations, of which this is an important example, seem related to the floating, biomorphic forms of the surrealist paintings of Joan Miró, or the sculptures of Jean Arp. The latter connection is particularly apt here, for unlike the thin, flattened, sail-like shapes of the later mobiles, the hanging objects in Calder's first kinetic compositions were usually more substantial, solid forms of carved wood, as is the case with the Smith work. The artist was also greatly interested in modern astronomical knowledge (Pluto had been recently discovered in 1930), and planetary metaphors pervade his art during this era. Here, the five distinctive shapes (some, such as the flattened double cone, appearing regularly in his work) approximate stars, asteroids, and other galaxial matter: each one spinning slowly on its own, yet also bound to a common network of larger orbits, much like the constituent elements of a discrete solar system.

More than most Calder works, this mobile almost playfully invokes the sometimes naïve, early imagery of science fiction — an association stemming largely from the sleek, machinelike simplicity of the steel ring and rod and the metallic polished surfaces of the dangling objects, so different from the primary colors often favored by the artist. This treatment is unique to the Smith College mobile, and it results from an interesting New York episode shortly after Calder created the work. Asked by the Art Deco artist Donald Deskey to borrow a sculpture for a design exhibition, Calder lent this mobile. Deskey, however, proceeded to nickel-plate the work without the sculptor's collaboration (and ironically, he ultimately chose not to use it in his show). The plating certainly changed the character of the mobile's parts, yet it does not completely obscure the pock marks, scratches, and dents that betray the hand of the carver. Moreover, the reflective surfaces of the abstract objects, sparkling brightly as they twirl, nicely accentuate the effects of randomness that concerned the artist throughout his career. Calder's knowledge of and reaction to this alteration of his work are unknown, but we can assume that he accepted it artistically, for he allowed the mobile to be shown a year later at the Pierre Matisse Gallery, where it was purchased by Smith College in 1935.

Further Reading

Marter, Joan M. *Alexander Calder.* New York: Cambridge University Press, 1991.

Prather, Marla, Alexander S. C. Rower, and Arnauld Pierre. *Alexander Calder: 1898–1976.* Washington, D.C.: National Gallery of Art, 1998.

William Merritt Chase

Franklin, Indiana 1849–1916 New York, New York

Woman in Black, c. 1890

Oil on wood panel

15⁵⁄₁₆ × 10 in. (38.9 × 25.4 cm)

Signed in brown paint, lower left: Wm. M. Chase

Purchased

1900:16

Woman in Black, a relatively small, unassuming panel painting by William Merritt Chase, nevertheless exhibits many of the pictorial features that marked his more ambitious compositions and led to his reputation as a skilled technician, powerful designer, and judicious assimilator of a range of stylistic influences. From his earliest days as a student in the Munich Royal Academy, he was drawn to the dark tonalities and virtuosic brushwork of the seventeenth-century Dutch old masters. His subsequent meeting with the by-then famous James McNeill Whistler in 1885 introduced him to the flattened spaces and reductive compositions of that artist. *Woman in Black* demonstrates the best of this mix, with its sure paint application, avoidance of overly detailed preliminary drawing, constant attention to values, and simplified, abstractive composition.

Chase's picture is a marvel of restraint, minimally composed of three interlocking shapes: the textured backdrop of drapery flecked with touches of red and green; the flat, unmodulated ground plane seemingly tipped down to further reduce the spatial depth; and the quiet, contained form of the young woman, set slightly to one side but balanced by her lateral gaze in the opposite direction. She is a thoughtful, stable figure, her clasped hands emerging from her three-quarter sleeves to reinforce the lines of her bodice and provide a visual foundation for the only other high-value note, her graceful neck and head. Here as well, the form is accented and warmed by judicious strokes of red at the throat, ear, and mouth. The result is a highly aesthetic essay in browns and blacks shot through with a subtle coloristic surface animation.

The pert, finely drawn profile of the model also serves to enliven the painting, and her distinctive features have allowed her to be identified as Marietta Benedict Cotton (1868–1947), one of Chase's many female students who would later follow a career as a portraitist. When the nineteen-year-old pupil first entered his studio, Chase immediately felt a desire to paint her. "Such a model," he later wrote about her, "is a treasure-find. It is the personality that inspires, and which you depict on canvas." *Woman in Black* was probably purchased directly from Chase by Smith President L. Clark Seelye, and though her identity likely remained unknown to the early generations of Smith students who studied this work, Cotton would have been an appropriate role model for the independent and successful graduates the college was just then sending out into the budding twentieth century.

Further Reading

Gallati, Barbara Dayer. *William Merritt Chase.* New York: Harry N. Abrams, 1995.

Pisano, Ronald G. *A Leading Spirit in American Art: William Merritt Chase, 1849–1916.* Seattle: Henry Art Gallery, 1983.

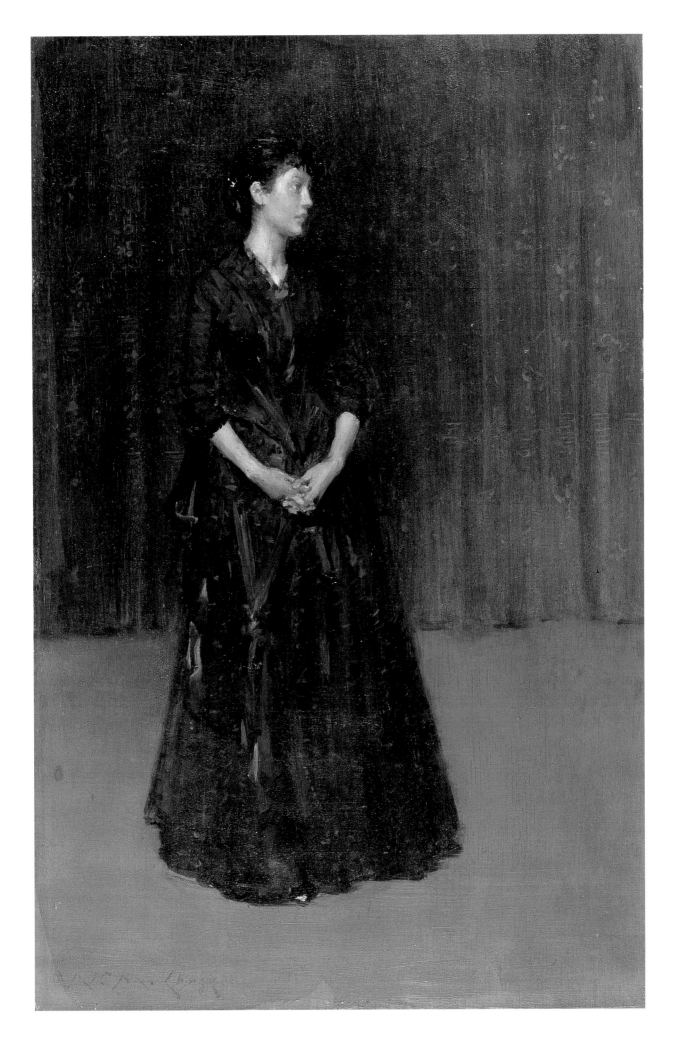

Thomas Cole

Bolton-le-Moor, Lancashire, England 1801–1848 Catskill, New York

Compositional study for *The Voyage of Life: Manhood,* c. 1840

Oil on academy board
12¼ × 17³⁄₁₆ in. (31.1 × 43.7 cm)
Not signed or dated
Purchased
1950:13

More than most artists of his generation, Thomas Cole believed devoutly in the moral mission of landscape painting. Though he painted a good many transcriptive "views" of recognizable passages of American scenery, he reserved his greatest efforts for several ambitious multicanvas series: ideal, allegorical works—a "higher style of landscape" in his own words—that would elevate and instruct the large crowds that flocked to see them. The most popular of these narrative groups was his four-part *Voyage of Life,* an easily understood metaphor of the course of human life played out by a lone male protagonist navigating a sometimes dangerous river in a small boat. Along the way, Cole's Everyman encounters a guardian angel, demonic spirits, and a variety of emblematic landscape features that give shape to the aspirations and challenges that mark the stages of his earthly pilgrimage. In the end, as an old man, the voyager in his battered boat finally reaches the open ocean, where beams of radiant light welcome him to his final, heavenly rest.

The path to this deliverance from worldly cares is not an easy one, and in the third canvas, *Manhood,* for which the museum's menacing sketch is a preparatory study, Cole depicts the darkest, most precarious moment of the cycle. At the time that he was working out the iconography and composition of this scene, the middle-aged artist was wracked with his own doubts and worries: He was struggling financially, the generous patron who had commissioned *The Voyage of Life* had died unex-

pectedly, and the future of the series, not to mention his career, seemed shrouded in uncertainty. "Trouble is characteristic of the period of Manhood," wrote Cole in his descriptive key to the paintings, and his own despair and pessimism appear to have marked this image to a degree that is unusual, even in his highly personalized oeuvre.

While the voyager and his boat (as well as the benevolent and evil spirits who will watch him from above in the final version) do not appear in this study, the terrifying forms of the landscape are more than enough to convey the dangers of his watery path. Moving in from the left, the river suddenly plunges into a narrow cleft in the fantastic rocks; furious rapids and half-submerged boulders are glimpsed throughout the serpentine descent of the stream. The arch of dark cloud forms and the dramatic "keyhole" view to the distance create the impression of a swirling vortex of destructive energy, with only the yellow and pink glow of the faraway ocean sky offering a ray of hope. The *Manhood* composition gave Cole the greatest trouble of the four, and his artistic struggle is evident in the inchoate shapes of the jagged rocks and the single skeletal tree at right. It is as though the entire landscape has been spun out of some kind of organic primal matter, still in the process of formation. This fury of creation, vigorously conveyed by Cole's loaded brush and glistening, oil-rich paint, contributes to the surprising visual power of the small study.

Further Reading

Parry, Ellwood C., III. *The Art of Thomas Cole: Ambition and Imagination.* Newark: University of Delaware Press, 1988.

Schweizer, Paul D., Ellwood C. Parry III, and Dan A. Kushel. *The Voyage of Life by Thomas Cole: Paintings, Drawings, and Prints.* Utica, N.Y.: Munson-Williams-Proctor Institute, 1985.

Truettner, William H., and Alan Wallach, eds. *Thomas Cole: Landscape into History.* New Haven, Conn.: Yale University Press, 1994.

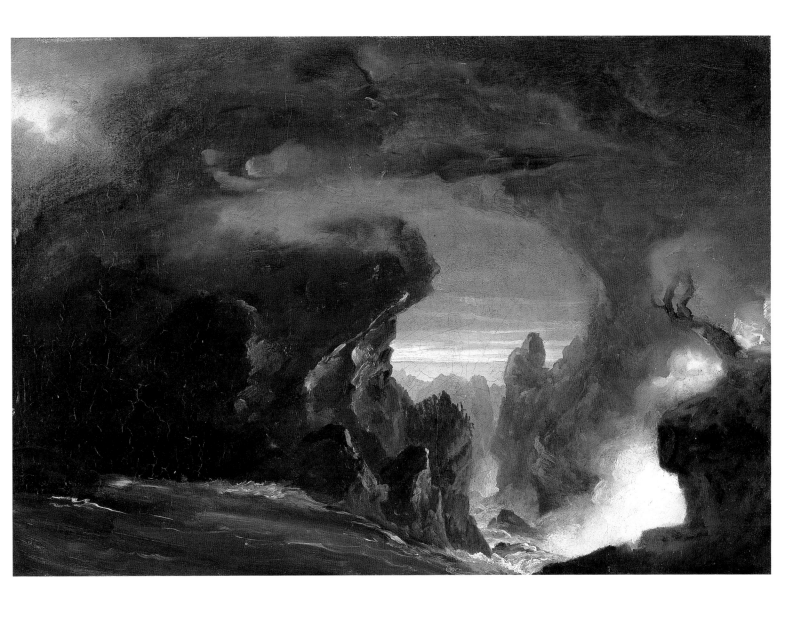

John Singleton Copley

Boston, Massachusetts 1737–1815 London, England

The Honorable John Erving, c. 1772

Oil on canvas

50½ × 40½ in. (128.3 × 102.9 cm)

Not signed or dated

Bequest of Alice Rutherford Erving, class of 1929

1975:52-1

One of the marvels of the career of John Singleton Copley is the astonishing speed with which he essentially taught himself to seize the likeness of his sitter, infuse it with a profound depth of character, and present it in a carefully calibrated environment of dress, posture, and attributes—a "portrait" that went beyond mere physiognomy to telegraph important clues of social and economic status to his audience. Copley had more or less mastered this subtle process by the end of his teenage years, but he continued to develop throughout his time in the colonies. In the several years prior to his departure for Europe in 1774, he painted a series of rich, sober portraits in which he pushed the effects of his normally deep chiaroscuro to a new level of psychological focus and intensity. His portrait of John Erving (1693–1786), a wealthy, Scottish-born merchant who had originally come to Boston as a common sailor, is a particularly successful example of the type.

Erving looms large in the picture's narrow slice of space; his piercing gaze—emanating from hard, glassy irises that all but subsume the whites of his eyes—creates a sense of almost overwhelming immediacy. Color is dense and highly saturated, particularly in the regal drapery swag and table covering at left. The depth of this hue nicely sets off the radiant still life, the silver inkwells sparkling with fluid touches of white and the bright letter—addressed to the sitter—floating in a sea of royal blue. The viewer's attention nevertheless focuses on Erving's face and hands, his bronzed skin warmed by contrast with the white neckcloth, wig, and sleeve ruffles. The merchant's seemingly resolute nature is conveyed by his tightly set mouth, although the high forehead rising above his bushy brows is surprisingly serene and uncreased. There is a liveliness to his visage, but signs of age appear in the loose skin under the chin and, more dramatically, on his left hand. This is a location of suppressed formal tension in the painting, for upon close observation, the powerful grip of the right hand appears to wring the left mercilessly. A link is formed that closes the circular sweep of Erving's arms, and here again, there is a kind of elastic force to the pose as he hooks his elbow over the ear of the Chippendale chair and leans his weight in the opposite direction.

The large head and firmly set hands convey the image of a man of thought and action, but it is in his costume that eighteenth-century viewers would have read further details of personality. The plum-colored suit is striking in color, but the material is of practical wool, the simple buttons are cloth-covered, and there is a complete absence of any gilt trim or fancy work. The unbuttoned opening in his vest and the dusting of wig powder on his right shoulder further inject a certain ease and informality that accord well with his casual pose. One is left with an impression of confidence, moderation, and even conservatism, for by the 1770s a suit with each of the components—coat, vest, and breeches—made of the same material was decidedly old-fashioned. Similarly, Erving's frizzed "physical" wig, as it was termed, was more voluminous and wider in silhouette than was currently the mode for younger men, many of whom had given up wigs altogether. In the end, Copley and Erving appear to have contrived a judicious image that underscores the sitter's acumen, probity, and traditional values—perfect attributes of the successful man of business.

Further Reading

Prown, Jules David. *John Singleton Copley.* 2 vols. Cambridge, Mass.: Harvard University Press, 1966.

Rebora, Carrie, et al. *John Singleton Copley in America.* New York: The Metropolitan Museum of Art, 1995.

Thomas Wilmer Dewing

Boston, Massachusetts 1851–1938 New York, New York

Lady with Cello, before 1920

Oil on canvas

20⅛ × 16¹⁄₁₆ in. (51.1 × 40.8 cm)

Signed in brown paint, lower right: T. W. Dewing

Bequest of Annie Swan Coburn (Mrs. Lewis Larned Coburn)

1934:3-4

Perhaps no American painter of the late nineteenth century so successfully created a distinctive body of work—utterly unlike that of his many professional peers—as Thomas Wilmer Dewing, who engaged in a lifelong exploration of elegant, enigmatic female figures in spare interiors and absorptive landscapes. In their technique, his paintings have little to do with the prevailing impressionist mode of his day, and though his women are usually constructed on the canvas with an underlying armature of immaculate academic draftsmanship (the fruit of his student years in Paris in the late 1870s), they have none of the hardened didacticism of standard atelier training. Instead, Dewing's work can most fittingly be associated with the small, rarefied strain of American painting known as Tonalism, a movement primarily concerned with landscape that boasted as one of its principal exponents longtime Smith College art professor Dwight Tryon. Like the work of his friend Tryon, Dewing's canvases are close-keyed, sometimes hazy explorations of mood and memory, often restricted to a single pastel hue that is nevertheless tremulous and unstable. Dewing, however, is unique in his pursuit of the tonalist idiom in the realm of figure painting rather than pure landscape.

His *Lady with Cello* is suffused in a burnished, green-gold tonality (with undercurrents of mauve and dun) that is evocative of gilded surfaces bearing the tarnished patina of age. It is a composition of distilled essences: a reduced interior, a single figure clad in a rich gown, the darkly iconic cello, the curiously undersized and spindly bench, and the flat, abstractive painting—a crucial self-referential pictorial element easily recognized as an example of Dewing's own treatment of the idealized landscapes inhabited by his women in reverie. Each element is tugged slightly askew—the frame to the right, the bench and its cushion away from the wall and to the left—provoking in the viewer a sense of spatial tension, a mildly charged feeling of unease experienced as a pregnant, suspended moment in time.

The binding element of the image seems to be the soothing retreat into the imaginative world of aesthetic contemplation suggested by both the solo melody of the cello and the diaphanous dreamscape of the framed work of art. Indeed, the tilt of the cello and the angle of the impossibly delicate bow accord with the sloping lines of the painting on the wall, rather than the chilly rectilinear space in which the woman sits. Dewing's love of music is well known, so it is not surprising to find this connection between his ethereal compositions and the insubstantial art of sound. His cellist, uncharacteristically modern with her bobbed haircut, seems visually defined by her music making. While the lower half of her body remains a wonderfully nebulous cascade of scumbled drapery, her figure immediately seizes into form above the bow, as though this focusing activity has willed her into consciousness. Still, she inhabits her own world, her eyes closed and her head delicately shrouded in a pointillist aura of moist pastel tones. It is as though the misty forms of the painting have gravitated toward the figure, enveloping and transporting her to what Dewing termed "the poetic and imaginative world where a few choice spirits live."

Further Reading

Hobbs, Susan A., and Barbara Dayer Gallati. *The Art of Thomas Wilmer Dewing: Beauty Reconfigured*. Washington, D.C.: Smithsonian Institution Press, 1996.

Pyne, Kathleen. "Evolutionary Typology and the American Woman in the Work of Thomas Dewing." *American Art* 7 (Fall 1993): 13–29.

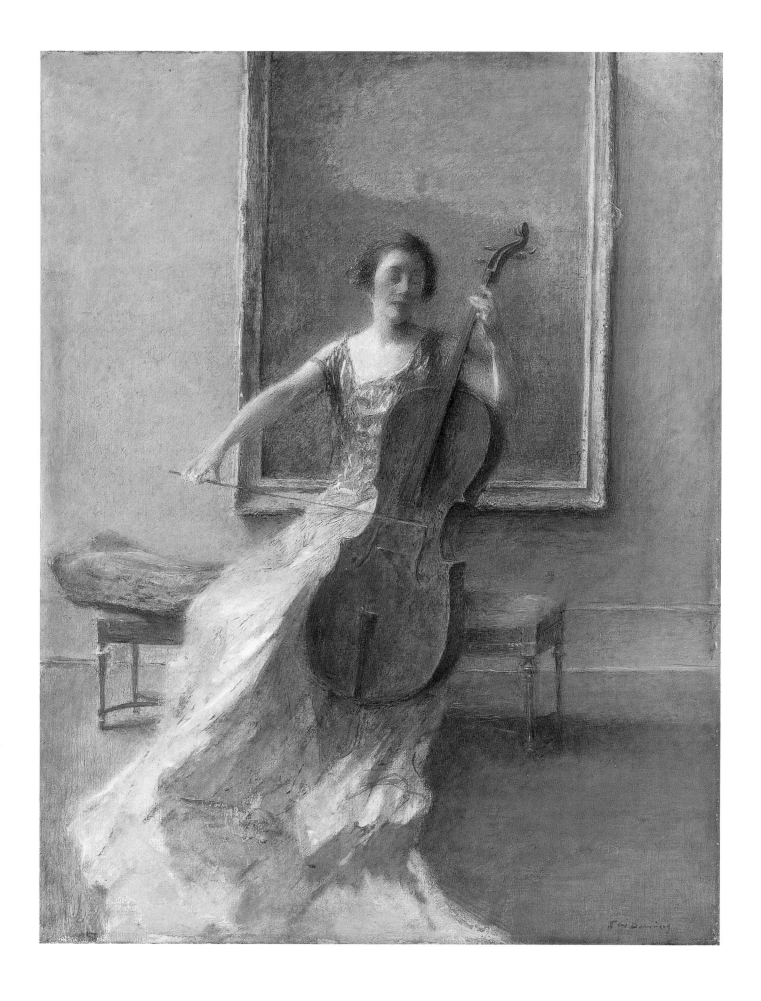

Asher Brown Durand

Jefferson Village (now Maplewood), New Jersey 1796–1886 New York, New York

Woodland Interior, c. 1854

Oil on canvas
23¹¹⁄₁₆ × 16¹³⁄₁₆ in. (60.2 × 42.7 cm)
Signed in black paint, lower right: A. B. Durand
Purchased
1952:107

Few American artists did more to establish and popularize the practice of painting out of doors—*en plein air*—than Asher B. Durand. His widely read "Letters on Landscape Painting," published just a year or so after he executed *Woodland Interior,* codified a kind of apprenticeship to nature to which the aspiring painter should willingly commit. There was, he felt, a degree of moral cultivation necessary for a proper appreciation of God's lessons in nature, but Durand placed even more stress on actually observing and copying raw botanical and geological minutiae. He believed, along with the influential English writer John Ruskin, that intimate familiarity with the basic components of a landscape composition could only come from prolonged exposure to the unedited complexity of the natural world. Each leaf or stone had a role to play in the painter's education, and Durand was firm in his conviction that painting in oil colors out of doors should not begin until these basic forms had been mastered with the pencil, no matter how long and no matter how many sketching trips it took.

Once an acceptable degree of proficiency had been reached, however, the student of nature was encouraged to sketch in oils out of doors, a practice made considerably easier by the invention of the collapsible tin paint tube in the early 1840s. In his approach to the oil sketch, Durand differed from many of his colleagues in his belief that broad, summary studies were of little use. If one was to go to the trouble of plein-air study, he maintained, the result should ideally be a fully realized paint-ing, even if its execution was rapid. Thus *Woodland Interior*—part, if not all of which was almost certainly painted out of doors—is nevertheless a highly finished composition, with particular attention paid to the mossy, mottled textures of the foreground trees and the effect of filtered light piercing the lacy screen of foliage. Durand often kept such studies as studio aide-mémoire, but unusually for his time, he also exhibited and sold them, just as he would his larger, final compositions.

In this case, the study, *Woodland Interior,* served as the preliminary version of Durand's grand watershed work, *In the Woods* (1855, The Metropolitan Museum of Art). When that painting was exhibited at the National Academy of Design, it was praised extensively by critics, who perceived it as inaugurating a new taste for highly naturalistic effects in landscape art, essentially bringing the era of Thomas Cole's allegorical narratives (exemplified by Smith's *Voyage of Life* study, pp. 140–41) to a close. Yet in both *Woodland Interior* and its nearly identical progeny, *In the Woods,* nineteenth-century viewers would have still found some measure of moral inspiration in its quiet forest clearing, for the arcing tree limbs and diffused effects of light of Durand's vertical compositions were often likened to the interior of a Gothic cathedral—an untouched, virginal setting appropriate for the nature worship so dear to mid-nineteenth-century painters and poets.

Further Reading

Harvey, Eleanor Jones. *The Painted Sketch: American Impressions from Nature, 1830–1880.* Dallas: Dallas Museum of Art, 1998.

Lawall, David. *A. B. Durand, 1796–1886.* Newark, N.J.: Montclair Art Museum, 1971.

Novak, Barbara. *American Painting of the Nineteenth Century: Realism, Idealism, and the American Experience.* New York: Praeger, 1969.

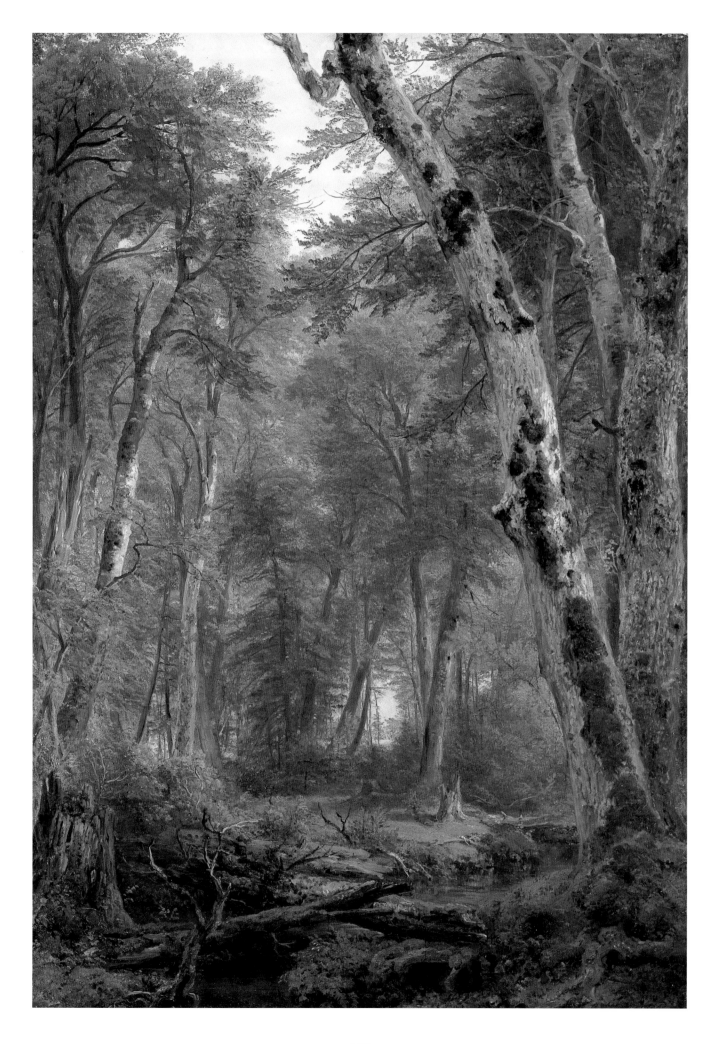

Thomas Eakins

Philadelphia, Pennsylvania 1844–1916 Philadelphia, Pennsylvania

In Grandmother's Time, 1876

Oil on canvas
16 × 12 in (40.6 × 30.5 cm)
Signed and dated on spinning wheel: Eakins 76
Purchased from the artist
1879:1

Traditionally regarded as the first work of art acquired by Smith President L. Clark Seelye, Thomas Eakins's *In Grandmother's Time* can rightly be considered the foundation of the Museum of Art's strong holdings in American art. Seelye apparently first saw the small canvas in the inaugural exhibition of the renegade Society of American Artists in New York, out of which he eventually purchased several paintings by various artists. At the time it bore the title *Spinning* and was advertised for sale at $200. Some months later, Eakins exhibited it, this time under its present title, at the Utica (New York) Art Association for the reduced price of $150. A canceled check in the Smith archives indicates that in the end Seelye paid Eakins only $100 for the work, which was nevertheless a good price for the artist at the time. The purchase by Smith of a work by this then "undiscovered" master was extraordinarily prescient; Eakins would see only one other painting bought by a public collection in his lifetime, and he would have to wait nearly two decades for that honor.

In Grandmother's Time is the first in an extensive series of over two dozen works by Eakins exploring historic American handicraft activities: spinning, sewing, and knitting. Beginning in 1876, when he likely witnessed a spinning-wheel display in the re-created "New England Log House" at the Centennial Exposition in Philadelphia, he devoted himself for some seven years to colonial revival themes in oils, watercolors, and sculpted reliefs. (Coincidentally, the recently opened Smith College was also a presence at the fair in 1876, displaying campus plans and photographs and distribut-

ing five hundred copies of a flyer explaining its new curriculum.) His elderly model, clothed in a nostalgic gown and mob cap, was a family relative known as "Aunt Sallie" King. She posed for the artist on several occasions during this period.

The painting exhibits several standard features of Eakins's early interior scenes. The warm rag carpet—its intense red hue a favorite of the artist at the time—establishes a forceful ground plane, with the figure and accessories rising with carefully plotted, geometric specificity from the floor. Color is otherwise restrained and sober, and the soupy background gives little indication of the exact nature of the room. The reduced illumination accents the downturned head (particularly the wonderful highlight on the satin ribbon) and the almost exaggerated hands—together hinting at the intellectual concentration and dexterous precision required by her task. The woman sits erect, making no use of the chair back to rest. Instead, she moves close to her machine, her foot working the pedal and her fingers twisting the fibers in a way that joins worker and tool in unified rhythm and action, as the busy whir of the wheel attests. Indeed, this animated, long-legged spinning wheel almost seems to lean into *her*, much like an affectionate pet eager to please. The overall tone of the work, however, is one of earnestness and calm. In fact, Eakins nicely underscores the peaceful, steadfast nature of this elderly person's work by contrasting her with the youthful, neglected toys in the shadows, somewhat innocently turned away from the central scene of labor.

Further Reading

Homer, William Innes. *Thomas Eakins: His Life and Art.* New York: Abbeville Press, 1992.

Sewell, Darrel. *Thomas Eakins: Artist of Philadelphia.* Philadelphia: Philadelphia Museum of Art, 1982.

Wilmerding, John, ed. *Thomas Eakins.* Washington, D.C.: Smithsonian Institution Press, 1993.

Thomas Eakins

Philadelphia, Pennsylvania 1844–1916 Philadelphia, Pennsylvania

Edith Mahon, 1904

Oil on canvas

20 × 16 in. (50.8 × 40.6 cm)

Inscribed on back of canvas: To My Friend Edith Mahon/
Thomas Eakins 1904

Purchased, Drayton Hillyer Fund

1931:2

Near the end of his life, the distinguished art historian
Meyer Schapiro observed that when portraits are classed
as that rarest of categories, the masterpiece, "they are
always based on empathy and sympathy, depicting—in
addition to a semblance—an interior life, a soul." This
is certainly true of Thomas Eakins's portrait of the pianist
Edith Mahon (1863–1923), long recognized as one of
the artist's most powerful efforts and, indeed, thought by
many to be among the greatest American portraits ever
painted. Mahon's almost palpable interior life, to say
nothing of her soul, has nevertheless seemed elusive to
generations of viewers. Eakins has managed to peel away
the protective Victorian veneer of detached composure
and emotional constraint to reveal in his sitter the often
hidden surfaces of deep psychological pain and weari-
ness. Yet the nature and source of her anguished reverie
seem to resist definition, even as it wells up so devastat-
ingly from within.

One of the most affecting paradoxes of the painting
lies in the fact that though Eakins's portrayal convinces
us that we know this woman so well that we share her
suffering (and that she forgets herself in our presence),
there are, in fact, few clues as to the events of her life
during the time that the painter knew her. Born in
London, she went to Philadelphia about 1897, where
she supported herself as a teacher and accompanist. She
played often in the Eakins household, and the artist
indicates a degree of familiarity in his inscription on the
back of the canvas, "To My Friend Edith Mahon." In
1931 Eakins's wife wrote cryptically that Mahon "had suf-
fered from great unkindness," and census records indi-
cate that she was divorced and that at least one of her
three children had predeceased her. Even the painterly
"facts" of this portrait, the most tangible remaining inci-
dent of her life, have been called into question. While
the closely cropped space and the immediacy of her
image leave an impression of a strong woman of signifi-
cant stature, a friend described her as "small and rather
frail looking." Mahon herself is reported to have disliked
the portrait, accepting it as a gift out of politeness. Six
years after Eakins's death, she sold it before returning to
England.

Eakins depicts his friend in a formal dress, seated
in a favorite studio chair, its baroque crest familiar from
other portraits. These loosely brushed elements, how-
ever, recede before the overwhelming presence of
Mahon's fatigued countenance. Her head, leaning back
somewhat resignedly against the chair back, seems
heavy, her shoulders burdened, and her features drawn.
The wisps of hair over her brow are dry and frayed, her
neck is creased, and her thin lips appear tightened and
resolute. Most telling are her eyes, which focus inward
rather than outward, effectively guarding her thoughts
from the viewer. The light of the portrait is somewhat
harsh—throwing her features into relief and accentuat-
ing the underlying skeletal mask. The touches of red at
her eyes, mouth, and nose do not so much warm the
image as leave an impression of a worn, haggard surface,
as though the visual penetration of her psyche has been
achieved with the use of a pumice stone. The effect pro-
duced by the image, no matter how many times it is
experienced, is profound and exhausting. In the particu-
lar features of his friend, Eakins has uncovered an emo-
tional touchstone that seems to resonate as powerfully in
the viewer as it does in the breast of Edith Mahon.

Further Reading

Wilmerding, John, ed. *Thomas Eakins.* Washington, D.C.:
Smithsonian Institution Press, 1993.

Edwin Romanzo Elmer

Ashfield, Massachusetts 1850–1923 Ashfield, Massachusetts

Mourning Picture, 1890

Oil on canvas
27¹⁵⁄₁₆ × 36 in. (70.9 × 91.4 cm)
Not signed or dated
Purchased
1953:129

Edwin Romanzo Elmer's eerie and affecting *Mourning Picture* has fascinated several generations of museum-goers, and the facts behind the painting are no less intriguing than the arresting visionary qualities of the image. Elmer, the last of twelve children born to a poor farming family in the hills of western Massachusetts, spent most of his life in an isolated area twenty miles north of Northampton. As a young man, however, he traveled to Cleveland, Ohio, where he successfully entered the silk thread business. On returning to Massachusetts about 1875, Elmer and his brother Samuel built (with their own hands) the imposing Italianate house seen in the painting. Its urban stylistic vocabulary served to announce the newfound prosperity of the Elmer clan, and the brothers and their families invited their parents to join them in their new mansion.

Within a few years, however, the others had moved away, leaving the artist, his wife, and their only child, Effie, as the sole residents of the large structure. Tragedy then struck in 1890, when the nine-year-old child died of appendicitis. Elmer's wife, Mary, was stricken with grief and could no longer bear to stay in the home they had shared with their daughter. The couple boxed up Effie's possessions and gave away her pets, but before leaving the house forever, Elmer painted this remembrance of their lives together. The parents, in mourning dress, are shown near the house seated on parlor furniture: Their hands are occupied with the standard domestic attributes of newspaper and knitting, but their faces are remote and impassive, blankly staring as though still stunned by their loss. To the left, dramatically silhouetted against the landscape, Effie stands with her pet lamb, her toys, and her nimble-footed kitten marching in from one side. They make a poignant group, their meticulous rendering and looming placement in the foreground leaving the impression that they are more alive, more "real" than the desolate, passive adults.

Nothing in Elmer's career prepares one for this powerful masterpiece produced by a forty-year-old artist with no known formal instruction in painting. The textured carpet of flowers at Effie's feet might indicate knowledge of similar symbolic flora in early quattrocento altarpieces, and the concentrated attention given to each butterfly, blade of grass, and distant leaf—as well as the sharp, fresh green hue used throughout—argues for some exposure to Pre-Raphaelitism. The emotional power and vital energy of the work, however, seem to stem more directly from the tragic circumstances it commemorates. The vibrant colors of the doll carriage, the exquisite curls of red ribbon on the grass, Effie's virtually tangible lace collar and strand of pearls: It is as though Elmer has willed his grief into a tight focus on the compacted matter of his daughter's world. The intensity pushes this quiet, crystalline scene nearly to the breaking point; indeed, as the painting has aged, the sky and clouds have developed a prominent craquelure that seems almost to result from the considerable repressed tension below. The effect is one of time arrested, and though her parents appear left behind, tied to a more prosaic realm, Effie herself seems strangely at home in this heightened, charged landscape.

Further Reading

Jones, Betsy B. *Edwin Romanzo Elmer, 1850–1923.* Northampton, Mass.: Smith College Museum of Art, 1983.

Edwin Romanzo Elmer

Ashfield, Massachusetts 1850–1923 Ashfield, Massachusetts

A *Lady of Baptist Corner, Ashfield, Massachusetts* (the artist's wife), 1892

Oil on canvas

32¹⁵⁄₁₆ × 24¹³⁄₁₆ in. (83.7 × 63 cm)

Signed and dated in brownish black paint, lower left: E. R. Elmer/ 1892

Gift of E. Porter Dickinson

1979:47

Just a year or so after he painted Smith College's *Mourning Picture* (pp. 152–55), Edwin Elmer executed *A Lady of Baptist Corner*, another highly personal and idiosyncratic canvas, this time featuring his wife alone. (The title was given the work in the twentieth century; it derives from the name of the village in Ashfield, Massachusetts, where Mary Ware Elmer [1860–1927] was born.) Here, as in the *Mourning Picture*, Elmer weaves together a record of his family and his mechanical accomplishments, depicting his sober wife—still dressed in mourning garb—at work before his whipsnap machine, one of several labor-saving devices invented by the artist. His machine was used to braid the silk threads that formed the ends of horsewhips, a regional cottage industry that brought extra money into many western Massachusetts households at the time. Mary Elmer, perhaps shown in their upstairs apartment in Shelburne Falls, Massachusetts, is said to have maintained a personal bank account for her earnings from this homework.

Elmer's striking image has something in common with the many late-nineteenth-century genre paintings that took as their subject a single, contemplative (often elderly) woman engaged in some sort of productive handiwork in a domestic interior. Yet the industrial emphasis of the whipsnap machine, with the unromantic, repetitive piecework it produced, is unusual and would seem to puncture the nostalgia and sentimental-ity normally associated with the theme. The view out the window, another standard iconographic element in such images of feminine solitude, is here bleak and barren. This dry, wintery landscape, moreover, is largely blocked by the unrelieved, flat surface of the machine. Indeed, the unmodulated planes of the device, the cool gray wall, and the central, compositionally complex passage of intertwined cranks and rods leave an overall impression of a cold, metallic starkness, in keeping with the austere demeanor of the mother who has so recently lost her only child. Perhaps the only touch of whimsy lies in the colorful, richly patterned carpet with its fantastic pavilions, bouquets, and foliate scrolls. This floor, tilting precipitously, almost seems subject to different physical laws than the squared-off pair of machine and worker above. Even the industrial-sized spools in the foreground hover dangerously at the lower edge of the pictorial space.

Yet despite this singular environment, the viewer's gaze ultimately rests on the calm, focused figure of Mary Elmer as she leans into the machine slightly and wraps her hands firmly around its metal handles. Her lowered eyes and her thin arms joining those of her husband's invention indicate a firmness of purpose and a resolute concentration brought to the task. But it is the almost religious quality of light, seemingly emanating from within the machine, that most noticeably marks her. Cascading down her snowy apron and creating a warm halolike glow around her head, it appears to separate her quietly from the spinning walls around her, providing a luminous moment of solace, perhaps, as she loses herself in the specialized work so associated with the ingenuity of her husband.

Further Reading

Jones, Betsy B. *Edwin Romanzo Elmer, 1850–1923*. Northampton, Mass.: Smith College Museum of Art, 1983.

Thomas Charles Farrer

London, England 1839–1891 London, England

View of Northampton from the Dome of the Hospital, 1865

Oil on canvas

28⅛ × 36 in. (71.4 × 91.4 cm)

Monogrammed and dated in red paint, lower right, initials conjoined: TCF 65

Purchased

1953:96

Though Northampton played host to the young artist Thomas Farrer for only a few months in the late summer of 1865, the fruit of that brief sojourn, his *View of Northampton,* is now acknowledged as the masterwork of his small oeuvre, as well as the most important nineteenth-century view of the town. This painting, the largest extant work he executed, can be seen as a hopeful "policy statement" for the Association for the Advancement of Truth in Art, a group of zealous young artists imbued with the precepts of John Ruskin and intent on overhauling what they perceived to be the lax and misguided methods of American landscape painting.

Farrer had arrived in the United States in the late 1850s, fresh from his training at London's Working Men's College, where the uncompromising Ruskinian philosophy of "selecting nothing and rejecting nothing" held sway. A dynamic teacher, he soon gathered around him a group of like-minded men who not only formed their small association during a meeting in Farrer's studio in 1863, but also founded an energetic periodical entitled *The New Path.* It was in these pages that they launched their attack on the status quo, indicting even the most prominent American landscape painters as insufficiently attentive to the minutiae of nature. In contrast, Farrer's "Pre-Raphaelites," as they were styled, became known for unusually meticulous and time-consuming studies of such humble subjects as patches of weeds and grass. Difficulty arose, however, when they tried to translate the results of their highly finished drawings—with dimensions measured in inches—into much larger paintings several feet in width. Members of the association had encouraged Farrer to make the attempt, and when he arrived in the congenial setting of Northampton, he evidently discovered a subject to his liking.

His panoramic view is from the hill where a state hospital for the insane had recently been constructed, and the spectator looks down on Paradise Pond, the adjoining area (which would become the campus of Smith College), the town center, and the Connecticut River valley in the distance. True to the Pre-Raphaelite philosophy, Farrer has taken great care in describing the topographical elements, particularly the tiny, cubical buildings huddled under the carefully delineated trees lining Northampton's thoroughfares. The trees are often discernible by type, such as the tall elms along Elm Street at left (they tower over a structure recognizable as the idiosyncratic residence designed by William Fenno Pratt and known as Hopkins House, one of the few buildings visible that remains on the Smith campus today).

The surface of the painting seems slightly matte and chalky, particularly in the distance, yet this in no way diminishes its intensity of vision. There is a glassy, unruffled stillness to the scene, a beguiling suspension of time that seems almost vacuum-sealed. It was this slightly clinical quality, however, that troubled the New York critics, who found much to criticize in the detailed view. Farrer had painted the Northampton of the surveyor and the real estate agent, one wrote; it was "the prose, not the poetry, of landscape." "Crude," "bald," "faulty," and "unbeautiful" were other words used, and though the painting had been praised enthusiastically while on view in Northampton, Farrer's experiment was dubbed a failure in New York. Shortly thereafter, his association ceased activity, and by 1872 Farrer had returned to England.

Further Reading

Ferber, Linda S., et al. *The New Path: Ruskin and the American Pre-Raphaelites.* Brooklyn: The Brooklyn Museum, 1985.

Lyonel Feininger

New York, New York 1871–1956 New York, New York

Gables I, Lüneburg, 1925

Oil on canvas

37¾ × 28½ in. (95.9 × 72.4 cm)

Signed and dated in green paint, upper right: Feininger/25; inscribed on stretcher in artist's hand: Lyonel Feininger/"Old Gables" (Lüneburg)

Gift of Nanette Harrison Meech (Mrs. Charles B. Meech), class of 1938, in honor of Julia Meech, class of 1963

1985:20

Although Lyonel Feininger was fifty years old when he first sought out the medieval brick buildings of the small north German town of Lüneburg, he had been intrigued by the expressive power of architectural forms his entire life. Born into a German immigrant family, he spent much of his childhood in Manhattan, where, at age fifteen, he took a job as a Wall Street messenger, delighting in his work among the earliest New York skyscrapers. As a young artist in Europe, where he lived for some five decades before fleeing Nazism in 1937, he had repeatedly expressed his wonder at what he termed "the quaint old houses" of Brussels, or the tall, rickety Parisian buildings he enjoyed sketching on the rue St. Jacques. Indeed, it was while living in Paris in 1906 that he took on the commission of drawing two serialized cartoons for the *Chicago Tribune*, "The Kin-der-Kids" and "Wee Willie Winkie," which were groundbreaking in their fantastic visual worlds of exaggerated, jagged architectural forms populated by angular, elongated inhabitants.

So it is not surprising that after a difficult year teaching at the famous Bauhaus school in Weimar, he and his wife set out in 1921 on a restorative tour of several towns, including Lüneburg, which featured the regional medieval style known as *Backsteingotik*. There, he made a number of drawings as he walked the streets and marveled at the patchwork series of Gothic and baroque façades—the former narrow and bristling with their towering stepped gables organized by prominent grids of brick moldings, the latter less busy, characterized by swooping rooflines and broader planes. It was, in fact, this intriguing juxtaposition of forms that he explored in a charcoal drawing a few years later and then chose as the central motif of *Gables I, Lüneburg*.

Feininger's street view is, in some respects, dependent on early explorations of cubist space by Braque and Picasso, whose paintings had profoundly impressed him when he saw them in Paris in 1911. His shimmering forms are built up from intersecting shards of space and matter; his paint surface is rather dry and mottled, with subtly valued, individual touches of the same hue defining the planes; and his objects are viewed simultaneously from two vantage points, with the main façade of the orange baroque building, for example, seen in perspective while its crown and volutes remain parallel to the picture plane. Yet Feininger rightfully distinguished his style from Cubism, suggesting at one point that his manner be dubbed "Prism-ism" for its refractive, gemlike effects of light. His buildings do seem internally lit and unusually vibrant in their coloring, giving off energized lines of force that rake the sky. Still, the street scene has not been so transmuted as to lose its spatial legibility. Thus, the foreground human figures loom larger than those nearer the buildings, and the slanting ground plane, though tipped up, lends a sense of momentum to the paths they thread through the small town. Lüneburg's historic architecture and modern residents are, at least at this point in Feininger's decades-long exploration of its urban character, compellingly bound together by this interpenetrating network of faceted modules of space.

Further Reading

Hess, Hans. *Lyonel Feininger.* New York: Harry N. Abrams, 1961.

Luckhardt, Ulrich. *Lyonel Feininger.* Munich: Prestel, 1989.

Ness, June L., ed. *Lyonel Feininger.* New York: Praeger, 1974.

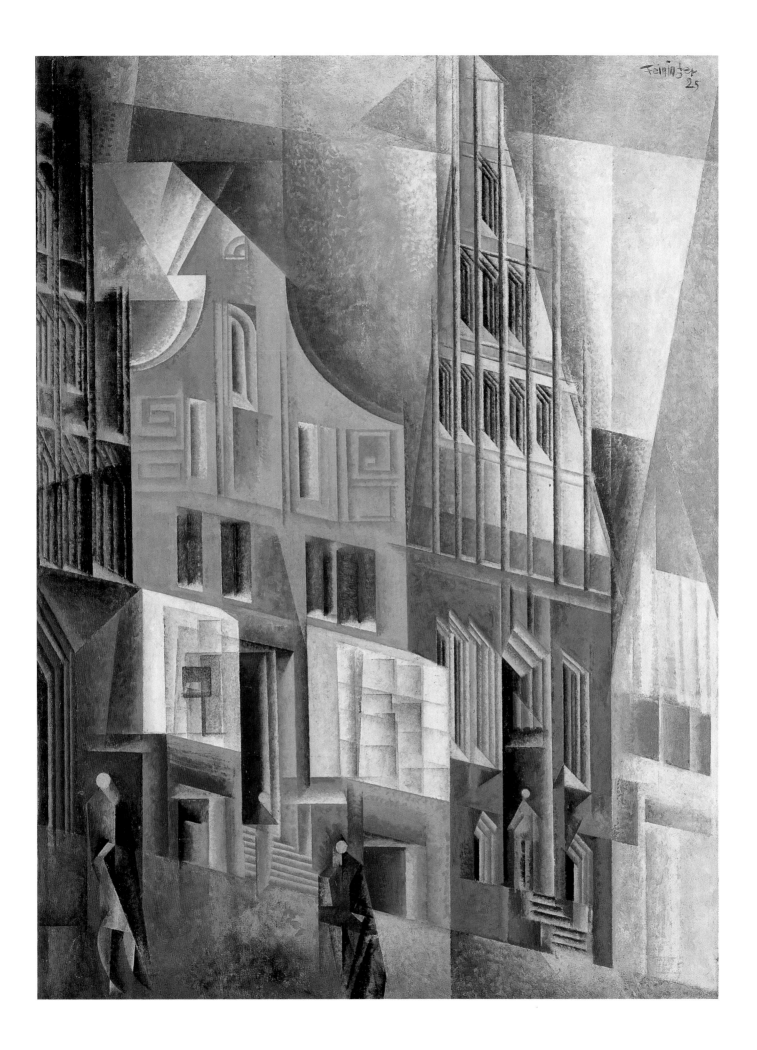

Erastus Salisbury Field

Leverett, Massachusetts 1805–1900 Leverett, Massachusetts

Bethiah Smith Bassett, c. 1836

Oil on canvas
35 × 28⅞ in. (88.9 × 73.3 cm)
Not signed or dated
Purchased
1985:29–2

In the early nineteenth century, the region of western Massachusetts did not possess sufficient economic inducement for urban-trained painters of the first order to consider settling along the Connecticut River or among the Berkshire Hills to ply their trade. The extended families spread over this rural area, whose patriarchs and matriarchs were often the original founders of their small towns and who commanded a good deal of local respect, were nevertheless hungry for portrait likenesses to commemorate their accomplishments and preserve the record of their clan. Erastus Salisbury Field, a fascinating figure who spent most of his ninety-five years in the tiny villages of Leverett and Sunderland, worked for several decades in his early career to answer this local need. With a minimum of stylistic and iconographic devices, he often succeeded in isolating what appear to be singular strengths of character in his sitters, rendering them in crisp, unflinchingly spare presentations that rarely fail to confer dignity.

During the summer of 1836, Field left the Connecticut River valley and made an extended visit to the Berkshire region, spending several months in Great Barrington, Egremont, and Lee. In the last town, he had the good fortune to attract the business of the prosperous Bassett family, who commissioned at least eight portraits (for which he likely charged about $4 each). In 1783 Nathaniel Bassett, a blacksmith and Revolutionary War veteran, had moved with his wife, Bethiah (1761–1849), from their Cape Cod birthplace to Lee, just five years after that town's incorporation. They were considered among the most important of Lee's founding families, and Bethiah, depicted here in her seventy-fifth year, presided over a large kinship network of nine children, several branches of in-laws, and many grandchildren.

Bethiah Smith Bassett exhibits all the hallmarks of a standard Field portrait: the bright highlight of the red chair at the sitter's shoulder, the cloudlike gray "halo" that seems to radiate from her head and upper body, and the quick (even sloppy) brushwork as glimpsed in the ends of the bonnet ribbons and the blocky, flattened fingers. More distinctive still is the flat, decorative patterning of the body, with the freely painted foliate motif of the silk shawl laid over the pyramidal silhouette of the bodice and exaggerated leg-o'-mutton sleeves. The tapering ends of the shawl meet where the hands cross, drawing attention to her worn book, a visual marker of intellect.

It is with some force that Bassett's solidly rendered head punctures this cool arrangement of two-dimensional shapes, seemingly occupying a more proximate order of space. Enframed by the whimsical, dotted ruffle of the bonnet, its ribbons almost gushing forward from her chin, the face of this septuagenarian is lively, despite the resolute cast of her features. Her eyes are shaded, but her brows are lifted with a hint of skepticism, an expression that opens her countenance considerably and forms a striking range of wrinkles on the forehead. Below, there is a firm matter-of-factness to the set of her mouth and jaw, a plainly rendered characterization that does not shrink from attending carefully to her moustache and double chin.

Further Reading

Black, Mary. *Erastus Salisbury Field: 1805–1900.* Springfield, Mass.: Museum of Fine Arts, 1984.

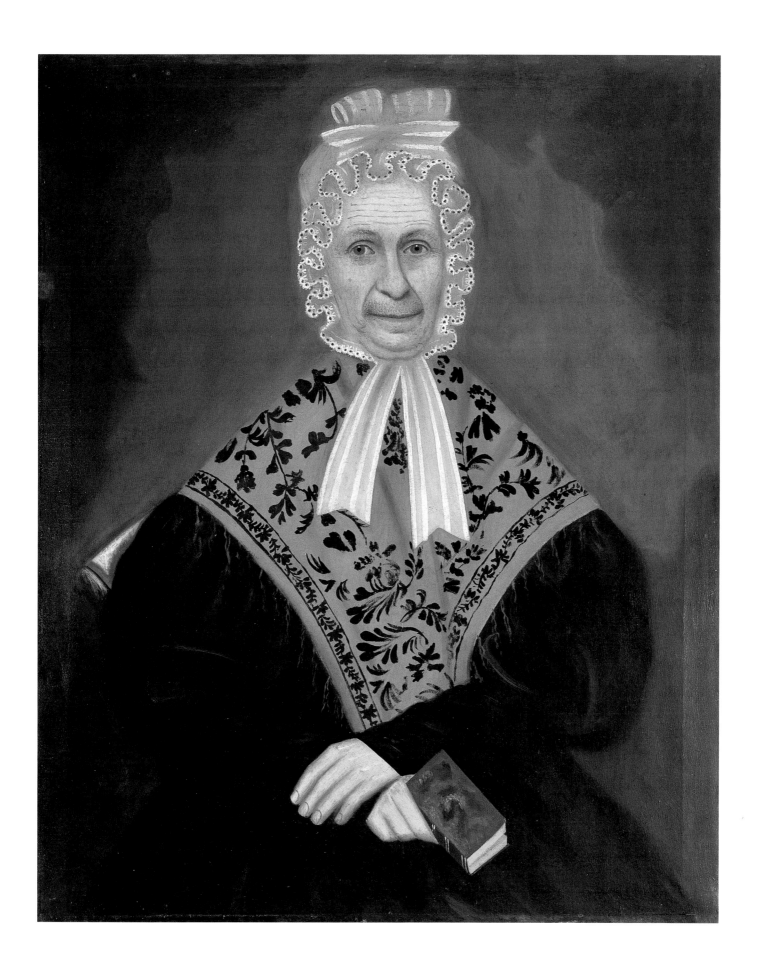

Daniel Chester French

Exeter, New Hampshire 1850–1931 Stockbridge, Massachusetts

The May Queen, 1875

Marble

16 × 14 × 7½ in. (40.7 × 35.6 × 19.1 cm)

Signed, dated, and inscribed on base: D.C.FRENCH./SCULP./Florence, 1875

Gift of Dr. and Mrs. Joel E. Goldthwait (Jessie Rand, class of 1890)

1915:8

When Daniel Chester French's *May Queen* entered the Smith collection in 1915 as an early alumna gift, the art professor Alfred Vance Churchill noted in a letter to then President Marion Burton that it was Smith's first example of marble sculpture and that it would be "valuable as an example to classes of marble and marble technique." It is, indeed, a pristine embodiment of the waning neoclassical mode in sculpture, which had largely governed American expatriate production during the middle decades of the nineteenth century. Though he would later practice a more "modern" style, characterized by greater naturalism and drama and less sentiment and delicacy, French here demonstrates his mastery of the prevailing sculptural vocabulary of his teachers, especially his fellow New Englander Thomas Ball, in whose Florentine studio he first modeled this bust in clay.

French's early career is a wonderful story of innate talent and curiosity, for he was able to achieve a remarkable competence in his art — most notably in his famous *Minute Man* (1871–74) for the town of Concord, Massachusetts — with only minimal instruction. Still, the limited facilities of the United States made it imperative for any serious sculptor to spend time in Europe, and in 1874, largely because of his friendship with Preston Powers, son of the famous artist Hiram, French decided to move to Florence, where the Powers family had long presided over a flourishing expatriate community of sculptors. On his way to Italy, French was

tempted to stay in Paris, but he wrote that he found the artists there too "realistic" and "opposed to idealization of any kind." Yet when it came time to produce a domestic-scale allegorical figure for one of his Boston financial backers, he seemed curiously unengaged by his youthful subject, which just a few years later he admitted was "rather foolishly called 'The May Queen.'" Even before the clay original had been translated into marble by Italian carvers, French wrote breezily to his brother about "The bust 'May Queen' or something," remarking, "The marble work is beautifully done, but I have outgrown the model and cease to have much regard for it."

The artist's ambivalence can largely be attributed to his realization that the late-nineteenth-century art world was beginning to dismiss works such as *The May Queen* as artificial and overly sweet, but this in no way detracts from his accomplishment in this early bust. Throughout his career, French was known for his attention to detail and finish, refining and polishing his marble surfaces once the hired carvers had completed their task. This care is evident in *The May Queen,* particularly in the delightfully active crimping of the neckline of the girl's classical chiton and the carefully delineated textures of the hawthorn leaves and buds threaded through her hair and spilling over the base. Despite his own doubts as to the wisdom of the enterprise, he has successfully melded the real and the ideal in his model, with the blank, undrilled eyes and the impossible sparkle of her polished white Carrara forehead giving way to the more intimate suggestion of a slight pudginess and trace of girlish baby fat in the cheeks and under her chin.

Further Reading

Cresson, Margaret French. *Journey into Fame: The Life of Daniel Chester French.* Cambridge, Mass.: Harvard University Press, 1947.

Richman, Michael. *Daniel Chester French: An American Sculptor.* Washington, D.C.: Preservation Press, 1983.

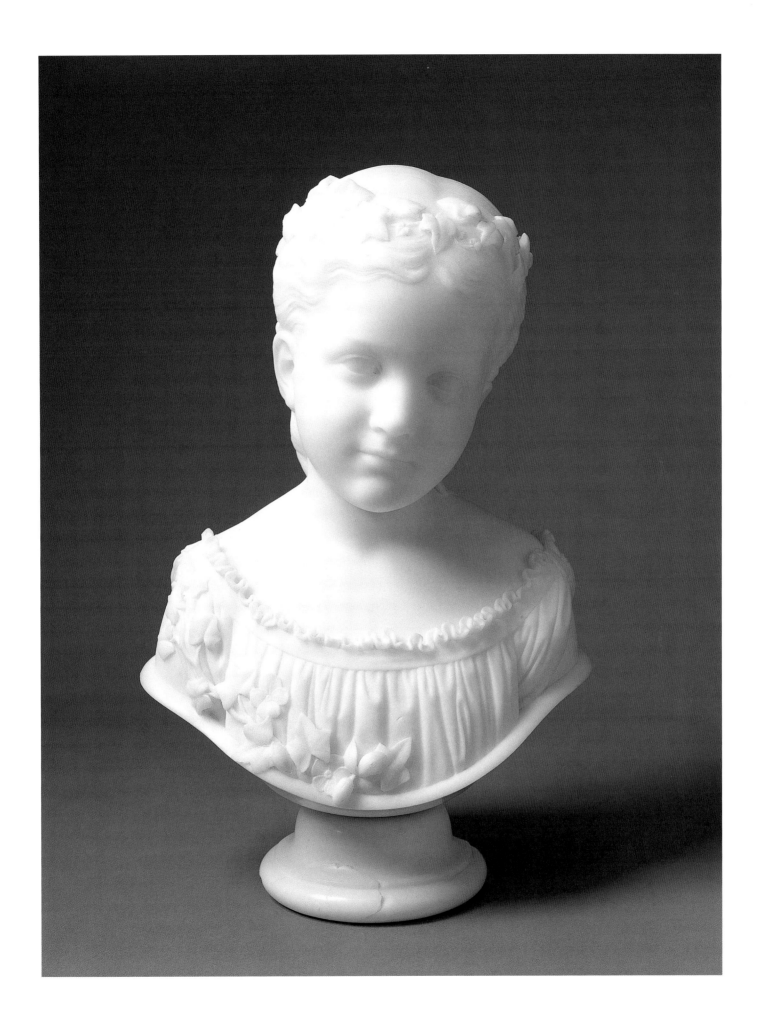

Robert Swain Gifford

Naushon Island, Massachusetts 1840–1905 New York, New York

An Old Orchard near the Sea, Massachusetts,
1877

Oil on canvas
22⅛ × 40¼ in. (56.2 × 102.2 cm)
Signed and dated, lower left: R. Swain Gifford 1877
Purchased
1916:6-1

When Smith President L. Clark Seelye traveled to New York and visited the inaugural exhibition of the Society of American Artists in 1878, he was attending the most progressive display of American art assembled anywhere in the nation. That he eventually purchased at least three paintings from this show, including R. Swain Gifford's *Old Orchard near the Sea*, briefly made Smith College the foremost institutional patron of the new American avant-garde. Gifford was slightly older than many of the relatively unknown artists who took part in that event, and his reputation had recently been established as a moody painter of the barren, rugged shore of his native Massachusetts. Reviewers thus took note of his "strong, poetic" contribution, calling it "massively painted" and elevating it above most of the other landscapes. Gifford seems to have agreed; he reproduced his composition in an etching of 1877, and in March 1879 it represented him as an illustration in an important article on contemporary artistic trends in *Harper's New Monthly Magazine*. With its unusually high price of $900, this work signaled a new ambition for Gifford (even though Seelye, ever in search of a good deal for the college, eventually paid only $450).

An Old Orchard near the Sea is typical of the artist in its simplified composition and asymmetrical clumping of the wizened apple trees—their scraggly, unpruned branches testifying to years of neglect and abandonment. The sky is clotted and brooding, with a hint of heavier weather moving in from the left. Aside from the rude shack, stranded wagon, and anonymous seated figures, there is little to note beyond the active, open brushwork itself; broad, dense, and layered, it is built up in the rutted foreground with pointillist dabs of dry color and a scrubbing in of thicker, silvery paint. During this period of the budding colonial revival, Gifford's audience responded vigorously to the poignant, sober air of melancholic retrospection in his work. Reading in the gnarled trees, spiky stubble, and bleak, hooded atmosphere a laudable, virile expression of the hardscrabble Puritan existence that had come to be romantically associated with this terrain, they indulged in a wash of aching nostalgia before his sterile moorland.

The critic Susan Carter, in a notably extended commentary on the painting, wonderfully epitomized this response:

> We can all of us, who are used to New England, recall such places as this is, and know the feeling and the look of the grass that yet grows up, and keeps partially green, out of dry earth that the sun bakes into a hard crust. . . . The picture is a poem in paint, full of the meat of thought, and palpable to the senses, till we smell the dry, warm air, and crunch the coarse grass beneath our tread; and the objects in the picture cluster about themselves a vast crowd of unseen associations of the near farm, the open, moaning sea, and through the pleasant summer weather blows a whiff from the winter days which scarred these trees so, and blew up the white sand to trench upon the fertile fields. Mr. Gifford's beautiful, rich colour and his firm use of his brush have long been admired; but in this fresh story-picture it is not till after we have appreciated the thoughts it awakens that we notice how rich and how fine are the browns, the purples, the blues, and the grey tones, so completely is the manner lost in the matter of this fine work.

Further Reading

Carter, S. N. "First Exhibition of the American Art Association." *Art Journal* 4 (April 1878): 124–26.

Hall, Elton W. *R. Swain Gifford, 1840–1905*. New Bedford, Mass.: Old Dartmouth Historical Society, 1974.

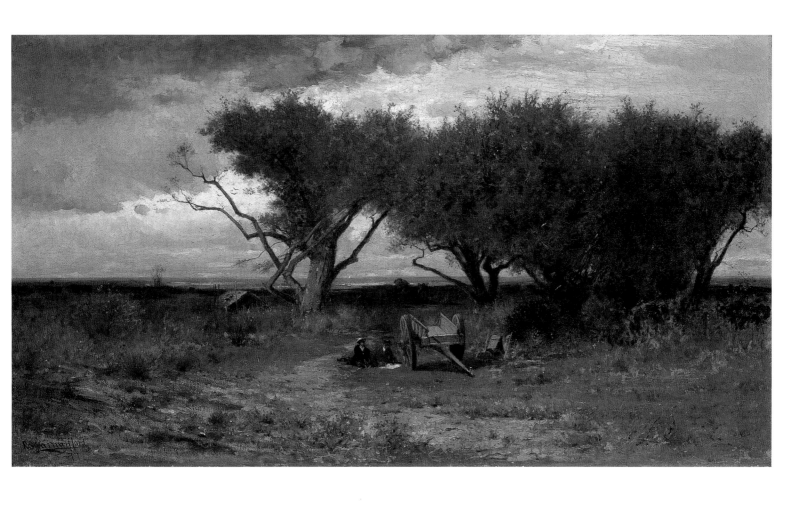

Marsden Hartley

Lewiston, Maine 1877–1943 Ellsworth, Maine

Sea Window – Tinker Mackerel, 1942

Oil on Masonite

40 × 30 in. (101.6 × 76.2 cm)

Signed and dated in black paint, lower right: MH/42; inscribed on back: Sea Window—Tinker Mackerel

Purchased, Sarah J. Mather Fund

1947:8-1

Sea Window—Tinker Mackerel was painted in the last year of Marsden Hartley's life, during a period of mixed personal fortunes. After a decade or more of financial difficulties and perceived neglect from critics, the artist was finally enjoying renewed fame and sales. Yet at the same time his health was declining precipitously, and his enthusiasm for his work was tempered by his increasing physical debility. The situation seems to have prompted him to adhere with even greater conviction to his self-identified role as the preeminent native-born painter of Maine, territory he had deliberately laid claim to when he first revisited his home state in 1937 after a relatively long absence. It was no doubt with a sense of solace and security that the artist returned to Maine subjects and, in particular, to his favored window view, which had preoccupied him during difficult periods in his career for some twenty-five years. In works like *Sea Window—Tinker Mackerel,* he was able to combine his love of still life and seascape, while also continuing his exploration of the symbolic, even religious significance of his humble iconography.

Hartley invested the lives of the New England fisherfolk he so admired with mystical import. In his search for a congenial location in which to paint, the stalwart simplicity of the local inhabitants was as crucial to him as the strong scenery that would inspire his paintings. In the small village of Corea, Maine, he felt that he had found all the necessary components for his art, including a generous host family, Forest and Katie Young and their children, who solicitously cared for the elderly artist. It was there that he painted *Sea Window—Tinker Mackerel,* with its affecting arrangement of glistening blue-gray fish arranged in the foreground like an offering before his view of faraway islands.

The vaguely Christian symbolism of Hartley's fish had been established in earlier works such as *Give Us This Day* (1938, private collection), but here they also function formally as an enlivening element in his conceptual, abstractive composition of overlapping planes and expressionistically worked areas of color. Their reflective, silvery tonality and the quivering lines of motion that surround them give this "school" of fish the appearance of swimming on the tipped-up, blood red tabletop, as though they have just been scooped out of the distant ocean. Other biomorphic forms, such as the floating clouds and the maroon blotches on the walls framing the window, further punctuate the rectilinear fields, yet with very different spatial results. The clouds diminish in size in the distance in much the same way that the animated brushwork in the water grows calm at the horizon. Hartley thus achieves a telescoping impression of depth, without resorting to conventional perspectival means. The darkened interior space of the viewer, in contrast, remains flat and compressed. Its somber tonality, coupled with the longing gaze across the sunlit sea, creates a balanced mood and a powerfully suggestive arrangement of interlocking parts.

Further Reading

Haskell, Barbara. *Marsden Hartley.* New York: Whitney Museum of American Art, 1980.

Robertson, Bruce. *Marsden Hartley.* New York: Harry N. Abrams, 1995.

Scott, Gail R. *Marsden Hartley.* New York: Abbeville Press, 1988.

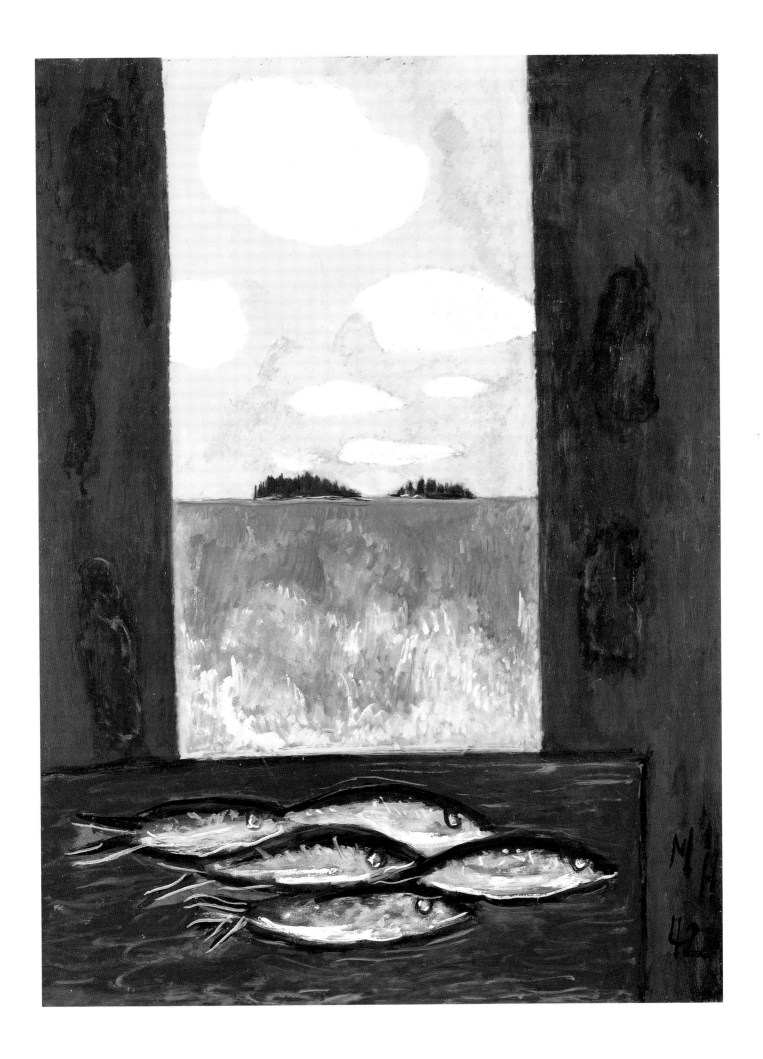

William Stanley Haseltine

Philadelphia, Pennsylvania 1835–1900 Rome, Italy

Natural Arch, Capri, c. 1855–76

Oil on canvas
15¹⁄₁₆ × 23¹⁵⁄₁₆ in. (38.3 × 60.8 cm)
Not signed or dated
Gift of Helen Haseltine Plowden (Mrs. Roger H. Plowden)
1952:4

William Haseltine's "rock-portraits," to use a term coined by the contemporary critic Henry Tuckerman, are utterly distinctive in their pronounced attention to the weathered, faceted textures of the cliffs towering dramatically above limpid seas. A graduate of Harvard in 1854, Haseltine no doubt became attracted to the pictorial possibilities of coastal geology while a member of the university's Natural History Society. Traveling within the influential orbit of the Harvard naturalist Louis Agassiz, the young painter, who once said that "every real artist is also a scientist," came to study the massive, slablike forms of the rocks that rise from the ocean at Nahant, Massachusetts. This resort was a primary inspiration for Agassiz's theory of a pervasive ice age, and Haseltine's petrologically precise drawings and paintings were seen as remarkably expressive of the telltale natural evidence of the glacial formation of the earth's topography. Indeed, after returning from a period of study in Düsseldorf, he became well known in his early career for these evocative compositions of water, sky, and rock — in all their elemental purity.

In 1866, however, Haseltine left his New York home and settled with his family in Europe, participating in the general American thirst for travel and change in the wake of the debilitating Civil War. Although he made frequent trips back to the United States, the remainder of his career was centered in Italy, where he exhibited rarely and became much less involved in the American art scene. Possessed of independent means, Haseltine did not suffer from his diminished public reputation. Living extremely comfortably in large apartments in Rome's Palazzo Altieri, he regularly sold his paintings to visiting American tourists, whose constant demand for a limited range of Italian subjects meant that the artist's work changed little over the years.

One such site, which Haseltine first visited as a student in 1858 and returned to at least four times, was the craggy island of Capri, in the Bay of Naples. The artist repeatedly explored its precipitous limestone cliffs, which plunge almost vertically into the sapphire depths of the Mediterranean; a Caprese landscape subject was almost always among the groups of paintings he occasionally sent to represent him at international exhibitions. The Centennial Exposition in Philadelphia, for example, included a painting of the famous Arco Naturale of Capri, although not, in all likelihood, the Smith canvas. Still, this moderately ambitious study of clear, bright sun breaking across the chiseled heights of the island is entirely typical of Haseltine's restrained tonal style. The cool blues of the sky and water, lending a pastel tinge to the flattened promontory in the distance, are very thinly painted. At left, the highly tactile forms of the rocks are constructed with more opaque paint, but the pictorial surface is still relatively sheer, with careful networks of olive green and blue veining shot through in a liquid medium. Light — indicated by cream-colored touches of slight impasto — edges the sharpest corners of the forms, but the most dramatic contrast comes from the "keyhole" view through the natural arch and its toothy, jagged upper contour silhouetted asymmetrically against the sky. Here, in the quiet play of these abstracted natural formations, Haseltine hints at the majestic force that underlies their genesis in the distant past.

Further Reading

Plowden, Helen Haseltine. *William Stanley Haseltine: Sea and Landscape Painter (1835–1900).* London: Frederick Muller Ltd., 1947.

Simpson, Marc, et al. *Expressions of Place: The Art of William Stanley Haseltine.* San Francisco: The Fine Arts Museums of San Francisco, 1992.

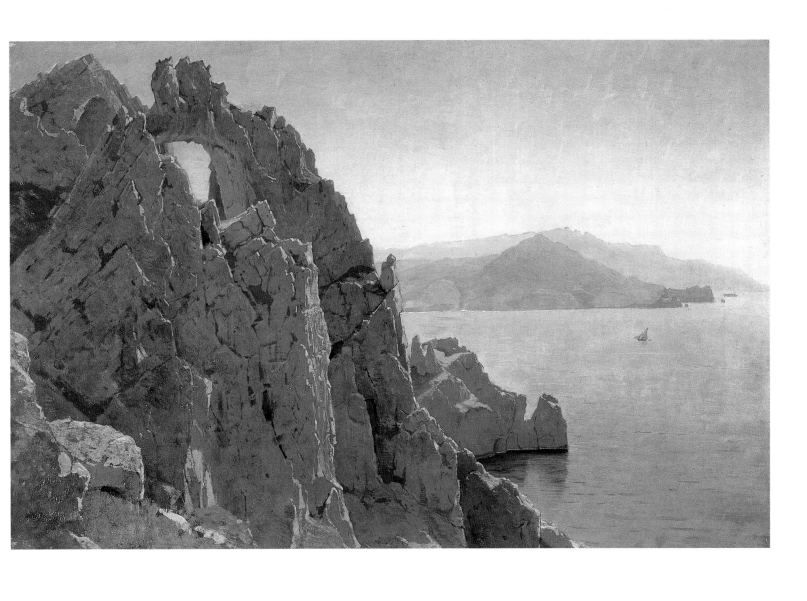

Childe Hassam

Dorchester, Massachusetts 1859–1935 East Hampton, New York

Cab Stand at Night, Madison Square, 1891

Oil on wood panel

8¹⁵⁄₁₆ × 14⅜ in. (irregular) (22.7 × 36.4 cm)

Signed and dated in blue paint, lower left: Childe/Hassam/1891; inscribed on back of panel, upside down, in pencil, across entire height and width of panel: Electric Light [illegible]

Bequest of Annie Swan Coburn (Mrs. Lewis Larned Coburn)

1934:3-2

No American impressionist was more devoted to the exciting visual spectacle of urban life than Childe Hassam, an artist who first explored the pictorial possibilities of Boston's parks and avenues in the mid-1880s, discovered the even grander boulevards of Paris while a student in the late 1880s, and later became the premier painter of his adopted city of New York, where he moved in 1889. Upon arriving, Hassam and his wife took a studio apartment on the second floor of a building at the corner of Fifth Avenue and Seventeenth Street, a perfect location for observing the bustle and flux of the heavy pedestrian, cab, and omnibus traffic concentrated in this developing commercial and entertainment district. He completed more than fifty New York paintings during the decade of the 1890s, and most of them depict scenes in the ten-block area surrounding his initial home, bounded by the famous parks of Union and Madison Squares.

In an interview Hassam gave just a year after completing *Cab Stand at Night, Madison Square*, he reflected on his attraction to street scenes: "There is nothing so interesting to me as people. I am never tired of observing them in every-day life, as they hurry through the streets on business or saunter down the promenade on pleasure. Humanity in motion is a continual study to me." In his pursuit of the momentary and the fleeting, he often had recourse to hiring a relatively new form of urban transportation, the one-horse hansom cab. Hassam would sit in the cab, stationary by the curb, and sketch his impressions of the crowds who streamed past his window. In the process, he became aware of the picturesque effects of his professional drivers. "There is no end of material in the cabbies," he explained. "Their backs are quite as expressive as their faces. They live so much in their clothes that they get to be like thin shells, and take on every angle and curve of their tempers as well as their forms. They interest one immensely."

In this small panel, Hassam turns the backs of his cabbies to the viewer as they huddle together for conversation and warmth while awaiting their fares. The street curves into the distance, with its lineup of lantern-lit cabs at the ready. The peach-colored twinkle of lights and the suggestion of a buzzing mass of people in the background perhaps signal the end of a performance, with the audience spilling onto the sidewalk in search of a way home. The warm glow of the throng, however, has not yet reached the small group of cabbies in the foreground. They stand alone in the bare, metallic glare of the high electric lamps that had been introduced along this stretch of Broadway several years earlier. While newspaper accounts of the time worried about the harsh effects of this new form of illumination—"dismal and depressing in comparison with the deep and agreeable yellow of the gas jets," according to the *New York Times*—Hassam embraces this resolutely modern scene, delighting in the artificial shift in tints of his nocturnal palette and the haunting quality of the saplings' shadows, reaching across the snowy pavement and up the cabbies' greatcoats like spidery blue veins filled with ice water. It is a daring pictorial statement that would have been inconceivable even a decade earlier, one that revels in the new possibilities of vision in the modern era.

Further Reading

Fort, Ilene Susan. *Childe Hassam's New York*. San Francisco: Pomegranate Art Books, 1993.

Ives, A. E. "Talks with Artists." *Art Amateur* 27 (October 1892): 116–17.

Hiesinger, Ulrich W. *Childe Hassam: American Impressionist*. New York: Jordan-Volpe Gallery, 1994.

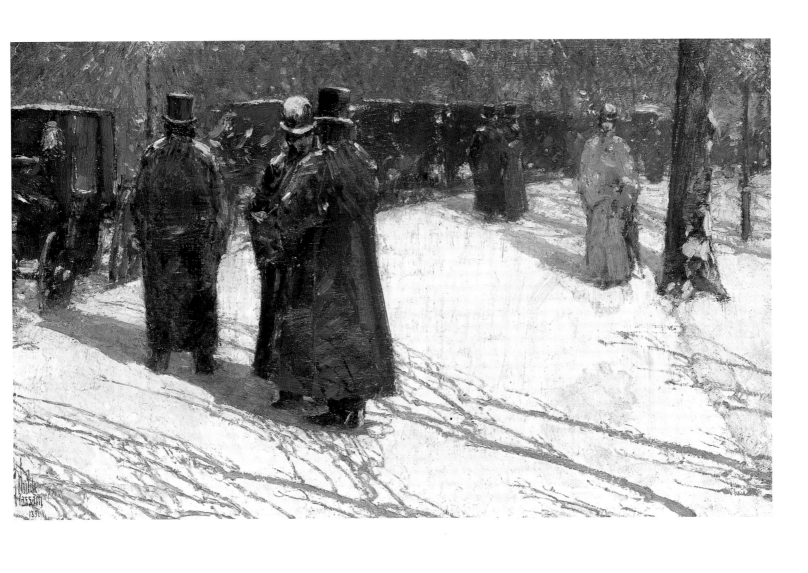

Childe Hassam

Dorchester, Massachusetts 1859–1935 East Hampton, New York

Union Square in Spring, 1896

Oil on canvas
21½ × 21 in. (54.5 × 53.3 cm)
Signed and dated, lower right: Childe Hassam 1896
Purchased
1905:3-1

Union Square in Spring, painted seven years after Childe Hassam returned from a student sojourn in Paris, marks a decided leap in his work toward greater abstraction and more radical compositional strategies. The artist had long since assimilated the broken impressionist brushwork and the penchant for transient, blurred effects of movement and atmosphere that he had first explored tentatively in Paris, but with the elevated point of view and the unconventional square format of this painting, he moved further toward an authoritative and personal embrace of the sprawling visual energies of New York, the city he championed as the greatest metropolis the world had known. His French predecessors, such as Claude Monet and Pierre-Auguste Renoir, were pioneers in the investigation of the novel, glancing perspectives on urban life achieved through a raised vantage point, notably in a pair of views of the Pont Neuf they painted in Paris in the 1870s. The advent of the skyscraper, however, allowed Hassam to push such effects far beyond these more gentle antecedents.

Union Square had been opened and developed in the early nineteenth century as a privileged residential enclave, surrounded by three- and four-story row houses inhabited by such prominent New Yorkers as the mining and railroad magnate Anson G. Phelps and the lawyer Samuel G. Ruggles. Yet few of these quiet structures remained by the time Hassam arrived on the scene, for the neighborhood had gone through several periods of comprehensive redevelopment and transition to retail and entertainment uses. As the southern anchor of the stretch of Broadway known as "Ladies Mile," the park had become bordered by vast cast-iron department stores, and other specialized "industries" — such as hotels, theaters, and piano showrooms — had also flocked to the neighborhood.

Hassam's view of this busy crossroads was likely taken from a perch atop the seven-story Century Building at the north end of the park, a structure housing a publishing company for which he had done some illustration work. Scanning from the left, he captures the blunt, protruding form of the Empire-style Union Square Hotel at the edge of his composition, the multibuilding complex of the Morton House Hotel and Union Square Theatre at center, and the giant double colonnade of the Domestic Sewing Machine Company at right. In the distance, the parallel thoroughfares of Fourth Avenue and Broadway extend the perspective to the hazy lower reaches of Manhattan, the prominent steeple of Grace Episcopal Church breaking the horizon just right of center. At the bottom of the composition, the humble roof of a public "comfort station" provides a more intimate bridge into the pictorial space.

With some background knowledge, these structures can be readily identified, but Hassam by no means paints an exacting architectural "portrait" of the square (indeed, several scholars have mistakenly assumed that his view faces north, rather than south). What seems to interest him are the contrasts inherent in this telescopic slice of urban topography: the twisting paths and relaxed islands of grass versus the rigidity of the densely built-up grid beyond, and the fresh colors of the budding leaves versus the smoky haze of the background. While the park might be seen as a refuge, it nevertheless possesses a sharp, acidic edge, with the close tones of Hassam's lichenous greens and pale yellows giving rise to scintillating optical vibrations. His paint fairly sizzles on the surface of the canvas, capturing the seasonal urban excitement the artist once referred to as "this Spring festival of life."

Further Reading

Fort, Ilene Susan. *Childe Hassam's New York.* San Francisco: Pomegranate Art Books, 1993.

Gerdts, William H. *Impressionist New York.* New York: Abbeville Press, 1994.

Hiesinger, Ulrich W. *Childe Hassam: American Impressionist.* New York: Jordan-Volpe Gallery, 1994.

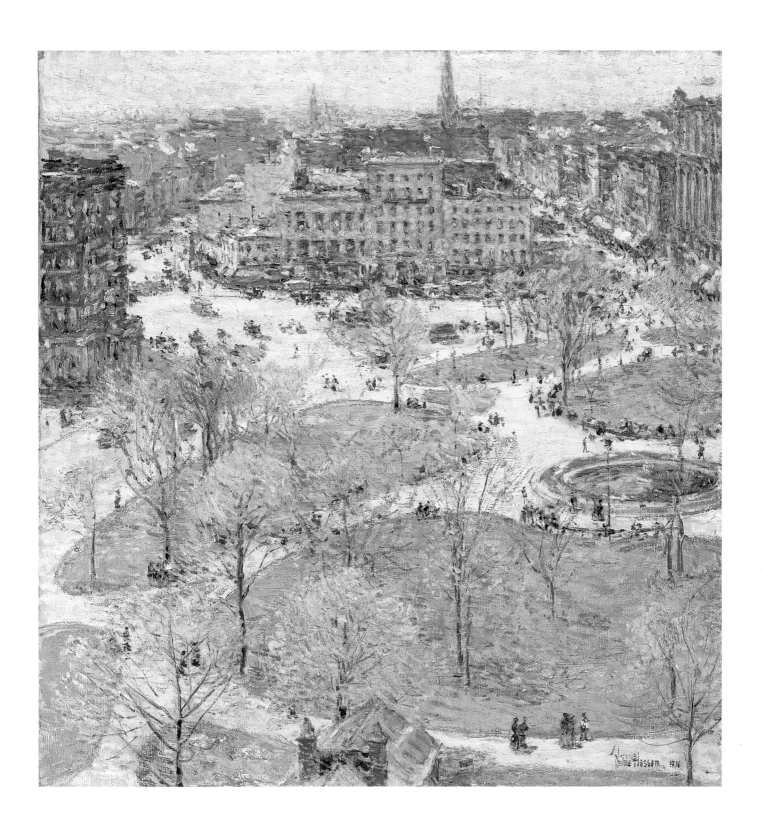

Childe Hassam

Dorchester, Massachusetts 1859–1935 East Hampton, New York

White Island Light, Isles of Shoals, at Sundown, 1899

Oil on canvas

27 × 27 in. (68.6 × 68.6 cm)

Signed and dated in maroon, purple, and black paint, lower right: Childe Hassam/1899; inscribed on back of canvas in brown paint over pencil, upper right: White Island Light Isles of Shoals/at Sundown./[initials in a circle, probably C.H.]/1899

Gift of Mr. and Mrs. Harold D. Hodgkinson (Laura White Cabot, class of 1922)

1973:51

Childe Hassam's views of New York constitute a remarkable artistic achievement, but his extremely productive career went far beyond the single category of "urban impressionist." Indeed, to judge by the numbers alone, the windswept Isles of Shoals, a cluster of bare granite outcroppings that rise from the sea ten miles off the coast of New Hampshire, became the artist's primary geographic touchstone; he is estimated to have executed some four hundred images of the islands during the three decades he visited them habitually. Individually and as a group, they are among the most luminous and brilliantly colored works of his oeuvre.

Hassam owed his experience of the Isles of Shoals to the poet and gardener Celia Thaxter, who had spent part of her childhood on White Island when her father served as keeper of the lighthouse, the same structure that is visible on the horizon in the Smith College painting. Her father later purchased several of the islands and developed them as warm-weather resorts, and as an adult she came to preside over a small artistic community that gathered each summer around her cottage on Appledore Island. Thaxter was renowned for her expansive beds of perennials, which she used largely as a cutting garden to provide a constant supply of flowers for her famed parlor, where Hassam was a regular guest. The two became devoted friends, and the artist began to work in a private studio nearby to enable him to paint the clouds of color that seemed to drift daily from her garden into her airy home. In 1894, however, Hassam lost his supportive friend to heart disease, and for the next five years he did not visit the island. When he returned in 1899, the year White Island Light, Isles of Shoals was painted, he began a new series of images that he would pursue for well over a decade.

With Thaxter gone, Hassam turned to the sea and began an extended exploration of the elemental confrontation of water and stone. Appledore was celebrated for its stark, vertiginous cliffs and its deeply cut fjords, such as South Gorge, the rugged inlet depicted here. Hassam takes full advantage of this dramatic topography, creating a shifting, almost galloping perspective with sudden visual plunges and abrupt leaps between two- and three-dimensional spaces. His brushwork is unusually assertive, with dry, bristling hatch marks swarming over his forms—the saturated cobalt blue, in particular, hovering insistently on the surface. These uniformly short strokes appear to arrange themselves like boldly colored iron filings, manipulated by some unseen magnet underneath the canvas. Yet the directionality of his brushwork also serves as the primary indicator of the varying textures described in the view: scratchy foliage bursting outward and spreading indiscriminately in the foreground, knobby protuberances swelling slightly in the rocks, and parallel ripples in the water creating a calmer impression of regularity and flow. It is resolutely conceptual in its construction, and in the end, we identify as much with the painterly act of dragging the loaded brush across bare canvas as with the affecting scene itself.

Further Reading

Curry, David Park. *Childe Hassam: An Island Garden Revisited.* Denver: Denver Art Museum, 1990.

Hiesinger, Ulrich W. *Childe Hassam: American Impressionist.* New York: Jordan-Volpe Gallery, 1994.

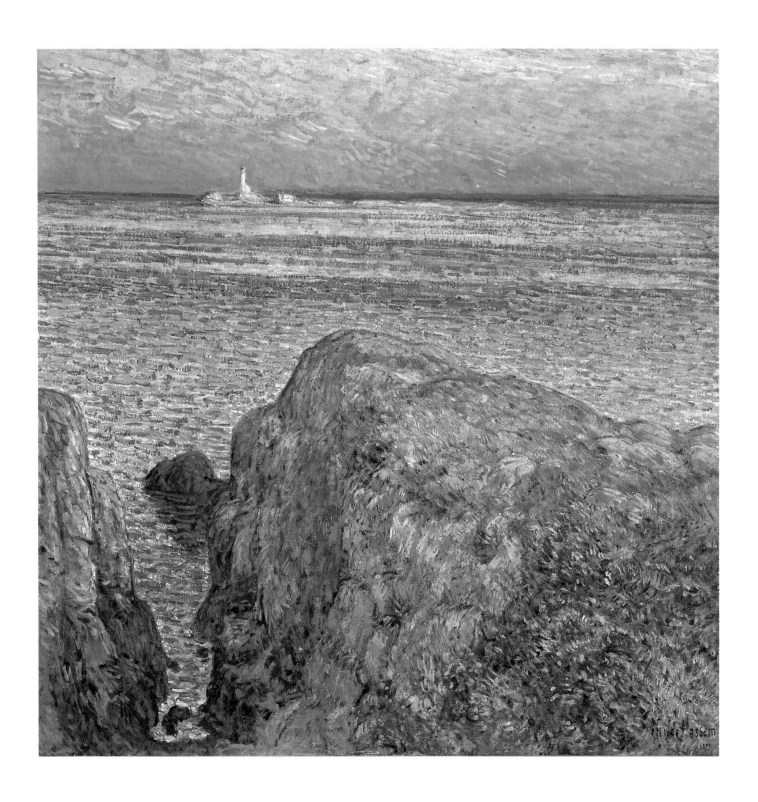

Martin Johnson Heade

Lumberville, Pennsylvania 1819–1904 Saint Augustine, Florida

New Jersey Meadows, c. 1871–75

Oil on canvas
15⅛ × 30⅛ in. (38.4 × 76.5 cm)
Signed in black paint, lower left: M. J. Heade
Purchased
1951:298

The life of Martin Johnson Heade was filled with contradictions. One of the most widely traveled nineteenth-century American artists, he nevertheless maintained a distinctly low profile in the cosmopolitan art capital of New York City. Socially and professionally unconnected, he was refused membership in the prestigious Century Association and National Academy of Design; one of his only artist friends was Frederic Edwin Church, whose grand, global landscape vision was the antithesis of Heade's small, intimate views of undramatic terrain. Though he sold hundreds of paintings, he went relatively unmentioned in the contemporary review literature. The critic James Jackson Jarves's tepid characterization of Heade's landscapes as "wearisome" in their "horizontal lines and perspective" was a typical comment. In this light, Heade's favorite subject of flat salt marshes seems appropriate to the man: ubiquitous and unremarkable, but also odd and lonely, even poignant in their celebration of the banal places bound by inland hills and the ocean shore.

Heade's marshes are actually fascinating "in-between" landscapes, flourishing environments for hardy strains of grasses that grow wild but were nevertheless harvested for a brief cutting season in late summer or early autumn—an unusual combination of the savage and the pastoral. Rutted and spongy, with snaking canals meandering into the distance, his resolutely horizontal landscapes seem to offer little to the eye accustomed to crashing waves or towering mountain ranges. Indeed, Heade's banded compositions seem to laugh in the face of received aesthetic theory regarding the picturesque and the sublime. Among the only notable pictorial elements are the huge haystacks—some in the nineteenth century rising to heights of twenty feet—which kept the salt grasses elevated and dry as they awaited use as fodder and packing. Perhaps their only visual comparison in American art is found in views of the western plains, where grazing buffalo dotting the prairie have a similar monumental presence.

New Jersey Meadows (the title was given the work in the twentieth century) may well depict the marshes near Hoboken, close to Heade's Manhattan home during the late 1860s and 1870s, but it could also refer to the Massachusetts marshes near Newburyport, where he first pursued this landscape subject. The tiny brown cow, in fact, with its curving back reiterating the lazy bend of the nearby canal, comes from a drawing in one of Heade's Massachusetts sketchbooks dated to 1862. The painting's proportions are normal for the artist: twice as wide as it is high, with nearly two-thirds of the canvas area devoted to the sky. Here, the changing effects of light and weather constitute the principal interest. A storm passes to the right, its screenlike sheet of dark rain giving way to blue sky and fluffier white cumulus clouds at the left. Bright sunlight breaks across the plain, setting the texture of its many-colored stipple strokes into relief. The absence of conventional framing motifs adds to the sense of movement and mutability. Heade's compositional elements—the clouds, the rutted ditches, the switchback canal, and the succession of haystacks receding infinitely into the distance—all induce a lateral rocking motion, a sweeping, panning vision that moves us naturally, not forcibly, through space. In the end, the artist takes advantage of his unpromising subject to connect the viewer with surprising effectiveness to the slow rhythms of the landscape.

Further Reading

Frazier, Nancy. "Mute Gospel: The Salt Marshes of Martin Johnson Heade." *Prospects: An Annual of American Cultural Studies* 23 (1998): 193–207.

Novak, Barbara, and Timothy A. Eaton. *Martin Johnson Heade: A Survey, 1840–1900.* West Palm Beach, Fla.: Eaton Fine Art, 1996.

Stebbins, Theodore E., Jr. with the assistance of Janet L. Comey and Karen E. Quinn. *The Life and Work of Martin Johnson Heade: A Critical Analysis and Catalogue Raisonné.* New Haven, Conn.: Yale University Press, 2000.

Winslow Homer

Boston, Massachusetts 1836–1910 Prout's Neck, Maine

Shipyard at Gloucester, 1871

Oil on canvas
13½ × 19¾ in. (34.3 × 50.2 cm)
Signed and dated in reddish brown paint, lower left: HOMER '71
Purchased
1950:99

With the end of the Civil War in 1865 and the completion of his first trip to Europe in 1867, Winslow Homer found himself free, in the late 1860s and early 1870s, to explore a range of new subjects—quite a few of them stemming from his experiences of the varied activities and terrain of the Atlantic seacoast. Whereas earlier he had evinced a mild interest in the touristic, leisured environment of Long Branch, a bathing place on the New Jersey shore, Homer was attracted instead to the traditional maritime trades of fishing and boat-building in Gloucester, Massachusetts (much like his predecessor Fitz Hugh Lane, the painter most associated with the site). The idle summer visitors who had been flocking to the Cape Ann port for several decades make no appearance in the Gloucester works that occupied Homer off and on throughout the 1870s.

Shipyard at Gloucester, a broadly brushed but careful study, is an important foundation work for this series. For some time, however, its title and identification have been disputed by scholars. According to the written record, Homer's earliest documented trip to Gloucester took place in 1873, thus the date of 1871, clearly painted by the artist in the lower left corner, suggested to many authorities that the location depicted in this work was necessarily another seaport, perhaps nearby Essex. Comparison with a securely documented contemporary photograph of the David A. Story shipyard in Gloucester Harbor, however, has affirmed the title. Homer clearly visited the port of Gloucester prior to the trip of 1873; the architectural details at left and right are unmistakably local. Though it is difficult to believe that there could still be lacunae in the biography of this much-studied artist, the Smith painting nevertheless stands as the only trace of Homer's initial visit to the harbor.

Beyond the realm of art history, the painting provides valuable information to naval historians regarding the construction of the typical Gloucester fishing schooner, or "clipper." Well over a dozen workers surround the hull, busily drilling, hammering, and planing. The distinctive outline of the local type of ship, with its sharply pointed ends, wide beam, and flattened bottom (so as better to navigate the shallow harbor of Gloucester), is readily apparent, as are the traditional methods of craftsmanship in use before the advent of power tools. Though anonymous, the shipbuilders are presented as a team, their black silhouettes nicely punctuating the solid, planar form of the hull. There is something heroic about the sleek vessel elevated on a kind of pedestal. Dwarfing its makers, it is lifted suggestively at the bow, as if already mounting a heaving Atlantic wave.

This effect is heightened by the dramatic perspectival rush of the foreground, with the thick oak slabs fanning out laterally and leading the viewer's eye to the gangboard and scaffolding. Homer accentuates the raw, solid qualities of these materials—still bearing the imprint of nature in their organic profiles and bark-lined edges. With the visually cacophonous pile of squared-off beams added at the left and the pervasive textures and warm tones of sawdust and wood shavings throughout, we are left to wonder at the ability of these workers to transform such rude building blocks into an object of such calculated refinement. Two years later, when Homer used this composition as the background for an engraving depicting several Gloucester boys intently building their own toy boats, the generational nature of this craft tradition, passed from fathers to sons, was also underscored.

Further Reading

Atkinson, D. Scott, and Jochen Wierich. *Winslow Homer in Gloucester.* Chicago: Terra Museum of American Art, 1990.

Hendricks, Gordon. *The Life and Work of Winslow Homer.* New York: Harry N. Abrams, 1979.

Ronnberg, Erik A. R., Jr. "Vincent's Cove in the 1870s: A Pictorial Record of Gloucester Shipbuilding." *Nautical Research Journal* 41 (December 1996): 209–18.

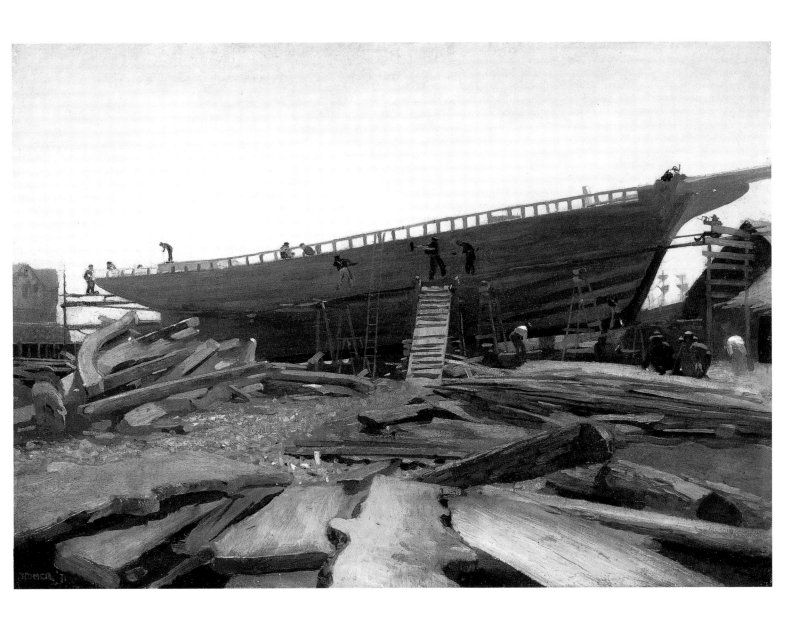

Edward Hopper

Nyack, New York 1882–1967 New York, New York

Pretty Penny, 1939

Oil on canvas

29 × 40 in. (73.6 × 101.6 cm)

Signed in green paint, lower right: EDWARD HOPPER

Gift of Mrs. Charles MacArthur (Helen Hayes, LHD, class of 1940)

1965:4

Edward Hopper's *Pretty Penny* is, on the one hand, closely linked to the formative years of the artist and to his lifelong pursuit of American architectural subjects; on the other hand, it stands as a complete (and even painful) anomaly in his career, a work he likely would have preferred never to have executed. The house depicted stands just down the road from Hopper's boyhood home in Nyack, some forty miles north of New York City. The Hopper home, built by the artist's maternal grandfather, was modest in comparison with its twenty-room neighbor, but its bracketed, clapboard exterior was of the mid-nineteenth-century vernacular tradition Hopper grew to love, memorably describing it as "our native architecture with its hideous beauty, its fantastic roofs, pseudo-Gothic, French Mansard, Colonial, mongrel or what not."

By the late 1930s, Hopper had become celebrated for his moody, haunting evocations of neglected revival-style homes, often bordering railyards or otherwise relegated to the dusty margins of formerly thriving towns. It was knowledge of this predilection that prompted the actress Helen Hayes and her playwright husband, Charles MacArthur, to attempt to commission the artist to paint a "portrait" of their large home in Nyack, which they had purchased in 1930, renamed Pretty Penny, and restored with great effort. The combination of Hopper's status as a neighborhood boy made good and the busy, eclectic exterior of their home—which they considered a sympathetic example of the typical Hopperesque architectural mode—no doubt seemed like the perfect match of artist and subject.

Hopper, however, unaccustomed to accepting commissions of any type, chafed at the imposition of a subject not of his choosing. After grudgingly making a trip to Nyack to scout the site, he pronounced the house unpaintable. "There's no light and there's no air that I can find for that house," Hayes remembered him complaining. Mindful of the celebrity of the patron and the generous fee of $2,500 that was offered, Hopper's wife, Jo, and his dealer, Frank Rehn, worked hard to convince the artist to reconsider. In the end, he rode the bus up from New York on two subsequent November days. Avoiding contact with Hayes as much as possible, he sat alone in the cold, making a series of careful drawings of the house. Jo Hopper's diary records his attempts to find the right angle that would allow him to simplify the façade—clarifying the lines, making it less fussy, and countering the homey, sweet appearance that Hayes and MacArthur had spent so much time achieving.

The chilly winter sunlight Hopper encountered helped to deaden the cheery mood of the house, and the bristly textures of the long, curving evergreen boughs, seemingly raking the picture surface from the upper left corner, effectively keep the assertive, sculptural details of the house in check, somewhat collapsing the three-dimensional qualities of the image. The angular, slanting shapes of the low shrubs are worked with a rougher style of brushwork than the house, imparting a sense of visual movement that also counteracts its more regular geometries. Though it must have been galling for Hopper to paint each of the individual brackets and clapboards of the house, they are treated, in their shadows, with a cool blue tonality not out of keeping with the artist's normal aesthetic. The warm light and glimpses of furniture in the windows, however, give Pretty Penny an open and friendly air, in contrast to the charged, anguished qualities of so many of his other domestic subjects.

Using a squared-off grid to transfer the composition from his drawing, Hopper actually completed the painting in relatively short order just before Christmas 1939. Fending off a last-minute request from Hayes to include her daughter, Mary, and her pet poodle, Camille, in the composition, Hopper must have been relieved to turn the finished composition over to his dealer. He never again accepted a commission.

Further Reading

Goodrich, Lloyd, et al. "Six Who Knew Edward Hopper." *Art Journal* 41 (Summer 1981): 125–35.

Hobbs, Robert. *Edward Hopper.* New York: Harry N. Abrams, 1987.

Levin, Gail. *Edward Hopper: An Intimate Biography.* New York: Alfred A. Knopf, 1995.

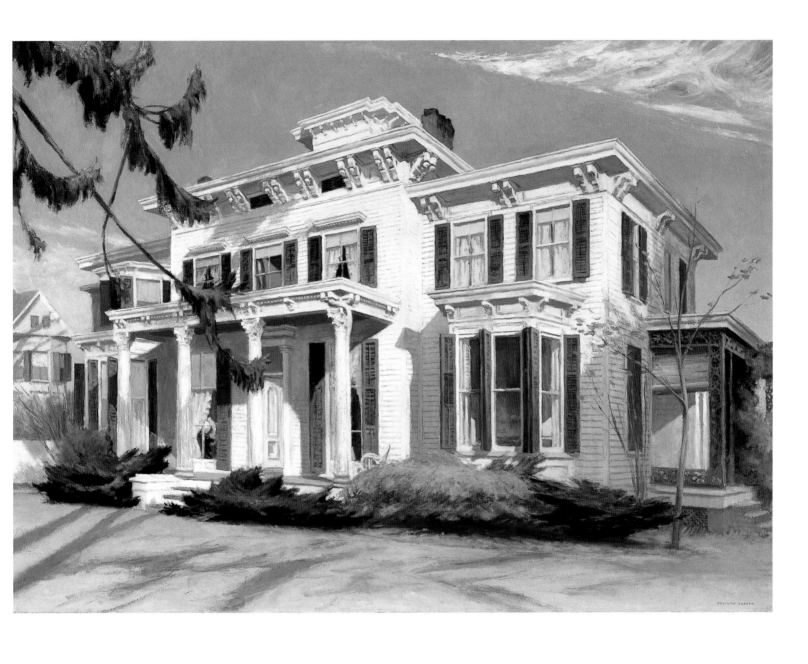

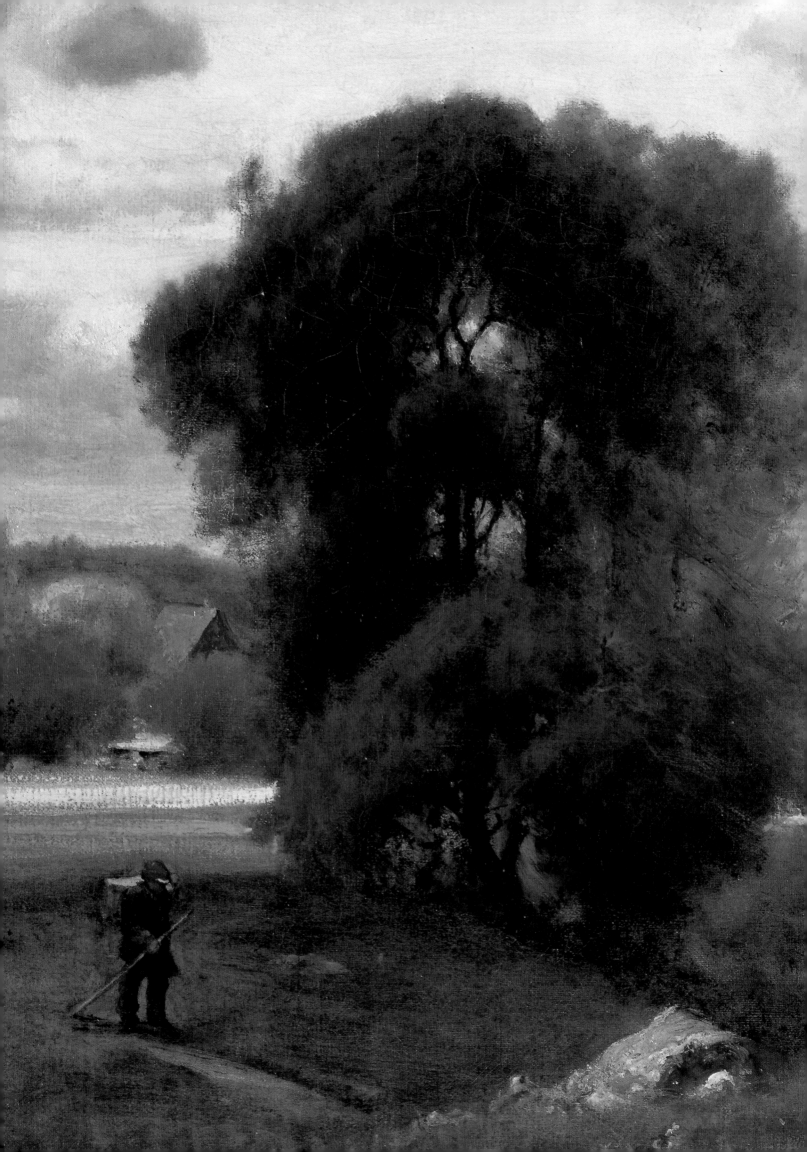

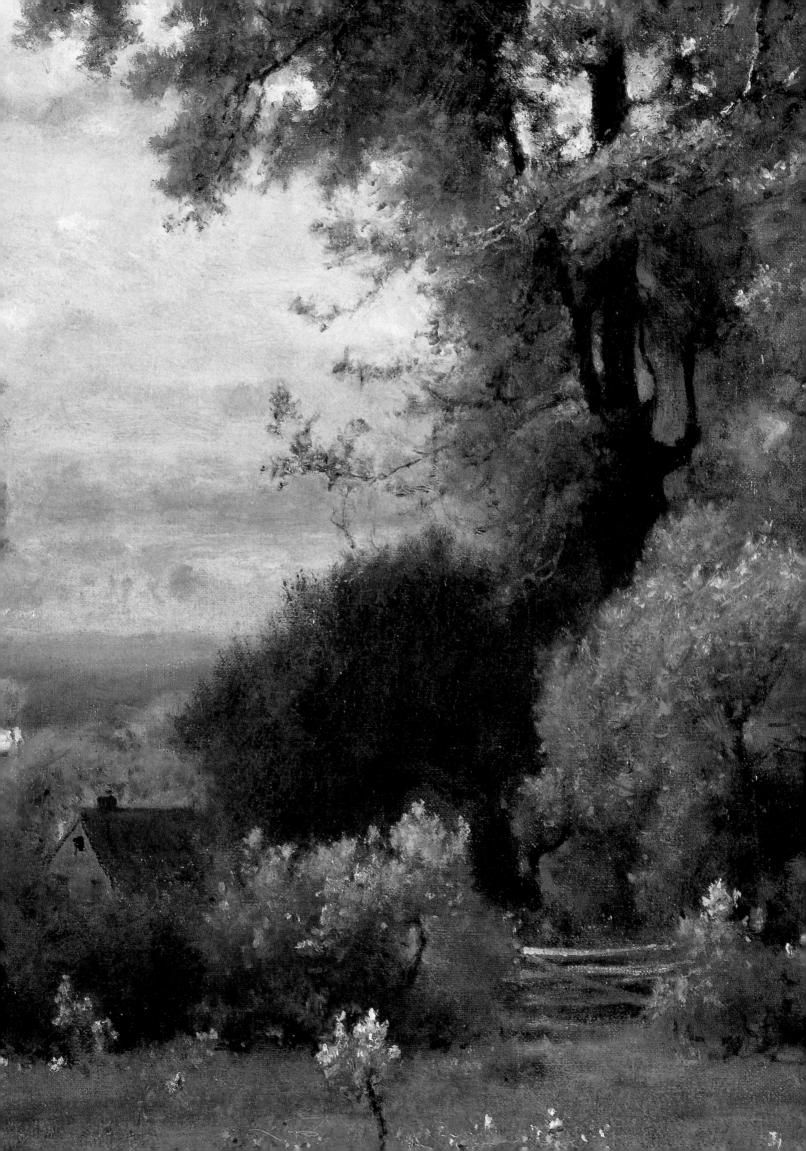

George Inness

Newburgh, New York 1825–1894 Bridge-of-Allan, Scotland

Landscape, 1877

Oil on canvas

25⅝ × 38½ in. (65.1 × 97.8 cm)

Signed and dated in black paint, lower right: G. Inness 1877

Bequest of Frank L. Harrington in honor of Louise Cronin Harrington, class of 1926

1989:6

Almost single-handedly, George Inness can be credited with effecting a sea change in that most important category of mid-nineteenth-century American art, landscape painting. Although he began his career in the mid-1840s at the same time as such luminaries of the Hudson River School as Frederic Edwin Church and Jasper Cropsey, within little more than a decade Inness had largely abandoned their careful approach to botanical and geological detail, as well as their grandiose, panoramic embrace of more terrain than the eye and brain can easily comprehend. Profoundly affected by the looser, more subdued style of the French Barbizon painters (whose work he studied during several European sojourns), Inness gradually moved toward a ruminant, painterly means of expression, one richly imbued with undertones of nostalgia, quietism, and mysticism. By the time of his death, he had become lionized as a poetic seer whose landscape vision had surpassed that of every other artist in the nation.

Part of Inness's innovative approach was a retreat from geographically specific scene painting; thus his Landscape, an important example of his mature style of the late 1870s, cannot be definitively associated with a particular place. After returning from his third European trip in 1875, he lived in Medfield, Massachusetts, near Boston, for two years and then moved to the New York area, painting in northern New Jersey and settling definitively in Montclair in 1878. This composition might be derived from any of these places, or from another location visited by the artist in earlier years; the "facts," Inness would have argued, are unimportant, as is the social utility or "message" that critics of painting often searched for at the time. Just a year after finishing Landscape, Inness made one of the many aesthetic pronouncements to which he was prone: "A work of art does not appeal to the intellect," he wrote. "It does not appeal to the moral sense. Its aim is not to instruct, not to edify, but to awaken an emotion."

The emotions awakened by Landscape necessarily depend on the individual viewer, but its general themes are favorites to which Inness returned again and again: a lone "peasant" figure moving slowly through the middle ground, a settled landscape with farm structures dotting the terrain, and a pronounced pictorial focus on a single tree — in this case forming the compositional crux around which his several, partially obscured vignettes seem to pivot. The brushwork of the painting is not at all consistent, as though the artist changed stroke with each passing mood. Thus the bright field at left is a boldly applied, uninterrupted streak of rich yellow paint, while the surrounding foliage is composed of his more characteristic dabbing. At times his brush is quite dry, used to indicate scratchy, tentative branches against the sky or the broken textures of the darkened foreground. Scale (among the figure, the log, the fence, and the nearby cottage) also appears unresolved, but overall, a soft, billowing impression and a certain sobriety of tone bring these elements into accord. Time seems heavy, and Inness leaves the viewer, as in all of his most successful canvases, with a suggestive, wistful distillation of memory and mood.

Further Reading

Cikovsky, Nicolai, Jr., and Michael Quick. George Inness. Los Angeles: Los Angeles County Museum of Art, 1985.

Gerdts, William H., et al. George Inness: Presence of the Unseen. Montclair, N.J.: Montclair Art Museum, 1994.

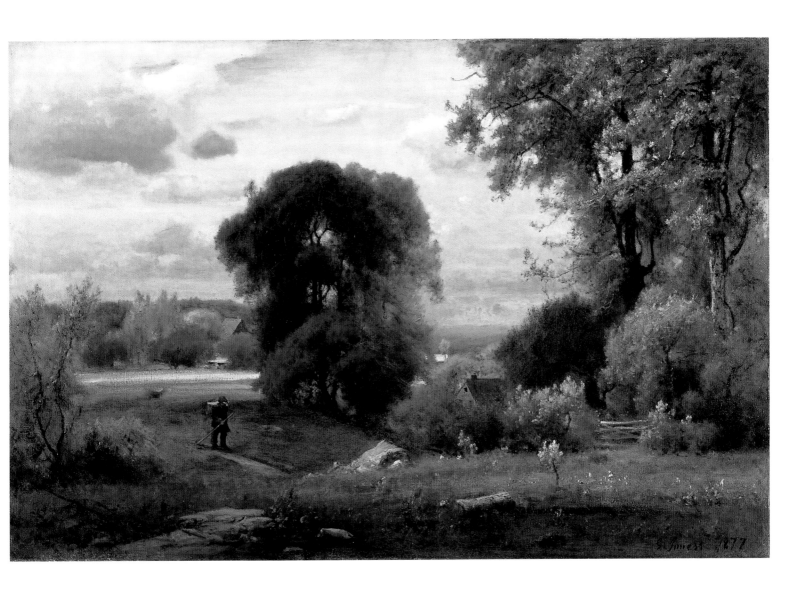

Rockwell Kent

Tarrytown, New York 1882–1971 Au Sable Forks, New York

Dublin Pond, 1903

Oil on canvas

28 × 30 in. (71.1 × 76.2 cm)

Signed and dated in blue paint, lower right: Rockwell Kent 1903

Purchased, Winthrop Hillyer Fund

1904:2-1

Dublin Pond was Rockwell Kent's first professional success, a work that exhibits the influence of his powerful mentor, Abbott Thayer, but also shows a more modern exploration of abstraction and compositional simplicity. Although he had studied briefly with William Merritt Chase as a teenager, the young Kent was still very much a student when he arrived in Dublin, New Hampshire, in the summer of 1903. Thanks to an introduction from his aunt, an amateur painter who had formerly studied with Thayer, the older artist had invited Kent to serve as his assistant, participating in the unusual studio practice he devised to safeguard his paintings against his own unstable nature and unpredictable experimentation in brushwork. Once he had worked a painting to a certain degree of finish, Thayer had it copied by one of his students and then worked further on the copy to push forward his conception, only returning to the original when it was clear that he had not ruined the initial motif.

As it turned out, Thayer had little need of an assistant that summer, and, impressed by Kent's ability, he encouraged him to paint on his own. The degree to which anyone in the tightly knit Thayer ménage could do that, however, is questionable. Highly idiosyncratic and domineering, the older artist demanded near-worship from his family and students. All were forced to bow to his odd notions of rustic living, and his own version of transcendental mysticism was the local gospel. This included an awed reverence for the blunt, hulking form of nearby Mount Monadnock and the quiet calm of Dublin Pond. Thayer's repeated exploration of these subjects usually took the form of somewhat top-heavy compositions with the central motif of the pine-clad mountain arcing gently against a narrow band of sky and trailing off to unfinished empty space below. This, not surprisingly, became the conceptual template for Kent as well.

Still, *Dublin Pond* is no slavish copy of Thayer's obsessive image. Its slablike, squarish arrangement of forms is much more elemental, even brutal, than his teacher's work. At the same time it is also contrived and consciously aesthetic in its reduced, close-keyed palette and its Asian-inspired asymmetry and subordination of the parts to the whole. The reflective surface has the quality of baked enamel, yet close examination reveals a textural relief of many layers of impastoed application. The eye is drawn to the borders of the interlocking parts: the irreal glow of the mint green sky meeting the blue-black mountain and, below, its darkened, ragged-edged reflection stitched together with the luminous water by Kent's splintered brushstrokes. With these extremes of contrast, one has to look hard to discern the delicate, thin forms of the evergreen trees and architectural structures along the water line. These subtle details nicely complicate the first impression of the painting as monolithic and starkly iconic. All told, it was a rather audacious decision by L. Clark Seelye to acquire *Dublin Pond* out of the Society of American Artists exhibition of 1904; it became the first public purchase for the little-known artist.

Further Reading

A Circle of Friends: Art Colonies of Cornish and Dublin. Durham, N.H.: University Art Galleries, 1985.

Kent, Rockwell. *It's Me, O Lord.* New York: Dodd, Mead & Co., 1955.

West, Richard V., et al. *"An Enkindled Eye": The Paintings of Rockwell Kent.* Santa Barbara, Calif.: Santa Barbara Museum of Art, 1985.

Franz Kline

Wilkes-Barre, Pennsylvania 1910–1962 New York, New York

Rose, Purple and Black, 1958

Oil on canvas
45 × 36⅛ in. (114.3 × 91.8 cm)
Signed and dated on back: Franz Kline 1958
Gift of Mrs. Sigmund W. Kunstadter (Maxine Weil, class of 1924)
1965:27
© 2000 The Franz Kline Estate/Artists Rights Society (ARS), New York

Although Franz Kline had been painting in New York in a variety of styles for over a decade, it was not until his one-person exhibition at the Charles Egan Gallery in 1950 that he burst into the critical limelight and popular consciousness. There he showed eleven large abstract canvases in what would become his signature mode of expression: stark arrangements of thick black bars seemingly moving through a worked white environment with the force of pile drivers. While only two of the paintings found buyers (they were priced at about $700 each), Kline's breakthrough style became seared into the minds of the writers, collectors, and artists who followed Abstract Expressionism. He would continue this path of exploration fruitfully for the rest of his comparatively short career.

Rose, Purple and Black, as the title implies, comes from the last period of Kline's work, when he allowed color to become more of an integral compositional agent than it had been in the "classic" black-and-white images of the early 1950s. Still, the complex, layered surface of the painting, along with the additive working method of the artist, ensures that viewers must become intimately acquainted with his active brushwork in order to discern its surprising chromatic range. Indeed, this invitation to "watch it happen" as his stratified relief of strokes takes shape constitutes one of the thrills of studying a Kline, a close-up pleasure in the fullness of his paint that is completely different from the experience of viewing his powerful, outsize compositions from a distance. Despite the slapdash appearance of his works (especially apparent in the splinterlike drips of black paint at the bottom in *Rose, Purple and Black*), Kline usually planned his paintings carefully, often working from smaller ink or oil-on-paper sketches. It was not uncommon for the thick black forms to be laid down over time with small brushes, and the major compositional elements were continuously tested, shifted, and painted over in an attempt to work out the optimal dynamic balance of weight, value, and hue.

In *Rose, Purple and Black*, this process is conspicuous in the disparity between the upper and lower forms. While the horizontal bar at the top is painted vigorously over lighter paint, the white and pink below are pulled back over the black in ragged, broken strokes, intensifying the sense of a void or recess. (Kline insisted, "I paint the white as well as the black, and the white is just as important.") The jumble of dragged, slashing strokes often allows fleeting glimpses through several layers to areas of colorful paint far more varied than the title would suggest. A deep red ground can be seen at the edges, for example, and in the mix of wet-into-wet touches throughout the work, shades of orange, brown, gray, silver, and light blue can be distinguished. In this respect, the blunt, near-monolithic, trapezoidal image and its dense envelope of creamy white can be understood as a pictorial result built on a process of gradual concealment. As Kline was once reported to say approvingly about the surfaces of the works of Albert Pinkham Ryder, "There are seven or eight others underneath it you can't tell about."

Further Reading

Anfam, David. *Franz Kline: Black and White, 1950–1961.* Houston: The Menil Collection, 1994.

Gaugh, Harry F. *The Vital Gesture: Franz Kline.* New York: Abbeville Press, 1985.

Paul Manship

Saint Paul, Minnesota 1885–1966 New York, New York

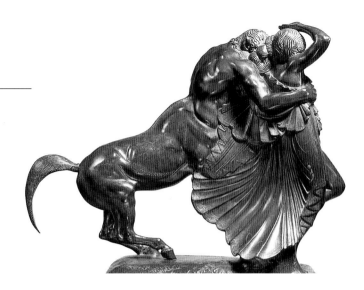

Centaur and Dryad, 1913, cast 1915

Bronze (edition 4/5)

28 × 18½ × 11½ in. (71.1 × 47 × 29.2 cm)

Signed and dated on ground on which figures stand: PAUL MANSHIP © 1913; inscribed on base edge, front left corner, below frieze: ROMAN BRONZE WORKS-N-Y-

Purchased from the artist

1915:14-1

Paul Manship's mature career began with a stunning, overnight success in 1913. Returning from a three-year fellowship at the American Academy in Rome, the sculptor showed ten small works at the Architectural League in New York. Sales were immediate, and the glowing reviews created a sensation. Of the exhibited sculptures, *Centaur and Dryad* received the most attention. Awarded the Barnett Prize by the National Academy of Design, it became even further distinguished when the Metropolitan Museum of Art purchased a cast of it in 1914. A year later, Smith College also bought a cast of *Centaur and Dryad*, making it the fourth acquisition from the artist in a matter of months and establishing the college as one of his strongest institutional supporters. Manship, clearly pleased with Smith's latest purchase, wrote art professor Alfred Vance Churchill in March 1915, "The 'Centaur and Dryad' is the piece, of all my small bronzes, on which I have expended the greatest effort; in fact, it was in the process of making, from the time that I began it until the day of its completion, for four years. I have always considered it, therefore, to be the best... of the small bronzes."

The long gestation period for *Centaur and Dryad* is closely tied to Manship's time in Rome, where his art underwent an evolution from a dramatic, tactile expressionism to a more taut, distilled stylization. His residency in Italy—far from the more popular and cosmopolitan Paris, where Auguste Rodin's tremulous, impressionistic surfaces were still the dominant mode—placed a lifelong aesthetic stamp on his oeuvre, but more important still was his six-week trip to Greece in 1912, where he discovered the streamlined, pure expression of preclassical, archaic sculpture. As Manship wrote of this then-underappreciated period, "We feel the power of design, the feeling for structure in line, the harmony in the division of spaces and masses—the simplicity of the flesh admirably contrasted by rich drapery, every line of which is drawn with precision."

Centaur and Dryad is a remarkable melding of the archaic love of etched pattern, smooth surfaces, and sin-

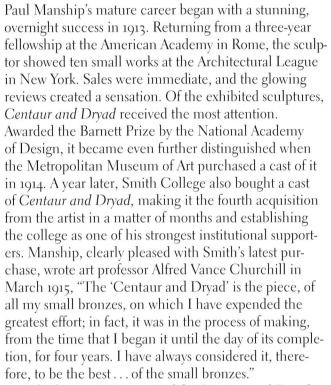

uous line with a modern predilection toward abstraction and a surprisingly intense evocation of passion and desire. The aggressive mood of the struggle between centaur and nymph is set by Manship's complex pedestal, with its bacchic grapevines snaking over the cushioned base, its exaggerated depictions of bawdy satyrs and maenads in low relief, and its inventive lower frieze of running animals (a fox catching a rabbit, a lion attacking a gazelle, rams butting heads, and so forth). Above, the meaty right arm of the centaur encircles the fleeing dryad as he rears back on his hind legs. Her garment, fanning out behind in a rhythmic series of radiating swallowtail folds, is secured only by a single band below her breasts, thus revealing her naked, open body for display. A study of dynamic torsion, she turns her head sharply away from the hot breath of the centaur, who pulls her shoulder toward him in the opposite direction. Her knee, still seemingly moving forward, cuts through space like the prow of a ship, while his tail answers with a downward, slicing curve like a scimitar. Although the schematized composition favors the frontal view, the frenzied conflict is even more apparent from the back, where the centaur's face is completely hidden as he burrows into her neck, their hair writhing and intertwining like a nest of twisting snakes. While this elevated level of emotion might seem a surprising addition to the collection of a women's college in 1915, President L. Clark Seelye nevertheless rationalized its presence on campus. Commenting shortly after its acquisition, he described Manship's theme as "the struggle of the beastly with the womanly," dryly concluding, "Smith is a most appropriate place for it."

Further Reading

Paul Manship: Changing Taste in America. Saint Paul: Minnesota Museum of Art, 1985.

Rand, Harry. *Paul Manship.* Washington, D.C.: Smithsonian Institution Press, 1989.

Rather, Susan. *Archaism, Modernism, and the Art of Paul Manship.* Austin: University of Texas Press, 1993.

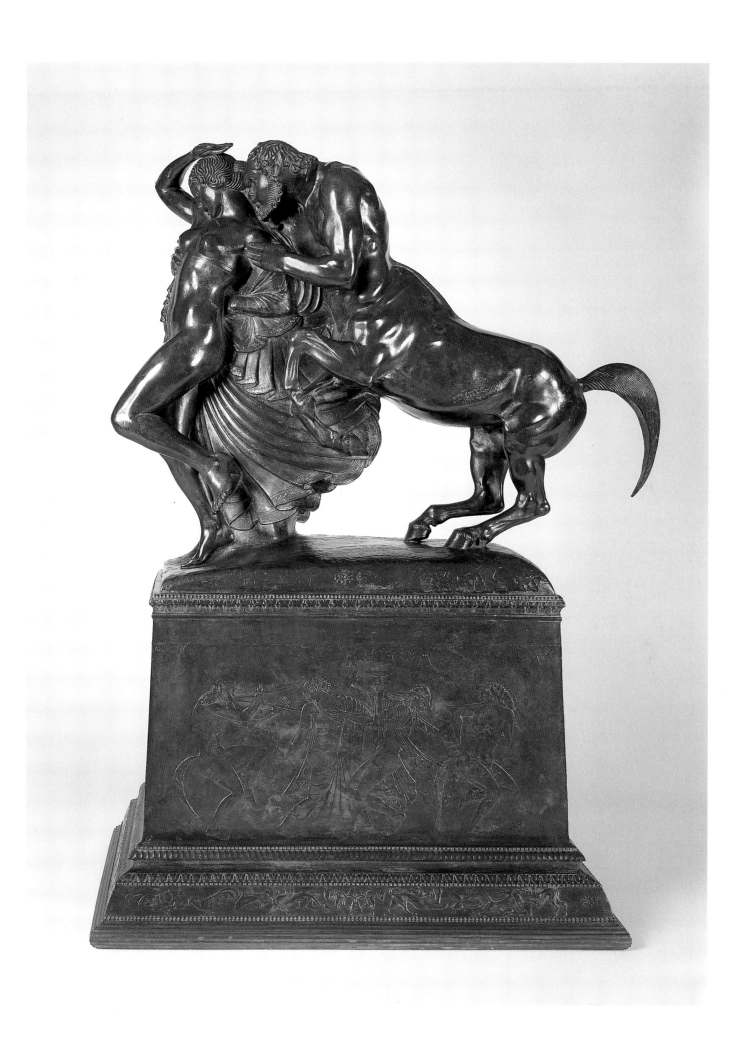

Alfred Henry Maurer

New York, New York 1868–1932 New York, New York

Le Bal Bullier, c. 1900–1901

Oil on canvas

28¹³⁄₁₆ × 36⁵⁄₁₆ in. (73.2 × 92.3 cm)

Signed in black paint, lower right: Alfred H. Maurer

Purchased

1951:283

As one of the earliest "finds" of the avant-garde dealer Alfred Stieglitz, A. H. Maurer is most often remembered as a pioneering twentieth-century American modernist whose still lifes and figure studies bear the imprint of Cubism and, especially, Henri Matisse's Fauvism. This abstractive work was never greatly appreciated in its day, and Maurer, who committed suicide after several decades of professional disappointment, is generally viewed as a casualty of the American public's refusal to support the progressive formal explorations of European-influenced artists between the world wars. Before he moved away from a more naturalistic mode, however, Maurer had achieved a relatively impressive record of success, winning the lucrative Carnegie Prize in 1901 for his Whistlerian *Arrangement* of an anonymous female model in aesthetic dress amid Asian studio props (Whitney Museum of American Art, New York).

In retrospect, the late 1890s and the first few years of the new century can be seen as the most engaged and fulfilling of Maurer's career. An expatriate living on the Left Bank of Paris, he threw himself into the lively bohemian community of young artists. Known for his love of cafés and dance halls, he cut a dandified figure in cape, spats, and felt hat. Although he was somewhat older than many of his friends, he nevertheless played an important social role in the Montparnasse community, which included Robert Henri, Mahonri Young, and George Luks, among others. It was during these years, about 1900–1904, that he painted a series of dark interiors of Parisian amusement palaces. Combining the impressionist love of the fragmented, charged spaces of

the public *café-concert* with the somber palette and direct application of paint of the Ashcan school, these works (many of which were lost in the aftermath of World War I) speak movingly of Maurer's identification with and sensitivity to the hard-worn working-class crowds who populated large emporia such as the Bal Bullier, a huge enclosed garden–dance hall popular at the time with students, clerks, and servants.

To judge from the number of times Maurer sent it to exhibitions, *Le Bal Bullier* was a painting of which he was particularly proud. In it he managed to capture both the unusual scale of the establishment—the cavernous dining area illuminated by electric lights and extending ambiguously into the distance—and the poignant loneliness of the edge of the dance gallery, where a few remaining clients take their last spin on the floor or simply pause and watch on their way out, holding their wraps. There is a suggestion of desperation in the manner in which the faceless dancers—heavy-footed, shadowy men embracing bony, teetering women—clutch their partners and lurch about the empty space. At the left, a trio of angular, slouching women, each one clad in a dingy shirtwaist and made up so as to exaggerate her coarse, blasé features, deflects attention toward the picture's edge, where a cut-off figure in a Spanish skirt hints at still another spectacle. Rising above it all is the presiding, ominous silhouette of a top-hatted man, whose isolation, anonymity, and elevated position of surveillance suggest connections to the viewer, or to the artist himself.

Further Reading

Madormo, Nick. "The Early Career of Alfred Maurer: Paintings of Popular Entertainments." *American Art Journal* 15 (Winter 1983): 4–34.

McCausland, Elizabeth. *A. H. Maurer.* New York: A. A. Wyn, 1951.

Reich, Sheldon. *Alfred H. Maurer, 1868–1932.* Washington, D.C.: National Collection of Fine Arts, 1973.

Willard Leroy Metcalf

Lowell, Massachusetts 1858–1925 New York, New York

Willows in March, 1911

Oil on canvas
26 × 29¹/₁₆ in. (66 × 73.8 cm)
Signed in gray paint, lower left: W. L. METCALF
Gift of Mrs. Charles W. Carl (Marie Schuster, class of 1917)
1955:7

Although Willard Metcalf began his career as a student of painting at the age of seventeen, he would have to wait until he was nearly fifty before achieving unqualified professional success. Throughout his student years in France and during most of his early maturity, his Barbizon-inspired work was generally well regarded, but financial stability was elusive, and a penchant for hard living at the edges of social propriety in New York took its toll on his personal life. It was in a moment of crisis and near-breakdown in 1904 that Metcalf, penniless, left the city and traveled to Maine to spend almost a year with his elderly parents. There he found spiritual and professional revitalization in the surrounding landscape. The confident, more resolutely impressionist canvases with which he returned in 1905 were immediately acclaimed as a stylistic breakthrough. Metcalf had found his principal subject matter in the New England terrain, and, fueled by increased sales and enthusiastic criticism, he flourished in his pursuit of the gentle, seasonal qualities of a region that, more than any other, had taken on tones of mythic nostalgia for Americans.

Willows in March is one of an important group of meditative winter scenes executed during yet another period of renewal and growth in the spare landscape of northern New England. Rebounding from an embarrassing divorce after his first wife left him for another painter, Metcalf somewhat impetuously asked Henriette McCrea, a woman nearly three decades his junior, to marry him. This they did in January 1911, spending the first few months of their married life in the quietly off-season art colony of Cornish, New Hampshire. In a sustained burst of exploration and creativity, Metcalf embarked on what historians now see as his single most successful year of painting. In particular, he tackled the pastel nuances of winter snowscapes, actually taking his easel outdoors and painting full-scale canvases in freezing temperatures.

Metcalf moved often in his work between a softly ruminant Tonalism and a more vigorously textured Impressionism, but in his winter scenes, the close-keyed, shrouded environments prompted some of his purest explorations of the former mode. Of these, Willows in March is pushed to an unusually abstractive extreme, with its shallow, tipped-up space, its meandering lines of scalloping hills, and its wispy screen of shrubs and saplings—the feathered tips of their branches seemingly hovering like tinted aureoles. The areas of snow are formed by a thick, relatively smooth blanket of pastelike paint, while the more tentative lines of the lavender-gray twigs are dragged fleetingly over this surface with a thin, dry brush. Metcalf uses a white glaze to unify the color scheme further—diminishing value contrasts, eradicating deep shadows, and lessening any remaining effect of depth. A silvery ether seems to cling to the painting's forms, and its texture and light leave an impression of insubstantiality akin to a translucent, tissue-paper collage. These subtleties were noted by quite a few reviewers, and the artist evidently thought it an important work as well: Within two years of its execution, he had included it in six important exhibitions before it was purchased by a Boston patron.

Further Reading

De Veer, Elizabeth, and Richard J. Boyle. Sunlight and Shadow: The Life and Art of Willard L. Metcalf. New York: Abbeville Press, 1987.

MacAdam, Barbara J. Winter's Promise: Willard Metcalf in Cornish, New Hampshire, 1909–1920. Hanover, N.H.: Hood Museum of Art, 1999.

Joan Mitchell

Chicago, Illinois 1926–1992 Paris, France

Untitled, c. 1960

Oil on canvas

50 × 38 in. (127 × 96.5 cm)

Signed in brown paint, lower right: J. Mitchell

Purchased with funds given by Mrs. John W. O'Boyle (Nancy Millar, class of 1952)

1981:30

Though her time in Northampton does not seem to have had any lasting effect on her work, Joan Mitchell holds the distinction of being the only abstract expressionist to have attended Smith College. She spent two years there beginning in 1942, later finished her undergraduate training at the Art Institute of Chicago, and subsequently passed a seminal fellowship year in France in 1948–49. She then returned to New York City, immediately immersing herself in the exciting downtown community of painters whose joint exploration of "heroic" subjects and grandly scaled nonrepresentational spaces had already crystallized into the loose movement now known as Abstract Expressionism. Greatly affected by the works of Arshile Gorky, Franz Kline, and Willem de Kooning, Mitchell adopted the strong gestural language of these painters; she soon became one of the few women accepted into their "club" as a peer.

With a tenacious philosophical consistency, Mitchell would remain devoted to this revelatory means of expression for over four decades. Disproving the thesis that "action painting" was inextricably linked to New York, she worked for most of this long period in France, where she moved in 1955 for part of each year, residing there more or less permanently as of 1960. Though her work went through a number of transformations during her career, her particular brand of Abstract Expressionism is notable for its richly varied spectrum of bright colors and its dependence on landscape imagery, which Mitchell claimed she never painted directly but rather experienced through emotion-tinged memories.

Smith College's untitled canvas was likely painted in 1960, during the last summer that Mitchell worked in the United States, when she visited East Hampton, New York, with her partner and fellow artist, Jean-Paul Riopelle, and his children. The temporary studio conditions of that visit might have led to the unfortunate flattening of the thickest areas of impasto (the still-tacky work was evidently stacked with another canvas, which has left the imprint of its weave in a number of areas of raised paint), but in every other respect it is a powerful example of what Mitchell would later describe as the "very violent and angry paintings" of the early 1960s.

The composition is anchored by several jostling horizontal bars of dark paint that serve as a kind of foundation for the explosion of crisscrossing strokes above. Mitchell's palette is unusual, with almost all the colors consisting of secondary or tertiary hues—violet, mustard yellow, brick red, evergreen, turquoise, and earthen brown. The individual touches throb in intensity against the painted white ground (an important formal component in all the work of her early maturity), but the coloristic mix nevertheless remains a bit muddy and confused. The tangled, chaotic brushwork is also a factor, with squarish, wet-into-wet strokes of a housepainter's brush, thick with viscous pigment, contrasting with liquid spatters and gravity-induced dripping patterns. An unresolved, dynamic tension results, in keeping with Mitchell's abhorrence of images that seemed overly pat and considered in their composition. It is all a bit off-putting, encouraging viewers who might otherwise linger too close to step back and take in the burgeoning painting from the greater visual distance generally preferred by the artist.

Further Reading

Bernstock, Judith E. *Joan Mitchell.* New York: Hudson Hills Press, 1988.

Kertess, Klaus. *Joan Mitchell.* New York: Harry N. Abrams, 1997.

Robert Motherwell

Aberdeen, Washington 1915–1991 Provincetown, Massachusetts

La Danse, 1952

Oil on canvas

30 × 38 in. (76.2 × 96.5 cm)

Not signed or dated

Purchased with the gift of Jane Chace Carroll, class of 1953, and Eliot Chace Nolen, class of 1954, and gift of the Dedalus Foundation

1995:7-1

© Dedalus Foundation, Inc./Licensed by VAGA, New York, NY

In 1948 Robert Motherwell almost casually created the compositional motif that would become his signature theme, sustaining him in a variety of media and scales for over four decades. Faced with the task of providing a visual accompaniment to a poem by the critic Harold Rosenberg, he filled half a sheet of rag paper with a shoulder-to-shoulder arrangement of heavy rectangular and rounded shapes brushed in rich, black india ink. This asymmetrical, rhythmic lineup of resolute bars and trembling ovals became *Elegy to the Spanish Republic No. 1*, the first of a remarkable series that "used black massively as a color form rather than an absence of color," as the artist later characterized it. Black became an assertive "protagonist" in Motherwell's work, a color he associated with Spain and all things Spanish. Profoundly affected by an early visit to Mexico in 1941, he similarly adopted ocher (reminiscent of traditional adobe walls) and deep red (blood and wine) as particularly meaningful and personally expressive hues.

All of this is evident in *La Danse*, where the A-b-A-b-A sequence of biomorphic black shapes relaxes somewhat from the percussive force of the *Elegy* forms but nonetheless retains a powerful iconic presence against the nested rectangles of thinly brushed sienna and more saturated orange-red. There is more than a little whimsy in this painting, where the quivering "figures" seem almost to breathe—expanding and contracting—as they shimmy to the left like an amoeboid conga line viewed through a microscope (though they also hold their own on a much larger scale, as evidenced by *La Danse II*

[1952, The Metropolitan Museum of Art], a version of the composition four times the size of the Smith painting). The black forms float in a kind of dimensionless environment, an arrangement that does not quite read as a figure-ground spatial relationship but that nevertheless sets up an opposition of organic and geometric shapes—another constant concern in Motherwell's oeuvre.

One other important development in the artist's early career was his discovery of his love of collage, which he first began using in 1943. The flat, additive qualities of that medium are defining characteristics of *La Danse*, but the torn, ragged edges usually found in Motherwell's collages are here replaced by precise, cut-out silhouettes, a slight stylistic anomaly usually attributed to the influence of Henri Matisse's *Jazz* series of *papiers découpés* of 1947 or, less directly, to the abstractions of Joan Miró. This has led some critics to complain of the pronounced decorative qualities of this and other Motherwell paintings of the early 1950s, finding them too calculated and pat, lacking in the artist's usual brushy experimentation. Indeed, Motherwell wrote often of the pleasure of the touch, of feeling his hand at work, of weighing the physical act of each stroke. In fact, close examination of the apparently seamless edges of his black forms reveals a good deal of adjustment and play, with late touches of the brush extending or reducing the borders of his fields of color. *La Danse*, in any event, seems to have pleased the artist, for though he subsequently destroyed much of his work from this period, Motherwell kept this painting for the rest of his life, moving it from studio to studio for nearly forty years.

Further Reading

Arnason, H. H. *Robert Motherwell*. New York: Harry N. Abrams, 1982.

Ashton, Dore, and Jack D. Flam. *Robert Motherwell*. New York: Abbeville Press, 1983.

Motherwell. Barcelona: Fundació Antoni Tàpies, 1996.

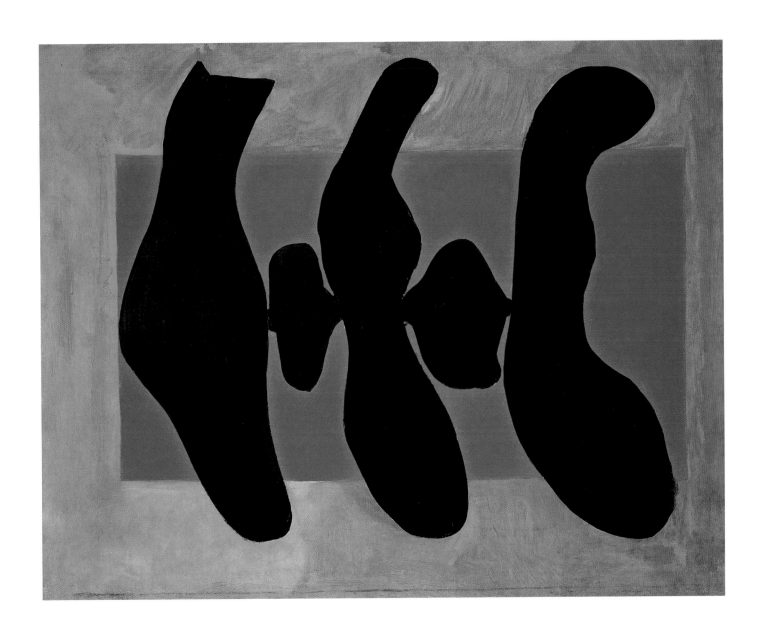

Elie Nadelman

Warsaw, Poland 1882–1946 New York, New York

Resting Stag, c. 1915

Gold-leafed bronze on wood-veneered base

14⅜ × 20½ × 10 in. (36.5 × 52 × 25.4 cm)

Not signed or dated

Purchased with income from the Hillyer, Tryon, and Mather Funds and funds given by Bernice Hirschman Tumen, class of 1923, in honor of the class of 1923

1983:24

Around 1915, when Elie Nadelman briefly turned from his better-known human subjects to a series of related fawn and stag statuettes, he was still enjoying what would be the apogee of his international reputation. Born into a cultured, liberal family in czarist Poland, he had studied at the Warsaw Art Academy before fleeing its conservative atmosphere for the more progressive climate of Munich in 1904. This too proved something of a disappointment, and six months later Nadelman left for Paris, where he would remain until World War I. After working for several years in a consciously reductive style at odds with the prevailing expressionistic virtuosity of Auguste Rodin, he became an overnight artistic celebrity when his solo exhibition of 1909 produced a storm of excited and favorable criticism. Though the fluent, classically inspired work he exhibited seems, in hindsight, relatively tame, it was received as a significant revelation, and at least one of his more innovative heads is thought to have served as a catalyst for Picasso's cubist pursuits. Almost immediately there were complaints of a lack of "depth" in Nadelman's sometimes decorative work (a charge that would plague him for the rest of his life), but for a period of about a decade his work was seen as defining an important new direction in modern sculpture.

It was thus as a notable figure of the avant-garde that Nadelman was received in New York when he arrived in 1914; his first American exhibition was staged by Alfred Stieglitz at his progressive 291 gallery a year later. During this period the artist always exhibited his drawings alongside his works of sculpture, and it is clear that the supple balance of swelling volumes in works like *Resting Stag* derives from the formal researches of these drawings, with their swinging lines of mounting curves and their suppression of anecdotal detail in favor of what Nadelman described as pure "plasticity." This he defined as an elemental internal life force or "will of matter," which he felt existed independently of an image's actual representational qualities. "The subject of any work of art is for me nothing but a pretext for creating significant form," he famously wrote in 1910.

A sense of this formal vitality so important to Nadelman is evident in the series of effortless arcing and scalloping curves that develop through the low-slung belly, powerful haunches, and elongated neck of *Resting Stag*. In the delicate act of licking its hind leg, the almost pneumatic body of the animal folds in on itself with affecting grace and equilibrium. The pleasing amplitude of the torso is nicely set off by the piquant sharpness of the rhythmically attenuated legs and the knobby antlers, which seem drawn in space with a whimsical, nervous hand. The weathered patina of the work—mottled, matte, and naturally blotchy where the gold leaf has been rubbed away to expose darker green and brown patches—also adds to the intimate, artisan-like finish of Nadelman's sculpture, a quality it shares with American folk art, of which he was a pioneering and passionate collector.

Further Reading

Baur, John I. H. *The Sculpture and Drawings of Elie Nadelman.* New York: Whitney Museum of American Art, 1975.

Kirstein, Lincoln. *Elie Nadelman.* New York: Eakins Press, 1973.

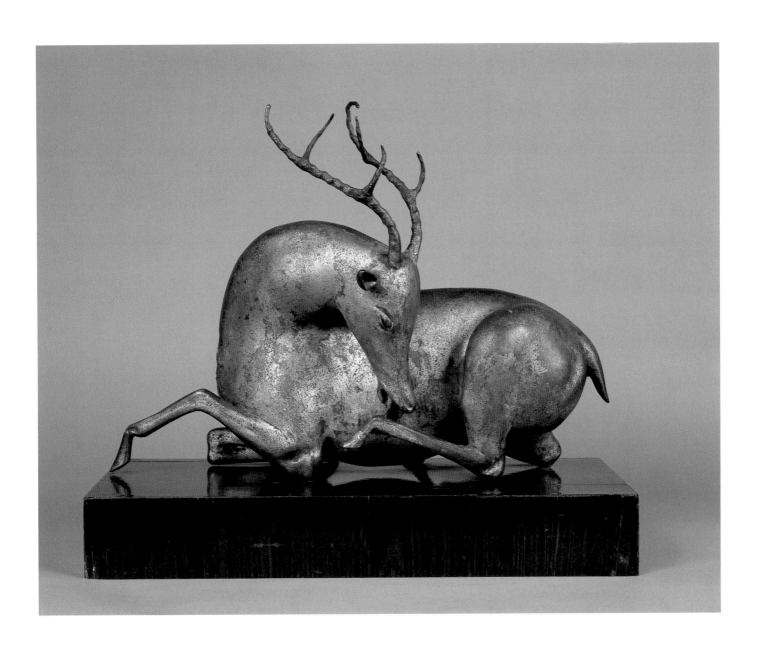

Louise Nevelson

Near Kiev, Ukraine 1899–1988 New York, New York

Moving-Static-Moving, 1955

Terra cotta
21 pieces of various sizes
Not signed or dated
Gift of the artist
1973:27-3
© 2000 Estate of Louise Nevelson/Artists Rights Society (ARS), New York

Even those who think they know Louise Nevelson's work well might be surprised by *Moving-Static-Moving,* a group of twenty-one abstract shapes in fired clay. Nevelson is known for her personal attention to room-sized installations and for the tight coherence of her found-wood assemblages, with each element carefully fixed in place by a battery of nails. In *Moving-Static-Moving,* however, the sculptor relinquishes that control, there being no prescribed manner in which the component parts should be arranged. What links these elements to her more famous work is the familiar matte black paint that became the artist's signature in the 1950s. "One of the reasons I originally started with black was to see the forms more clearly," she once explained. "Black seemed the strongest and clearest."

Before she developed her interest in large-scale wood constructions, Nevelson had worked prolifically in terra cotta, especially during the years following the death of her dealer, Karl Nierendorf, in 1948, a personal setback that prompted a retreat from public exhibitions for several years. Always obsessed with quantity, Nevelson and her assistants produced hundreds and hundreds of blunt terra-cotta pieces during this time, with the artist roughly shaping or cutting them from huge slabs of clay and an assistant later hollowing them out once they had hardened. Their worn, pitted surfaces and fragmentary nature have been connected to Nevelson's fascination with Aztec and Mayan ruins in Mexico and to what she saw as an elemental, "primitive" expression. (Some critics, however, found them derivative of earlier work by Robert Laurent and Constantin Brancusi.)

Visitors to Nevelson's four-story house on East Thirtieth Street in Manhattan remember huge piles of the forms lying about. Numbers of them were grouped into compact arrangements that the artist called "Gifts of the Sea" in her well-received installation, *Royal Voyage,* at the Grand Central Moderns Gallery in 1956. "She had lots of anthropomorphic pieces painted black that previously hadn't found their way to any given sculpture," remembered the director of the gallery. "They were interesting forms in themselves and she simply placed them on the floor, in a random happening." A similar expediency probably led Nevelson to give *Moving-Static-Moving* to Smith on the occasion of her honorary degree in 1973. Though the work bears the date of 1955, some of the pieces were likely fashioned during earlier years. The title is also recycled, having been given previously to a group of similar terra-cotta slabs stacked on metal dowel rods, the parts capable of being rotated in space (*Moving-Static-Moving Figures,* c. 1945–48, Whitney Museum of American Art, New York).

Whatever the genesis of the work, it has proven a boon to the teaching mission of the museum. With no installation instructions from the artist beyond the suggestion of an asymmetrical, multitiered pedestal, groups of students over the years have repeatedly explored the sculptural elements of shape, mass, texture, and silhouette as they arrange the forms in different configurations—sometimes dense and closely interlocked, sometimes scattered and open, but always revealing of the tactile and visual richness of pure spatial relationships.

Further Reading

Glimcher, Arnold B. *Louise Nevelson.* New York: Praeger, 1972.

Lipman, Jean. *Nevelson's World.* New York: Hudson Hills Press, 1983.

Lisle, Laurie. *Louise Nevelson: A Passionate Life.* New York: Summit, 1990.

Georgia O'Keeffe

Sun Prairie, Wisconsin 1887–1986 Santa Fe, New Mexico

Grey Tree, Fall, 1948

Oil on canvas

39⅞ × 29⅞ in. (101.3 × 75.9 cm)

Not signed or dated; inscribed in artist's hand in pencil on stretcher, at bottom under canvas tacking edge: 2 Glue size 10/25/47; at top under canvas tacking edge: Turpentine & Little Linseed Oil 5/28/48 Dutch Boy zinc white

Gift of the Robert R. Young Foundation in memory of the family of Robert R. Young

1987:13

© 2000 The Georgia O'Keeffe Foundation/Artists Rights Society (ARS), New York

From the earliest years of Georgia O'Keeffe's career, trees had occupied an important place in her personal iconography. She and her husband, Alfred Stieglitz, were greatly attached to certain magisterial chestnuts and birches at the Stieglitz family summer home at Lake George, New York, and she was also known to paint an occasional "arboreal portrait," letting a distinctive tree — the associative qualities of which reminded her of a friend or acquaintance — stand in for that person. Once she began to spend time in her beloved New Mexico, however, the lush greenery of Lake George seemed oppressive to her, overwhelming in its contrasts with the hot, bare desert she had adopted as her natural "place."

Still, trees — usually desiccated skeletal remains — sometimes figured in the desert landscapes she painted at her small house on the remote property called Ghost Ranch (north of Santa Fe). However, it was not until her purchase in 1945 of a more historic adobe structure at the nearby Hispano-Indian village of Abiquiu that she pursued the subject in earnest. Her new home looked down on the Chama River, a tributary of the Rio Grande, and its banks were lined with impressive ranks of cottonwood trees, a species of poplar. She often walked by the river, forming a collection of perfectly rounded rocks from its bed, and she had large windows cut in the walls of her new home to enable her to study the trees in all seasons. The cottonwood paintings, which she pursued for about a decade beginning in the mid-1940s, constitute one of her least-known series, perhaps because their soft, billowing forms seem unusually amorphous next to her typically hard-edged compositions (the famous Pelvis and Patio Door series, for example, are contemporaneous with the cottonwood paintings).

O'Keeffe painted *Grey Tree, Fall* during a difficult period following the death of Stieglitz in 1946. For the next three years, the settling of his complicated estate frequently required her presence in New York, cutting significantly into her time in New Mexico, and into her painting. It must have been with some relief that she arrived in Abiquiu in October 1948 and immediately set to work on *Grey Tree, Fall,* a canvas she described in a letter at the end of that month: "My first painting — a dead tree surrounded by the autumn is very gentle and pleasant and high in key but it holds its place on the wall alone more than forty feet away." The cottonwood is a burgeoning grey presence at the center, as much a network of rivers or arteries as it is solid branches and twigs. It reads as a fluttering efflorescence of dark-edged, folded planes, as vibrating envelopment rather than firm stability. Most remarkable are the radiant colors that form a kind of pulsating aura around the tree. The liveliness of these hues, along with their names — citron, peach, melon — seem to act synesthetically on the palate as well as the eye, reminding us of O'Keeffe's own visceral response to pure color, memorably revealed in her confession late in life of often feeling the urge "to eat a fine pile of paint just squeezed out of the tube."

Further Reading

Cowart, Jack, and Juan Hamilton. *Georgia O'Keeffe: Art and Letters.* Washington, D.C.: National Gallery of Art, 1987.

Eldredge, Charles C. *Georgia O'Keeffe: American and Modern.* New Haven, Conn.: Yale University Press, 1993.

Lisle, Laurie. *Portrait of an Artist: A Biography of Georgia O'Keeffe.* New York: Seaview Books, 1980.

Charles Sprague Pearce

Boston, Massachusetts 1851–1914 Auvers-sur-Oise, France

A Cup of Tea, 1883

Oil on canvas
27 × 22½ in. (68.6 × 57.1 cm)
Signed, lower left: Charles Sprague Pearce — Paris —
Bequest of Annie Swan Coburn (Mrs. Lewis Larned Coburn)
1934:3-6

Mary Cassatt may now be the best-known American expatriate painter to have taken up residence in France in the late nineteenth century, but in her embrace of the radical impressionists she was anything but typical. Far more numerous were artists such as Charles Sprague Pearce, who happily apprenticed themselves to the more conservative masters then dominating the crowded ateliers that made Paris the most vibrant and cosmopolitan city of the international art world. Pearce — who after arriving in France at the age of twenty-two would never again reside in the United States — eventually married a French artist and purchased a small country estate outside Paris. He threw himself into all the expected channels of success for an aspiring, versatile academic painter: study under the famous Léon Bonnat, exhibitions and medals at the Salon, portrait commissions from titled grandees, and frequent trips to the French provinces, Spain, and North Africa to search for "exotic" subjects.

In an effort to establish a reputation during the early part of his career, Pearce pursued a number of more or less "orientalist" themes — Arab genre studies, ancient Egyptian biblical reconstructions, Greek mythological scenes — that demanded a high degree of archaeological and ethnographic detail. For a brief period in 1883, the year in which he first achieved a measure of professional renown, he added Japanese subjects to his arsenal. Thus he joined the extremely diverse group of Western artists who sought aesthetic renewal in the spare forms, nuanced color, and suspended quietude of the Asian art then making its way to Europe and America. A Cup of Tea revels in its careful description of Eastern fabrics and ceramics, but, in the best academic tradition, it remains a pastiche — a careful arrangement of model and studio bibelots designed chiefly to showcase the artist's taste and compositional prowess.

Above all, the painting demonstrates the exquisite technique for which Pearce was celebrated. The face and hands of the woman appear flawless, rendered softly and with utmost control, as though viewed through a silken veil. Critics often faulted him for this smooth academic emphasis, noting a lack of emotional sympathy — a coolness and austerity that seemed almost clinical. Indeed, one Boston reviewer of A Cup of Tea, wearied by Pearce's "too placid sweetness," found in "the beautiful vase at her back" and "the delicately-finished teacup" held by the model, "as much expressive value as the woman" herself. Still, by this point in his career the artist was experimenting with bolder, fresher brushwork, as evidenced in the activated textural effects of the bare walls and the rich impasto highlight on the shoulder of the vase. His freest indulgence, though, is found in the floral imagery, both in the dance of the brush that creates a shower of colorful blossoms seemingly scattered across the blue-gray silk of the model's kimono and in the actual spring blooms that frame her on either side. The rendering of the billowing, complex textures of the mass of pink peonies is remarkable, but in his quick evocation of the spiky irises — each petal a single, unblended stroke of creamy white and lavender — he makes his most forceful and eloquent reply to his critics.

Further Reading

Lublin, Mary. A Rare Elegance: The Paintings of Charles Sprague Pearce (1851–1914). New York: Jordan-Volpe Gallery, 1993.

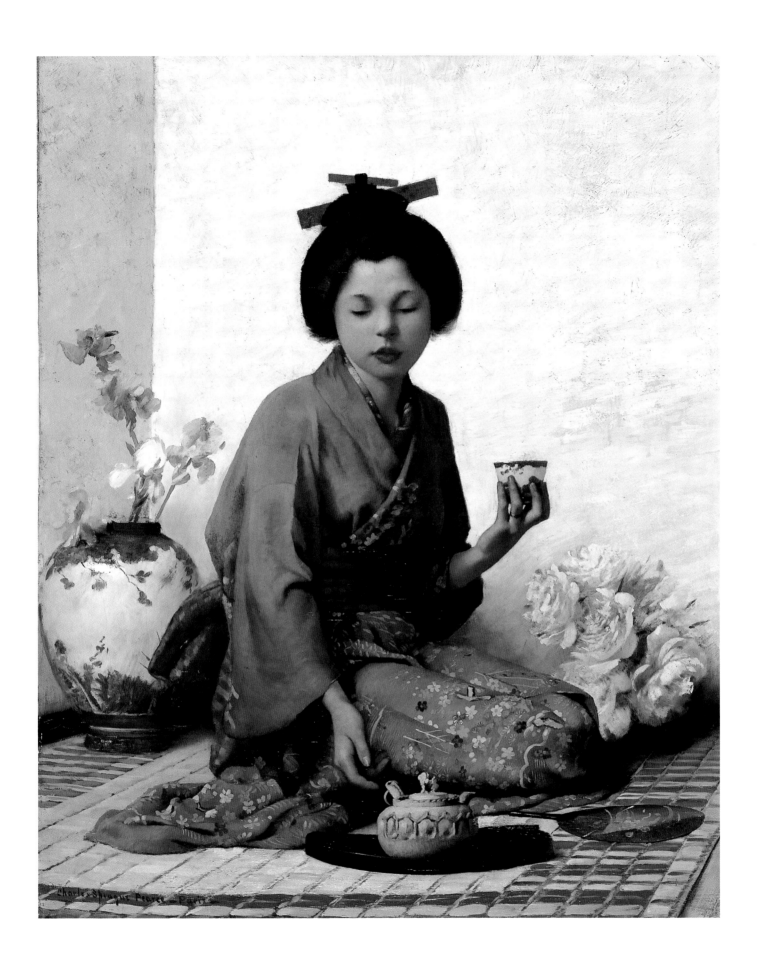

John Frederick Peto

Philadelphia, Pennsylvania 1854–1907 New York, New York

Discarded Treasures, c. 1904

Oil on canvas

22 × 40 in. (55.9 × 101.6 cm)

Signed with forged signature in black paint, lower right: WMH[in monogram]ARNETT

Purchased, Drayton Hillyer Fund

1939:4

Along with his friend and idol, William Harnett, John F. Peto occupies an important place in the tradition of trompe-l'oeil still-life painting that developed in Philadelphia in the late nineteenth century. Although both spent much of their careers toiling well outside the limelight of cosmopolitan art circles, Harnett's precise, even magical arrangements of perfectly rendered objects—antiques, musical instruments, game—attracted a certain notoriety shortly before his death in 1892, prompting a significant rise in his prices. Peto, on the other hand, working quietly in his softer, more generalized style in the small resort community of Island Heights, New Jersey, was almost completely erased from the documentary record.

This disparity in name recognition resulted in the epidemic of false Harnett signatures that were later added to Peto paintings by unscrupulous dealers. Indeed, when Harnett's reputation was resuscitated in 1939 by a revelatory exhibition entitled *Nature Vivre*, some of the works included—such as the show's centerpiece, *Discarded Treasures*—were actually Petos masquerading as Harnetts, and it was as a masterwork of the latter artist that Smith College made its much-heralded purchase of this brooding, precarious pile of worn volumes. A decade later, when the meticulous research of the art critic Alfred Frankenstein proved conclusively that Peto's oeuvre had been wrongly sublimated into Harnett's, Smith College once again moved quickly, issuing a dramatic press release reattributing the painting to Peto, thus providing an institutional imprimatur for Frankenstein's revelations.

Painted near the end of his life, when the artist was suffering from Bright's disease, *Discarded Treasures* is imbued with an unmistakable air of resignation and a haunting evocation of time's inevitable ravages, but its doleful mood can also be linked to the general fin-de-siècle anxiety about change and the abandonment of more traditional ways of life. In the case of books, long considered a precious repository of a culture's most important values, narratives, and lessons, the modern technology of Peto's day produced industrial machines capable of churning out thousands of cheaply bound copies per hour. The hand-crafted leather volume—and the culture that surrounded it—seemed endangered, if not wholly eradicated. In *Discarded Treasures*, the character of the books on the junk-shop table is indeterminate; the hand-rubbed spines announce no titles or authors, and the few visible pages of type are illegible—a decaying heap reminiscent of indecipherable ruins. These incommunicative volumes, though they bear visible signs of use indicating once-cherished ownership, are now reduced for quick sale, available for "10 cents each."

Peto's dramatic illumination, chaotic composition, and rich use of paint amplify considerably these themes of neglect and nostalgia. An intense beam of light, as though from a small window, breaks across the jumbled, teetering mass, accentuating the protruding edges of some books and casting others into a thick shroud of darkness almost unbelievable in its enveloping pitch. The volumes are scattered in a manner suggestive of violence, their pages and backs forced into unnatural and damaging configurations. The entire composition is a movement-filled web of slashing lines and angles replete with formal interest. But perhaps the most distinctive quality of the painting is the artist's use of color: oddly radiant pinks, teals, and rusts composed of dense, matte paint that seems at once chalky and claylike in texture. It is this plangent sense of touch that gives Peto's anonymous shapes—his cubic slabs of dusty, velvety color—the elemental abstractive quality that found such favor with the devotees of modern art who enthusiastically greeted this painting at the time of its rediscovery in 1939.

Further Reading

Frankenstein, Alfred. *After the Hunt: William Harnett and Other American Still Life Painters, 1870–1900*. Berkeley: University of California Press, 1969.

Wilmerding, John. *Important Information Inside: The Art of John F. Peto and the Idea of Still-Life Painting in Nineteenth-Century America*. Washington, D.C.: National Gallery of Art, 1983.

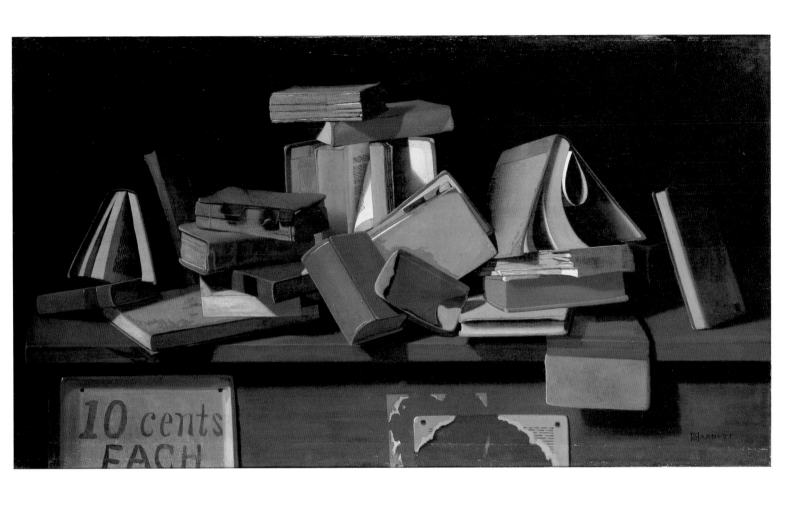

Albert Pinkham Ryder

New Bedford, Massachusetts 1847–1917 Elmhurst, New York

Perrette, c. 1885–90

Oil on canvas mounted on paper composition board
12¹³/₁₆ × 7¹¹/₁₆ in. (32.5 × 19.5 cm)
Signed in red paint, lower left: A. P. Ryder
Purchased, probably from the artist, Winthrop Hillyer Fund
1893:1

Of all the early purchases of American art made under
Smith's first president, L. Clark Seelye, *Perrette*, by
Albert Pinkham Ryder, is certainly one of the boldest.
In his mid-forties at the time he painted it, the romantic,
childish painter had already started to withdraw into his
dark and cluttered boardinghouse rooms, exhibiting
infrequently and laboring slowly over his small, rumina-
tive paintings, some of them receiving years and years —
and layers and layers — of his idiosyncratic attentions. His
public was not large, but from the start his supporters
recognized something rare and poetic in his jewellike,
almost enameled images (and they frequently congratu-
lated themselves on their skills of discernment, using
the acquired taste for Ryder's art as the dividing line
between cognoscente and philistine). Smith College
thus placed itself at the forefront of the aesthetic and
intellectual elite when in 1893 *Perrette* became the first
painting by the artist to enter a public collection.

It is one of several small works from the late 1880s
and early 1890s taking as their subject a poor, guileless
young woman in a pastoral setting. In this case the
source is a fable by Jean de La Fontaine that explores
the dreams of profit and wealth of a young farm wife as
she carries her milk to market, only to see these hopes
dashed when, her head in the clouds, she trips and spills
the milk. The Perrette fable had been represented a
number of times in the eighteenth century (notably by
Jean-Honoré Fragonard), but in Ryder's day the subject
was quite esoteric. Typically, he selected the earlier
moment of the milkmaid's dreamy state, rather than the
disastrous pratfall that had more commonly been figured
by artists. As though a sympathetic emanation of her dis-
tracted thoughts, the landscape tips up dramatically to
form a series of sinuous, two-dimensional shapes that
rhyme pleasingly with the forms of her body — the tree,
in particular, twisting in space as if hoisting up its own
pail of milk. The intertwined pair of cows also forms a
lighthearted S-curve; a flowing line moves from the
spinal ridge of the ponderous foreground animal up
to the rolling back and whiplike tail of its companion,
who appears to use the slender tree trunk for a teasing
game of hide-and-seek.

Ryder's unstable methods and materials caused his
paintings to darken and change almost immediately (the
artist once used the verb "ripen" in discussing his work).
At times, the pernicious, fluidic underlayers of bitumen
he used resulted in paintings literally melting before
the eyes of their owners, who often resorted to drastic
procedures to "restore" the images. *Perrette*, because of
its early entrance into a controlled and documented
museum collection, is thus valued by Ryder scholars as
an unadulterated example of his work. As early as 1931,
when viewers were already scratching their heads at the
rhapsodic turn-of-the-century descriptions of the artist's
color, the cultural critic Lewis Mumford pointed to
Perrette as one of the few paintings that still hinted at
its former beauty. Since then, the Smith canvas, like all
Ryders, has further deteriorated, with wide drying cracks
and black, open seams appearing in a number of areas.
Yet even if the famed chromatic sparkle of a century
ago has somewhat lessened under his resinous blanket
of thickened medium, the burnished, old masterish
patina Ryder sought — with its mellow, green-gold tonal-
ity secured by countless glazes — can still be readily
appreciated.

Further Reading

Broun, Elizabeth, et al. *Albert Pinkham Ryder.* Washington,
D.C.: Smithsonian Institution Press, 1990.

Homer, William Innes, and Lloyd Goodrich. *Albert Pinkham
Ryder: Painter of Dreams.* New York: Harry N. Abrams, 1989.

Augustus Saint-Gaudens

Dublin, Ireland 1848–1907 Cornish, New Hampshire

Diana of the Tower, 1899

Bronze on self-base

36 × 14¼ × 11 in. (91.4 × 36.2 × 27.9 cm)

Inscribed on front face of tripod base: DIANA/OF THE/TOWER; signed and dated on top of base platform, proper right rear: AUGUSTUS/SAINT-GAUDENS/MDCCCXCIX; bronze or copper circular inset stamped on top of base platform, front, proper left: COPYRIGHT/ BY AUGUSTUS/SAINT-GAUDENS/M/DCCCXC/IX; inscribed on top of base platform, proper left rear: AUBRY BROS/FOUNDERS. N.Y.

Purchased, Winthrop Hillyer Fund

1900:22-1

The decades-long collaboration between the architect Stanford White and the sculptor Augustus Saint-Gaudens is one of the most fruitful in the history of American art. Saint-Gaudens's first great public triumph, his *Farragut Memorial,* owed a great deal to the sensitive bluestone pedestal designed by White, and when the bronze statue was unveiled to a stunned audience in New York's Madison Square in 1881, it was heralded as the beginning of a new era in public sculpture. A decade later, the two friends returned to the northeast corner of the same park. There, several hundred feet away from the Farragut statue, White was completing his Madison Square Garden, the famous sports and pleasure palace with its signature tower modeled after the Giralda spire of Seville, Spain. At White's invitation, Saint-Gaudens conceived of a culminating "weathervane" for the tower, an 18-foot, 1,800-pound figure of Diana at the hunt.

This project was a labor of love for the two men, with White paying the costs of fabrication and Saint-Gaudens undertaking the statue without a fee. For the sculptor, the project allowed him to pursue a purely ideal figure — a welcome break from his customary work in portraiture. The *Diana* statue thus became his first and only fully finished nude. From the moment of the unveiling, however, White and Saint-Gaudens were dissatisfied with the work. Though placed at an elevation of 347 feet (the highest object in New York City at the time), *Diana* appeared oversized and heavy from the park below. An elaborate whirl of drapery conceived by the sculptor as a wind rudder ballooning from her shoulder was also deemed unsuccessful. In an admirable display of humility and perfectionism, they committed to

considerable extra time and money, and Saint-Gaudens fashioned a new *Diana,* this time only thirteen feet tall. In this second version, the drapery was diminished and the figure's proportions were attenuated significantly: The face was thinner, the limbs longer, and the torso less cylindrical and barrel-chested. From the second unveiling of 1894 until the destruction of Madison Square Garden in 1925, Diana's sprightly, easily legible silhouette pirouetted in the sky above the prizefights and circuses taking place in the great auditorium below.

Although there were scattered objections to the statue's nudity, *Diana* quickly became a much-loved landmark in New York. Perhaps seeking to forestall unauthorized copies, Saint-Gaudens copyrighted the second version of the work and began to produce reduced-scale replicas (often including slight variations in the pedestal and proportions). The Smith *Diana* is one of at least a dozen of the smaller-sized reductions, which Saint-Gaudens periodically sold to private patrons, yielding him a profit of about $100 with each sale. It is unique among the many copies, however, in its ability to turn on its three-sided pedestal — a feature made possible by a bronze knob and gear-driven apparatus built into the base. Indeed, the sensitive design of the pedestal contributes greatly to the impression of lightness and motion of the statue above. The sphere appears intriguingly precarious as it balances on the heavier podium, and because of the tripartite configuration of the latter, the body of Diana never seems to lock into a specific plane, to resolve into a stable rectilinear relationship with the viewer. Always alert and rotating, her flexed, elastic figure remains breathless in its anticipation of the moment of release when bow, arrow, and hunter will all snap from their perfectly calibrated balance of dynamic forces.

Further Reading

Dryfhout, John H. *The Work of Augustus Saint-Gaudens.* Hanover, N.H.: University Press of New England, 1982.

Greenthal, Kathryn. *Augustus Saint-Gaudens: Master Sculptor.* New York: The Metropolitan Museum of Art, 1985.

Wilkinson, Burke. *Uncommon Clay: The Life and Works of Augustus Saint Gaudens.* New York: Harcourt Brace Jovanovich, 1985.

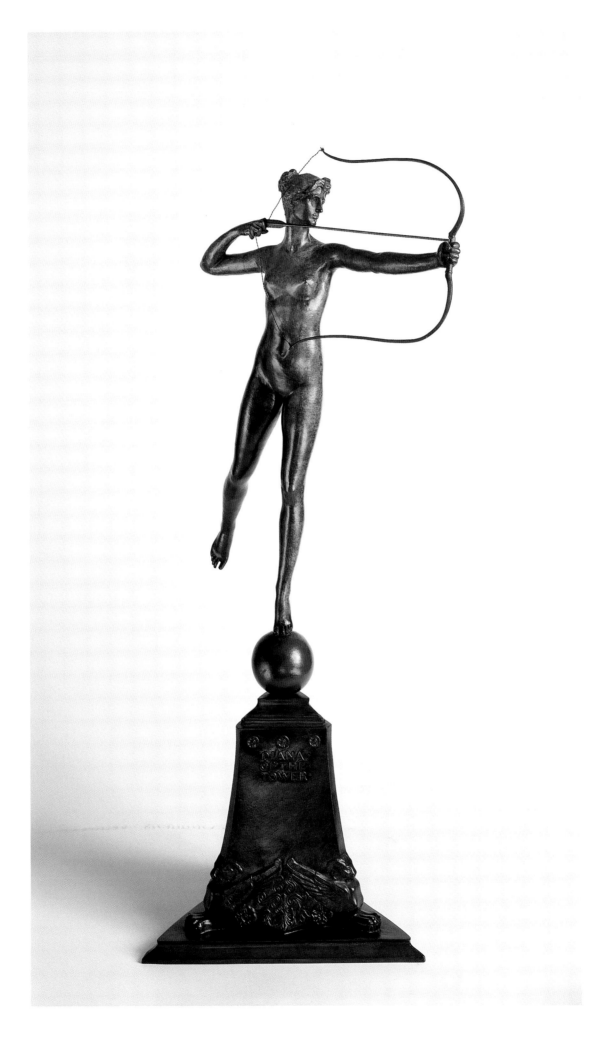

John Singer Sargent

Florence, Italy 1856–1925 London, England

My Dining Room, c. 1883–86

Oil on canvas

29 × 23¾ in. (73.7 × 60.3 cm)

Not signed or dated

Purchased with funds given by Mrs. Henry T. Curtiss (Mina Kirstein, class of 1918) in memory of William Allan Neilson

1968:10

Born to expatriate American parents, John Singer Sargent spent his peripatetic youth traveling between European spas and resorts. His first real measure of stability and identification with a single place of residence came in 1874, when he moved to Paris and became the prized pupil of Charles-Emile-Auguste Durand (Carolus-Duran), a swashbuckling painter of dramatic society portraits. To some critics, Sargent quickly became the equal of his master, and after a series of enthusiastic reviews of his submissions to the Salons of 1882 and 1883, the young painter had every reason to consider himself at the beginning of a lifetime of success in the international art world of Paris. In an act of exuberant self-confidence, Sargent abandoned his walk-up studio in the bohemian Montparnasse district and rented a small, purpose-built house at 41, boulevard Berthier, locating himself in a high-culture, wealthy neighborhood of the Right Bank. With a private rose garden, a large second-floor studio decorated in aesthetic fabrics and papers, and a modest suite of private, public, and staff rooms on the ground floor, this artist's residence became the first true home Sargent had known. It would seem to have been with some measure of pride that he painted one of these rooms and pointedly titled it *My Dining Room.*

In this work Sargent successfully blends the lessons of his teacher, Carolus-Duran, with the avant-garde currents of Impressionism, a style that attracted him without ever winning him over completely. Carolus-Duran preached direct painting, wet into wet, and he placed the greatest stress on a correct sequence of values, a principle of pictorial organization far more important than color in his view. Sargent's somber palette of grays and duns bespeaks this influence—a range of middle hues that is neither cool nor warm, from which he works up and down to the blazing whites of the tablecloth and the deepest browns of the shadowy sideboard. The blurred brushwork, however, moves beyond Carolus-Duran's academic manner. The highlights on the bottles at left, for example, are small globs of pure white seemingly flicked onto the surface, and the amorphous linens and china on the table are formed by smooth, buttery paint that appears effortlessly stroked on the canvas, as if with a feather. A sense of palpable atmosphere swirls and eddies amid these objects awaiting removal after a meal.

The foreground chair is pushed back as if its occupant has just left the table, and one feels the warmth and lingering conversation of a space recently inhabited by such animated visitors as Oscar Wilde, whom Sargent entertained here on at least one occasion. Another touch of the personal is found in the tripartite horizontal frame hanging low on the wall above a background table; it featured three informal sketches of the artist Paul Helleu, a close friend from Sargent's student days. During the period of the mid-1880s, Sargent painted a small series of dining-table scenes, and each one conveys a certain quiet attachment to the intimate detritus of the repast, along with a moving connection to the friends and relatives he encountered in these private places. It is a sentiment somewhat at odds with the usual description of Sargent as detached and uninterested in conversational small talk. In the case of *My Dining Room,* there may also be a certain wistfulness associated with the scene for the artist; in 1886, impoverished by the scandal that developed around his daring *Madame X* (1884, The Metropolitan Museum of Art), he was forced to give up his home and decamp for England, where he resided for the rest of his life.

Further Reading

Fairbrother, Trevor. *John Singer Sargent.* New York: Harry N. Abrams, 1994.

Kilmurray, Elaine, and Richard Ormond, eds. *John Singer Sargent.* Princeton, N.J.: Princeton University Press, 1998.

Olson, Stanley. *John Singer Sargent: His Portrait.* New York: St. Martin's Press, 1986.

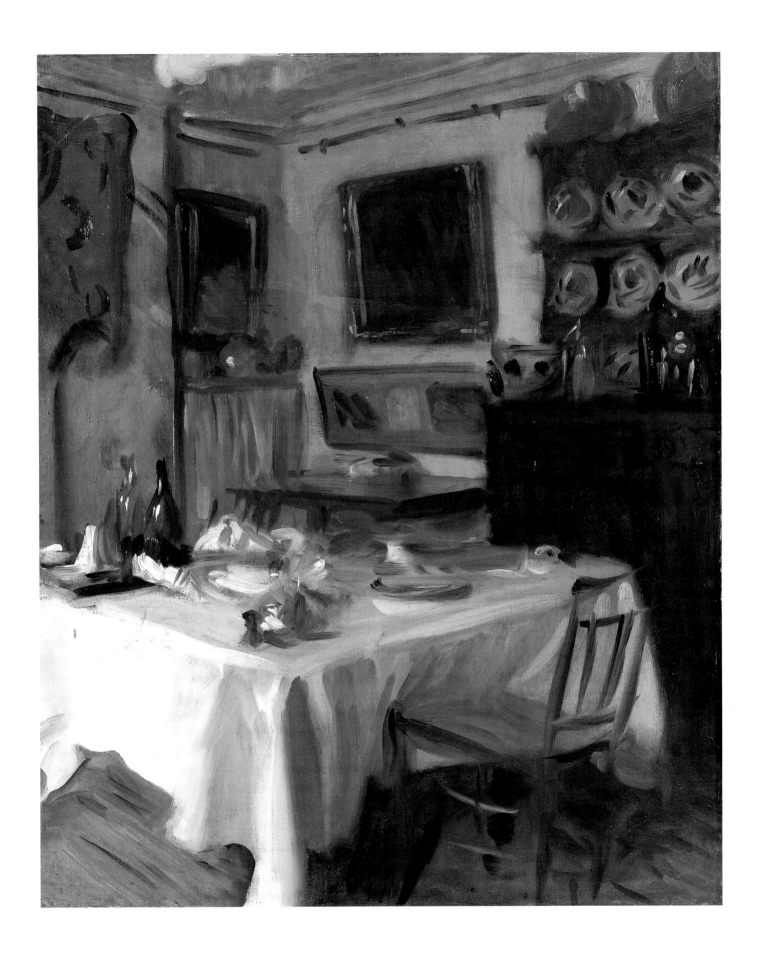

Charles Sheeler

Philadelphia, Pennsylvania 1883–1965 Dobbs Ferry, New York

Rolling Power, 1939

Oil on canvas
15 × 30 in. (38.1 × 76.2 cm)
Signed and dated in black paint, lower right: Sheeler-1939
Purchased, Drayton Hillyer Fund
1940:18

In 1938 Charles Sheeler received perhaps the most generous commission of his career, one wonderfully adapted to the themes and aesthetic concerns that had crystallized in his work during the previous decade. *Fortune,* the glossy magazine that chronicled and celebrated the modern marriage of business and industry, engaged the artist to execute a series of paintings on the theme of "Power" (Sheeler eventually painted six works). The patron made no other demands of subject, the paintings would remain the property of the artist, and he was free to exhibit them as he pleased. *Fortune* asked only for the right of first publication. Knowing that Smith College was interested in purchasing a Sheeler, the artist's dealer, Edith Halpert, offered the museum a preview of the series. Much to Sheeler's delight, *Rolling Power,* a close-up view of the drive wheels of the famous Twentieth Century Limited steam engine, was purchased before the exhibition at Halpert's Downtown Gallery closed. Since then, it has become a well-known icon of the period's reverence for the machine. A dense image packed with tactile values and visual information, it effectively transmutes the compressed, charged volumes of its machinery into a pristine relief of overwhelming purity and otherworldly plasticity.

The seemingly narrow range of hues chosen by Sheeler was ideally suited for *Fortune's* commercial reproduction needs, but his carefully nuanced blend of color only becomes apparent when the original painting is studied closely. With controlled subtlety bordering on the sensual, he works through infinitesimal gradations of gray, blue, rose, eggshell, and lavender, with a tawny reddish-brown tonality reserved for the shadowed recesses that throw the myriad bolts and rods into sharp relief. The result is an uncanny, almost brittle oscillation between the flawless, pearlescent surface planes and the bristling accumulation of layered contours and edges, the artist's exacting armature of pencil lines still very visible.

Though the low point of view forces viewers into a kneeling posture before the powerful wheels and pistons (*Fortune's* explanatory captions were rich in religious imagery), it is actually quite difficult to come to an understanding of scale and context in the work. From several feet away, the moderate-size canvas looks like a small slotted opening exposing the impossibly complex workings of a Swiss watch, while at close range, the wall of silent technology described by Sheeler might as well be a sheer stone cliff carved with indecipherable geometric hieroglyphs. Only the irregular beat of the ends of the railroad ties hints at the landscape through which the streamlined engine moved at speeds of up to one hundred miles an hour.

This denial of context is a hallmark of Sheeler's work, and at the time of the exhibition, he was criticized by at least one writer for his interest in power's "static shell" as opposed to its "throbbing internal life." That the artist aestheticized the machine and scoured it of any trace of grease or rust is undeniable. Similarly, the accusation that he discounted, even ignored, the contributions of human labor in the creation and servicing of his noble industrial forms seems relevant here, as it is throughout his oeuvre. Yet the intensity of Sheeler's formal means nevertheless argues for a visceral connection to this wondrous assemblage of linked components. His own personal identification with his immaculate mechanical world is perhaps conveyed by the only passage of the painting where the geometric rigor is relaxed: the single plume of smoke at lower right seemingly emanating from Sheeler's tiny signature like a cartoonish dialogue balloon. Though the mammoth Twentieth Century Limited might be momentarily stilled, the artist, an inveterate cigarette smoker, is nevertheless present and actively puffing away.

Further Reading

Fillin-Yeh, Susan. "Charles Sheeler's *Rolling Power.*" In *The Railroad in American Art: Representations of Technological Change,* edited by Susan Danly and Leo Marx. Cambridge, Mass.: MIT Press, 1988, 147–64.

Lucic, Karen. *Charles Sheeler and the Cult of the Machine.* Cambridge, Mass.: Harvard University Press, 1991.

Troyen, Carol, and Erica E. Hirshler. *Charles Sheeler: Paintings and Drawings.* Boston: Little, Brown, 1987.

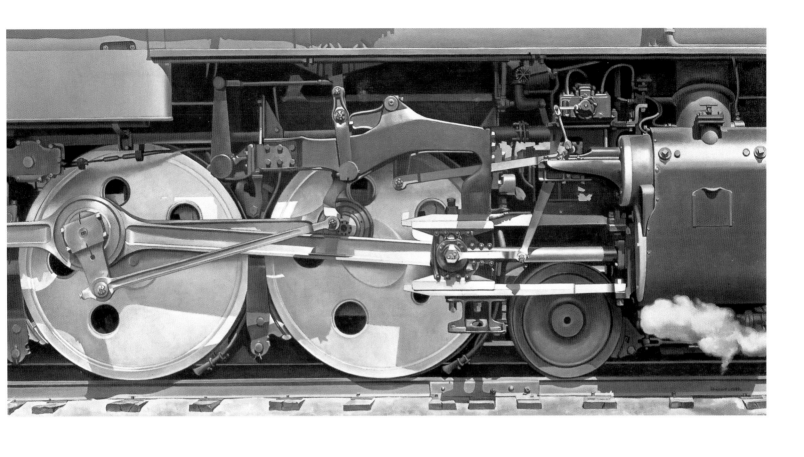

Lilly Martin Spencer

Exeter, England 1822–1902 New York, New York

Reading the Legend, 1852

Oil on canvas

50⅜ × 38 in. (127.9 × 96.5 cm)

Signed and dated, lower left: Lilly M. Spencer/Artist/1852

Gift of Adeline F. Wing, class of 1898, and Caroline R. Wing, class of 1896

1954:69

The extraordinary career of Lilly Martin Spencer stands alone in the middle decades of the nineteenth century. An indefatigable worker, she painted actively for over sixty years and, in her heyday, was virtually the only woman to achieve viability as a professional easel painter in the art capital of New York. Indeed, Spencer was the primary means of support for her family of eight children; her husband, Benjamin, an unsuccessful artist, served as her occasional assistant. Her pathbreaking achievements may be best understood against the background of her unusual upbringing in Ohio by French émigré parents deeply involved in the reform movements of communitarianism, abolitionism, and women's suffrage. Their proto-feminism was demonstrated early in Spencer's life when her emerging talent became evident; the household was broken up, and the father accompanied his teenage daughter to Cincinnati, where she began her professional career.

Life, though, was never easy for Spencer, and from the moment she moved to New York in 1849, she was forced to struggle for sales and recognition in an art world unaccustomed to the presence of a professional woman. She had high hopes of establishing herself as a history and literary painter, but like many American artists, she found the market unreceptive. In her case, critics made it clear that they preferred her still lifes and humorous domestic scenes—subjects thought to be more in keeping with her gender. A further blow came in 1851, when the American Art-Union, an art lottery that had consistently supported her, was declared illegal. In this climate, *Reading the Legend*, a romantic view of a young couple contemplating the picturesque ruins of Ireland's Blarney Castle, became one of her last attempts to work in a more elevated style. When the painting was shown at the National Academy of Design's annual exhibition of 1853, however, it was ignored by critics, and its subsequent appearance at art auctions in 1856 and 1860 indicates a similar lack of appreciation among collectors.

This public disinterest notwithstanding, *Reading the Legend* clearly demonstrates Spencer's mastery of the brush and the precepts of academic figure painting. The modeling of the couple and their dog is solid and complex, and throughout the composition the artist is attentive to surface textures—especially in the brilliantly rendered floral shawl, the slight impasto of the dotted lace fichu, and the way in which the silk dress and butternut coat wrinkle and stretch in response to the actions of the bodies beneath them. Light and dark values are kept in a state of dynamic balance, and the various levels of space are carved dramatically out of the rich, complementary chiaroscuro of the upper and lower halves.

Spencer builds a natural upward momentum into the composition, linking the shadowed ground plane with the soaring tower—blind and toothless—that rises like a dream from the dense undergrowth attempting to reclaim it. This line of visual narrative is anchored by the self-possessed dog, his sober expression and proprietary command of the cane and hat humorously suggesting a more gentlemanly demeanor than that of his nearby master, sprawled informally on the ground. Highlights then lead diagonally to the reflective woman, who functions as the crux of the composition. Unconsciously fingering the ribbons of her bonnet as it falls over her knee, she deflects attention through her uplifted gaze back to the castle itself, visualizing the story read aloud by her anonymous partner and thoughtfully mediating between text and image. By depicting the man with his back to the viewer, Spencer subtly constructs a painting embodying the woman's experience of the tale, creating a rare nineteenth-century alternative to the more typical masculine point of view.

Further Reading

Bolton-Smith, Robin, and William H. Truettner. *Lilly Martin Spencer, 1822–1902: The Joys of Sentiment.* Washington, D.C.: National Collection of Fine Arts, 1973.

Lubin, David M. *Picturing a Nation: Art and Social Change in Nineteenth-Century America.* New Haven, Conn.: Yale University Press, 1994.

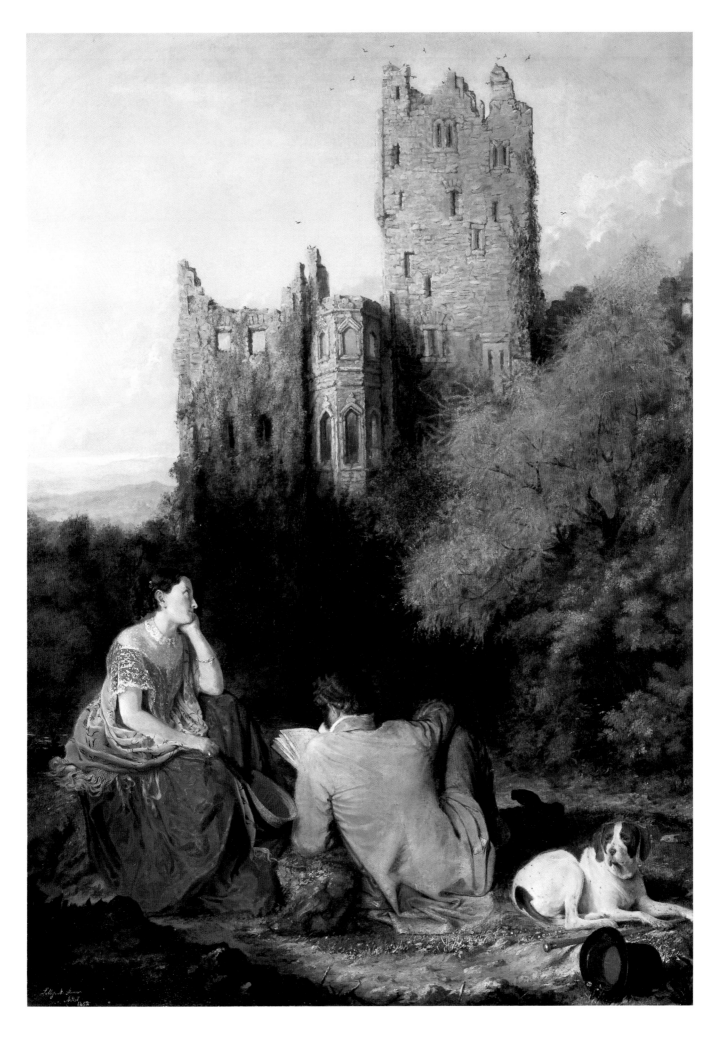

223

Florine Stettheimer

Rochester, New York 1871–1944 New York, New York

Henry McBride, Art Critic, 1922

Oil on canvas

30 × 26 in. (76.2 × 66 cm)

Inscribed in green paint, within composition, middle left: B/HENRY H/MCBRIDE Mc/Stetthei [obscured] Florine S; signed and dated in black paint on stretcher: By Florine Stettheimer 1922

Gift of Ettie Stettheimer, the artist's sister

1951:198

The art of Florine Stettheimer inhabits two overlapping worlds. One is highly personal and rarefied, intelligible only to the select group of friends and family privy to the visual puns and coy in-jokes seeded throughout her paintings. The other is more philosophically grounded in early-twentieth-century modernism, concerned with nonlinear theories of time, the flux of memory and intuition, and the exploration of phenomenological, flowing space. These worlds come together arrestingly in the series of what her fellow artist Marsden Hartley called "her fragrant portraits, . . . penetrations in the mind and spirit of these highly accentuated types." Her sisters and her mother—with whom she lived most of her life cocooned in the privileges of wealth—as well as a charming group of artists, writers, and dancers who flocked to the Stettheimer salon, all found themselves, along with their accomplishments and foibles, spread on the painter's canvases like pastel cake frosting. This highly original blend of sweetness and light, however, almost always carries multilayered associative meanings that season and transform the rococo prettiness for which her art has sometimes been dismissed.

The playful qualities of *Henry McBride, Art Critic* document a friendship that developed between artist and writer in their later careers; the portrait was executed when both were in their fifties. After a lackluster early career teaching art, McBride had begun writing criticism for the *New York Sun* in 1913. Gradually, he became an important advocate and interpreter of the advanced European art, notably Cubism, then making its way to America's shores. At the same time, he wrote sympathetically about the American avant-garde, furthering the careers of Georgia O'Keeffe and John Marin, among others. McBride appears to have first noticed Stettheimer's work in 1918, at an exhibition in New York. He continued to review her work enthusiastically for several years before making her acquaintance. By 1922, the year of the portrait, they had become good friends,

and McBride was a frequent guest that summer at the artist's vacation home in Sea Bright, New Jersey.

Stettheimer includes McBride's likeness five times in her painting—once at the center, where he looms in a grandmotherly way on a dowdy, triple-overstuffed rocking chair–throne, and four times in the portrait's quadrants, where his tiny, dapper figure locates itself in a series of fantastic scenes alluding to his hobbies and activities as a critic. A devotee of tennis, McBride clutches a scorecard for the Sea Bright International Tennis Tournament, which he followed with great interest that summer. Glancing to the lower left quadrant, he sees a smaller, identically dressed version of himself presiding as a line judge on the courts, the players—weightless sprites in white—pirouetting gaily on the lawns. To the right, McBride is pictured in a less formal moment, painting a winding picket fence reminiscent of one he had recently erected around his small farmhouse in Pennsylvania—a Tom Sawyerish project he complained of repeatedly in letters to the artist.

Above, two more renditions of the critic stand gazing into dreamy landscapes symbolizing the best of nineteenth- and twentieth-century American art. At right, three witty quotations from Winslow Homer's sea paintings of the 1880s and 1890s allude to McBride's interest in restoring the reputation of that painter (he launched a similar crusade on behalf of Thomas Eakins). And at left, in the most brilliant passage of the work, Marin-like skyscrapers tower above works representative of other contemporary painters he championed—a self-referential bouquet of flowers for Stettheimer and the famous *Standing Woman* of Gaston Lachaise, for example. Despite this service to his native culture, McBride was often criticized for elevating French art above that produced in New York. By choosing only American works of art for his portrait, Stettheimer might have been gently tweaking her friend for his Continental sympathies, literally waving the flag of patriotism above his demure, slightly dazed countenance.

Further Reading

Bloemink, Barbara J. *The Life and Art of Florine Stettheimer.* New Haven, Conn.: Yale University Press, 1995.

McBride, Henry. *Florine Stettheimer.* New York: The Museum of Modern Art, 1946.

Sussman, Elisabeth, et al. *Florine Stettheimer: Manhattan Fantastica.* New York: Whitney Museum of American Art, 1995.

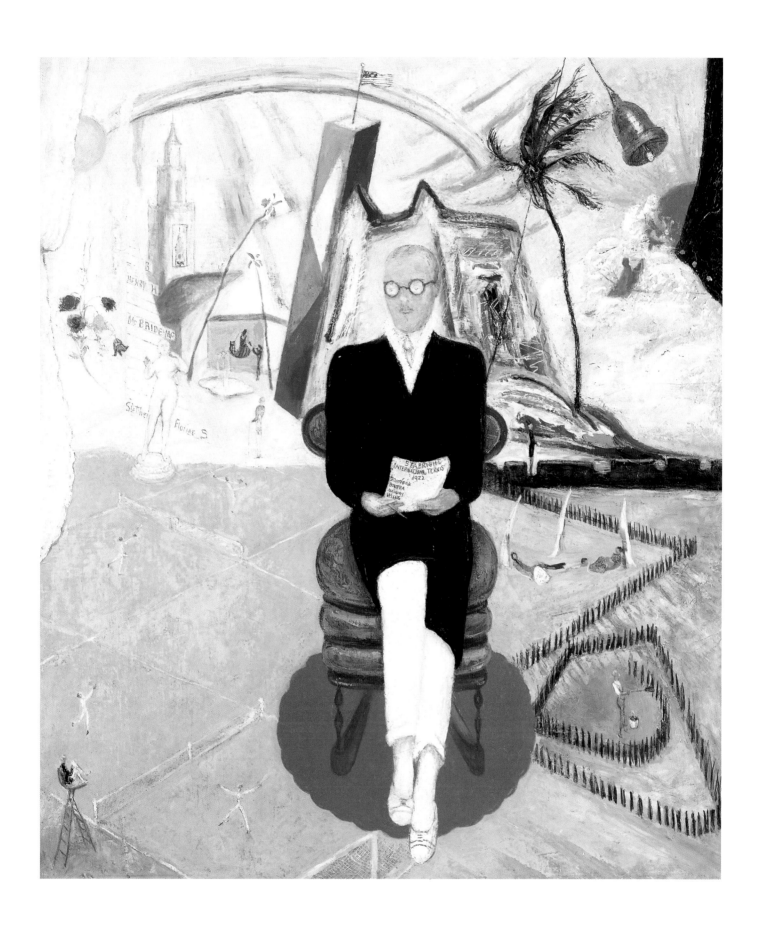

John Storrs

Chicago, Illinois 1885–1956 Mer, Loir-et-Cher, France

Auto Tower, Industrial Forms, c. 1922

Painted plaster

12⅞ × 3¼ × 2⅞ in. (32.7 × 8.3 × 7.3 cm)

Inscribed in plaster on rear above base: JS [conjoined initials, S reversed] 2550

Purchased with funds given by Mr. and Mrs. Duncan Boeckman (Elizabeth Mayer, class of 1954)

1989:1

Among the small group of American sculptors working in the early twentieth century to incorporate the lessons of Cubism and Futurism into a professional practice still dominated by waning Beaux-Arts precepts, John Storrs is not as well known as might be expected. Storrs's inventive work forged a unity of expression between the plastic media of sculpture and architecture. In addition, his spiritual investment in the spare simplicity of distilled geometric form gave a weightier philosophical cast to the sometimes surface-oriented effects of the style that came to be known as Art Deco. Personal circumstances, however, forced him to divide his time between the Loire Valley in France and his hometown of Chicago, a frustrating situation for the artist, which prevented him from becoming fully integrated into the larger art centers of New York and Paris.

As a young student in his early twenties, Storrs searched restlessly for the right teachers and material examples of art that would speak to his developing aesthetic sense, and during a seven-year period he must have come close to setting a record in studying at no fewer than ten art academies in Hamburg, Paris, Chicago, Boston, and Philadelphia. The strong angularity of the Vienna Secession movement appealed to him, but perhaps his most profound influence in this early period was the powerful personality of the aged Auguste Rodin, whose palpable, quavering style would nevertheless have little to do with Storrs's mature, architectonic

work. By the time of his first one-person show in 1920, he had produced a number of cubist figural sculptures, the faceted planes of his blocky forms often strengthened and defined in space by selective surface painting. His primary experimental idiom, however, would become single, rectilinear towers—sleek and evocative in their suggestion of soaring skyscrapers, but self-contained sculptural statements, nonetheless, in their investigation of purely abstract volumes.

Auto Tower, Industrial Forms, while representative of these compositional essays in three-dimensional space, is somewhat anomalous in its specific iconography and witty transformative instability between architectural totem and upended automobile. Although not overly devoted to the cult of the machine, Storrs admired American technical ingenuity, and he was particularly fond of the stylish roadsters just then being introduced to the market. Through a complex series of flared curves, parallel incisions in the plaster, and judicious accents in black paint, he suggests the streamlined, speeding form of an open-topped auto, seemingly taking off like a rocket, its wheels spinning. The lower half of the work, in contrast, appears more sober in its thoughtful exploration of planar edges, deeply channeled voids, uncut surfaces, serrated textures, and mosaic patterns. These stark effects do not distance the work from the viewer, however, for far from being cold and clinical in its outward appearance, Auto Tower, Industrial Forms bears traces of the hand of its carver—scratches, smudges, and less-than-straight lines that humanize the sculpture and tell the tale of the playful fiddling with form that underlies its conception.

Further Reading

Frackman, Noel. John Storrs. New York: Whitney Museum of American Art, 1987.

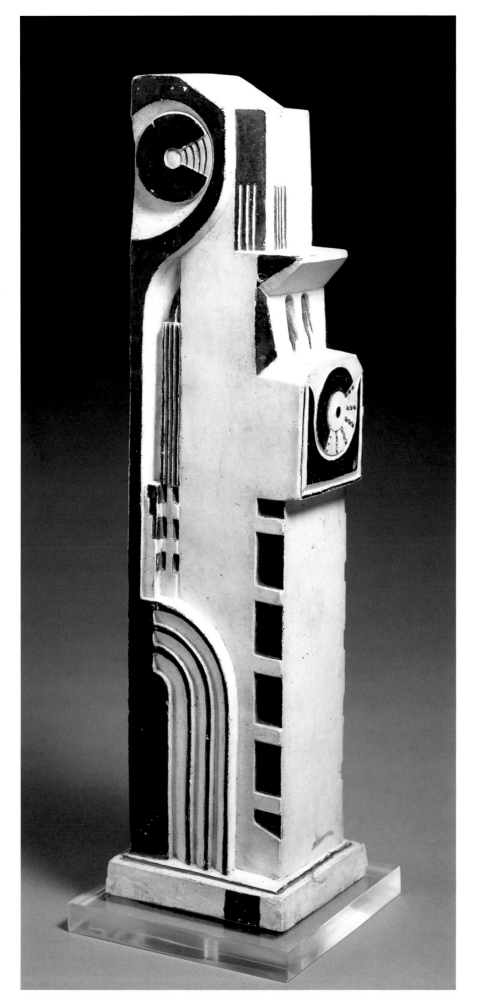

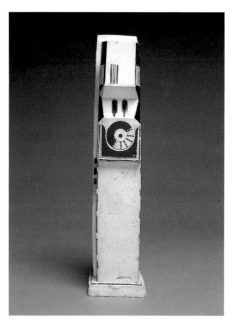
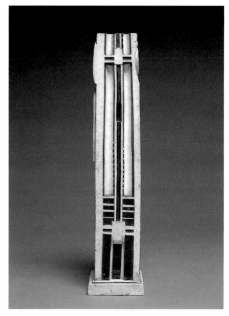

227

Gilbert Stuart

North Kingston, Rhode Island 1755–1828 Boston, Massachusetts

Henrietta Elizabeth Frederica Vane, 1783

Oil on canvas
65⅞ × 38⅝ in. (167.3 × 98.1 cm)
Not signed or dated
Gift in memory of Jessie Rand Goldthwait, class of 1890, by her husband, Dr. Joel E. Goldthwait, and daughter, Mrs. Charles Lincoln Taylor (Margaret Rand Goldthwait, class of 1921)
1957:39

Gilbert Stuart's portrait of the ten-year-old Henrietta Elizabeth Frederica Vane — a rarity in his oeuvre in that he did few full-length canvases and even fewer of children — came at a propitious moment in his early career. The young colonial had attempted to establish himself in London in 1775, but after a year or so of penury and near-starvation, he had somewhat sheepishly become a student and assistant of his compatriot, Benjamin West, whose success in England inspired many a late-eighteenth-century American artist. Stuart chafed under the less talented West, but his deliverance came in 1782, when his novel portrait of William Grant (*The Skater,* National Gallery of Art, Washington, D.C.) became a sensation after it was unveiled at the Royal Academy annual exhibition. This was the recognition he needed to enable him to move out on his own into the competitive London portrait trade, and soon thereafter the parents of Henrietta Vane, a Norfolk branch of a family studded with noble titles, commissioned this portrait of their only daughter and heiress.

Stuart places his well-dressed sitter in a generalized outdoor setting in keeping with the standards of British portraiture of the era. Her childish figure is made to seem grander and more imposing through the device of the heavy cloak that engulfs her and passes over her extended arm. This upward-reaching gesture provides some focus to her pose, as she delicately grasps the trailing vine of a trumpet honeysuckle plant. The meandering sprig appears to wind down to meet her light-tipped fingers, and her touch almost seems to pull it into a more tangible, concrete existence, at odds with the translucent, generalized dabs of foliage surrounding it. Below, for example, a basket of flowers already gathered is treated in a most summary fashion, as though it were being glimpsed through shifting, shadowed waters.

In this confident pictorial statement, the twenty-eight-year-old artist announces his mastery of the free, painterly style and radiant, silvery illumination that were the hallmarks of the aristocratic English likeness. The sky is vigorous and brushy, with rich yellow paint casually scribbled into the blue surrounding her head, the clouds retreating in this area so as to form a kind of azure halo. Her dress is resplendently luminous, the long, looping strokes of white melting into the transparent gray underlayer. Throughout, there is a pleasing fullness to Stuart's paint, nowhere more so than in the rich bronze-colored fabric accents to her costume — the oversize bows and, in particular, the dramatic hat, its floral sunburst built up as if with gesso. The blend of color on her face is, appropriately, more modulated and smooth, with the slight plumpness in the cheeks contrasting nicely with the delicate point of her chin, a feature that has prompted some viewers to discern a slightly impish quality in this otherwise poised and self-possessed youngster.

Further Reading

Evans, Dorinda. *The Genius of Gilbert Stuart.* Princeton, N.J.: Princeton University Press, 1999.

McLanathan, Richard. *Gilbert Stuart.* New York: Harry N. Abrams, 1986.

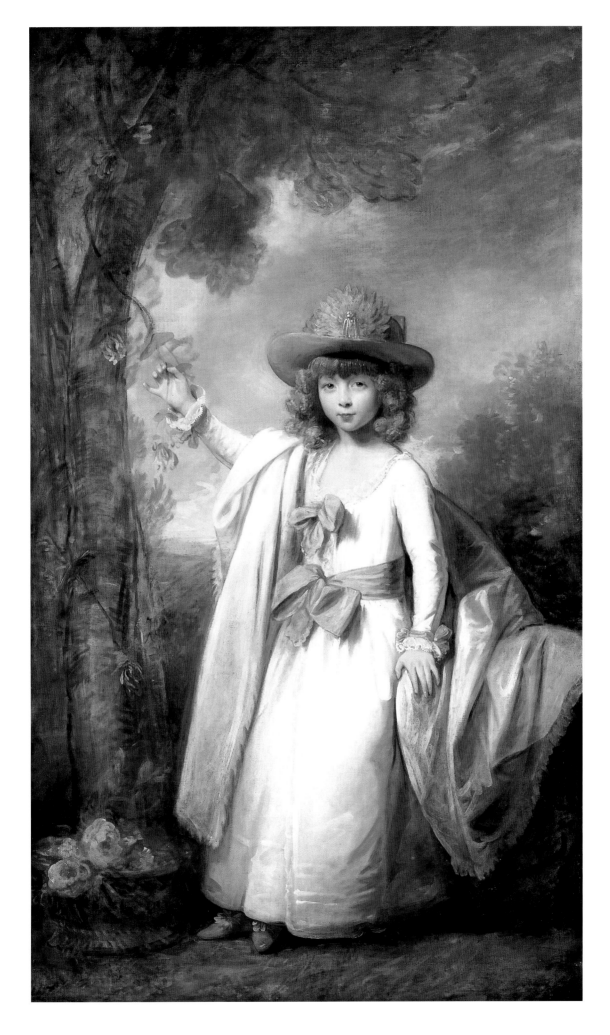

Dwight William Tryon

Hartford, Connecticut 1849–1925 South Dartmouth, Massachusetts

The First Leaves, 1889

Oil on wood panel
32 × 40 in. (81.3 × 101.6 cm)
Signed in blue-green paint, lower right: D. W. TRYON
Purchased from the artist
1889:6-1

The artist most closely linked to Smith College is surely Dwight Tryon. A professor at the college for some four decades (during which time he was a prominent figure in New York art circles), he brought a level of professional renown to Smith that few educational institutions could match. Though Tryon only visited the campus every three weeks to offer criticism to students, he worked hard on Smith's behalf, playing a significant role in expanding the college's collections through his many donations as well as his encouragement of other strategic gifts and purchases. On his retirement, he and his wife gave the funds to construct Smith's first freestanding art museum, the Tryon Gallery.

Tryon studied in France for nearly five years, and when he sailed back to New York in 1881, he bore the distinct imprint of the Barbizon tradition, a plaintive, summary style that he had imbibed through contact with such older artists as Charles-François Daubigny. In this he was not alone, and during the early years of his career his broad, solidly composed landscapes had little to distinguish them from many others then being produced by young painters returning from extended periods of European study. In May 1889, however, several years after joining the Smith faculty, Tryon was taking one of his habitual walks through the countryside surrounding his summer home in South Dartmouth, Massachusetts, when he was seized by the arresting motif of a line of slender birches, just beginning to leaf out, at the edge of a field. This became *The First Leaves,* a turning point in his life that stands as the template for nearly all that followed in his lengthy career.

The formula Tryon hit on consists of three rigorously parallel bands: meadow, trees, and sky—with the tips of the diaphanous branches forming a continuous, slightly humpy rhythm of two-dimensional "hillocks" traced against the creamy sky. The architecture of the composition is simple and clear, but this reduced, distilled quality in no way precludes the creation of the rich, poetic effects for which Tryon became famous—particularly his stylistic hallmark, the shimmering, feathery brushwork. His application of paint here is rapid and discontinuous. The foreground area consists of a web of impasto strokes smeared onto the panel, with the reddish color of the wood support occasionally remaining visible. Tryon's dabbing brush moves in many different directions, but his active surface nevertheless leaves a quiet, peaceful impression—the fresh, mossy green of new spring growth lingering like a mist among the yellowed, winter-desiccated weeds. The middle zone is even more variegated in tone, with a mosaic of mustard, brown, chestnut, and lavender strokes giving a sense of spatial depth to the distant hills.

The manner in which this bewildering mix of pastel hues holds together and coalesces into a logical, if abstractive, whole was something new in American art, and *The First Leaves* accordingly won the Webb Prize of the Society of American Artists for the most promising landscape by an American artist under forty. Critics were favorably impressed by the painting's originality, with the *New York Sun* dubbing it "perhaps the finest landscape of the year." Although his style is today known as Tonalism, reviewers in 1889 were hard-pressed to define Tryon's "new look." The *Magazine of Art* observed that its "effect of delicate iridescence of color" had "something of the quality of a Sisley," and the *New York Times* likewise found the color scheme suggestive of "the extreme impressionism of France." In time, Tryon's style would seem less radical, but even those who found this early painting unsuccessful, like the critic for the *New York Tribune,* had to admit that it definitely revealed "new lines of progress" for the future.

Further Reading

Merrill, Linda. *An Ideal Country: Paintings by Dwight William Tryon in the Freer Gallery of Art.* Washington, D.C.: Freer Gallery of Art, 1990.

White, Henry C. *The Life and Art of Dwight William Tryon.* Boston: Houghton Mifflin Co., 1930.

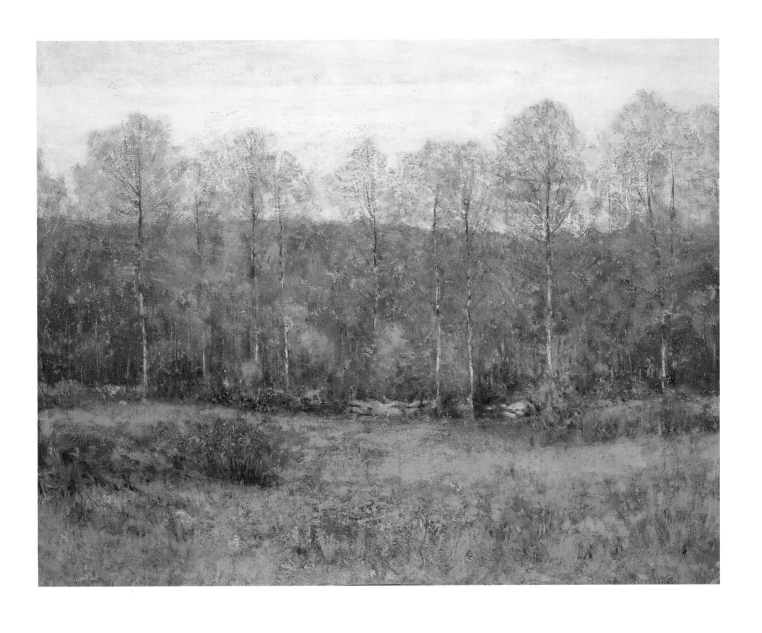

James McNeill Whistler

Lowell, Massachusetts 1834–1903 London, England

Mrs. Lewis Jarvis (Ada Maud Vesey-Dawson Jarvis), 1879

Oil on canvas
25 × 16 in. (63.5 × 40.7 cm)
Not signed or dated
Purchased, Winthrop Hillyer Fund
1908:2-1

Whistler's portrait of the Irish wife of his friend and supporter, a Bedfordshire gentleman brewer with artistic pretensions, was executed during one of the most difficult moments in the painter's career, and the rushed sitting and uncharacteristic bust format he was forced to employ for the sake of expediency left him dissatisfied with the result. Still, in its wistful, subdued range of dim pastels and its demure, ghostlike quality, *Mrs. Lewis Jarvis* stands as a fully representative example of the highly aesthetic, consciously distilled art of Whistler, which during the decade of the 1870s more than any other was greatly concerned with portraiture.

In the months leading up to the Jarvis likeness, the artist had suffered a very public humiliation when his libel suit against the imperious, conservative critic John Ruskin netted him a paltry farthing in damages. Whistler had spent a great deal in court costs, and at the same time, his relationships with formerly supportive patrons and creditors, such as Frederick Leyland, were faltering. Forced into bankruptcy in the spring of 1879, Whistler reluctantly put his beloved "White House" in London up for sale, made plans for an auction of his possessions, and prepared to depart for Venice, where he would spend more than a year recuperating from these setbacks. In this darkest hour, Whistler's friend, Lewis Jarvis, lent him fifty pounds, though he himself could ill afford it and had no hope of ever seeing it repaid. In thanks, the artist agreed to paint a portrait of Lewis's wife, Ada. She traveled to London for a sitting in mid-August, even as her host was packing for his departure.

Whistler's canvas is rough and irregular in its weave, creating a constant underlying texture, which his evanescent image never fully covers. As a result, Lewis's faint visage seems thin and hovering, stained onto the fabric rather than painted — absorbed into its thirsty fibers. The hues are low in tone, the dress a light coppery green, the background the palest of lavender-grays, and her hair a slightly richer auburn, a soft patch of ambient color that gives no real sense of local texture. Her eyes are hazel and seem somewhat small and intense set within her fine, carefully modeled face (traces of delicate drawing are visible at the chin, nose, and ears). All in all, her calm, retreating, but nevertheless iconic form seems to repel both the bright light of the modern gallery and the probing gaze of the interested viewer. This effect is accentuated by Whistler's reeded, burnished gold-leaf frame, which further quiets the wan image within.

Further Reading

Houfe, Simon. "Whistler in the Country: His Unrecorded Friendship with Lewis Jarvis." *Apollo* 98 (October 1973): 282–85.

Young, Andrew McLaren, et al. *The Paintings of James McNeill Whistler.* 2 vols. New Haven, Conn.: Yale University Press, 1980.

INDEX